me + lia

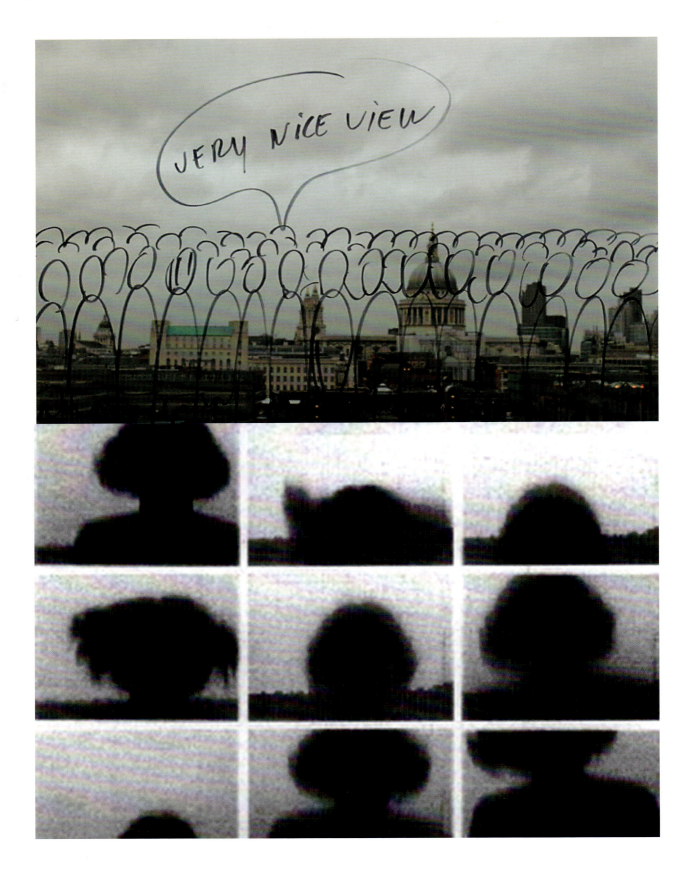

Edited by Kristine Stiles

STATES OF MIND
DAN & LIA PERJOVSCHI

Essays by
Kristine Stiles
Andrei Codrescu
Marius Babias

Interviews by
Roxana Marcoci
Kristine Stiles

Nasher Museum of Art
Duke University
2007

Published in conjunction with the exhibition *States of Mind: Dan and Lia Perjovschi*

Nasher Museum of Art at Duke University, August 22, 2007–January 7, 2008.

Nasher Museum of Art at Duke University
2001 Campus Drive,
Durham, North Carolina 27705
(919) 684-5135
www.nasher.duke.edu

COVER
Dan Perjovschi, *Nice Show*, 1999.

Detail, Lia Perjovschi, installation view of *Timeline: Romanian Culture from 500 BC until Today*, 2006, "Periferic 7 International Bienniale," Iasi, Romania.

BACK COVER
Dan and Lia Perjovschi, installation view of *4 Us*, 1992, Bucharest.

INSIDE COVER
Frontispiece of *Vom muri si vom fi liberi*, Bucharest: Editura Meridiane, 1990.

PAGE I
Dan Perjovschi, *Me + Lia*, 1999.

PAGE II
Dan Perjovschi, detail from *The Drawing Room*, 2006, Tate Modern, London.

Lia Perjovschi, still from *Loop*, 1997, black-and-white video.

Catalogue-in-publication data are available from the Library of Congress.

Library of Congress Control Number: 2007929640

ISBN: 978-0-9389-8930-1

Distributed by Duke University Press.

The exhibition, *States of Mind: Dan and Lia Perjovschi*, and related programs are sponsored in part by the Duke University Provost's Common Fund, Mary Duke Biddle Foundation, and Duke University's Office of the President.

Additional program support was provided the Romanian Cultural Institute, New York, NY, and the Department of Art, Art History & Visual Studies, and the Visual Studies Initiative, Duke University.

Nasher Museum exhibitions and programs are generously supported by the Mary Duke Biddle Foundation, Mary D.B.T. Semans and the late James H. Semans, The Duke Endowment, the Nancy Hanks Endowment, the K. Brantley and Maxine E. Watson Endowment Fund, the James Hustead Semans Memorial Fund, the Marilyn M. Arthur Fund, the Victor and Lenore Behar Endowment Fund, the Sarah Schroth Fund, the Margaret Elizabeth Collett Fund, the North Carolina Arts Council, the Office of the President and the Office of the Provost, Duke University, and the Friends of the Nasher Museum of Art.

Copyediting by Nathan K. Hensley and Laura Poole.

Printed in Canada.

Book design by Klugman Braude Design, Knoxville, Tennessee.

Harun Farocki and Andrei Ujica, *Videograms of a Revolution*, 1992, courtesy Harun Farocki and Andrei Ujica.

The primary type for this catalogue was set in Filosofia. Designer Zuzana Licko was born in Bratislava, Czechoslovakia in 1961 and emigrated to the U.S. with her family in 1968. Secondary type was set in TheSans, part of the Thesis typeface family. This neohumanist, sans serif face was designed by Lucas de Groot in the mid-1990s.

Contents

Director's Foreword

The Nasher Museum of Art at Duke University is very pleased to present the first mid-career retrospective of the work of Dan and Lia Perjovschi. Working under extremely adverse conditions before the Romanian Revolution of 1989, these two artists have since had to cope with rapid changes—changing conditions of artistic freedom, of material well-being, and of political and psychological pressures—all of which have profoundly influenced their artistic projects. Here in the West, where material conditions are generally easier, we may face other constraints produced by our intensely materialistic and seemingly superficial consumer society, and the work of these relentlessly engaged and observant artists offers a profound meditation on these varied, and varying, conditions.

Given the increased international recognition that Dan and Lia Perjovschi have enjoyed during the past few years, we are proud to acknowledge that this exhibition represents a long-standing commitment to the work of these two extremely talented artists. Professor Kristine Stiles, our colleague in Duke's Department of Art, Art History & Visual Studies, met the Perjovschis during a trip to Romania in 1992, and has become the foremost scholar of their work, first publishing on the artists in 1993. Dan first visited Duke in 1994, and both artists taught in the department for a semester in 1997. At that time, they were given their first two-person exhibition at Duke's Institute for the Arts. Since that time, they have exhibited extensively throughout the world. We are very pleased that the splendid new Nasher Museum of Art will be the venue for this important retrospective, which also commemorates a fifteen-year alliance between two artists and a scholar.

Our first debt is to the artists themselves, Dan and Lia Perjovschi, whose energy, enthusiasm, and generosity have been prodigious. It has been a tremendous pleasure working with them. We are also enormously grateful to Kristine Stiles, who agreed to organize the show and to write and edit this important catalogue. Her dedication to the artists' work, and to every aspect of the project, has been critical to its realization.

Tremendous thanks are also due to the other catalogue essayists, Marius Babias and Andrei Codrescu, who have provided lively and readable texts to help us understand the Romanian historical and cultural background, unfamiliar to many Western audiences. Roxana Marcoci, Curator of Photography at the Museum of Modern Art, has generously allowed us to reprint her interview with Dan Perjovschi, first published on MoMA's website in May 2007. We also thank Corina Suteu, Director of the Romanian Cultural Institute in New York, and *Revista 22* in Romania, for their support and assistance.

We are also grateful to the lenders who generously made works available for the exhibition. These include Marius Babius; the Ludwig Forum für Internationale Kunst, Aachen, Sammlung Ludwig; the Museum of Modern Art, New York; Lombard-Freid Projects and Jane Lombard, Lea Freid, and Cristian Alexa; Brad Marius; Dan and Lia Perjovschi; Galerija Gregor Podnar; and an anonymous lender.

We thank Duke's Department of Art, Art History & Visual Studies, the Visual Studies Initiative, and our colleagues Jack Edinger and John Taormina for their extremely generous efforts in scanning images for the catalogue. Thanks are also due to Trevor Schoonmaker, the Nasher Museum's Curator of Contemporary Art, who advised on many key points, and to Dr. Laurel Fredrickson, our Mary Duke Biddle Foundation graduate student intern, who worked closely with Kristine Stiles on all aspects of the project. Finally, we are grateful to the exhibition's funders: the Mary Duke Biddle Foundation; Duke's Department of Art, Art History & Visual Studies, and the Visual Studies Initiative; the Office of the President and the Office of the Provost, Duke University; and the Friends of the Nasher Museum. Thanks to their generous support, we are able to present this important exhibition and catalogue at the highest possible level.

Kimerly Rorschach
Mary D.B.T. and James H. Semans Director

Curator's Acknowledgments

I would like to thank Lia and Dan Perjovschi whose art and life has inspired my work as an art historian, and whose friendship, trust, respect, generosity, hospitality, and laughter have been sustaining for fifteen years. Kim Rorschach's invitation to curate an exhibition at the Nasher was the impetus for me to launch this mid-career retrospective of the Perjovschis' work. I applaud her for being the first museum director in the U.S. or abroad to recognize the singular and collective significance of the Perjovschis' art. Laurel Fredrickson has in every way, and without the title, functioned as the assistant curator for this exhibition. Her partnership has been one of imagination, endless attention to detail, and commitment. This exhibition and catalogue could not have been realized without her labor and assistance.

Andrei Codrescu, Marius Babias, and Roxana Marcoci have all contributed texts that bring intellectual breadth to the catalogue, and their involvement in the project has been rewarding. Julie Klugman Braude produced an elegant catalogue design without sacrificing the experimental nature of the Perjovschis' art; she worked with grace and patience under pressure for the many days and long hours we spent together placing the images selected for the book and making tireless revisions. Kim Rorschach, Kathy O'Dell, Susan Jarosi, Jay Bloom, Laurel Fredrickson, Nathan Hensley, and Laura Poole all offered thoughtful editorial suggestions for this text.

With the blessings of Hans Van Miegroet, Chair of the Department of Art, Art History & Visual Studies at Duke University, the staff have all made extensive contributions of time and labor to this exhibition including William Broom, Betty Rogers, and Linda Stubblefield, but especially John Taormina, Director of Visual Resources, and Jack Edinger, Photographer and Image Specialist. Jack deserves the lion's share of recognition for the many months he spent producing over six hundred superb images of the Perjovschis' oeuvre, and then responding with calm to last-minute requests for even more images. Many at the Nasher Museum have been instrumental in making this exhibition a success, including Sarah Schroth, Rebecca Swartz, Wendy H. Livingston, Carolina Cordova, Myra Scott, and Shelby Spaulding. Special thanks to Trevor Schoonmaker for his attention to and advice on this exhibition. Also Peter Paul Geoffrion for exquisite photographs of some of Lia and Dan's works and to Brad Johnson for his unparalleled skill in exhibition design and installation, as well as for his advice ranging from conceptualizing the space to placement of objects and framing of pictures. Jane Christy (Christy's Custom Picture Framers in Durham) spent many hours consulting on and making the frames for this exhibition. Tackle Design reconstructed the technological surveillance apparatus for Dan Perjovschi's drawing installation *Scan*, 1993, and Mark Olson, Director of New Media and Information Technologies at the John Hope Franklin Center at Duke University, created the first webcasting component for *Scan* and facilitated the redesign of this important work. Julie Tetel, Octavian Esanu, and Corina Apostol provided translations from Romanian to English for this exhibition; Corina also served as my research assistant, enthusiastically contributing to various aspects of the exhibition.

Corina Suteu, Director of the Romanian Cultural Institute in New York, enthusiastically supported the exhibition by bringing Romanian curators to the opening. Cristian Alexa, Director of Lombard-Freid Projects in New York, provided gracious assistance for many requests. Thanks to Lia Perjovschi for her permission to enlarge one of her photographs of Dan Perjovschi's installation *rEST* at the 1999 Venice Biennale. Special thanks also to Wolfgang Günzel for permission to enlarge two of his photographs of Dan's installations for this exhibition: *White Chalk Dark Issues*, in Essen, Germany, and *On the Other Hand*, at Portikus

in Frankfurt-am-Main. Lombard-Freid Projects in New York, Galerija Gregor Podnar in Ljubljana, Galeria Helga de Alvear in Madrid, and Gallery Yujiro, in London, all supported this exhibition.

The 1991 exhibition "State of Mind Without a Title," curated by Romanian artist Sorin Vreme and Romanian art historian Ileana Pintilie, inspired the modified title of this exhibition. Their exhibition took place in the city of Timisoara where the Romanian Revolution began. Their title also served as the muse for Dan and Lia's performances during that event. Uniquely capturing the psychological circumstances of the period, the title equally foretold how the Perjovschis' art would register as clear, embodied states of mind.

My passion for Romania was literally sparked when someone attached a plastic explosive to my rental car in the summer of 1991, blowing out the back window of the vehicle in a village in the area of Buchovina, in the the northeast corner of Romania, where I was visiting the monasteries and painted churches. As someone whose scholarship has always been devoted to destruction and violence, I took this attempt to encourage me to leave the country as a particularly Romanian invitation to return. Dr. H. Keith H. Brodie, then President of Duke University, and Adrian Bejan, J. A. Jones Professor of Mechanical Engineering at Duke, supported that return six months later with a travel grant to research and teach in Romania. That year, 1992, I met Lia and Dan Perjovschi.

Kristine Stiles
Professor, Department of Art, Art History & Visual Studies
Duke University

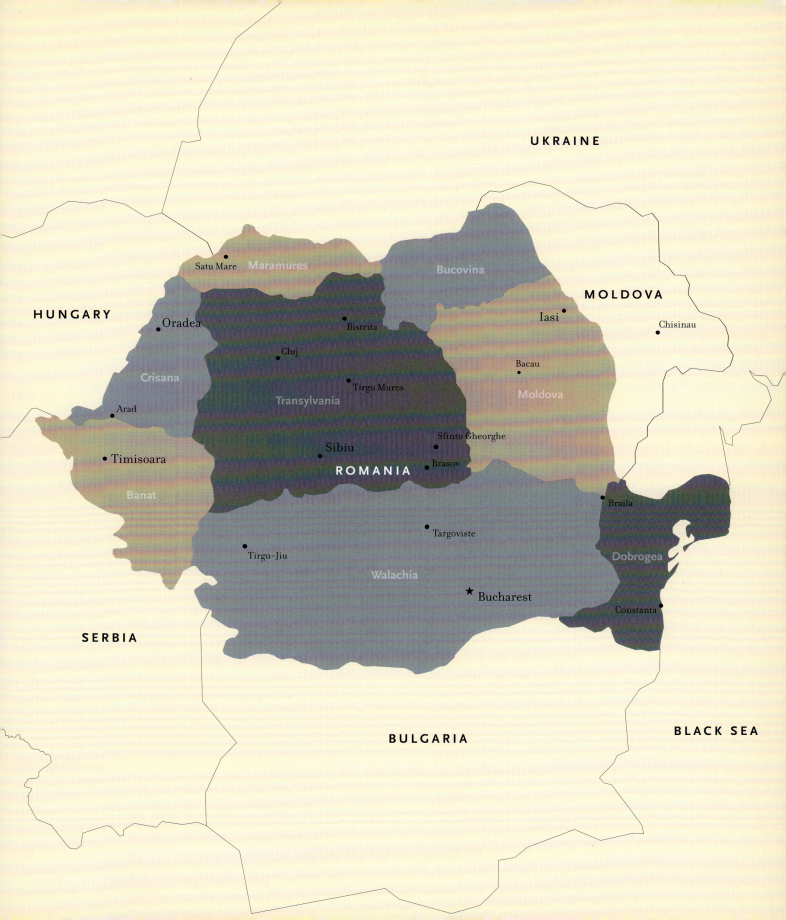

Kristine Stiles

STATES OF MIND: Dan and Lia Perjovschi

Dan and Lia Perjovschi's art is of singular significance in the development of experimental art in Romania since the late 1980s. The Perjovschis' work matured under the double pressures of Romanian socialism and Soviet communism. In response to these influences, both artists forged original and challenging forms of visual expression in drawing, performance, installation, and conceptual practices, as well as in the analysis and use of mass media (especially television and newspapers). Both artists have also been heralded internationally, included in many biennials throughout the world, and featured in dozens of international group and solo exhibitions. The current exhibition, however, is the first retrospective of their work, one that follows ten years after Duke University hosted their first two-person show in the United States in 1997. That year the Perjovschis served as artists in residence at Duke: Dan taught experimental drawing, and Lia taught performance, installation, and video. [Figs. 354–356] Knowledge of the Perjovschi's lives in pre- and post-Revolutionary Romania is critical to understanding their art.

The Perjovschis were born in 1961 in Sibiu, situated in the center of Romania in the Fagaras Mountains, the highest peaks of the Southern Carpathians; Sibiu's archeological remains date from the Late Stone Age.[1] [Fig. 1] Dan and Lia met as children while attending special schools for the training of artists in Sibiu, and became romantically linked as teenagers. [Fig. 2] During their studies, these art schools were closed by the former dictator Nicolae Ceausescu, and the Perjovschis graduated in 1980 from a Pedagogical School. Dan entered the Academy of Art in Iasi, a city on the eastern border of Romania; his studies were interrupted by nine months of military service. Lia remained in Sibiu even after their marriage in 1983. The couple was only able to live together after 1985, when Dan finished his studies and was appointed to a museum position in Oradea, on the Hungarian border of Romania. [Fig. 3] There, Lia obtained a post designing stage sets for the theater.

In 1987, Lia was finally admitted to the Academy of Art in the capital city of Bucharest, after six years of being informed that she had annually failed her entrance exams. Such manipulative measures arose

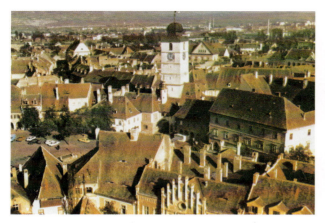

Fig. 1, above
View of Sibiu.

Fig. 2, right
Dan and Lia Perjovschi, art class,
1979, Pedagogic Lyceum, Sibiu.

from the widespread corruption that reflected the repression and scarcity that the Romanians increasingly experienced in the late 1970s and throughout the 1980s, which only became more severe and punishing. Romanians were not permitted to travel; typewriters were illegal; books were restricted; and knowledge and information from the West were tightly controlled. Shortages of basic goods and services (food, water, and electricity), as well as limited access to professional advancement, resulted in a barter economy that encouraged favoritism and nepotism in exchange for gifts, promotions, and other advantages. This system meant that although Lia may have successfully passed her exams, she might also have been excluded in favor of those from whom the examiners could gain advantages. But their refusal to permit Lia to enter an art academy was also an example of how, in the former Romanian communist system, officials controlled antiauthoritarian behavior, of which Lia was perceived to be guilty as early as high school. The result was that between 1980 and 1985, the Romanian authorities assigned Lia to various forms of manual labor and service jobs: painting ornamental Christmas tree balls; fabricating suitcases in a leather factory; and collecting electrical bills for the state.

A grave example of Lia's resistance to the corrupt system occurred in 1980, when she led a protest by her fellow employees at the Christmas ball factory. She complained about the appropriation of workers' wages by the managers, showing records of hours worked and balls produced for which they had not been paid. Lia recalled how the director addressed the crowd gathered behind her:

> "Really!" he said, "Who agrees with Amalia?" No one spoke. Silence. From that time on, I thought my ears grew because I listened so hard to their silence; I couldn't believe that I could hear so much silence. Then the director said: "You know what, you are an instigator; and if I can, I will put you out [of the factory and future employment] with an I." Workers received the mark of "I" when they were deemed undisciplined troublemakers, dangerous, and unworthy of hire. "In this case," I replied, "I quit." [2]

Lia stormed out of the room. Later the other women explained their lack of support with a variety of excuses: "Look, Lia', you know I have three kids." "It's not the first time something like this has happened." "I can't be like you." "You have a family to support you." Some women told her that they also worked as prostitutes and feared that if they confronted the director, he would report them to the police. "Somehow everyone had a reason not to support me," Lia remembered. After this event, Lia's parents accused her of quitting her job because she was "lazy." [3]

The Revolution began on 16 December 1989 in Timisoara, on the borders of the former Yugoslavia and Hungary, and by 20 December had spread to the cities of Sibiu,

Cluj, and Brasov. [Figs. 4, 25–26] Traveling from Oradea and Bucharest, Dan and Lia met in Sibiu to be with their families over Christmas and to participate in the street protests. By 21 December, the Revolution had reached Bucharest and fighting had broken out in Sibiu. Encountering the couple Liviana Dan (an art historian) and Mircea Stanescu (an artist) during the protests, the Perjovschis were fortunate in being able to remain in their friends' apartment for several days to escape the violence, as civilians were being shot in the streets. Meanwhile, Ceausescu and his wife Elena fled Bucharest, were apprehended, accused of crimes against the state, and then shot by a firing squad on Christmas Day 1989. [Fig. 228] The perfunctory execution, which was later televised, was met with cheering and weeping crowds throughout Romania.

Fig. 4
View of Timisoara.

Fig. 3
View of Oradea.

The tape of the event showed the couple as arrogant, defiant, and unrepentant to the very end. Far from spectacular, the circumstances of the dictators' execution were stunning in their banality: the couple lay dead in a dilapidated, inner courtyard of an army base schoolhouse in the small town of Targoviste, eighty kilometers northwest of Bucharest. This scene stood in marked contrast to the fact that they had exercised absolute control over Romania for over twenty years, during which time they bankrupted the state, in large measure due to having built the ostentatious Palace of the People (Palatul Poporului), one of the three largest buildings in the world. [Fig. 139] For its construction, Ceausescu razed large sections of the middle of Bucharest, including villas, schools, monasteries, and other municipal buildings in a city once described as the "Paris of the East." These offenses (and many others) led to the Revolution, later discovered to have not been a popular uprising, but rather one orchestrated from within the party and those closest to the Ceausescus.

Early in 1990, Lia was approached to take a position in the new Youth Department in the Ministry of Culture as a result of her leadership role in the Art Academy

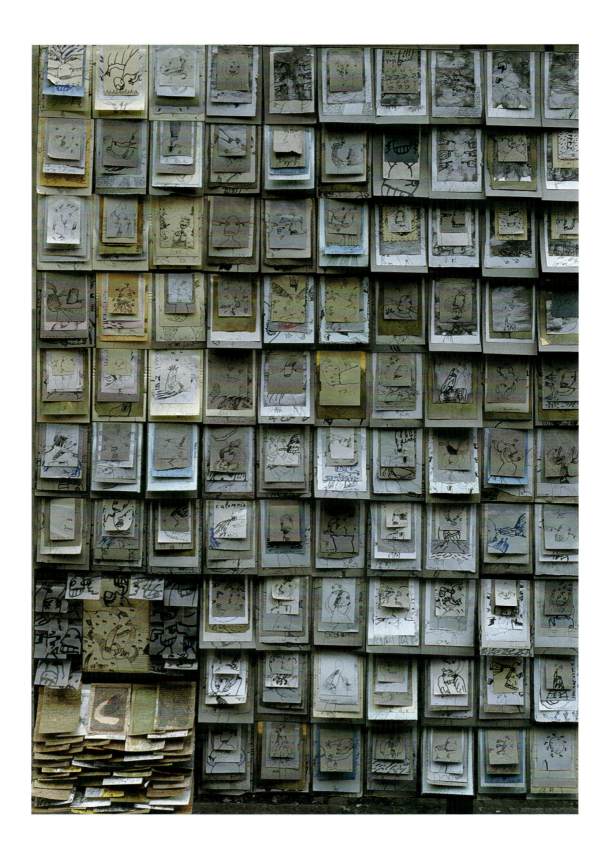

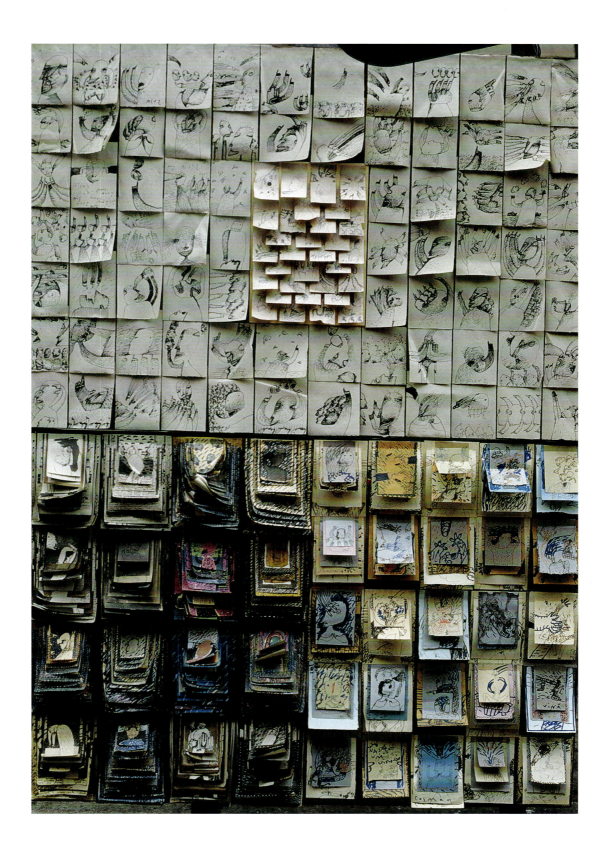

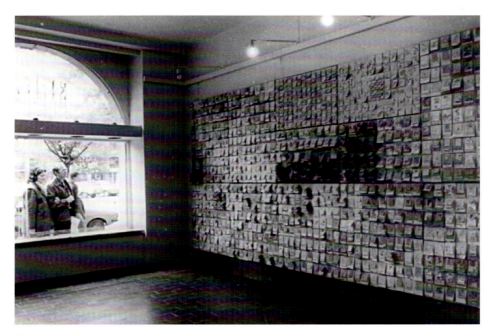

Network (called Atelier 35),[4] Lia declined the offer and suggested Dan (along with Carmen Popescu, a young art historian) in her place. Dan and Carmen were hired.[5]

In the decades following the Revolution, the Perjovschis rose to prominence both in Romania and abroad. Dan pioneered large-scale, site-specific drawing installations with literally thousands of figures, varying in scale and drawn on everything from the floor to the walls and ceiling, depending on the site. [Figs. 5–7, 297–299] He would eventually use the fax machine and email to transmit his drawings, which he also collected in a number of artist books. [Figs. 8–9] Dan's reputation in Romania spread rapidly due to the drawings he began creating in 1991 for *Revista 22*, the leading Romanian independent newspaper, established

Figs. 5–7, previous pages and above
Dan Perjovschi, *Anthropoteque*, 1990–1992; details of panels 1 and 4 and installation view; ink and watercolor on pastel on paper.

Courtesy of Ludwig Forum für Internationale Kunst, Aachen, Sammlung Ludwig.

student movement during the Revolution. Seizing the opportunity for Dan to move to Bucharest, and because Dan was more familiar with the National Young Artist

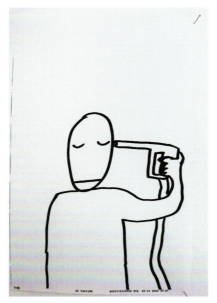

Figs. 8–9
Dan Perjovschi, *I shoot myself in the foot*, 2005, Exit Gallery, Peja, Kosovo: fax project; and detail, fax drawing.

by the Romanian dissidents who founded Group for Social Dialogue (to which Dan still belongs).[6] [Figs. 55–56] Dan continues to this day to work for *Revista 22*, using drawings to respond to and analyze specific social, cultural, and political topics covered by the newspaper. For *Revista 22*, Dan also wrote about contemporary art exhibitions and authored columns on body and performance art. Over time, his commentaries grew from analyses of local topics into discussions of the relationship between Romanian and international art, and he began to write short pieces on art and aesthetics for various magazines. In 1998, at the urging of Gabriela Adamesteanu, a noted Romanian novelist and former editor-in-chief of *Revista 22*, Dan contributed a biweekly column to *Revista 22*. Originally lengthy and discursive, these commentaries have become shorter and more concise over time. According to Dan, this is "because my writings mirror my drawings; because I like to be short and definitive."[7]

Lia was first recognized for intensely personal body art performances, realized between 1987 and 2005. These actions were primarily concerned with identity but also incorporated interaction with the public. [Fig. 10] Her performance work overlapped with the development of her archive project, *Contemporary Art Archive*

Center for Art Analysis (CAA/CAA), which she began in 1997. [Fig. 161] From its inception, CAA/CAA has operated as an analytical and critical platform devoted to the scrutiny of the construction of history and aesthetic and social formations. Lia situates CAA/CAA in a global context that also analyzes the current evolution from labor- to knowledge-based societies and economies. As an outgrowth of CAA/CAA, she has begun to make drawings and small-scale models for what she calls the *Knowledge Museum*, which will have seven departments (see page 92). [Figs. 169, 226]

Together in 1992, the Perjovschis created their first pair of newspapers, which functioned as catalogues for their work. Lia expanded this practice under the rubric of CAA/CAA, which has produced numerous newspapers on specific themes. [Figs. 146–153] Also through CAA/CAA, Lia performs conceptual/pedagogical actions in workshops, a mode of art-making related to public education at the nexus of art practice, art institutions, and the analysis of history. She also uses drawing to meditate on these themes, sketching what she calls *Mind Maps (Diagrams)*. [Figs. 11, 322, 374] These conceptual diagrams chart dynamic and unexpected relationships culled from the books she reads on many topics. Her *Mind Maps (Diagrams)* reveal the interdependency of

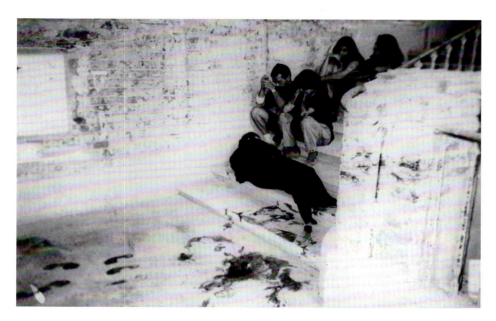

Fig. 10
Lia Perjovschi, *I'm fighting for my right to right to be different*, July 1993; performance in Art Museum, Timisoara.

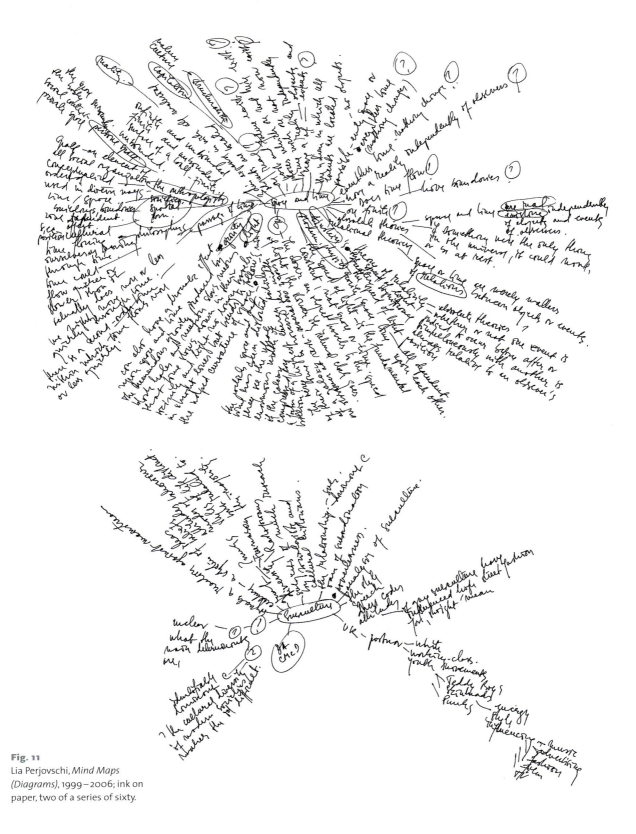

Fig. 11
Lia Perjovschi, *Mind Maps
(Diagrams)*, 1999–2006; ink on
paper, two of a series of sixty.

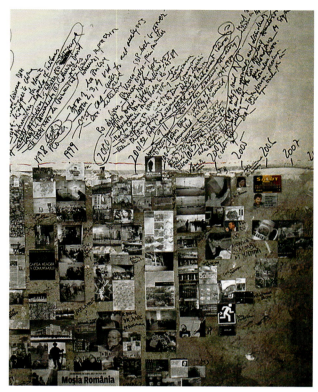

Fig. 12, above
Lia Perjovschi, *Timeline: Romanian Culture from 500 BC until Today*, 2006; installation in Turkish Bath, Iasi; collage and drawing.

Fig. 13, above right
Dan Perjovschi, *Nice Show*, 1999; marker drawing.

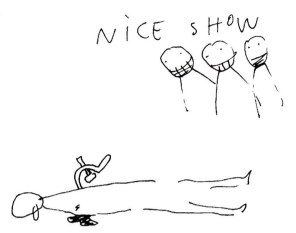

and architecture, and covered such topics as the human body, the city, XXI century, center and periphery, art market, cultural policies, and manipulation. Through this program, the Perjovschis succeeded in introducing the general Romanian public to avant-garde performance, installation, video, and conceptual art. The impact on artists, art institutions, and the public of this nationally televised series cannot be overstated. Equally impressive was the openness of Romanian television at that time, which broadcast images of body art performances so radical that few networks in the U.S. would air them even today. In the 2000s, the Perjovschis have traveled extensively and been involved in and commented critically upon the international art scene.[8]

diverse categories of information in ways that recall her *Timelines*, which feature idiosyncratic constructions of history, fleeting lines of development, regression, and circularity that reflect on the inherent artifice of historical time. [Figs. 12, 18, 377]

In 2000, the Perjovschis designed and hosted a television series, titled "Everything on View." The series ran on Romanian National Television (TVR 1) for three hours (10:00 a.m. to 1:00 p.m.) each Saturday for ten weeks from October to December. [Figs. 156, 360] Produced by Ruxandra Garofeanu and directed by Aurel Badea, the series was hosted by the Perjovschis, who appeared with historian Adrian Cioroianu (currently serving as the Minister of Foreign Affairs for the Romanian government). "Everything on View" included sections on visual art, politics, dance, film, theater, literature,

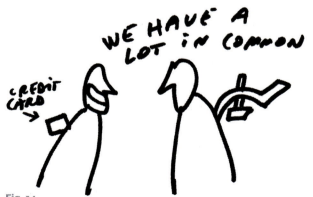

Fig. 14
Dan Perjovschi, *We Have A Lot In Common*, 2007; marker drawing.

Throughout their personal and artistic developments, Dan and Lia have lived as a couple and grown as individual artists. Despite their shared history and influences, they have developed remarkably consistent individual bodies of work, each internally coherent and distinct from the other. This retrospective exhibition honors the Perjovschis' separate but mutually enhancing oeuvres in the spirit of an historical record of persistence, courage, and vision.

INTRODUCTION

Two images appear on the front cover of this catalogue: Dan Perjovschi's drawing *Nice Show* (1999),[9] and a photograph of Lia Perjovschi's installation *Timeline*,[10] which was exhibited at the second international Romanian Biennale in Iasi, Romania, 2006.[11] [Figs. 12–13] In Dan's drawing, two viewers congratulate the prone Eastern European artist for his successful exhibition. The artist lies face down on the ground, profusely bleeding from having been stabbed in the back by the hammer and sickle, notorious symbols for the industrial proletariat and the peasantry celebrated by communism. While the artist suffers from his physical and emotional wounds, the public remains insensitive to the foundations upon which his illustrious work rests; with the feeble word "nice," it applauds the artist's "show" without the slightest regard for how his historical experience produced such a critical vision.

Eight years later, in 2007, for his one-person wall-drawing installation at the Museum of Modern Art in New York, Dan made a second, related drawing. Two people stand chatting. One figure has the now-familiar hammer and sickle embedded in his back and the other has been stabbed in the back by his credit card. The man with the hammer and sickle says to the man with the credit card: "We have a lot in common." [Fig. 14] In this 2007 drawing, Dan—himself an artist of international renown—levels the playing field between the once suffering Eastern European artist and his previously smug capitalist comrade, who now bleeds to death in credit card debt.

These two drawings address the often false dichotomies between the West and countries of the former Soviet bloc, exposing the destructive potential the two systems paradoxically share. In another related drawing, Dan responds to the West's caricature of peoples from the Balkans as strange and different, examining the psychological prejudices and xenophobic pretensions—national and ideological—that inform the two drawings described above. After nearly two decades of backbreaking work in the business of art, he writes:

<div align="center">

I AM NOT EXOTIC
I AM EXHAUSTED

</div>

As a drawing composed only of text, this piece is unusual in Dan's oeuvre.[12] But the words here function as images, summoning the concepts of exoticism and exhaustion and linking them in a suggested, but unresolved symmetry. While exoticism conjures individualistic notions of how another person comes to be considered different, exhaustion evokes a common sensation of deep fatigue. Dan's drawing links the universal (the human feeling of being exhausted) to the specific (the individual's perception of what is "exotic") through alliteration in the repetition of a consonant sound, "EX." As an English prefix, "ex" is derived from the Latin for external, or outside, but it also means past. The wordplay leaves the artist caught in the conundrum of always remaining the other. Forever doomed to the periphery, somewhere other than the center, he cannot escape being seen as the outsider, while equally joining the center as a consequence of being a citizen from an ex-communist country and an ex–Eastern European; even though Romania joined the European Union in 2007. Such knotty paradoxes are a key part of what makes Dan's drawings funny, even though the laughter is always self-conscious. For viewers cannot help but reflect on the realities he portrays, which contributes to their increasing sense of discomfort.

Figs. 15–16, previous page and above
Lia Perjovschi, *Research File. General Timeline: From Dinosaurs to Google Going China*, 1997–2006; collage and drawing on paper, two in a series of thirty-one.

In an earlier version of the drawing, one that includes a figure, Dan distributed the words in a different way:

> I AM NOT
>
> EXOTIC
>
> I AM
>
> EXHAUSTED

This placement of the words on the page is important, since it emphasizes his identity: "I AM NOT" and "I AM." Dan's personalized statement does not accuse viewers, but still subtly suggests that it is they who have pictured him as the exotic Romanian. [Fig. 17] When read vertically, the drawing creates a visual pattern, with the vowels A/E/A/E alternating with the phrases "AM EXOTIC" and "AM EXHAUSTED." This pattern suggests connections between Dan's work and Concrete Poetry, which emphasizes the visual or auditory content and form of language.[13] Taken together, these aspects of the otherwise seemingly simple work have the tendency to erase the specific, namely each viewer's particular relation to the exotic, and replace it with the more common idea of being completely worn out. This approach undermines difference (exoticism) by using humor to level the circumstances in which competition and alienation emerge so that commonality (exhaustion) is emphasized. As Dan has noted, he first made this drawing in 2002 as a way to "escape" what he called "this jail-exhibition . . . the exoticism of 'After the Wall' [the exhibition of Balkan art at the Moderna Museet in Stockholm in 1999]."[14] Given Dan's sense that the exhibition presented Eastern European artists as exotic, it is ironic that the show was curated by Bojana Pejic, herself a Serbian art historian and, therefore, another "exotic" from the Balkans. In this comment and his work, Dan offers a critique of the impulse of art criticism to turn selected groups of artists and their work into curiosities. In this sense, Dan's work calls attention to the difficulties that attend the representation of historical processes, as well as the subsequent circulation of those representations outside their original contexts.

For her part, Lia's work is also engaged with the complexities of history, taking political and personal experience, as well as representation itself, as its main themes. In her 2006 *Timeline* of Romanian history, she wrote directly on the wall in Iasi, selecting dates that create a narrative of events most significant to her. [Fig. 18] This obstinately personal work has little in common with official, so-called objective histories, which can flatten out and obscure interpersonal relationships and historical interconnections in ways that render events hardly recognizable to those who have experienced them. History lives for Lia. She constantly reinterprets it in relation to her patterns of learning.

Lia's interest in timelines may be understood as a form of retaliation: it represents the assertion of the subject in control of her sense of time's meaning, emphasizing the authenticity of individual choice in the narrative of how history develops. Below the handwritten dates of *Timeline*, Lia glued photocopied images that indicate

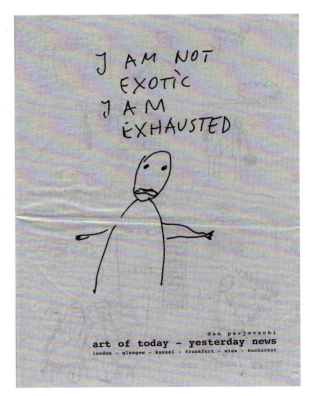

Fig. 17
Dan Perjovschi, cover of *art of today—yesterday news*, 2002; newspaper.

Fig. 18
Lia Perjovschi, *Timeline: Romanian Culture from 500 BC until Today*, 2006; installation in Turkish Bath, Iasi; collage and drawing.

individuals, places, buildings, and objects—central axes around which history is constructed and unfolds. Although these images are intended to animate and augment the *Timeline*, the pictures actually reinforce the instability of history. For these apparently self-contained and self-evidently meaningful images require captions to articulate their references. Conversely, as German cultural critic Siegfried Kracauer pointed out in 1936, even with captions, images can quickly lose recognizability and meaning. His observations have been repeated, mostly without citation, by theorists especially of photography ever since.[15]

Indeed, Lia's insistence upon accurate citation reveals her passion for righting injustice and correcting history.

Such is the response of one who has been made to submit to the distortion of events by the active reshaping of them, as it was in Romania under the yoke of dictatorship. But her own eccentric renditions of time and events also reiterate such practices by intrinsically questioning the notion of historical fact. Thus, Lia's *Timelines* are aesthetic models for broader considerations of how history is shaped and by whom; focusing on key historical figures and representations of them, they are also meditations on the complexity of visual images and their importance to notions of time and memory. [Figs. 15–16] In this regard, her work might be said to reflect on the interrelationships among power, prestige, and oppression, such as those immortalized by the English poet Percy Bysshe Shelley in his sonnet *Ozymandias* of 1818. In the poem, Shelley described the Egyptian Pharaoh Rameses II (1304–1237 BCE), known to the Greeks as Ozymandias.

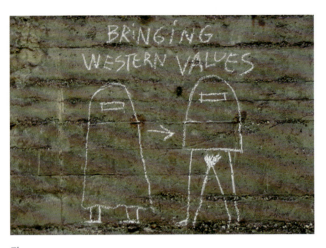

Fig. 19
Dan Perjovschi, *Bringing Western Values*, 2003; chalk on wall.

He wrote that the great leader's funeral monument bears this inscription:

> My name is Ozymandias, king of kings
> Look on my works, ye mighty, and despair!

But Shelley completes this picture by observing:

> Nothing beside remains. Round the decay
> Of that colossal wreck, boundless and bare
> The lone and level sands stretch far away.[16]

Time sweeps clean the past. The time Shelley invokes here is the same time that in her work Lia simultaneously seeks to capture, contain, and parody. This construction of time is also the time that Dan's fleeting drawing installations (which are almost always destroyed after the exhibition) reinscribe as temporary pictures of the vanity of life and art. In these ways, the Perjovschis' works touch upon the ancient theme of *vanitas* in a new visual vocabulary, one that cautions viewers about the transience of life and the egotism of art.

Lia's Romanian *Timeline* also captures qualities of temporal and spatial hybridity, introducing a complexity that troubles historians' attempts to organize and chart time. She installed her *Timeline* in a ruined and recently semi-reconstructed Turkish bathhouse,

a historic monument remarkable for its architecture and for being the only building of its kind preserved within a monastic ensemble of buildings: the Cetatuia Monastery, a priory of the Eastern Orthodox Christian faith in Iasi.[17] Thus, the very placement of Lia's installation encapsulated the inconsistencies and contradictions of historical hybrids. Using them as a metaphor for the incongruities of the twenty-first century itself, Lia's Iasi *Timeline* points to the conceit in imaging that this moment in history represents the first truly global culture, forgetting the silk and spice trade routes crisscrossing the planet and the great migrations out of Africa that a hundred thousand years earlier gave rise to different races. Lia's *Timelines* plunge viewers into contemplation, stirring them to consider how the onslaught of competing conditions and sources of knowledge mesh national and international narratives in a cacophony of information. In addition to her *Timelines*, she

Fig. 20
Dan and Lia Perjovschi, *4 Us*, 1992; installation in cellar of Podul Gallery, Bucharest.

draws *Mind Maps (Diagrams)* on a variety of topics, highly personal schemas that lay out intricate patterns of associations whose materials she culls from her readings on a wide range of subjects and themes. Evident in her *Mind Maps (Diagrams)* and in other works, Lia's eclecticism demonstrates how knowledge is constructed through an amalgamate of patterns of interrelationships.[18]

What I am pointing out about the two works on the cover of this catalogue is how they demonstrate some of the ways in which the Perjovschis' art explores questions of who possesses the power to shape history and how individuals and collectives are perceived within history. Such concerns are tied both to the distortions of history through which the Perjovschis have lived, and to the contentious historical context they entered in 1990, a situation that put an end to their twenty-seven years behind the Iron Curtain. In this sense, it is both ironic and poignant that voices from the West sought to prescribe, if not curtail, the notion of historical self-determination just at the moment when Romanians began to take charge of it. For in the summer of 1989, just months before the Romanian Revolution, Francis Fukuyama published his infamous essay "The End of History?"[19] Fukuyama, at the time deputy director of the U.S. State Department's policy planning staff and analyst at the conservative RAND Corporation, had already claimed the end of "ideological evolution." He argued that this shift in constructions of knowledge and politics would bring about the advent of universal Western-style liberal democracy—never mind the complexities of the shifting ideological cross-breeding taking place around the world. In this "new world order," as it was

Fig. 21
Lia Perjovschi, *Listen: Report from Belgrade*, 1999, performance taping; interviews with Belgrade citizens after NATO bombings.

called in the 1990s, history would still be dictated from above, even as it simultaneously became a commodity in the global market and, paradoxically, would be prescribed by the only remaining superpower, the United States, which itself had lost credibility and become increasingly suspect.

Into this fray, the Perjovschis unleashed their art and its bold individual, social, and historical critique. Consider Dan's drawing *Bringing Western Values* of 2003, which could be said to have addressed retrospectively the arrogant contradictions of Fukuyama's (later discarded) pronouncements. [Fig. 19] In *Bringing Western Values*, Dan juxtaposed two women: one wears the traditional burqa (the loose garment with veiled eyeholes worn by Muslim women), and the other keeps her head modestly covered with the veil of the burqa, but her body is naked below it. In this drawing, Dan addressed the vanity that informs the project of bringing liberal democracy to "fundamentalist" nations.

His drawing countered the ill-conceived notion that Western civilization is somehow superior with a picture that shows how the West "liberates" women by turning them into sex objects. Dan made this drawing at a time when he was "really mad" (as he phrased it) about the Bush administration's program of "Winning Hearts and Minds" in the Middle East by alternately dropping bombs and food on populations.[20] Dan could not have anticipated that three years after creating *Bringing Western Values*, in 2006, the paparazzi would photograph pop star Britney Spears stepping out of a limousine wearing no underpants. In this context, his drawing became prophetic of just how confused Western values had become at the very moment that Romania was in the process of joining the West by becoming part of the European Union.

Fig. 22
Dan Perjovschi, *Alone and Gray*, 1989; ink on paper.

Lia has also brought attention to such issues. In 1999, for example, she recorded interviews with Serbian citizens soon after NATO forces bombed the capital city of Belgrade in April of that year. Their testimonials recounted the fear and astonishment of being bombed by the very forces intended to protect them. Titling her action *Listen: Report from Belgrade* (1999), Lia exhibited photographs of her intervention, as well as the tapes (to which the public could listen) as her contribution to the exhibition "BELIEF" in Belgrade that summer.[21] [Fig. 21] In this way, she provided aesthetic witness to traumatic events and exposed the self-satisfaction of triumphal historical pronouncements, as well as the hypocritical actions of liberal democracies.

I began this introduction by discussing the two cover images on this catalogue in order to emphasize how the Perjovschis' work exhibits densely intricate, overlapping, and shared states of mind. Both artists have emerged from the obscurity in which Romania once found itself with work that testifies to the capacity of art to instruct and heal. The Perjovschis' art also bears witness to how, before 1990, Romanian artists found their means of expression in humble materials, resourcefully transforming meager assets into powerful aesthetic commentaries on the human condition. Dan and Lia continue today to live and work modestly, to create ephemeral installations and actions, and to eschew the increasingly self-conscious art-world spectacle. To remember the lessons of their past, I have selected an illustration for the back cover of this exhibition catalogue to remind the public of the foundational conditions of their lives and art. It is a documentary photograph of the Perjovschis' first collaborative installation, *4 Us*, which they made in 1992. [Fig. 20]

In *4 Us*, Lia and Dan lined in transparent plastic the narrow space of a dank, dark, tiny basement room of the Bucharest building that housed the Artist's Union gallery Podul.[22] The installation was part of a group show titled "Transparency," curated by art historian Alexandra Titu. For this exhibition, the Perjovschis decided to remain at a distance from the other artists. As Dan pointed out: "At the time the habit was to stuff the space

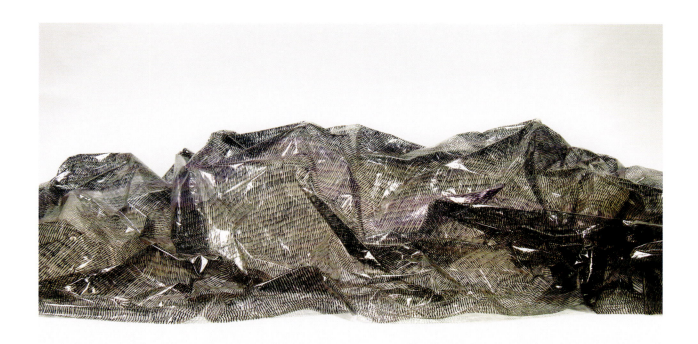

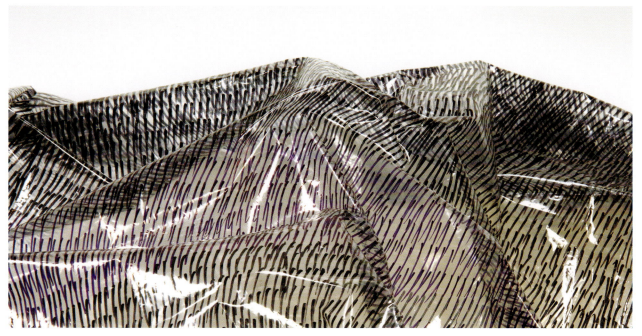

Figs. 23—24
Lia Perjovschi, *Abdeckplane*, 1996;
marker on plastic sheet.

EROII DIN TIMIȘOARA SÎNT
NEMURITORI
SĂ FIE JUDECAȚI
JOS DICTATURA
JOS COMUNISMUL
JOS COMUNISMUL
JOS CEAUȘESCU
LA SIBIU SE TRAGE ÎN POPULAȚIE
JOS CEAUSESCU
JOS CEAUȘESCU
JOS CEAUȘESCU

with art works, like a huge cacophony, and we wanted a bit of space for us; the gallery was called 'The Attic,' so we chose the cellar." [23] Separating themselves from the others while they continued to participate in the exhibition, the Perjovschis established what would become their signature position within Romanian culture: they remain simultaneously at the center, exemplary of the most advanced experimental art in Romania, and at the periphery, where they critique its institutions and artistic practices.

More important, *4 Us* commemorated the cellar room in which Dan and Lia had lived in Bucharest when Dan first moved there from Oradea.[24] Their tiny room—much like the space in *4 Us*—was large enough only for their single bed, which they shared with cockroaches; the toilet and running water, shared with others, was down the hall. Wrapping *4 Us* in plastic, they closed off a symbol of their intimate past, as well as honored the struggle of their lives: packing up an image of their shared history in a manner also permitting its transparency. Is it any wonder, given such experiences, that Dan created a series of works titled *Alone and Gray* (1987–1989)? [Fig. 22] Or that Lia would continue her childhood practice of repetitively "drawing rain" in the creation of works that transformed falling water into whole fields of meditational graphic marks?

Lia's technique is evident in *Abdeckplane* (1996), a drawing made on plastic sheeting used to protect surfaces during house painting. Lia maintained the German word for the sheet—*Abdeckplane*—as the title for the work, which is a combination drawing and sculpture. [Figs. 23–24] Especially characteristic of the kinds of inexpensive and readily available materials that the Perjovschis would select for making art, the unassuming plastic was made to become a complex image by cross-hatching the entire surface in black marker. When the marker faded in some places, it changed color into shades of purple and beige. When the sheet is arranged in different formations of heaps and folds, a strange but fantastic landscape results. The repetitive process of making the same marks in order to produce such an object is precisely the reflective action

one needed to travel mentally away from the harsh circumstances of life in pre-1989 Romania. Like a magic carpet, an object like *Abdeckplane* could transport its maker to other lands. Once the Perjovschis began to travel in 1990, however, such an object, purchased in one of those previously "foreign" places, became iconic of their journey.

The distance traversed between such works as *Nice Show* and *Timeline*, on the front cover of this book, and *4 Us*, on the back cover, is the expanse charted by this retrospective, the space between Dan and Lia Perjovschi's past and their present.

BEFORE AUGURS AFTER: PART I DAN
Dan Perjovschi remembered the Revolution, especially as he and Lia experienced it in Sibiu:

> Three degrees of people participated in the Revolution: people in the windows making supportive gestures with peace signs; people walking on the walkways as if they are passers by; people in the street protesting. On the 21st of December, Ceausescu was still in power and we joined them.

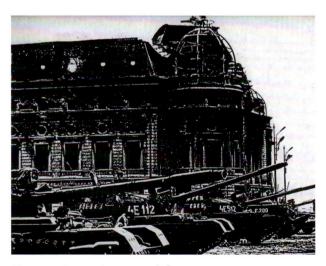

Figs. 25–26, opposite page and above
Graffiti and tanks during Romanian Revolution, 1989. Translation of graffiti, top to bottom: The Heroes of Timisoara Are Immortal; Let Them Be Judged; Down With The Dictatorship; Down With Communism; Down With Ceausescu; In Sibiu They Are Shooting At The People. From *Vom muri si vom fi liberi* (Bucharest: Editura Meridiane, 1990): 109, 193.

For the first time in my life it took guts to go on the street; we got the first gas and had police pointing guns at us, and the Army pointing guns at us, too. When we got to Sibiu, we left stuff at Lia's parents house and joined the Revolution; we got caught and spent 8 or 9 days in Liviana Dan's and Mircea Stanescu's apartment; we cried when they announced that Ceausescu split. I had a beard so we could not go out. We guarded the building with kitchen knives; we drank water from compote; we lost track of days. In Sibiu more than 100 people were killed, including bad and good people. The Army fought the Securitate. By night we went to give blood; there were bullets; we went to the morgue to give blood; they didn't need our blood because half the town had come to give blood. There were cars coming with bodies to the morgue. I would never forgive myself if we had gotten shot.[25]

This is the way the Perjovschis made the transition from communism to representative democracy.

"Communism, like fascism, created an art which was used in the service of its own doctrine," writes Romanian art historian and curator Ileana Pintilie in the introduction to her book on Romanian performance art, adding: "artists were asked to renounce intellectualism, individualism and cosmopolitanism [signs of the 'decadence' of the West]."[26] Pintilie further points out that Romanian intellectuals experienced a kind of "gulag" in the 1950s, during a time in which art was "organized in the form of 'regional' exhibitions" and "judged by artists and critics from Bucharest" whose authority emanated from the capital and who "imposed the party's commands throughout the country."[27] In the mid-1960s, pressure on Romanian artists to follow the communist doctrine of socialist realism eased. The relaxation of standards came to a close when the Soviet army and members of the Warsaw Pact invaded Prague in August 1968, ending the famed "Prague Spring," itself an expression of Western antiauthoritarian youth movements that protested not only the Vietnam War but also Eastern bloc oppression. Unexpectedly Ceausescu

stood against Moscow and declared Romania's solidarity with Czechoslovakia. For a few months, Romanians believed that their country might align itself with the West. Hopes were dashed as Ceausescu's "anti-Soviet declarations" were increasingly understood to be "pure rhetoric."[28] The hardening of communist ideology in Romania increased in the 1970s, with "severe tightening of political control in all domains" and with the growth of Ceausescu's "neo-Stalinist cult."[29] Moreover, while the leaders of the Union of Artists were considered "enlightened" for turning a blind eye to what artists made in their studios, these very same officials were also recognized as "despots," imposing strict restrictions on public culture and continually regulating artists. In response, "a split artistic personality" developed, dividing artists between their "public style" (practiced for official exhibitions) and "personal style" (practiced in the studio).[30]

Harsher political conditions in the 1980s affected all aspects of private life. As I wrote in 1993:

Silence was maintained efficiently by the Romanian secret police, the Securitate, which enforced Ceausescu's crushing control. Its success derived in large measure from the sheer force of rumor, and the fact that the Securitate,

Fig. 27
Dan Perjovschi, one of sixty-seven, *Postcards from America*, 1994.; ink on pastel paper mounted on cardboard. Courtesy of private collection.

with its system of informers, numbered about one in six Romanian citizens. No one remained above suspicion. Fear and secrecy resulted in the effective supervision of all aspects of Romanian life. Stealth was augmented by reports of reprisals against challenges to authority, threats that were invigorated by actual punishments. Extreme even among nations of the former Soviet bloc, Romanians endured their conditions in isolation. Preventing its citizens from travel, the government retained Romanian passports and politically sequestered the nation from exchange with most of the world. Romania resembled a concentration camp especially in the late 1970s and 1980s when the Perjovschis were in their teens and twenties.[31]

The devastating drop in the standard of Romanian living throughout the 1980s resulted, in large measure, from both Ceausescu's fanatical determination to pay off the national debt and his continued building campaign. During the period, "hope of change or any alternative declined."[32] Coping with their own despair, Romanians developed a wicked sense of humor, typified by the following joke, popular in the late 1980s:

> A woman goes into a Bucharest butcher shop and asks the two butchers behind the empty counter for a steak. They reply politely, "We have no steaks." She requests a chicken. "No chickens." "How about some bacon?" "No bacon." Undaunted, she continues: "A sausage?" "No sausage." "Fish?" "No fish." Departing as graciously as she entered, she thanks the butchers for their assistance. One butcher observes: "What a crazy woman." The other butcher replies: "Yes, but what a memory!"

Dan and Lia Perjovschi began their artistic careers in the midst of this disastrous national situation, saved in part by their shared mental clarity and sense of the tragic comedy of their times.

"How it really was in 1985?" Dan began his answer to a question about his years in the Academy of Art in Iasi.

Fig. 28, top
Dan Perjovschi, *Boat*, 4 March 1967; ink on paper.

Fig. 29, above
Dan Perjovschi, *Alone and Gray*, 1988; paint on paper.

"The water in the glass froze in the dorm; I was living on the fat from the pig that my parents sent me with garlic and tomato on it; we got a food card and sold it to buy books; we stole soup."[33] Dan continued:

> Between 1971 and 1975, I was in grammar school. In 1972, Ceausescu launched his "July Thesis," the first time he interfered in the realm of culture after he came back from North Korea and made guidelines about Romanian culture that explained what should be done in all cultural productions. The repression began in 1973. Lia and I never joined the Communist Party, which

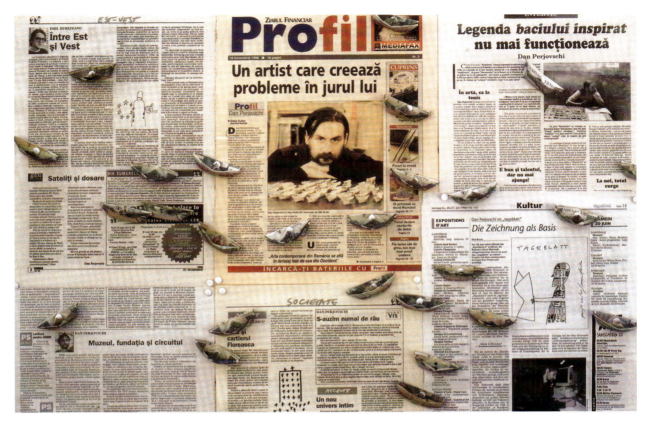

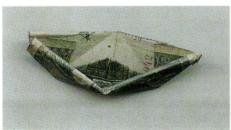

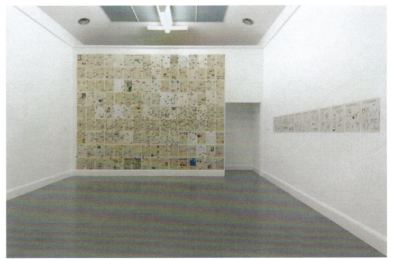

Figs. 30—33
Dan Perjovschi, *Press Stress*, 1999;
installation and details, including
Romanian lei with portrait of
Constantin Brancusi folded into
boats. Courtesy of Collection
Marius Babias, Berlin.

was very unusual for the people who were first in their class. When we graduated, Ceausescu mandated that painting would be taught at only one of the four art academies across Romania; they tried to limit access and they also blocked access to the Union of Artists, which gave one the right to earn money, have a studio, gallery exhibitions, and borrow money to do a catalogue. In the beginning of the 1980s, they froze even the right to join the Union of Artists and froze access to teaching in the art schools.[34]

Ten years after the 1989 Revolution, Dan reflected on the dire period when he was studying at the Academy of Art in Iasi, performing *Still Life* (1999) during "Periferic 2," a performance festival in Iasi. [Figs. 270–272] For his performance, Dan set up an artist's easel and began painting a still life from a composition that artist Matei Bejanaru had arranged for him, using a Romanian hand-carved wooden bowl, a tall brown ceramic water pitcher, and a red ceramic teapot. Bejanaru positioned these objects on a wrinkled bit of unprimed canvas, with an additional piece of cloth appropriately draped for teaching students to draw contour and shadow. Dan sat painting this banal image for four hours, demonstrating his skill at modeling and realism, and invoking the dreary tedium and dogged rigidity of the regime's outmoded, Stalinist-like approach to artistic training.

The earliest extant images created by Dan were saved by his Aunt Leonida. "Tanti Nono," as the family called her, played a key role in encouraging and supporting Dan's desire to be an artist, carefully saving several drawings of elaborate sailing vessels Dan had made in 1967, when he was six.[35] [Fig. 28] Fish swim in the water surrounding Dan's ships—stylized fish that would reappear, doubling as surrealistic eyes, in the work he produced at the art academy nearly twenty years later. [Figs. 29, 331–333, 335] Like fish, boats also return in Dan's oeuvre.[36] Small rowboats dot the surface of his installation *Press Stress* (1999). [Figs. 30–33] But in this work the awe of the child has been replaced with the incisive, analytical, and yet playful vision of the mature artist. For Dan made the tiny crafts in *Press Stress* by

folding paper *lei* (Romanian currency) and pinning the resulting boats to pages of the weekly journal *Revista 22*, as well as other Romanian newspapers in which his interviews or drawings appear. These include foreign newspapers like *Letzebuerger Land* with whom Dan published drawings as his contribution to the European Biennale "Manifesta 2" in 1998. With the newspapers as background, Dan intended to present a wall where only drawings, rather than language, could be seen. This wall of images became the metaphorical sea on which the money-*cum*-boats bobbed. Floating on the newspapers, the boats wryly ride the waves of current events that trouble the social waters of Romanian cultural and political life as reported in *Revista 22*. In this way, Dan indicates that, as a member of the media himself, he too is responsible for the stress portrayed in and caused by the press, but can relieve it through the humor of his drawings.

Press Stress also comments on the relation between economics and art. For the historical portrait printed on the lei Dan used for his boats is none other than the renowned Romanian sculptor Constantin Brancusi. Brancusi's portrait, however, decorates the lowest denomination of paper lei, money so devalued that it has almost no worth. By using currency to make art, *Press Stress* accentuates the relation between the diminished value of Romanian money and old news; it also underscores the economic poverty of this culturally rich nation whose most celebrated artist appears on its least valued currency. Dan made this work during a period when controversy raged worldwide about how to renovate Brancusi's famed World War I memorial complex. Brancusi's memorial had been installed in the Romanian town of Targu-Jiu in 1938, and was a cultural treasure that the Romanian communist government in the 1950s threatened to demolish as an example of "bourgeois art."[37] Under the leadership of Emil Constantinescu, the government sought to renovate this sculptural ensemble—which includes Brancusi's muchadmired sculptures *Endless Column* (1918, 1938), *Gate of the Kiss* (1937), and *Table of Silence* (1937–1938)—as a special millennium project to be completed by the year

2000 at a cost of $2 million.[38] Such cultural expenditures, however significant, appeared excessive during a period of economic hardship, when the Romanian economy struggled to recover from the past and enter the European Union.

Finally, as much as *Press Stress* pointed to the irreconcilable contradictions within Romania, Dan made the work for a Western European audience, and exhibited it first in Stockholm in "After the Wall" (discussed in the Introduction). In this international context, *Press Stress* dryly mocked the West's tendency to identify Brancusi as the only Romanian artist of interest or value. It also cleverly presented Dan as Brancusi's heir, juxtaposing a color photograph of Dan (who appears in an interview in one of the newspapers) with the Brancusi/lei boats. In this way, Dan suggested an association between himself and Brancusi that is impossible to miss. Indeed, in his first interview (while still a student in the art academy in 1985), Dan spoke of Brancusi. "After the camp we did near Tirgu-Mures, where I saw some sculpted portals in the manner of Brancusi," he told fellow artist/interviewer Gabriel Brojboiu, "I tried to merge these motifs—the portal and the portrait."[39] Although Dan believes today that this statement represents "youngster bravura," it is significant that Brancusi again appears in *Press Stress*.[40]

A newspaper article saved by Tanti Nono also demonstrates the continuity of themes that have fascinated Dan throughout his life. [Fig. 34] It describes an annual contest in Sibiu that took place in 1967, on the International Day of the Child, when children were invited to draw directly on the pavement. Reflecting on the themes of that article, Dan remembers:

> As usual in the communist country, all kids' contests had to be dedicated to World Peace. This contest was held as a function of the communist kids' organization called "Pioneers." At eight years old when you entered first grade, you were obliged to become a Pioneer; they gave you a red tie around your neck and you became part of a quasi-military type of organization. Later on when Ceausescu developed his theory of defending communism and imagined the concept of

Zilei internaționale a copilului i-a fost dedicată o interesantă întrecere devenită tradițională, la care au participat pionieri din școlile municipiului Sibiu. Vă prezentăm în clișeu un aspect de la concursul de desene pe asfalt, organizat de Consiliul municipal al pionierilor și Comitetul municipal de luptă pentru apărarea păcii, în Piața 6 Martie. În medalionul din stînga, sus, doi dintre protagoniști

Fig. 34—35, above and right
Dan Perjovschi (middle left) drawing on pavement during "International Day of the Child," 1967, and during 9th Biennale, Istanbul, 2005.

Figs. 36—38, opposite and following pages
Dan Perjovschi, detail, *Cycle Anthropograme II*, 1986; *Cycle Anthropograme I*, 1986; *Cycle Anthropograme II*, 1986; ink on paper.

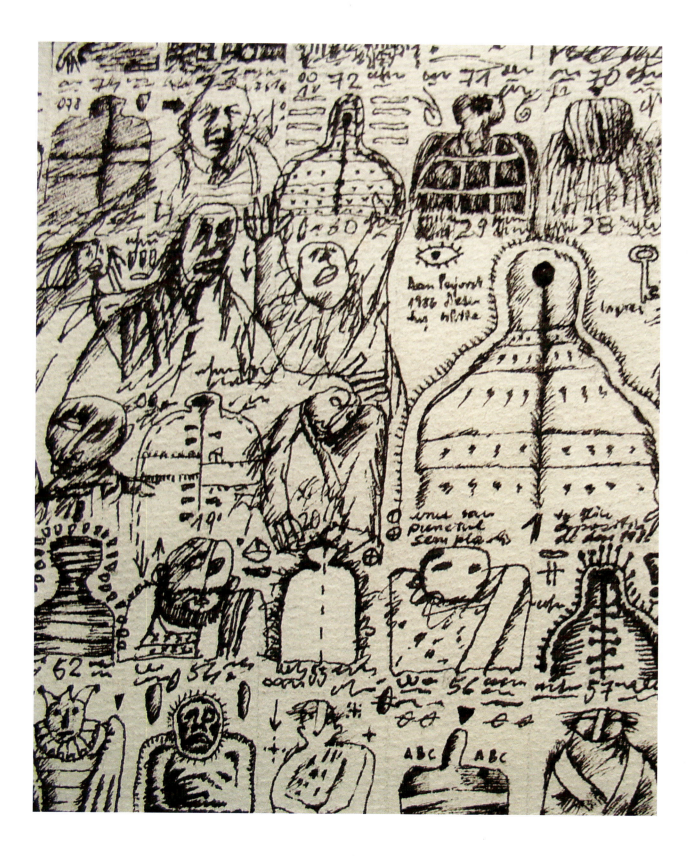

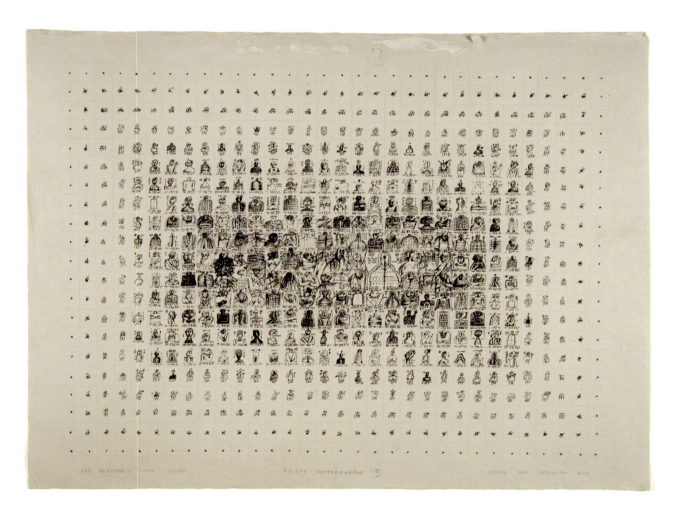

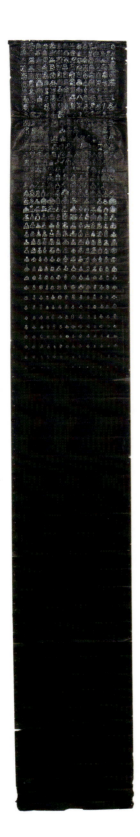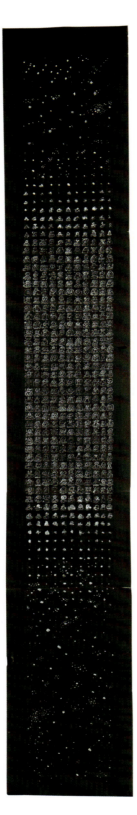

Total War, a part [of the nation's defense] was allocated to Pioneers (from eight to fourteen years old). I did not know at the time I was part of that machinery . . . so much for World Peace. So I'm afraid I got the second or third prize for some stupid stereotype of a Peace drawing.[41]

Although today Dan deprecates his activities as a Pioneer for all that they implied about state propaganda, the clipping shows that Dan's social training accounts, in part, for his commitment to ephemeral and participatory public art. In other words, the techniques Dan learned in youth programs paradoxically shaped his own methods, which would later critique the very apparatus that influenced them. In addition, the competition had the children drawing on the pavement in blocks assigned to them. These squares may also explain part of Dan's predisposition to employ squares in his own early drawings, units that would become grids in his mature floor, window, and wall installations.

Undeniably, the structure of the grid is foundational in Dan's work, and he arrived at its organizing principle in the mid-1980s, when he began working toward his graduation exhibition at the Academy of Art. As he explained to Gabriel Brojboiu:

> I worked for this show for two years. I now look back and see a kind of path that I didn't intend from the beginning. The first works were events in my life. The first work in the show is *The Bride*.[42] Then I tried to avoid the banality of portraits, which are a familiar genre, by fading the central figure into the background and then painting an egg instead of a head. Then I put some portraits in a triangle, or I dislocated the head from the trunk and put them into a cage, like the self-portrait. . . . The two halves of the portrait or the two halves of the portals come together to form another personality. On the other hand, I assumed symmetry as a provocation, as a problem that has to be solved. And this theme and this problem, I will continue after the show, which is just a pause on a path that is much longer.[43]

The portal, namely the cube within which he drew his portraits, is the container for a wide variety of figures Dan drew in grids on an equally diverse range of media. As Dan would later add: "These portal characters eventually shrunk into a grid."[44]

Some of the earliest works in which Dan employed the portal-turned-grid are a group of drawings from 1986: *Cycle Anthropograme I* and *II, Scroll I* and *II*, and *Confessional*.[45] [Figs. 36—43, 337] In the two *Scroll* drawings in this exhibition, Dan drew hundreds of small figures inside the portal/grids using white ink on delicate sheets of carbon paper, held together by clear tape.[46] In *Scroll II*, the figures gradually disappear, as they also do in *Cycle Anthropograme I* and *II*, where the drawings fade either in the center or margins of the compositions, leaving a void. Some of the fantastic and infinitely varied figures in both *Cycle Anthropograme I* and *II* resemble devils, jesters, and other character analogies to individuals of the period. A female figure in *Cycle Anthropograme II*, to the right of the composite central figure with head and shoulders resembling the dome of a church (Dan?), might possibly represent Lia.

For *Confessional*, Dan scratched images of figures both in and outside of grids on all three sides of the structure's walls, which comprise from three to five hanging scrolls per side, depending upon the size of the installation. That the public is invited to enter a confessional where the walls teem with figures suggests that they are being asked to confess to the people, metaphorically represented in Dan's drawings. Dan made and exhibited this work several years before the Revolution, certainly long before Romanian society began to examine its complex informant system: one so pervasive that it is only now beginning to be disclosed and one for which anything resembling a Truth and Reconciliation program will take years to be formed. The metaphorical witnesses scratched on the easily damaged walls of *Confessional* can only be viewed, however, when seen against an exterior source of light. The poetry of viewers' dependence upon illumination as an aspect of *Confessional* is striking for the way it requires both physical and mental insight to come from without before it may

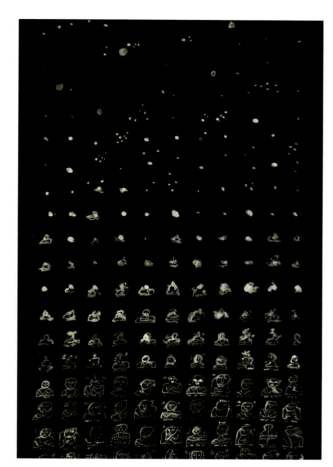

Figs. 39—41, previous page and above
Dan Perjovschi, *Scroll II*, 1986. Courtesy of private collection. *Scroll I*, 1986; detail of *Scroll I*; ink on carbon paper. Courtesy collection Brad Marius.

be achieved within. The fragility of the work's construction is also moving for how it also alludes to the intricate and vulnerable task of righting the past and recovering from it.

Seven years later, Dan created *Scan* (1993), a work that relates to *Confessional*, by approaching the question of informants from a different perspective. [Figs. 46, 344.] In the later work, Dan first laid out a grid on three large canvases and then drew in the hundreds of portraits that people the portals. Next he asked technicians to construct a system for surveying this populace, one in which a robotic camera systematically roams

Fig. 42 – 43
Dan Perjovschi, *Confessional I*,
1986; and detail 1986; six panels
with drawings scratched onto
carbon paper rolls, central panel
with mirror.

across the ground of the huge drawing, and transmits the resulting images to a television monitor. By turning captured portraits into observations, *Scan* provides surveillance of the very same figures to whom viewers confessed in *Confessional*. Both works bear another striking similarity in reverse. The thirteen panels of *Confessional* all fit into the small commercial box (approximately 8" x 12" x 3") that originally housed the carbon paper rolls used in the work. These dimensions matter. Dan had few other options in pre-1990 Romania but to work on such humble materials where finer art papers were a luxury and difficult to obtain. But rather than depend on the outer worth of material, Dan focused on the philosophical significance of the inner meaning of art. At the same time, Dan eventually became so frustrated with the complicated and expensive technology needed for *Scan* that he made *Manual Scan* (1995). [Figs. 44 – 45] This portable sculpture contains a canvas roll (on which he drew a grid with figures). It is embedded in an iron frame, which, when cranked, moves the images in a loop. Ironically, because of its heavy metal frame, *Manual Scan* is also not easy to transport.

The twin themes of surveillance and portability so pervasive in Dan's work are also the subjects of his massive drawing installation *Anthropoteque* (1990 – 1992), an unsurpassed witness to the impossibility of fathoming cultural secrets and uncovering truths buried in the intertwining of society and individual lives. [Figs. 5 – 7, 47 – 49] *Anthropoteque* contains some 5,000 drawings assembled in units containing as many as fifteen flip images in graduated sizes, one on top of another. The whole can be broken down into movable panels so that the huge installation (measuring some ten feet high and sixteen feet long) can be carried in a suitcase—if necessary. Visually stunning, *Anthropoteque* must also be understood to have revolutionized the possibilities for contemporary drawing. For while some artists have worked on a similarly grand scale (Sol LeWitt's wall drawings come to mind), none have created a comparable installation so multilayered that it is simultaneously a drawing, an assemblage (of uneven stacks, varying in size, color, and number of flip drawings),

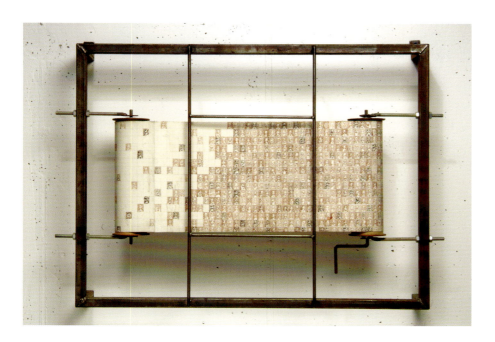

and a painting (with colors ranging from vibrant, mixed shades to muted monochrome tones). Initially, Dan intended the drawings to be handled so that, theoretically, one could flip through and see every image. But even when this was still possible (before the work had entered a museum collection), seeing all the work was a practical impossibility because of the size of the piece, the number of drawings, their inaccessibility (some installed too high, others too low), and the way one drawing nested inextricably within another.

In addition to its commanding physical appearance and potential for audience interaction, *Anthropoteque* is emotionally gripping, especially when considered in the context in which it was created: when the memory of total state control over the Romanian people was fresh, and when the specter of full-scale government surveillance continued to live in the minds of Romanian citizens. But even without that circumstance, *Anthropoteque* is a masterpiece of twentieth-century art and drawing, incomparable in its visual beauty, conceptual scope, textual and material complexity, and scale. It is also a magisterial testimony to the impact of state efforts to obtain private information from and about citizens, efforts that transformed the Romanian

populace into mutual enemies, spies, and informers. But *Anthropoteque* is not limited to a visual commentary on Romania in particular, or on totalitarian dictatorships in general. Its message is even more universal: *Anthropoteque* stands as a warning about the human consequences of surveillance around the globe in the twenty-first century, and an aesthetic condemnation of all Machiavellian regimes. [Fig. 229]

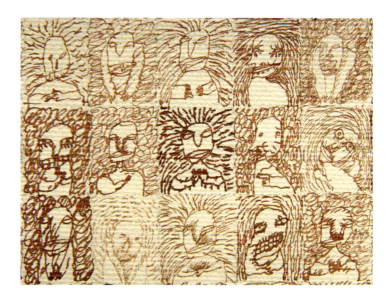

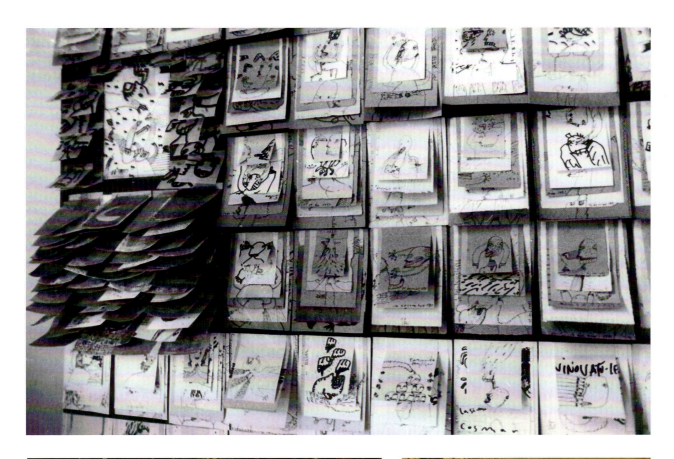

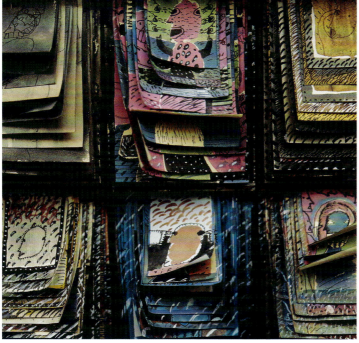

Finally, *Anthropoteque* belongs to a sequence of works bearing similar titles, varying from *Anthropograme* to *Anthropogramming*. In these invented, hybrid, and differently spelled terms, Dan indicated that his drawing functions as visual language at the intersection of anthropology (the study of human culture) and grammar. "'Gram'[47] as far as I remember, or somebody told me (actually it was Andrei Oisteanu[48])," Dan has noted, "is related to grammar; so, for me, *Cycle Anthropograme* meant 'The Alphabet of People,' while *Anthropoteque* is a kind of 'Library of People.'"[49] As a language of humanity, each figure simultaneously represents the individual and the collective, a theme common in socialist countries such as Romania before 1990. Thinking about this combination in Dan's work, German art historian and museum director Werner Meyer has observed that Dan managed, "as an academically trained artist, to elude the restraints and the aesthetical dictates of state-controlled cultural activities [by developing] this form of drawing as a popular [and] radical instrument of self-assertion and political and social criticism."[50] In short, from about 1983 to 1999, Dan represented ever-vaster assortments of ever more anonymous figures that fit into systematized grids (or units, as in the flip drawings). These collected figures form a commune of unidentified individuals who eventually fade and disappear into nothing (as in *Anthropograme II* and *Scroll II*), or become so imbricated in a system of others that they are lost (as in *Anthropoteque*). In *Anthropogramming* (1995), Dan would take these metaphors of disappearance even further.

Dan made *Anthropogramming* for an artist residency, sponsored by ArtsLink, at the New York alternative space Franklin Furnace, directed by artist Martha Wilson. [Fig. 50] During the first part of his residency, Dan sketched a loose grid on the walls and then for about three weeks carefully drew each figure inside its own unit. At the opening of the show, he provided erasers for the public to begin erasing his drawing:

> I realized that the opening was scheduled on December 1st, the National Day of Romania and the day dedicated to AIDS in New York. I could not ignore the coincidence, so I gave rubber gums at the opening and transformed the work into a destruction party. People enjoyed it a lot. Me not. Then the next ten days I finished erasing it all. When I left New York, there was nothing left behind me.[51]

Some critics compared this aspect of the performance/installation to Robert Rauschenberg's famous *Erased DeKooning* (1953), the drawing that the younger artist requested from the older (who at the time was more famous) and then erased it.[52] But rather than follow this ancient mythological practice of metaphorically castrating the father to gain his dominion (as Rauschenberg had done in his honorific and obliterating act), Dan made the public complicit in the disappearance of his own art, shifting the focus from two

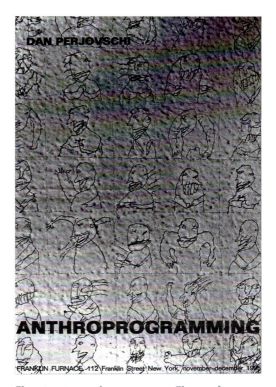

Figs. 47–49, previous page
Dan Perjovschi, details of *Anthropoteque*, 1990–1992; ink and watercolor on pastel paper. Courtesy of Ludwig Forum für Internationale Kunst, Aachen, Sammlung Ludwig.

Fig. 50, above
Dan Perjovschi, *Anthropogramming*, 1996; newspaper.

competing generations of male artists to the role of reception and the responsibility of the public to art. The strategic introduction of erasure in *Anthropogramming* could be said to reflect a number of elements Werner Meyer observed in operation in Dan's work: the artist's "nomadic existence in the international exhibition business;" his talent in making "a virtue of the necessity of material shortage with his small ephemeral drawings;" and his ability to learn from the past how to "evade the dictatorship," as well as apply that lesson to sidestepping "the Western art market."[53]

In 1992, Romanian artist, curator, and critic Calin Dan already addressed the ephemeral and disappearance in Dan's work. His perceptive comment bears repeating:

> Dan Perjovschi belongs to that rare species of skeptics who do not believe in the object[ive] virtues of culture. The uniqueness, longevity and

Figs. 51—52
Dan Perjovschi, 9th Istanbul Biennale, 2005; installation and detail *Going European*; marker on wall.

Fig. 53, opposite page
Dan Perjovschi, *rEST*, 1999; installation in Romanian Pavilion, 48th Venice Biennale; marker on floor.

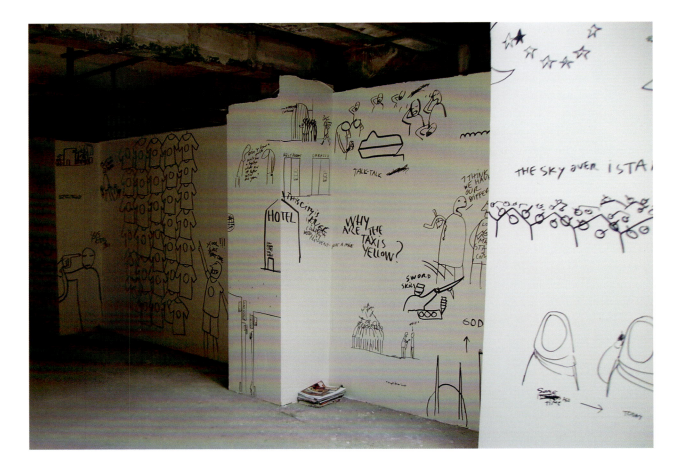

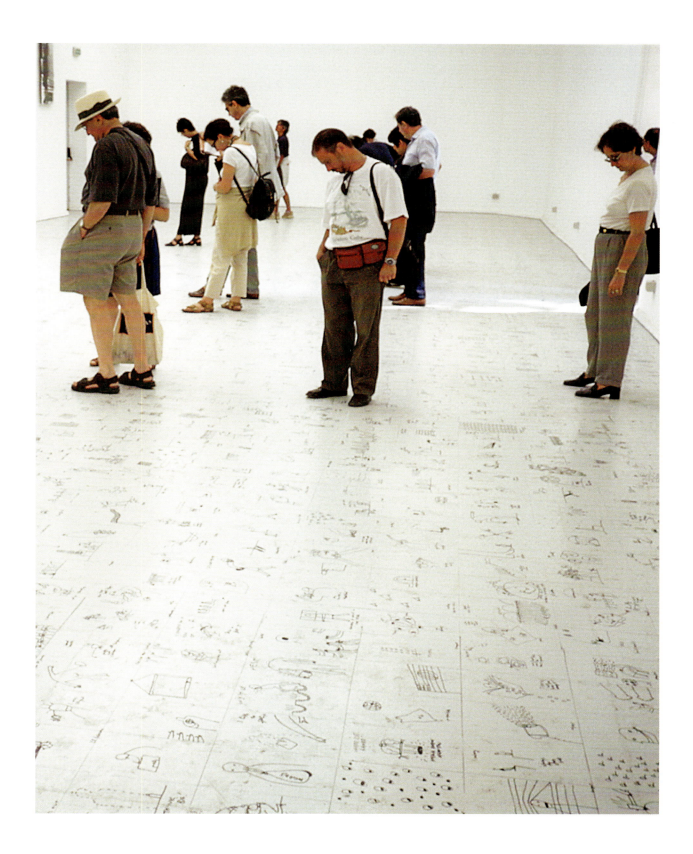

loquacity of the object don't make up values in a fragile world where being present is everything. The artist is present, hence ephemeral.[54]

Indeed, the very fact and quality of Dan's mental "presentness" accounts for the intensity of his visual analysis, which penetrates and then charts subtle relationships among actions, attitudes, beliefs, and social practices, as well as objects and their uses. In this way, Dan's work captures the intangible, interactive affect that is the very content of what is called "context:" context *is* affect.[55] The intensity of this concentrated presence—the deep extent to which the artist is present in each moment—contributes, paradoxically, to Dan's ephemeral transience. For to be present in this moment means to exist only for now, not before or after, as French philosopher Henri Bergson pointed out in 1896 about the relationship between matter and memory.[56]

Just as visitors to *Anthropogramming* assisted Dan in erasing his drawings, they gradually scuffed them away in his installation *rEST*, created for the 48th Venice Biennale[57] [Figs. 53, 358] This wholly sardonic title referred to the demanding installation, which consumed weeks of drawing and was far from a "rest." In addition, his emphasis on "EST" (meaning "east" in Romanian) was

Fig. 54
Dan Perjovschi, *Red Apples*, 1988; installation in the artist's flat in Oradea; drawing on paper.

a cipher for Dan's identity. For this enormous floor drawing, Dan used permanent marker to lay out a grid, each unit of which was about 8 x 12 inches and filled with figures that told a story (rather than the solitary portraits that comprised *Anthropogramming* and *Scan*). When the exhibit opened, the public stepped on *rEST*, "erasing it while walking," Dan explained. "That freed the drawings and the grid disappeared under the peoples' feet; I saw a new possibility to float free."[58] Dan began to use this freer method in subsequent projects, the first being his *3(6)* installation in 2001 for IBID Projects in London, where he drew without a grid on walls, ceiling, and floor. The method of letting the drawings "float free" released Dan from the grid to make bigger, looser, autonomous drawings, and as a result opened his drawing to more permutations, the introduction of text, and a wide variety of new elements that enhanced his notorious sense of humor which is simultaneously biting and self-deprecating.

Departure from the grid also opened Dan's practice to more individual drawings through which he could more directly analyze social situations, as in the drawings he made for the 9th Istanbul Biennale in 2005. [Figs. 51—52] For example, in *Going European*, Dan depicted two male heads: one sports a long drooping mustache, characteristic of those worn by Turkish (and Slavic) men—as well as Stalin—while the other has a type of mustache made infamous by Hitler. For Dan the "guy with the Stalin-like moustache represents Turks, who want to be European but who have to be careful about what kind of European because they can end up being a Hitler."[59] The simplicity of the drawing belies the complexity of its messages: for no matter which political direction a nation goes, the way may be paved with nefarious mustached men (Stalin and Hitler); or, Turkey aims to join the EU and will become fascistic in the process. In either case, Dan Perjovschi, who wears the Slavic/Stalin style mustache, implicates himself in the contradictions.

But Dan's drawing *Going European* (2005) was not the first time he had made such open, polyvalent drawings. In 1988, Dan created his first installation, *Red Apples*.

[Figs. 54, 273–275] He made it as a homecoming present for Lia, who was returning to Oradea from Bucharest were she was studying in the art academy. In *Red Apples*, Dan completely lined the couple's flat in white paper and drew on every surface in black pen. He then lined a drawer in the room in white. Leaving it open, he placed two bright red apples in it, a symbol of erotic pleasure, reinforced by the many times Lia's name appears on the walls of the room along with drawings of interpenetrating male and female figures. Dan and Lia lived in the installation in their apartment from 10 to 24 April that year.

Two years later, in 1990, Dan began working for the journal *Contrapunct*, and later for *Revista 22* in 1991. [Figs. 55–56] For both publications, he used individual drawings to amplify news items, a drawing style that also contributed to the large installations so characteristic of his work in the 2000s. What I am underscoring is that Dan's international renown for making "public art" derives from and directly relates to his real-time employment in visually analyzing news. Yet while Dan's actual wage-earning labor responds to the lived concerns of Romanian daily life and to the fight for a more just Romanian society, his capacity to penetrate present circumstances — by reading local and international newspapers, watching television,

Figs. 55—56
Dan Perjovschi, first cover drawing for *Revista 22* [Bucharest], no. 100 (1991); a drawing from this issue.

and paying close attention to local customs and practices — permits him to speak directly to any audience, anywhere on the globe.

One drawing for *Revista 22* provides a key point of ingress into Dan's remarkable capacity to visualize concepts, attitudes, and practices. In this work from 1994, Dan draws a simple figure that has just sewn his own mouth shut in a zigzag pattern; his hand still holds the thread connected to the suture. The image floats (one of the features of Dan's art that differentiates it from cartoon narratives), hovering in the middle of a news item devoted to "state secrets" and the Securitate. The drawing punctuates the article visually, supporting the author's discussion of state policies

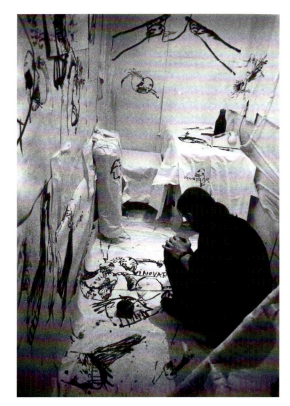

idea or situation, he attempts to imagine himself experiencing the issue and asks himself: "How would I live in this situation?" In trying to draw an image related to state secrets, Dan experienced a "dramatic situation," and responded emotionally: "You will tie my lips, again?!" He continued:

> I was considering this to be the major achievement of the revolution—to speak, to act free. So if I have to self-censor my own drawings because I might be prosecuted for telling a state secret, that's too much.[62]

In this way, Dan's drawings for *Revista 22* continue to extend his life experience and function as models for free speech.

Working regularly each week to comment visually on the news, Dan did not initially consider that his job at *Revista 22* constituted a form of art practice different from, though equal to, his work in the art world.[63] But while it took some years to appreciate the relationship between the two, Dan had already made free-floating drawings in two prior installations: *Red Apples* (as I mentioned earlier) and his public installation/performance *State of Mind Without a Title* (1991) for an exhibition with the same name, curated in Timisoara by artist Sorine Vreme and art historian Ileana Pintile.[64] [Figs. 57—58, 277] In the latter work, Dan lined the walls of

regarding the identification, definition, and structure of the Romanian laws regulating state secrets. Dan explained that under these laws, "what is not explicitly permitted is implicitly forbidden to be spoken:" in other words, even things unspoken might have once qualified as state secrets.[60] Until the open discussion of this issue that resulted from the *Revista 22* article, Romanians had to guess what was permitted or forbidden to be discussed in public, a policy that resulted in silencing and self-censoring.

"The dramatic change in Romania," Dan further pointed out, "is that intellectuals now try to imagine what might happen *before* it happens, instead of waiting until it happens."[61] Dan's drawings contributed to this change by making the affective response generated by such experiences visibly palpable. As Dan illustrates an

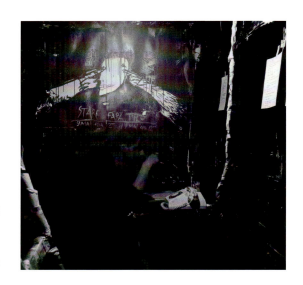

the janitor's room in the Timisoara Museum of Art with white paper (as he had done in *Red Apples*). He lived in this room for three days, drawing on the walls, floor, and ceiling of the tiny space until they were almost entirely black. Dan identified this installation/drawing and performance as a "happening," because the public could participate by viewing him through a window in the door. The last photograph of *State of Mind Without a Title* depicts the artist drinking coffee in near darkness—an emotive but highly critical reference to the bleak living conditions that continued to prevail in Romania until the mid-1990s and in some regions still today.

Lia also participated in the exhibition "State of Mind without a Title," using but altering its title for her performance, *Nameless State of Mind* (1991). [Figs. 59, 95, 220] First Lia constructed a large collaged textile and paper silhouette-like, shadow object, which she painted black and gray. For the performance, she glued her "shadow" to her shoes, and then hung what she called her "character doll" (a doll that doubled as a shadow) from her back. Scuffing along with her shadow under her feet, carrying the doll trailing behind on her shoulders, Lia walked in the streets of Timisoara like a somnambulist. Lia walked through Victoria Square (known as Opera Square before the Revolution) and from the Metropolitan Cathedral to the Opera House, where tens of thousands had demonstrated, founding the "Free of Communism—Area" only two years before. Then Lia walked beyond these civic spaces to a district of domestic houses where she randomly and spontaneously abandoned her shadow, that dark shape of nameless things contingent with the body. So it was in Romania.

Nameless State of Mind can be taken as a microcosm of the many ways Lia used performance from 1987 to 2005 to demonstrate how the body is the physical being

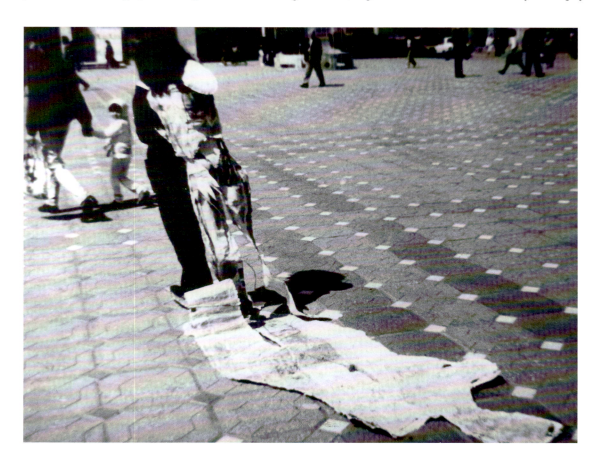

effected by historical and political circumstance and contains ephemeral will, that force necessary to move about in and change the world. Unsurpassed in Romanian post-1989 performance, Lia's actions have metaphorically addressed the circumstance of a nation and its citizens dragging their past behind them while also actively engaging in the effort to heal and to construct a different future. I will return to *Nameless State of Mind* below. For the moment, let me now turn to the development of Lia's art and begin, more or less, at the beginning.

BEFORE AUGURS AFTER: PART II LIA

No childhood art by Lia survives. The earliest known works are from a series of Ex Libris bookplates that she exhibited at the Astra Library in Sibiu, following graduation from high school.[65] These tiny, delicate drawings, sometimes depicting harsh content, were collected in 1988 in a small book published in Italy by Mario De Filippis (who also published a book of drawings by Dan that has since been lost). The bookplate *In Memoriam, Thomas Mann* exemplifies how Lia condensed complex experiences into notations related to various authors' lives. [Fig. 60] Lia's drawing reflects on an aspect of the great German novelist Thomas Mann's life, referring to the drug addiction of the author's son Klaus, who died by suicide. Lia's *J. L. Borges* bookplate likewise refigures its subject, making rich use of Argentine writer Jorge Luis Borges's interest in heteroglossia; the result is

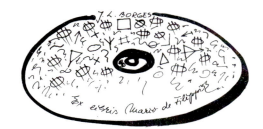

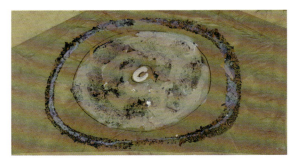

Fig. 61, top
Lia Perjovschi, *J. L. Borges*, 1980–1987; bookplate, ink on paper.

Figs. 62–68, above and opposite page
Lia Perjovschi, *Mail Art/Discreet Messages*, 1985–1988; dyed and collaged envelopes.

a drawing that represents the process of dismantling language in a hermeneutics of pure sign.[66] [Fig. 61] Both bookplates attest to the sophistication of the then nineteen-year-old artist, and document the critical role literature played for Lia, tutoring her in the resolution of life conflicts and showing her ways to imagine alternatives to her existence in Romania.

Her earliest works investigate the relationship between language and inscription, but graphic marks also appear—this time on Lia's body—in *Test of Sleep* (1988), an action she performed for the camera in the Perjovschis' Oradea apartment, where Dan photographed her. [Figs. 69–70, 200–208] (Lia sent the photographs of her action to an international Mail Art[67] exhibition in Mexico on Visual Poetry.[68]) In *Test of Sleep*, Lia first drew directly on her skin, making the marks of an untranslatable and private language that resembled hieroglyphics. She animated these elusive marks with hand, arm, and body signals that she made in prone, sitting, or standing positions, actions that suggested that the indecipherable words could be grasped only by reference to

Fig. 60
Lia Perjovschi, *In Memoriam, Thomas Mann*, 1980–1987; bookplate, ink on paper.

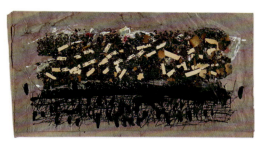

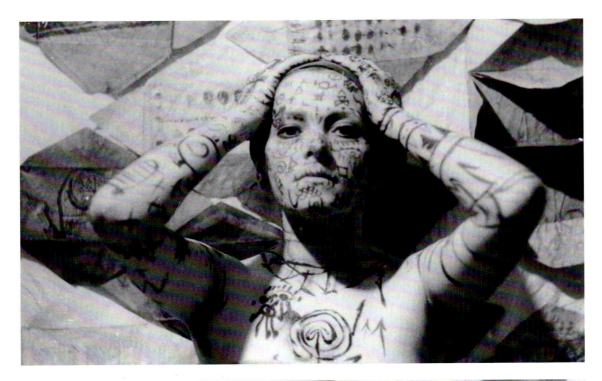

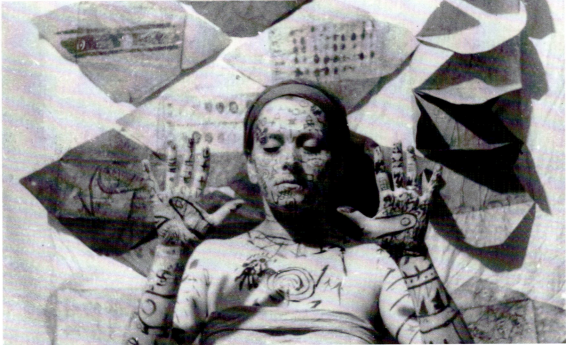

Figs. 69–70
Lia Perjovschi, *Test of Sleep*, June
1988; performance in the artist's
flat, Oradea, with *Mail Art/Discreet
Messages* as backdrop.

her silent, corporeal movement. As her comment on the work explained, Lia associated *Test of Sleep* with the verb "to complain," indicating that the performance signified "grief, pain or discontent, [and] a formal accusation or charge," presumably leveled against the conditions of Romanian life.[69] *Test of Sleep* also presented a warning that sleep is a metaphor for other states of mind, and stood as an admonition to remain awake to one's purpose and action in life.

Lia characterized *Test of Sleep* as a "discreet" form of communication, a description that shows how this action relates to her earlier series *Mail Art/Discreet Messages* (1985). Two photographs of *Test of Sleep* depict Lia standing before a wall on which she has assembled envelopes from her Mail Art practice; the envelopes form a temporary backdrop for her performance. [Figs. 69–70] She made the color-impregnated *Mail Art/Discreet Messages* by boiling otherwise commonplace envelopes in textile pigments, infusing them with rich tones of deep yellow, dark red, and forest green, among other colors. [Figs. 62–68, 72, 304] Then she dried and ironed them before mailing them through

the international postal system. Some envelopes have no decoration except color; others are enhanced with paintings of abstract images (one closely resembles her *Borges* bookplate); a small quantity have the commercial imprint of leaves and flowers on the inner flap; and she collaged a few with strips of paper from a French travel guide, cutting vertically to ensure that no words would be legible.

Fig. 71, top
Lia Perjovschi, *Our Withheld Silences*, 1989; strips of paper, printed text, and mixed media. Courtesy of private collection.

Fig. 72, above
Lia Perjovschi, *Mail Art/Discreet Messages*, 1985–1988; dyed and collaged envelope.

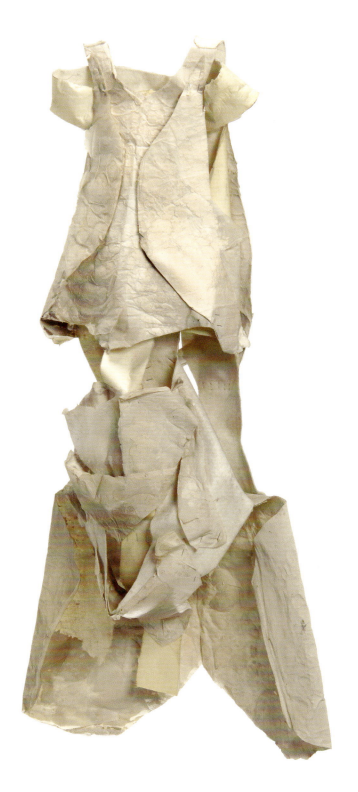
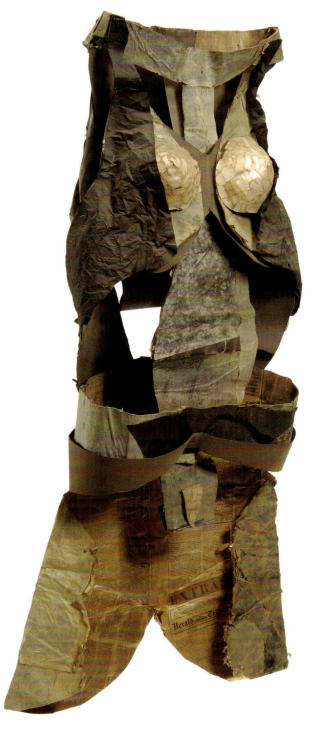

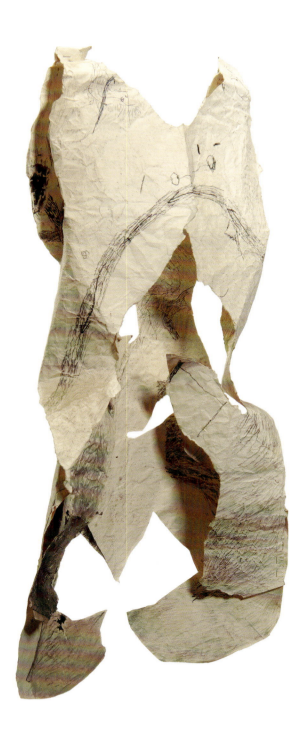

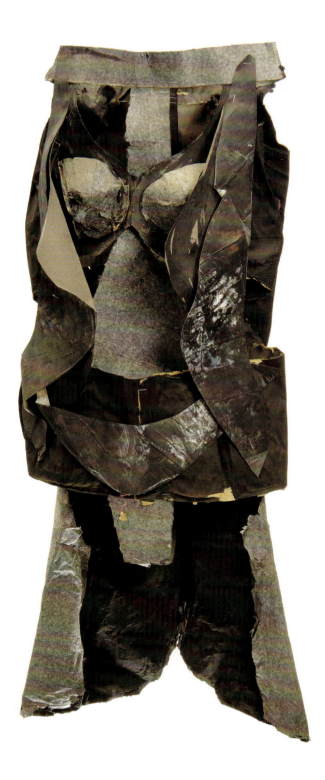

by twisting a long drawing into the form of a tower, but a tower that could be drawn out in the form of a tail.[78] [Fig. 338]

The links between text and image in Romanian art run even deeper. In an evocatively titled essay, "Image, Writing, Breathing" of 1993, Andrei Plesu, philosopher and former Romanian Minister of Culture, summoned the time-honored "*con-substantiality* between image and writing" (Plesu's emphasis), and pointed out that "writing came into being as a pictogram, that is as an epiphenomenon of the image" associated with divine origin and revelation.[79] Lia's sculptural series, *Map of Impressions* (1989–1992), anticipated Plesu's suggestive connection between text and body in material aesthetic form. [Figs. 74–81, 306–307, 314, 342]

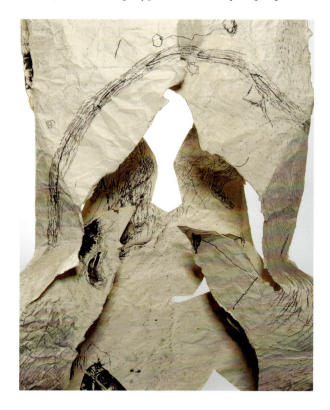

Fig. 81
Lia Perjovschi, *Map of Impressions: Paper Drawing*, 1989; costume/ sculptures; paper, newspaper, paint, thread, textile staples, and other media.

Map of Impressions features composites that fuse costume with sculpture. Lia fabricated them from paper, newspaper, cloth, string, and other collage elements. Each is subtitled according to its appearance, and identifies a different quality or aspect of the body: "White" simulates pubic hair on a woman's body through stitching and a sharply articulated bra (made with the same kinds of strips of print that Lia used in *Our Withheld Silences* and *Mail Art/Discreet Messages*); "Black" and "Sexy/Frivole" are, as their titles suggest, smoky and dark, one with gold bra, and with intricate overlays of fabric that suggest a woman's sex; "Ripped From Wall" is white and was literally stuck to and ripped from the wall on which it was made, incorporating plaster that adhered to it. "Paper Drawing" is white and covered with Lia's distinctive, highly expressive line-drawings, demonstrating the topological qualities that all the *Map of Impressions* share.[80] Together these works visualize different aspects of the body/psyche nexus, from the pure to the erotic, verbal to nonverbal, light to dark; they offer a glimpse of the shape, complexity, and "color" of the spirit/body they surround.

When Lia exhibited the whole series of *Map of Impressions* in 1992 (together with the entire series *Our Withheld Silences*), she wired all of the *Map of Impressions* with sound, creating an installation, which had a barely audible hum, buzz, or scratchy noise. [Fig. 307] In this way, Lia signaled the sounds of embodiment, both in corporeal substance and in acts of reading, as *Our Withheld Silences*, stationed below the costumes, were also implicated in the sound. Lia has compared the *Map of Impressions* series to a Möbius strip, that object with only one surface and one edge created by twisting a strip of paper in the center and attaching the ends.[81] This comparison emphasizes the phenomenological reality of the interconnectedness of interior mind (or emotion) and exterior body (or form), making it clear how *Map of Impressions* amplifies Plesu's interpretive comment: "Writing is embodied breathing, a hieroglyph of the vital soul itself."[82] "Everyone in Romania silently calls out loudly," Lia once noted, foreseeing Plesu's language. "I wanted to draw attention to that

inner life, to make it possible for people to understand it without words."[83]

All these varied objects, from *Mail Art/Discreet Messages* and *Test of Sleep* to *Our Withheld Silences* and *Map of Impressions*, address in one way or another the nexus of language and action also examined in Mail Art, Concrete Poetry, and Performance Art. Early in her practice, Lia utilized these experimental forms, which played significant roles throughout the world, especially where communication was constrained and/or censored.[84] All three genres were part of a semantic field that permitted her to invent alternative forms, that imagined new ways of using visual language to share corporeal narratives. Mail Art offered artists in totalitarian nations access to an antiauthoritarian, international network below the radar of censors, and in democratic countries it permitted resistance to the voracious art market that transformed art into goods bought and sold at extravagant prices. Performance recovered the social force of art, and became one of the last and most effective modes of resistance to multiple forms of domination, a claim supported by the fact that performance artists throughout the world, from the 1960s to the present, have been the most frequently arrested and incarcerated artists.[85] Finally, Concrete Poetry bypassed language as context and grammatical structure in favor of imagining the individual letter and word as an isolated instance of objective truth. According to Augusto de Campos, a member of the Brazilian Noigandres Group, which pioneered visual poetry in Latin America in the 1950s, Concrete Poetry reestablished "contact with the poetry of the vanguards [at] the beginning of the century (Futurism, Cubo-Futurism, Dada et. al.)," recuperating work that "the intervention of two great wars and the proscription of Nazi and Stalinist dictatorships had condemned to marginalization."[86] It is no surprise, then, that these media entered Lia's oeuvre in the years 1985 to 1989, when political repression in Romania was at its most severe.

Indeed, Lia performed *Test of Sleep* the very year that Dan was first visited by the Securitate, after he had received the Grand Prize at "The Biennial of Portraits"

in Tuzla, Yugoslavia (now Bosnia-Herzegovina), for one of his *Scroll* drawings. When Dan applied for the papers necessary to travel to Tuzla, the Securitate promised to get him a passport, as well as other means of support, *if* he would become an informer. Dan refused. In subsequent visits by the Securitate, he held firm. This threatening context confers the additional meaning of the artists being under direct surveillance and, thus, accounts even further for Lia's interest in and use of her body as a field of "discreet" communication. Moreover, in such a circumstance, the title *Our Withheld Silences* redoubles the meaning of silence, marking these objects simultaneously as forms communicating a mute state (on the part of the Romanian citizenry), an intention to deny speech (on the part of the government), and a will to repress speech (by those very same citizens suppressed by the government).

Lia's works represent a microcosm of the conflicts and themes in Romanian culture during a period when the populace and artists alike learned to do what Alexandra Cornilescu called "hedging." In Romania before 1989, hedging was a critical necessity where every word and deed was under constant scrutiny. Hedging in this context meant that one needed "to say one thing and to mean something else, to speak in layered codes impenetrable to informers, and often confusing even to friends, and to use one's eyes and gestures as if they were words."[87] This was the "discourse of fear" common in Romania, where if "an object, phenomenon, or person was not named, it did not exist."[88] I have written elsewhere that Romanian silences, such as those articulated in both Dan and Lia's work, must be understood in the context of a "conspiracy of silence," namely a complex traumatic environment that culminates in the sense of being contaminated.[89] Romanians felt contaminated by their traumatic past, and journalistic metaphors in the early 1990s referred to the nation as a "dead" or "diseased body," an "organism . . . undergoing some form of therapy . . . severe pain . . . nightmares," and in need of "shock therapy."[90] As Harvard literary critic Elaine Scarry has argued, such painful experiences "actively destroy" language, a process that

Figs. 82–83, above
Lia Perjovschi, *Don't See, Don't Hear, Don't Speak*, November 1987; performance at Academy of Fine Arts, Bucharest.

Figs. 84–85, opposite page
Lia Perjovschi, *For My Becoming in Time*, October 1989; performance at Academy of Fine Arts, Bucharest.

brings about "an immediate reversion to a state ante-rior to language."[91] Scarry insists that trauma sometimes causes so much suffering that "the person in pain is . . . [so] bereft of the resources of speech . . . that the lan-guage for pain should sometimes be brought into being by those who are not themselves in pain but who speak on behalf of those who are."[92] Lia's work repeatedly conjures that "anterior state," much like the apparatus of a dream, condensing and displacing meaning. Mute, but gesturing, Lia's art spoke on behalf of Romanians' somnambulant existence, exposing how the internal spaces of an otherwise unreadable private suffering belong to the surface of silence, as in a Möbius strip.

Once Lia arrived at the Bucharest Academy of Art in 1987, she immediately began producing performances with (and for) her peers in an "Experimental Studio" that she organized. These events were primarily perfor-mative, serving as a kind of visionary mental training for the Revolution to come. In this context, one cannot overemphasize the fact that in Romania at that time, few dared to share their knowledge of experimental art for fear of exposure or repression, and when they did it was often only with a small and trusted group of artists. Thus, Lia came to performance initially through her work in the theater, Mail Art, and her interest in Hungarian television, which she watched (using a

dictionary, as she did not speak Hungarian) while living in Oradea, a city on the border of Hungary. She only began systematically to learn about the rich history of Romanian avant-garde performance after meeting art-ist Geta Bratescu and anthropologist Andrei Oistaneau in 1989.[93]

Lia defined her first event at the art academy, *Mov-ing Picture* (November 1987), as "an operation carried out under controlled conditions in order to discover an unknown effect." It was also, she said, an effort to simulate "something like the motion of iron file dust on a sheet of paper by means of a magnet."[94] *Moving Picture* included students standing behind movable panels (a kind of corporeal film strip), moving in such a way that each person's actions elicited further movement from others behind their screens. *Don't See, Don't Hear, Don't Speak* (November 1987) had students enacting the famous maxim—"see no evil, hear no evil, speak no evil"—by first covering their eyes, then their ears, and finally their mouths. [Figs. 82–83] The communicative strategies of both these performances, coming as they did two years before the Revolution, must be described as being similar to the "hedging" I discussed above, as both works indirectly addressed the quixotic Romanian situation of the late 1980s: while a desperate need for communication and response existed, any rejoinder

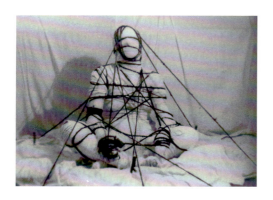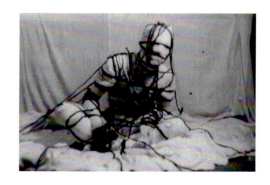

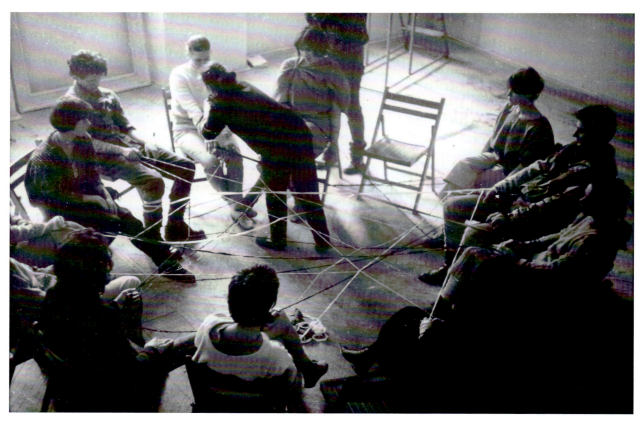

Figs. 86–87
Lia Perjovschi, *Annulment*,
September 1989; performance in
the artist's flat, Oradea.

Fig. 88
Lia Perjovschi, *Magic of Gesture/
Laces*, November 1989; perfor-
mance at Academy of Fine Arts,
Bucharest.

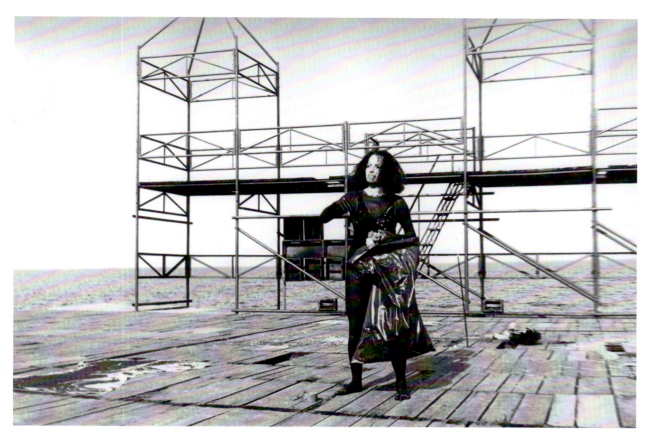

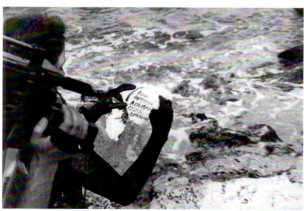

Figs. 89—92
Lia Perjovschi, *Prohibited Area to Any External Utterance*, 1991, performance in Costinesti, Black Sea Coast; different texts balled up in red tissue paper and thrown to the audience. Reproduced text is the title of the performance.

would have been suppressed in a paralyzed society encouraged neither to see, hear, nor speak, even as it was expected to report on itself using those faculties.

The following year at the art academy, just months before the Revolution, Lia organized two even bolder performances: *For My Becoming in Time* (October 1989) and *Magic of Gesture/Laces* (November 1989). [Figs. 84–85, 88, 209] In the former, she again placed fellow students behind panels. This time, however, after they thrust their anonymous hands (painted in various colors) through the panels, Lia cleansed the hands by "washing" them with white paint. Then, turning to the audience with her own hands covered in white, Lia shook hands with the viewer/participants. With its symbolic white paint, *For My Becoming in Time* suggested that through personal action one could purify the past and forgive the other. In *Magic of Gesture/Laces*, Lia explored even further the relationships between past and present, self and other. For this work she tied twelve students together in a circle so that if one moved, each motion would tighten the laces binding the group. For Lia, this performance represented an experiment in choice, requiring participants to agree to connect and affect each others' positions in space and over time, and to decide whether or not to disengage and untie themselves. Some struggled to get out of the ropes, while others wanted to remain connected. In both *For My Becoming in Time* and *Magic of Gesture/Laces*, Lia sought to awaken fellow students from their conditioned collective slumber, a theme to which *Test of Sleep* had earlier been dedicated.

In the midst of such performances in Bucharest, Lia also performed *Hopeless Dialogue* in Sibiu in April 1989, and *Annulment* in Oradea in September 1989. These two works referred directly to her intimate life with Dan at a time when their marriage was severely tested and strained. She performed *Annulment* (like *Test of Sleep*) at home alone, while Dan took photographs.[95] [Figs. 86–87, 211–219] In this action, Lia and Dan bound her body with medical gauze and then tied her up with strings so that she had to struggle to break free (an action that she then translated into *Magic of Gesture/*

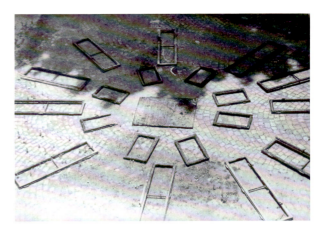

Figs. 93–94, above and opposite page
Lia Perjovschi, *About Absence*, 1990, installation inside yard of Academy of Fine Arts, Bucharest; found burned windows, rope, stones.

Laces two months later). Lia has written that *Annulment* simulated healing and self-protection, explaining that the work referred to both a "legal declaration that a marriage is invalid" and a form of "self-defense." She associated her bindings (and her will to free herself from them) with the self-protective defense martial art of Japanese Aikido.[96] In *Hopeless Dialogue*, Lia again meditated on the relationship between truth and lies in the obscurity of both personal and national affairs. Seating fellow artists in front of a light and behind a screen, she placed viewers in front of the screen so that they could only see dim movement behind it.[97] Following Plato's *Republic*, viewers were positioned such that they "would in every way believe," in Plato's words, "that the truth is nothing other than the shadows of . . . artifacts."[98] Lia condemned her audience to know reality as mere shadow, like the prisoners Plato described chained to the ground inside the cave. Meanwhile, Lia stationed herself on the same side of the screen as the audience. Standing with her back to viewers and writing in white chalk on the screen's white surface, she had images of her own art works projected onto her back. In these ways, Lia doubled and redoubled the obscurantism of shades of truth and reality by creating shadows of shadows, written in white on white: the truth of one's own experience, unseen and unknown, carried on one's back. While *Hopeless Dialogue* had its sources

in personal issues posed by her intimate life with Dan, the performance also spoke to general questions about certainty and authenticity raised by the Revolution. She amplified these topics in three works: a temporary installation titled *About Absence* (1990), and two performances of 1991, *Prohibited Area to Any External Utterance* and *Nameless State of Mind*.

About Absence related to the period immediately following the Revolution, when Lia asked Ion Stendl, her professor, how to proceed. His response was direct: "Now you can take your colleagues and make your installations—be free."[99] Lia recalled that although "we enjoyed the idea of being free to no longer draw the human figure realistically, the question became: 'What to do out of nothing?'"[100] [Figs. 93–94] Lia met this challenge in *About Absence*, using found, burned window frames that she supported in a vertical position by black ropes tied to cobblestones. Although today she criticizes this work as "too romantic and metaphorical,"[101] the photographs of the exquisite installation attest to an

ability to convey the central point of *About Absence*: truth and freedom arrive initially in the form of a void. Like the ancient Chinese philosopher Lao-Tzu, *About Absence* reconfigures the relationship between presence and absence:

> Thirty spokes unite in one hub;
> It is precisely where there is nothing,
> that we find the usefulness of the wheel.
> We fire clay and make vessels;
> It is precisely where there's no substance,
> that we find the usefulness of clay pots.
> We chisel out doors and windows;
> It is precisely in these empty spaces,
> that we find the usefulness of the room.
> Therefore, we regard having something
> as beneficial; But having nothing as useful.[102]

Tzu's thoughtful text confirms the lesson that *About Absence* underscores (with its use of passageways—windows—as metaphors for this reversal): "nothing"

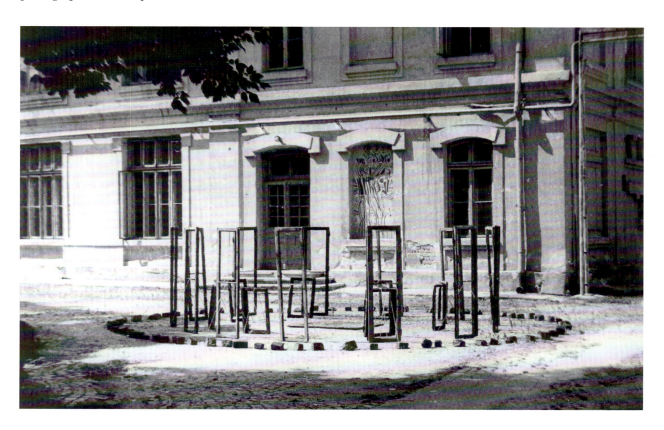

At this time, Lia was a leader of the Student League in the Bucharest Art Academy, an organization involved in sustaining the growing protest movement, "Piata Universitatii [University Plaza]." This was the name given to the anti-neo-communist, several-months-long demonstration for a democratic society that took place in the city center by the University of Bucharest. The situation heightened between May and June 1990, when Lia and Dan were both active in street protests and demonstrations. The plaza at the city center was later branded "Romanian Tiananmen" after Romanian coal miners were surreptitiously brought (probably by the Securitate) to crush the protest, a violent event that took place between 13 and 15 June 1990. Given this context, *Prohibited Area to Any External Utterance* reminds viewers of an actual battle for freedom of speech, travel, and for the general conditions of democracy.

As noted above, many of these works relate to *Hopeless Dialogue*, perhaps none more than *Nameless State of Mind* insofar as Lia projected images on her back in the former and carried her character doll on her back and her shadow on her feet in the latter. [Fig. 95] Her complex use of the shadow and doll demand more attention. One year after performing *Nameless State of Mind*, Lia hung upside-down nine silhouette-like shadows

is itself a possibility. Today, *About Absence* eloquently tutors viewers about the burden of making art in a condition no longer restricted by rigid, prescribed, academic canons; it also instructs them about how Lia met the sudden unknown of boundless possibility—equally experienced as emotional and psychological emptiness—with a temporary solution fabricated from a charred Revolution.

In a different but parallel way, *Prohibited Area to Any External Utterance* further amplified the political-aesthetic situation. [Figs. 89–92, 339] With her mouth taped closed, Lia undertook a series of puzzling actions and then threw cryptic "messages," balled up in red tissue paper, to her audience. This work reiterated a continuous theme in her art: the ambiguous conditions under which information is constructed, and the external and internal exclusions entailed in any utterance. In this regard, *Prohibited Area to Any External Utterance* referred directly to, and must be situated within, its historical context.

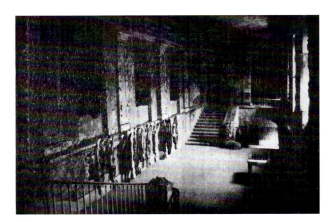

Fig. 95, top left
Lia Perjovschi, *Nameless State of Mind*; June 1991, performance in Timisoara.

Figs. 96–97, above and opposite page, top
Lia Perjovschi, *Topsy Turvy World*; 1992, installation in Art Museum of Timisoara; paper, cloth, and paint.

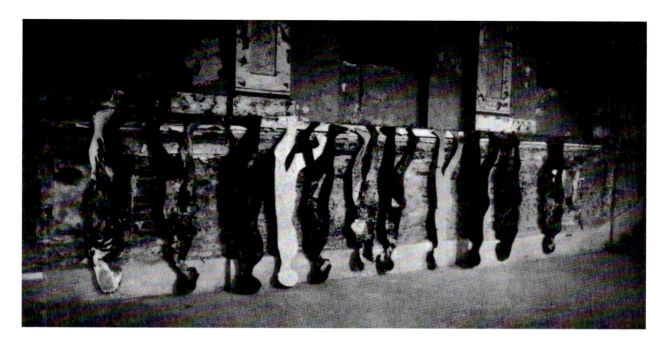

in the central hall of the eighteenth-century "Hall of Honour" in Timisoara's Baroque Palace, now the Art Museum situated in Piata Unirii [Union Square]. [Figs. 96–97] For the exhibition "The Earth: Intermedia,"[103] Lia constructed the shadows of fabric and paper and painted them in black, gray, and white. She called the installation an "intervention," and titled it *Topsy Turvy World* (1992). The show's premise issued from what its curator, Ileana Pintilie, identified as Romanian folk culture's cosmological notions of earth: "the joint work of Good & Evil (God and Devil)."[104] Pintilie described *Topsy Turvy World* as "a whole procession of uncertain characters walking ghost-like past walls [evoking] the negative energies of a world at odds with itself."[105] Certainly, Lia's silhouettes acknowledged the reversal of Romania's direction two years after the Revolution, but suggested a fate met with joy, fear, and anxiety as well. For these figure/shadows hanging upside-down against a wall could equally have signified that Romanians were "up against the wall," like their dictator and his wife, threatened by the firing squad of history.

Even before the Revolution, Lia had used "silhouette/shadows" and a *Map of Impressions* in various installations to indicate such experiences. In 1989, she

installed a *Map of Impressions* flat against the corner of a wall, titling the piece *Work for the Vertical Edge of a Wall*. The installation of a "shadow" in a niche in Bucharest, and the introduction of a *Map of Impressions* in a similar niche in Galeria Noua in Sibiu (1990), followed. [Fig. 98] Six years later in 1996, she would also do a performance titled *Approach*, which included picking people at random and following them: "I would imitate his position (like a shadow) then I would leave, in search of

Fig. 98, above
Lia Perjovschi, untitled, 1990;
installation of paper shadow in
niche, Galeria Noua, Sibiu.

Figs. 99–110, following pages
Lia Perjovschi, *I'm fighting for
my right to be different*, July 1993,
performance in Art Museum
of Timisoara.

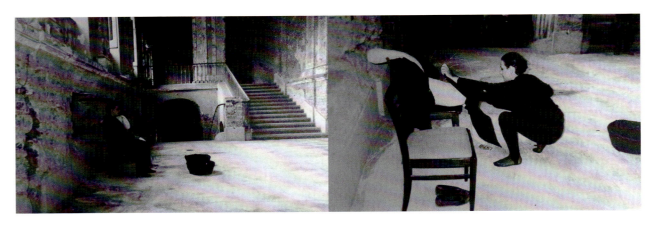

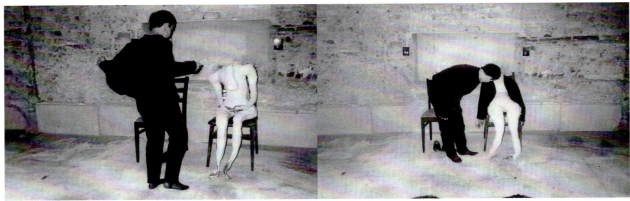

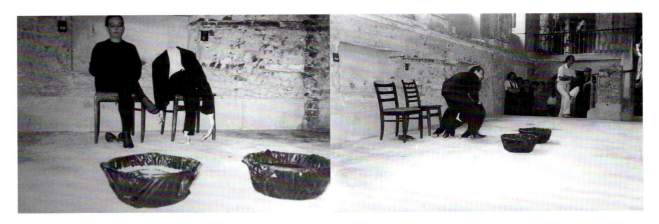

60

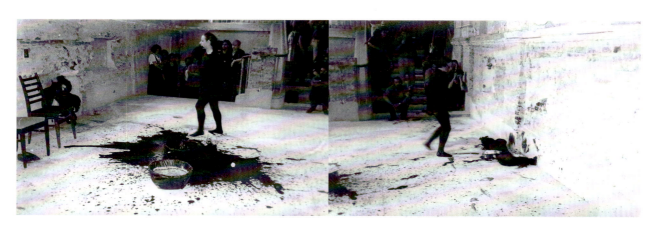

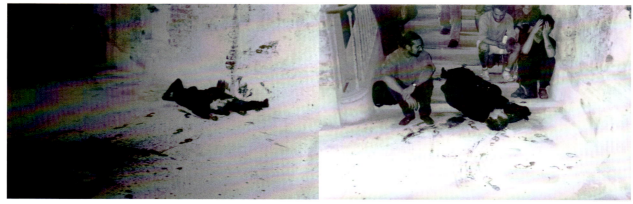

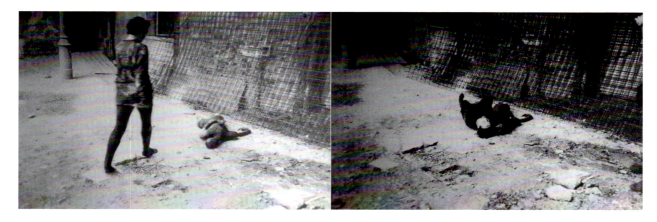

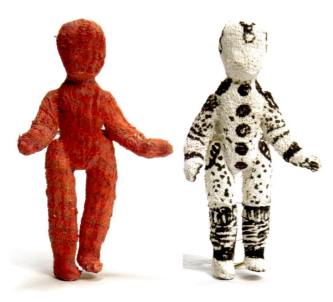

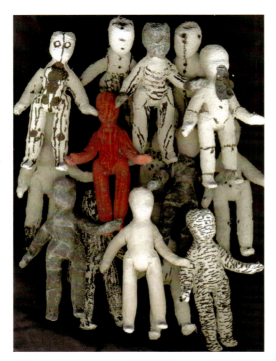

another."[106] Whether at the abyss of the vertical edge of a wall, cornered in a niche, hung from and/or projected onto one's back, or shadowing another person, these objects point to experiences that are known but unseen and only vaguely recognized. Such a state of indefinite understanding is associated with traumatic dissociation where realities too painful for the conscious mind to acknowledge hover to be repeated unconsciously in life. Lia's shadow in *Nameless State of Mind* may be compared to the scars from lashings that formed the image of a cherry tree on Sethe's back, the heroine in Toni Morrison's Nobel Prize–winning novel *Beloved* (1987).[107] Although Sethe could not see this image, she could feel the scar with her fingers, re-experiencing the memory of traumatic physical pain with so much emotional agony that she murdered her child "Beloved" rather than condemn her to live as a slave. What I am suggesting is that the character-doll Lia carried on her back in *Nameless State of Mind* resembles the murder of Beloved, insofar as Lia abandoned her creative effigy in the streets of Timisoara, she herself a damaged child of Romania.

Lia's shadow-turned-character-doll emerged full blown again two years later, this time transformed into a life-sized, stuffed double of Lia. She interacted with this doll in her performance *I'm fighting for my right to be different* (July 1993).[108] [Figs. 10, 99–110, 308] Taking up the question of difference, vivid in her concept of herself as an "alien and a dreamer,"[109] Lia performed a series of intense emotional and physical interactions with the doll, ranging from gentle to aggressive and violent. Lia began the performance dressed in a man's black suit (under which she wore a black shirt and tights). Sitting next to the doll, Lia talked to it quietly, then took off her suit and put it on her "character." Shifting the gender of the doll to male, and describing it as "bad, dirty, and spoiled,"[110] Lia doused in black paint the displaced male alter ego of herself and began throwing it around the room. She heaved the doll/self, heavy and soaking, against the wall and at the public. No one moved. After each difficult assault, Lia lay down next to the doll and assumed its fallen and abused position.

Figs. 111–112, above
Lia Perjovschi, *Pain H Files*, 1996–2003; detail of two dolls: twenty-four mass-produced dolls, hair removed, wrapped in gauze and painted.

Figs. 113–114, opposite page
Lia Perjovschi, *Pain H Files*, 1996–2003; detail of three dolls: seventeen plaster of paris painted dolls.

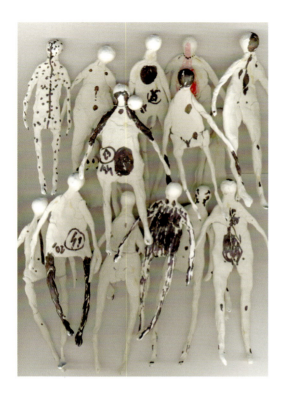

The performance ended when she kicked the doll down a flight of stairs and out of the performance space. The last images of the artist lying on the ground with the doll splattered with black paint are pictures of distress, sorrow, and mourning, emotions easily read on the faces of viewers observing this scene of self-directed savagery.

I'm fighting for my right to be different could be understood as an exorcism and a double suicide, leaving the question: Which Lia won? The performance could also be read as an after-image of the bodies Lia witnessed in the streets of Sibiu and on national television during the Revolution. The character-doll, or alter ego, may also be taken to represent simultaneously father, husband, and fatherland, a shadow of Romanian patriarchy. It could stand for the gendered aspects of the artist herself and her many invented male personae, wrestling with such social conventions as the dilemma of being artist, wife, and potential mother. Indeed, Lia performed *I'm fighting for my right to be different* ten years after suffering an illegal abortion in 1983, during the period when Ceausescu mandated that birth control was illegal,

prohibiting condoms and other birth control devices. Abortion was banned, too, and women were expected to surrender their unwanted children to the State. These children were known as "Ceausescu's children," and were the very people who were severely neglected in the notorious Romanian orphanages. The political conditions of a tumultuous Romania and the intense trials of her repeated attempts to enter an academy of art meant that having a child would further compromise Lia's ability to work as an artist. This dilemma is not confined to women of the former Romania and totalitarian societies. Renowned female artists from Mary Cassatt and Georgia O'Keeffe to Carolee Schneemann, Eva Hesse, and Judy Chicago have all written about their decision not to have children in ways that reiterate Lia's choice.[111]

A further essential reference for the meaning of *I'm fighting for my right to be different* is one that Lia inserted in her monograph *amaLIA Perjovschi*. There, in a two-page spread featuring pictures of the performance, she added a small photograph of the two women in Ingmar Bergman's film *Persona* (1966). This gripping drama explores the psychological encounter and life-threatening battle of identity between Elisabet Vogler (played by Liv Ullman), a famous stage actress recovering from a nervous breakdown, and Alma, her nurse (played by

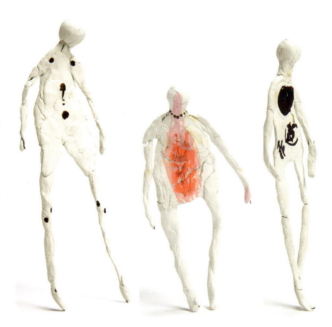

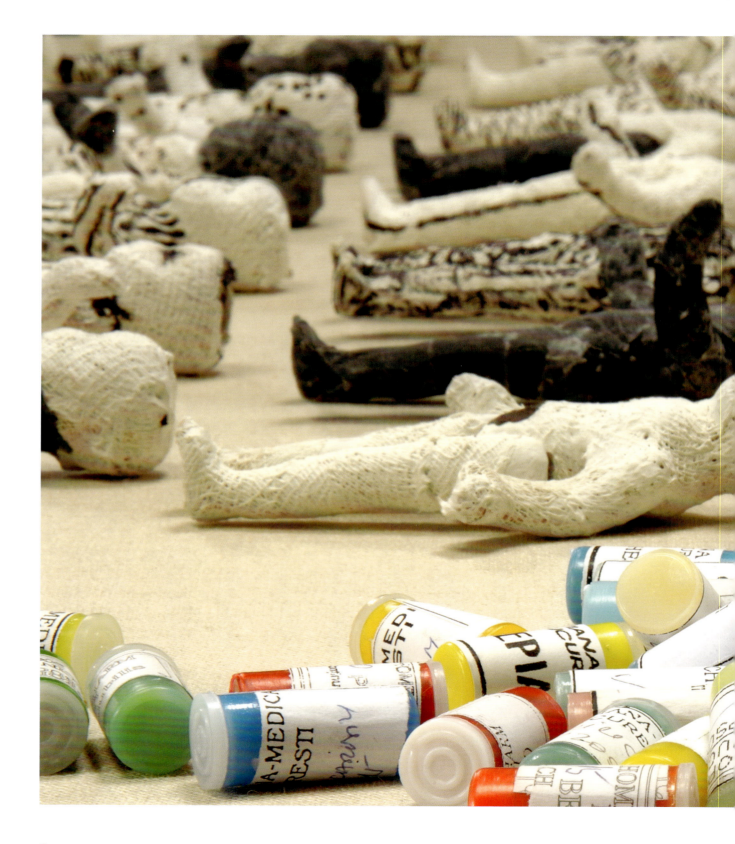

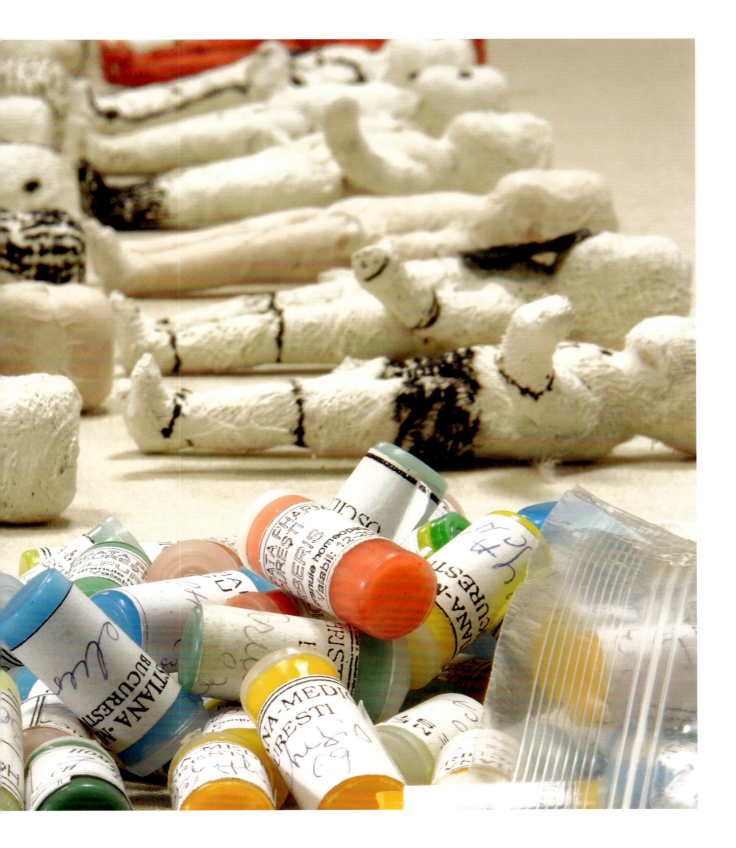

Fig. 115, previous pages
Lia Perjovschi, *Pain H Files*, 1996–
2003; twenty-four mass-produced
dolls, hair removed, wrapped in
gauze and painted, with homeo-
pathic pill containers in foreground.

Figs. 116 – 118, above
Lia Perjovschi, *Pain H Files*, 1996–
2003; ink and marker on paper.

Bibi Andersson). *Persona* presents a series of inter-
twined psychological situations: the fraught condition
of transference in the psychoanalytic relationship
between therapist and patient; the perplexity of disso-
ciation and memory in multiple personality; the reality
and therapeutic challenge of self- and other-directed
physical and emotional violence; the complexity of
sexuality; the test of motherhood; and the emotional
devastation of betrayal. All these issues, while too com-
plex to unpack here, have played some role in Lia's life,
which her work (until the mid-1990s) required viewers
to consider directly. But one point demands more
attention: the special role of art in healing, made early
in the film. Nurse Alma says to patient Elisabet: "I have
a tremendous admiration for artists; I think that art
has enormous importance in people's lives, especially
for those who have problems."

Art historians, clinical psychologists, and psycho-
analysts alike have long argued for the therapeutic value
of art, and those specializing in the history of perfor-
mance art have also drawn direct parallels between

performance and healing. In this regard, Lia's per-
formance *I'm fighting for my right to be different* is
immediately connected to a series of small sculptures
she produced on the role of healing titled *Pain H Files*
(1996–2003). [Figs. 111–112, 115, 361] This work
consists of a set of twenty-four commercially pro-
duced dolls that Lia altered by first pulling out their
hair and then wrapping the dolls in gauze (just as she
had wrapped herself in her performance *Annulment*
eight years earlier). Next, she painted her physiologi-
cal symptoms on the dolls in black and occasionally
in red so that she could more precisely articulate to
her homeopathic doctor her own bodily sensations.
These ranged from tingling and becoming flushed with
heat and numbness to sharp pain, throbbing feelings,
headaches, and even temporary blindness.[112] She also
produced a set of drawings to accompany the figures,
drawings that also identified places on her body where
painful or uncomfortable sensations had occurred.
[Figs. 116–118, 362] Gradually becoming dissatisfied
with the altered mass-produced dolls, Lia fabricated
a second set of seventeen dolls from plaster of paris
and painted each figure to express corporeal pain. [Figs.
113–114] Together the two sets of dolls, the drawings,
and the actual homeopathic remedies in tiny colored
plastic tubes prescribed by her doctor comprise the
sculptural whole of *Pain H Files*.

For Lia, *Pain H Files* represents the aesthetic equivalent of a "case history" (the word she uses in Romanian is *anamneza*, which derives from the Greek word for "reminiscence" and is adapted from the French into Romanian). Beginning with the idea of the investigation and accumulation of data about an illness and progressing to mediation on the processes or patterns of a life, *anamnez* also refers to the evolution of Platonic and Socratic theories of memory, including speculation on the immortality of the soul. Lia writes that her interest in these concepts derives from "remembering ideas that the soul contemplates in another existence, or reminiscence theory."[113] In this sense, her shadow reenters the *Pain H Files* as an aesthetic theme in the form of the familiar character-doll (another recurrent subject), insinuating that the foundation of illness resides in memories that continue to elude the artist and take root in the body.

I know of no work of art quite like *Pain H Files*, either for its originality or intrinsic beauty, a unique aesthetic born of the combination of eccentricity, concept, and execution. On the one hand, Eva Hesse's odd materials and uncommon shapes are perhaps the closest in quality and character to the *Pain H Files*, even though Hesse's work is abstract rather than figurative. On the other hand, while the *Pain H Files* are figurative they have nothing in common with the vogue for figurative abjection and sentimentality in the 1990s. Moreover, they could not be further in meaning or use from the magical dolls associated with voudon, the term derived from the Fon language of the African Dahomey peoples, meaning "spirit" or "deity" and used to affect (or protect against) affect in or from another person. The dolls of Lia's *Pain H Files*, together with their accompanying refined drawings, are matter-of-fact and meant for use in diagnosis: works of art addressed to real symptoms related to actual physiological and psychological problems. To make this case even more strongly, Lia adamantly insists that the dolls should not be photographed in a manner that would make them "appear to gesture; they must be seen like bodies lying on a flat surface in an MRI machine for analysis."[114] But

even standing, the dolls appear like zombies, awaiting reanimation of the unhealthy body with the powers of homeopathy.

In July 1996, the same year that she began making the *Pain H Files*, Lia undertook to "measure" fellow artists in a performance titled *Searching, selecting, measuring (height and weight)*. [Fig. 351] She staged this action during an international performance festival held at St. Anna Lake in Romania organized by artists Uto Gusztav and Konya Reka. Lia dressed in white to distinguish herself from the other artists (who were mostly dressed in black) before she stood next to or lay down in front of each selected person. The mixture of this unconventional approach to art with such rational objectives as "selecting and measuring" is characteristic of the *Pain H Files*. This work makes it clear how Lia's aesthetic investigations reside at the intersection of conflicting and converging impulses, such that I would describe her art as follows: neither both, nor neither, art nor life.

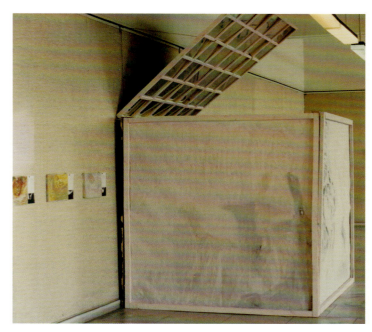

Fig. 119
Lia Perjovschi, installation view of graduation exhibition at Academy of Art, Bucharest: *About Couple or The Pinky Life of My Parents*, 1993; wooden box, multi-paned, mirrored top, oil paint; and three units of *32 Moments in the Life of Hands*, 1993; oil paint on canvas, photographs, and drawings.

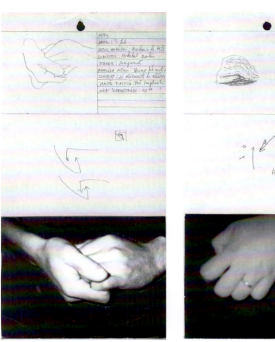

Figs. 120–121
Lia Perjovschi, *32 Moments in the Life of Hands*, 1993; photograph and graphite on paper.

In this simultaneous avoidance and embrace of both art and life, Lia's work succeeds where so many artists' practices aim but miss the intangible, subtle mark.

The second group of dolls that comprise *Pain H Files* bears the exact shape of the character-doll that Lia used in *I'm fighting for my right to be different*, which, in turn, is identical to the two life-size dolls that she made the same year for an installation on the subject of her parents' marriage. [Fig. 119] Titled *About Couple or The Pinky Life of My Parents* (1993), this installation was produced for Lia's graduation exhibition at the Bucharest Academy of Art. It comprised a room-sized box painted pink with a mirrored, multi-paned window as a ceiling, which was propped ajar to reflect the interior where the two character-dolls (her parents or a couple) sat in their domestic setting. The title refers ironically to the former communist period when it was obligatory to join the party. (Only one of each set of Dan's and Lia's parents joined: Dan's mother and Lia's father were required to join, as a kindergarten teacher and a worker

in an electrical plant, respectively.) In her commentary on this now-destroyed installation, Lia quoted from an English dictionary entry for the word couple: "a man and woman married, engaged, or otherwise paired; two equal and opposite forces that act along parallel lines," a definition that applied as aptly to her own marriage as to that of her parents.[115]

In addition to *About Couple or The Pinky Life of My Parents*, Lia exhibited *32 Moments in the Life of Hands* (1993) in her graduation show. [Figs. 120–125, 309–310] For this work, she produced three variations on the language of hands in three media: photography, drawing, and painting. Each variation is a set of thirty-two works comprised of a slim sheet of paper containing a photograph of her hands, which she has positioned in different expressive attitudes, and a drawing that graphically translates the gestures in the photograph. Next she produced a painting, again interpreting the chain of media through which she had explored expressive moments in the photograph and drawing. *32 Moments in the Life of Hands* demonstrates the conceptual relation between, and the translation from, one medium to another. Painted in sweeping gestures and thick impasto, the paintings exhibit the emotive qualities of color and convey a sense of physical and mental animation; the photographs capture Lia's performative hand events much as the camera also displayed her performances; and the drawings communicate the tension and conceptual intensity of precise moments in the life of hands, hands that are the sources for making art.

Later that year, Lia expanded her dialogue with hands into a video installation, *Similar Situations* (1993). She produced this work for the first Romanian video exhibition "Ex Orient Lux," curated by Calin Dan, in which Dan Perjovschi also participated (with *Scan*, discussed above). [Figs. 311–313] In his exhibition catalogue statement, Calin Dan emphasized that Romanians had traditionally been "suspicious of new media;" that media art was rarely produced by artists in the period before 1989; and that the exhibition sought to "prove to the skeptical Romanian audience that media

are more than a consumer good and possibly more than a political weapon." He continued: "Media are self-definition and self identification of the human being in the postindustrial, posttotalitarian era."[116] Lia's *Similar Situations* certainly bore out that claim. Animating the static representations in *32 Moments in the Life of Hands*, the work engaged her hand movements in a silent, lively dialogue with the camera that was displayed on nine monitors. In *Similar Situations*, Lia also combined this hand movement with an installation of rain, comparing the movement of hands to "winking of eyes," and juxtaposing the "blink" that can "ignore . . . the facts" to the "flowing freely . . . smooth and unconstrained in movement" of water.[117] Such unusual contrasts also

appear in her video *Loop*, made in 1997. For *Loop*, Lia jumped up and down for twelve hours before the camera. The record of her hopping motion, combined with the contour of her hair, appears to record the explosion of an atomic bomb, a visual commentary on the outer and inner worlds of the artist. [Frontispiece and Fig. 199]

Once again, through a diverse exploration of media and themes, Lia's conceptual approach to her own hyper-expressivity hides as much as it exposes. She took up the tension between revelation and concealment in a body of work titled *Hidden Objects* (1996) and *Hidden Things* (1996). [Figs. 126–129] *Hidden Objects* is a series of small balls covered in handmade paper. On the surface

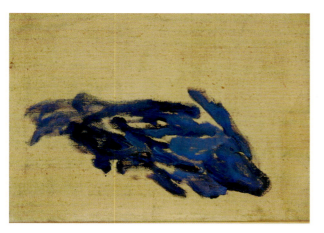

Figs. 122–125
Lia Perjovschi, four paintings from,
32 Moments in the Life of Hands,
1993; oil on canvas.

of one ball is a drawing in Lia's tentative, tentacle-like hand, similar to the drawings in one of the two series of *Hidden Things*.[118] The drawings in *Hidden Things* trace her comings and goings in enigmatic ways that screen as much as they depict. Equally impenetrable are the second series of *Hidden Things*, where ethereal squares embedded in gossamer, handmade paper refuse to unveil even the slim information of the drawings.

It may be difficult to imagine how such inscrutable tiny sculptures and works on paper can resemble two performances realized by Dan—*Untranslatable* (1994) and *Live! From the Ground* (1998)—but the effort to narrate through nearly opaque means links the two in a marriage of things and acts exceedingly hard to grasp. In *Untranslatable*, performed at City Gallery in Raleigh, North Carolina, Dan stood behind a piece of glass suspended in space, recounting a history of his life as he repeatedly hit his head on the pane, sometimes with force and other times barely audibly. [Figs. 130–131] Three years later in 1997, he performed a variation of this piece for a performance festival, "Akcja [Action]," in Kracow, Poland. Dan also punctuated this second performance of *Untranslatable* by tapping his head on a

Figs. 126–129, opposite page
Lia Perjovschi, *Hidden Things*, 1996; collage embedded in paper handmade from banana bark; *Hidden Things*, 1996; ink on handmade paper; *Hidden Objects*, 1996; four styrofoam balls covered in handmade paper. Detail of ball two with graphite drawing of the artist's movements through a city; handmade paper. Courtesy of private collection.

Fig. 130, above
Dan Perjovschi, *Untranslatable*, 1994; performance at City Gallery, Raleigh, North Carolina.

Fig. 131, left
Dan Perjovschi, one of sixty-seven, *Postcards from America*, 1994; ink on pastel paper mounted on cardboard. Courtesy of private collection.

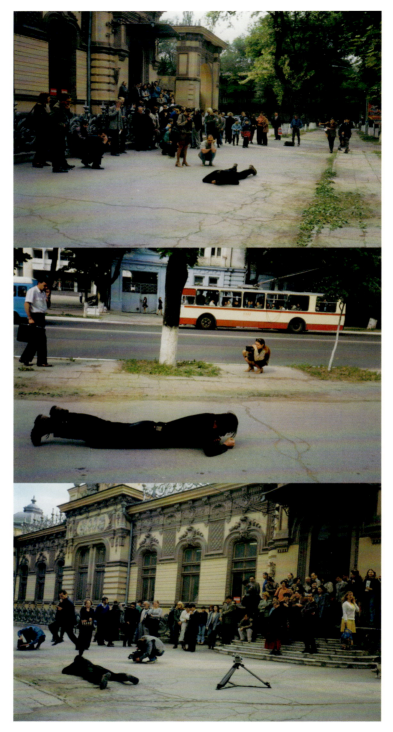

Figs. 132–134
Dan Perjovschi, *Live! From
the Ground*, 1998, performance
in Chisinau.

piece of suspended glass. He then turned to the wall and began drawing. Next he invited the audience to come up and erase his drawings. When no one complied, Dan began erasing his own work and then drawing again. Erasing and drawing, erasing and drawing, until viewers trickled forward to erase, Dan gradually created a tense interaction in which his own work, no matter how quickly he drew, was challenged with disappearance.

Live! From the Ground (1998) was Dan's contribution to the performance festival "Gioconda's Smile from Mythic to Techno-Ritual," organized by Octavian Esanu in Chisinau, Moldova.[119] [Figs. 132–134] For this performance, Dan crawled inch by inch (like a soldier in basic training) along the main boulevard of the capital city of Chisinau. He called out statements such as: "Ground to center! Ground to center! Come in! Come in! Do you hear me? I can't hear you! Please come in!" In addition to his concerted attempts to communicate with "the center" from "the periphery," Dan also called out descriptions of what he saw along his route, describing the landscape inches away as enormous, filled with "gorges" (cracks in the sidewalk), a "forest" (some grass), boulders (bits of rock or sand on the street), and so forth. "If you have no perspective," Dan stated later, "everything looks huge, every crack seems impossible to pass."[120] Of his performance, Dan has written:

> The Romanian "tradition" is based on the "acceptance of fate." The sword spares the swooping head. The whole communist and post-communist period was a crawling movement. We do not want to tear ourselves off the ground. (The earth we glorify so much.[121]) Our expectations have always been low. Our future has been buried. "Technology" has become a goal for its own sake. Ceausescu made our heads swim with "technology growth" and "computerization." And look what came out of it! Now it's the same. Romanian and Moldova do not live in (and do not need) technology. Computers are bought, but human relations are still based on files, stamps, registrations. The new invention

after communism is to use technology as a façade. Instead of increasing productivity, of leading to a more elastic decision, technology became the excuse for hyper-bureaucratization, the laptop and the cellular phone became what Kent cigars and blue jeans had been some years ago. . . Labels. What's the use of the Internet if we look at the World FROM THE HEIGHT OF A FROG'S KNEE![122]

Both *Untranslatable* and *Live! From the Ground* were excruciatingly painful to watch. The fear of broken glass injuring the artist in *Untranslatable* was matched with the recognition of the intellectual, emotional, and physical danger Dan has experienced in his life. In *Live! From the Ground*, both male and female viewers choked with

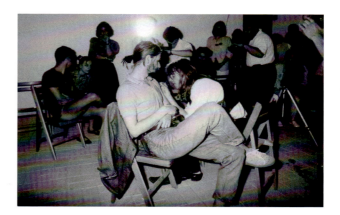

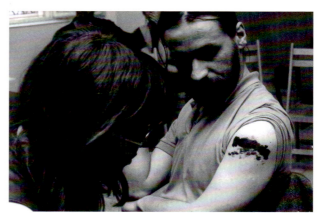

Figs. 135–137, above and following page
Dan Perjovschi, *Romania*, 1993; performance in Timisoara: tattoo.

Figs. 138, following page
Dan Perjovschi, *Erased Romania*, 2003; performance in Kassel: removal of tattoo. Courtesy of Galerija Gregor Podnar, Ljubljana, Slovenia.

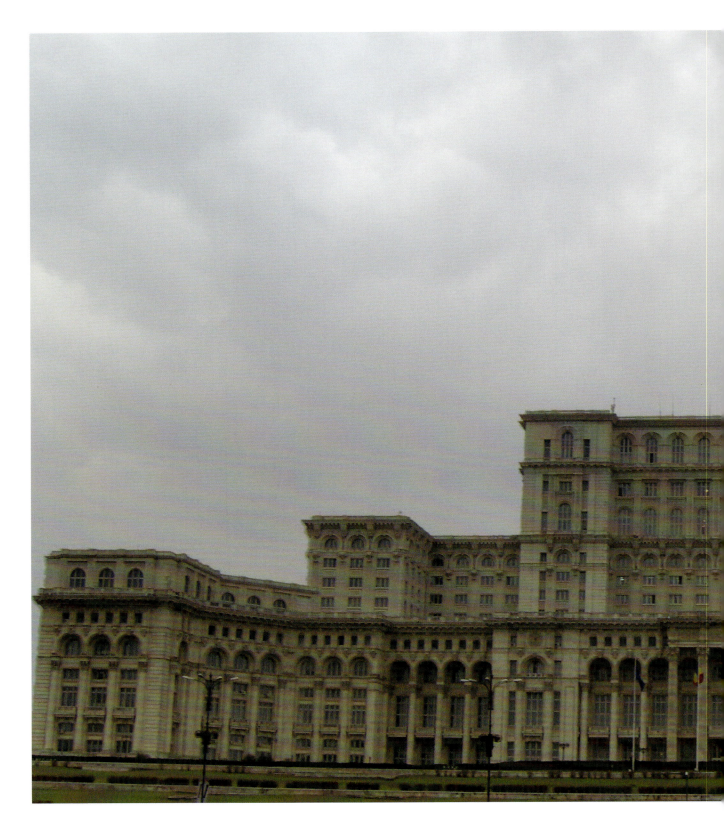

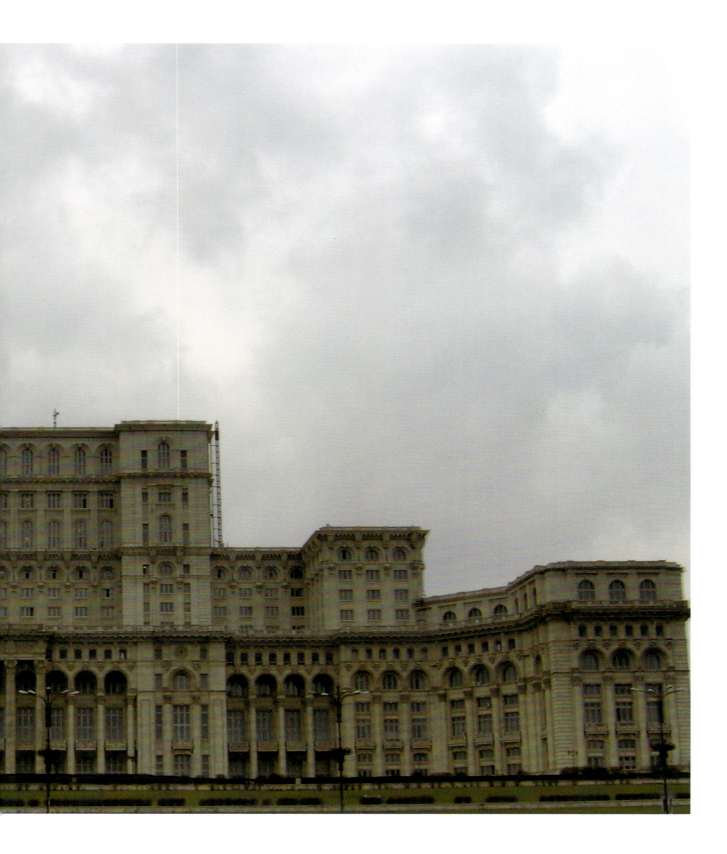

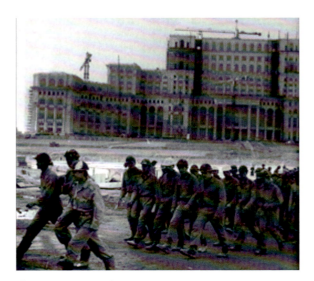

Figs. 139–140, previous page and above
Building previously called Palace of the People, 1984–1990; House of the People, 1990–2003; and Palace of the Parliament, 2003–present.

emotion as they viewed the tall, striking, self-possessed artist—a man of caustic wit with an enormous capacity to identify and empathize with human frailty, as well as to transform it into compassionate humor—crawl along the street calling for help from "the center." Dan's action, however, was not simply on behalf of himself alone. Seeking to attain a higher position in life, he also called out for Romania and the Republic of Moldova (the former lands of Bessarabia, which were the birthplace of his father and ancestors). Neither sentimental, maudlin, nor kitschy, these two performances evoked responses similar to those viewers experienced while watching Lia perform *I'm fighting for my right to be different*: a sober confrontation with unfathomable realities articulated and conveyed by two relentless artists.

"Dumb but true," Andrei Codrescu has written in another context about Romanian experience, "like all things evacuated by the very truth they claim."[123] I interpret Codrescu's "dumb" (in the context of Dan and Lia Perjovschi's work) to represent the density of truth and "hidden things" that never shed their obtuse character even as they empty out the very events they enunciate.

This is certainly the case with Dan's dual performances *Romania* (1993) and *Erased Romania* (2003), two connected performances that involved Dan first in having his upper arm tattooed with the word "Romania" and, a decade later, having the same tattoo removed. [Figs. 135–138, 141, 300, 343]

LIADAN: DIZZYDENTS FROM DIZZY
Dan performed *Romania* at the performance festival "Zone 1," organized by Ileana Pintilie in 1993, where Lia also performed *I'm fighting for my right to be different*. As I wrote that year, Dan's tattoo externalized the mark of his oppressor and simultaneously breached the code of secrecy that governs trauma:

> With the word "Romania" emblazoned on the surface of his body, Dan Perjovschi staked the authenticity of his existence on a name. His tattoo divulges the dependence of his identity upon his country. . . . But his tattoo is also an indeterminate sign signifying the synchronicity of a visible wound and a mark of honor. A symbol of resistance and icon of marginality, it is a signature of capture, a mask that both designates and disguises identity. As a symbol for the charged complexity of Romanian national identity, the tattoo brands his body with the arbitrary geographical identity agreed upon by governments, and displays the ambiguous

Figs. 141
Dan Perjovschi, *Erased Romania*, 2003, performance in Kassel. Courtesy of Galerija Podnar, Ljubljana, Slovenia.

psychological allegiances such boundaries inevitably commit to the mind. His action-inscription also conveys some of the content of the accreted spaces of Romanian suffering and guilt, guilt that Dan Perjovschi addressed when he explained that in Romania, where both prisoners and citizens alike habitually were transformed into perpetrators, guilt and innocence intermingle inseparably. And he asked, "Who may point a finger?"[124]

Fig. 142
Lia Perjovschi, *CAA Kit*, 2002. Poster documenting CAA activities.

Nine years later, Pintilie again invited Dan to participate in "Zone 4." He responded with a promissory letter that his contribution to "Zone 4" would be the performance of the removal of his tattoo on its tenth anniversary, or whenever he received funds to undertake the process. [Fig. 363]

In 2003, Perjovschi performed *Erased Romania*, having his tattoo sequentially removed during René Block's exhibition "In the Gorges of the Balkan" at the Kunsthalle Fridericianum in Kassel, Germany. In Dan's words:

> The Block show scanned the Balkan region and I used this project to get out of the Balkanic umbrella. Kunsthalle Fridericianum paid for the [necessary] three sessions and partially for the trip and accommodations while I underwent the treatment. It was obligatory to have at least three weeks in between laser sessions. First one I did at the opening (30 August); second at the midterm (30 September); and the last session at the [closing party] of the show (November 23). As far as I know, they spent about 1,500 euro.[125]

With the tattoo erased, Perjovschi declared himself "healed" of Romania. Dan's declaration coincided with the moment when he and Lia began to identify themselves as "dizzydents" (dissidents) from "Dizzy" (Romania), a declaration made after the artists became embroiled in conflicts with Romanian curators and artists over the proposal to found the first National Museum of Contemporary Art (MNAC) in the Palatul Parlamentului (Palace of the Parliament). [Fig. 139]

In order to appreciate this clash, and the full extent of the Perjovschis' contribution to Romanian culture, it is important to understand that their practice is a time-based, socially engaged model of art that supports public education, the production of knowledge, and cultural renewal. This is particularly true of Lia's work in the late 1990s and 2000s. But it is equally true of Dan's later large-scale drawing installations, which use the psychology of laughter to comment critically and ethically on political and cultural conditions. The Perjovschis' oeuvre can be divided into two mutually enhancing phases: the first loosely characterized by more private, intimate work, and the second by public

art addressed to public concerns. These later works reach beyond the individual instances of their production, as for example Dan's work for the newspaper *Revista 22* and Lia's newspapers such as *Zoom* (1998). [Figs. 143, 146–153] The point is that after the mid-1990s, their work did, indeed, change, and although the conflict over the National Museum of Contemporary Art only came to a head in the early 2000s, the Perjovschis' decision to identify as "dizzydents" from the land of "Dizzy" makes the division between the two periods of their art more explicit. [Fig. 145] In their confrontation with MNAC, they not only challenged the construction of Romanian history directly (as some Romanian artists, especially Romanian filmmakers, have done), but they also demanded change by carrying out courageous dissident acts against influential figures in Romanian culture. At the same time, Dan and Lia recognized the folly (their dizzydence) of their insistence that Romanian culture openly address its past in a land (Dizzy) where such resistance has primarily been met with censure.

The Perjovschis' practice entails a conceptual approach to cultural engagement that also includes a willingness to put themselves on the line for their society. Their response to the placement of MNAC in the Palace of the Parliament is an object lesson in what is entailed, culturally and personally, in a commitment to resistance. Much critical and art historical attention has focused over the last decade on the notion of artists as "social workers."[126] But this term simply revises conceptual approaches to art that have been in place since the social activism of the early twentieth century, especially in communist and socialist countries where putting art at the service of the nation is a cultural tradition, one that the Perjovschis inherited in Romania. In order to examine these aspects of the Perjovschis' practice, it is worth recounting the history that led to the conflict over MNAC.

After the Revolution, the monstrous building—Palatul Poporului (Palace of the People)—was scaled down in nomenclature alone to Casa Poporului (House of the People). But it was popularly known as Palatul Nebunului, or the Madman's Palace. In the mid-1990s, officials scaled the building back up to Palatul Parlamentului (Palace of Parliament), setting off a cunning linguistic chain that manipulated meaning (and through it, history) by transforming a "Palace" into a "House," only to return it to a "Palace."[127] The subtle but significant shifts in taxonomy reveal the connections between the new Palace of the Parliament and the old, oppressive Socialist Republic of Romania: the word "palace" is retained for both regimes, and with it the memory of the once exiled Romanian monarchy, the shadow at the

Fig. 143, top left
Dan Perjovschi, stack of eleven bound volumes of *Revista 22* [Bucharest], containing Dan's drawings from 1991–2006.

Fig. 144, above
Lia Perjovschi, Presentation of CAA documents as *Detective* table, Ljubljana and London, 2000.

Fig. 145
National Museum of Contempo-
rary Art (MNAC) wing in Palace of
the Parliament, 2006.

center of Romanian parliamentary democracy. Other new titles for old buildings conveniently folded the unsavory past into a present-future void of history: the self-conscious naming sublimated historical misery, thereby resisting the acts of remembrance and mourning necessary to healing.

No matter. In 2003, Donald Rumsfeld (Secretary of Defense under U.S. President George W. Bush) determined that Romania was to be part of the "New Europe," and after this designation it became a "training range and military port" for U.S. military expansion in its "fight against terrorism."[128] These developments shed light on two further aspects of the Palatul Parlamentului affair: the structure is the third-largest building in the world. In 2004, this colossal public works project—second only in mass to a U.S. military headquarters (the Pentagon) and an American shrine to capitalism (the Chicago Merchandise Mart)—became the site of the National Museum of Contemporary Art.

With the MNAC now added to Palace of Parliament, the infamous structure combines all the features of the military-industrial-communication-complex, with the additional benefit of now being an entertainment center as well. [Fig. 145]

The Perjovschis refused to participate in any exhibition on this site, or to sell their works to MNAC.[129] They described their rationale in the following terms:

1) In an emerging art scene with no production funds, no mobility funds [for travel], and basically not enough white cubes [exhibition spaces] to show the art works [of contemporary artists], the making of such a cultural Pentagon is not the solution. More than 2 million euro were spent to adjust the building [House of the People] for

caa
caa
caa

(center for art analyse)

liadan perjovschi

12 berthelot street
p.o. box 17
70700 bucharest 1
romania
tel/tax: +421/310.01.17;
tel: +421/424.72.95
perjovschi@yahoo.com;
perjo@ong.ro

project in the frame of
"Profetic corners"
Curator:
Anders Kreuger
Iaşi Biennal 2003
"Periferic"

Normalcy
Meaning
Relaxation

caa:

1. Please try to outline a rough sketch of the context you/we are experiencing nowadays (an inventory of positive and negative things).
2. How would you draw a blueprint of building normalcy?
3. How do you see your personal future? What about that of Romania? (or about the future in general)
4. Please recall a few important things that had a great impact on you (your own, personal deposit of positive thoughts).
5. What projects did you fail to achieve? (and why)
6. What major projects did you succeed in achieving?
7. What are your projects for the future?

Sorin Antohi
Ciprian Mihali
Marius Oprea
Dan Petrescu
Alina Mungiu-Pippidi
Joanne Richardson

lia perjovschi

sens

short guide

art in public space (ro)
some independent positions

From left to right • **First line:** Communist heritage, queues for food, January 1990 (from Stefan Constantinescu's *Archive of pain*, photo Dan Hansson) • Timisoara revolution, December 1989 • Bucharest revolution, December 1989 • **Second line:** Timisoara 1989, popular cenotaphs • Bucharest 1990, Civic Alliance (AC) protest meeting • Bucharest, University square, Mai-June 1990 anti-communist students protest, hunger strike • **Third line:** Bucharest 1990, June 14-15 first miners invasion. The coaltar revolution • Bucharest 1990, June 13, Police invade University Square and beat the protesters • Bucharest 1990, June 13-15, civilians beaten on the streets by policemen's, miners and secret service agents •
(photos from 22 Magazine archive, Emanuel Pârvu, Ovidiu Bogdan, i22@iong.ro and Timisoara Revolution Memorial, Traian Orban director, amrtim@fasting.ro)

DETECTIVE DRAFT

2005

Lia Perjovschi
presents

Formats

curated by
Georg Schollhammer

in the frame of
Viena Days in Bucarest

may 2004

waiting
r o o m

in the frame of ECF
(European Cultural Foundation) action line

Enlargement of Minds
Crossing Perspectives

seminar
Theatre Instituut Nederland (TIN)
Amsterdam 16-18 June 2003

"In 2002 the ECF launched the action line "Enlargement of Minds". With the aim of exploring, analyzing and anticipating the cultural dimension and implication of EU Enlargement and beyond. It comprises a series of seminars, research, publications, artistic and cultural events that tackle the cultural aspects of EU Enlargement. It contains various viewpoints, and involves cultural operators, opinion leaders, policy makers, media professionals and artists debating the cultural challenges, opportunities and risks that enlargement brings to those "included" and those "excluded" from the process. EoM intends to stimulate proactive contribution to European cultural policy making and advocate new forms of exchange and encounter. In terms of scope, EoM will address the challenges for the "cultural project Europe" after the first wave of accession in 2004 (Czech Republic, Cyprus, Estonia, Hungary, Latvia, Lithuania, Malta, Poland, Slovakia, Slovenia) and the second wave planned for 2007 (Romania, Bulgaria). But EoM extends beyond the present accession process. It seeks to draw attention to the larger European cultural area, including those countries that will not be part of these two accession."
Crossing Perspectives is a vital component of the series.

some art position

Nevin Aladag
Matei Bejenaru
Pavel Brăila
Mircea Cantor
Daniel Knorr
Oliver Musovik
Rassim
Anri Sala

Figs. 146–153, previous pages
Lia Perjovschi, *CAA* and *CAA/CAA*
newspapers, 1998–2005.

Figs. 154–155
Meetings and presentations in
the Perjovschi's "Open Studio"
from 1996–present.

is Romania where the process should be more transparent. The Prime Minister (an art collector) is quoted as saying about the location: "Either here (Ceausescu Palace) or nowhere. . . ."; 6) The museum was established, putting all the state spaces together (6 venues) under the same umbrella. This was the year, 2002, when things were supposed to go the other way, decentralizing State Power.[130]

Backing up this commanding argument with action, Dan also refused the invitation to contribute his art to the opening exhibition of the museum, and promptly posted the official invitation on the Internet so that any Romanian artist could respond. Officials were inundated with offers from artists they did not want, but who ironically sought to participate and to belong to the new museum. Lia was never invited. This was no oversight, but rather confirms the fact that some in the official Romanian art community fail to grasp the significance of her work. This snub also delivered overt punishment for Lia's aggressive critique of Romanian cultural practices, particularly through her development of the *Contemporary Art Archive Center for Art Analysis (CAA/CAA)*. [Figs. 144, 367, 370] The Perjovschis' resistance to the Palace of Parliament scheme has resulted in a prolonged, ongoing standoff between them and some Romanian critics and curators.

The Perjovschis simply refused to be complicit in the association of contemporary art with the historical crimes signified by the Palace building; their stance also represented a refusal of the implicit co-option of living artists by the state. They have pointed out that those in control of the museum have the power and authority to marginalize artists who do not conform. Further, they emphasize that the new authorities exercise this power in ways consistent with those used by the more explicitly repressive Union of Artists before 1990. Dan and Lia suggest that an old (and all too familiar) structure of intimidation has reappeared in a new guise under the democratic system. Making the difficult decision to remain outsiders, the Perjovschis identify themselves as "dizzydents" for the purpose of collaborating in the

art purposes; 2) The building is the Parliament. On one hand, we do not know of any good art institutions located in the parliamentary buildings [of other nations], and, on the other, after having culture under [the thumb of] politics for 50 years to put it [here] is like a bad joke; 3) This is the ugliest building on Earth. This is the dictator's Palace; 4) Between the city and the building is about one mile of empty fields. That is exactly the distance between the leaders and the citizens. Now this distance will apply to visual art too; 5) Absolutely nobody was consulted. This

reconstruction of "Dizzy" and its cultural institutions and practices.

The Perjovschis initially accomplished this goal by opening their studio to the public in 1996, offering an open meeting place for discussions among international and Romanian artists, journalists, art critics and historians, writers, filmmakers, and philosophers. [Figs. 154–155, 325] (See the *AutoChronology* in this book for an extensive list of meetings hosted in their Bucharest studio.) This open practice evolved from Lia's original impetus for *Contemporary Art Archive* (*CAA*), which she began in 1997 and expanded in 2001 to *Center for Art Analysis* (hence the title *CAA/CAA*) for the purpose of "preserving a space for criticism" in a country where criticism of institutional practices could quickly isolate artists.[131] Collecting masses of information and images, Lia conceptualized the archive as an "institution" with an obligation to share its knowledge with the public. Teaching at Duke University in 1997, both artists realized that they needed to begin "to teach Romanian students, not Americans!!!!"[132] They set about this task upon returning to Romania in 1998.

Drawing on Lia's archive, the Perjovschis began a rigorous series of public programs and lectures throughout

Fig. 156
Dan and Lia Perjovschi, *Everything on View*, 2000; television screen capture of the live broadcast.

Romania and eventually Europe. With each presentation, they distributed and displayed catalogues and books on the topic of their lectures, and under the umbrella of *CAA*, wrote and assembled newspaper publications, distributed free, but sometimes printed at their own personal expense. [Figs. 146–153] They began these publication practices in 1992, with their first two-person exhibition "Perjovschi/Perjovschi," at Simeza Gallery in Bucharest, and they continue publishing newspapers both collaboratively and individually today. [Figs. 276, 314]

Other ways that *CAA/CAA* helps foster the development of Romanian art include providing support for numerous young Romanian artists; backing the independent art scene in Romania throughout the 2000s; lobbying for artist-run spaces like H.Arta (in Timisoara), Protokoll (in Cluj), and Vector (in Iasi); and providing assistance with contacts, funding opportunities, and media coverage. The Perjovschis mounted the exhibition "Position Romania" in Vienna in 2002, using forty percent of their allocated budget (from Forum A9 Transeuropa, MuseumsQuartier 21, Vienna) to bring young Romanian artists to Austria, many for the first time. Their mentorship has extended even beyond funding, however, to their active involvement in artists' careers. The Perjovschis' help enabled Maria Crista, Anca Gyemant, and Rodica Tache, the three artists who founded H.Arta, to secure an artist residency fellowship in Vienna. Similarly, Raluca Voinea, who now edits the online art journal *www.e-cart.ro*, was able to study at the Royal College of Art in London, an opportunity facilitated by introductions to British critics made possible by Lia.[133] In addition, the Perjovschis acted as advisers to artist Attila Tordai S (Protokoll's manager), who spent time studying in Germany after receiving a Rave Scholarship for Curators, Restorers, Museum Technicians and Cultural Managers. Through workshop sessions, debates, lectures, meetings, and even direct advocacy, Dan and Lia coached emerging artists and introduced them to principles of managerial organization. [Figs. 161, 370, 373]

CAA also launched a public art and education program, mounting numerous exhibitions such as "Dia(pozitiv)"

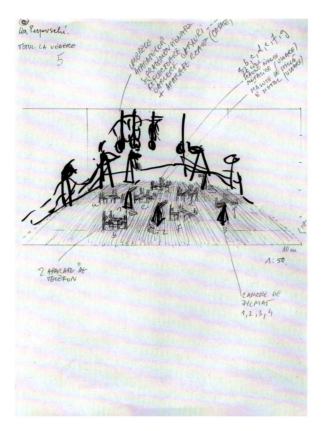
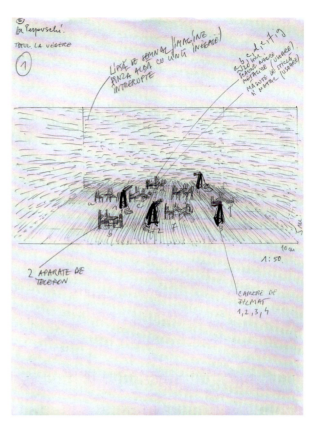

Figs. 157—158
Lia Perjovschi, sketches for the set of *Everything on View*, 2000; ink on paper.

(1998), a show Lia organized at Bucharest's Atelier 35 to expose the public to new art forms, such as installation art. For this show, Lia made some one hundred slides of a variety of art installations from around the world. Together the Perjovschis provided a gallery lecture for the exhibition and organized a program featuring speakers from various fields. Two years later, in 2000, the couple organized an installation and public dialogue on the subject of "Kitsch" with Razvan Exarhu, a well-known FM radio announcer again at Atelier 35. For this event, they designed the exhibition space as if it were an apartment, including common objects appropriate to a home, placing things on the floor as if in a flea market. They hung nothing on the walls. The entire arrangement was a tutorial aimed at rethinking artistic practice and refiguring conventional dichotomies between life and art, culture and commerce. During the exhibition's two-week run, and unsolicited by the artists, the public spontaneously brought objects to add to those on the floor: the exhibition transformed into an installation-happening. As Dan recalled, "It was not a great project, but a popular one!"[134] The following year, 2001, Lia mounted "CAA Kit: Visual ID/Defragmentation" at Atelier 35, an installation that examined Western visual and conceptual strategies for exhibition design. In 2003, Dan and Lia together presented "Waiting Room: Several Artistic Positions from South-East Europe" as part of the conference "Enlargement of Minds/Crossing Perspectives." Held at the Theater Art Institute in Amsterdam, this three-day event brought together artists from countries described by the Perjovschis described as "leftover from the European process of accession (Romania, Bulgaria, Moldova, Albania, Turkey)." Between 2003 and 2007, these extensive activities have only multiplied and the network in which the Perjovschis participate has grown internationally.

The Perjovschis have been especially successful in utilizing mass media to educate Romanians about art. Their work in this area has engaged them in television interviews and events that they broadcast on national television from their studio. Moreover, they also became part of a team with Ruxandra Garofeanu, an art historian and TV producer, collaborating on the unprecedented television series *Everything on View*, a title that captures the Perjovschis' goal to make communication in Romania transparent. [Figs. 156–158, 360] Lia and Dan served as moderators for the show, and much of its visual material came directly from Lia's CAA archive. The program's unconventional content and new forms of visual presentation demonstrated to a general audience how experimental art intersects with politics and society, making *Everything on View* especially popular with audiences in Romania.

Dan has described the Perjovschis' television adventure as a "splendid failure" for the ways in which the team "lacked the time to cover their complex subjects adequately," for the sharp differences in individual member's cultural knowledge, and for the fact that—for Lia and Dan—their work was a kind of "performance art before the nation," while for other members of the team, the program was just a "job."[135] These discrepancies resulted in battles that "made everybody nervous," Dan remembered, "which was good."[136] To whatever degree the Perjovschis felt their concept had failed, commercial television programmers quickly identified the artistic and experimental nuances of the program, and they adopted ideas from technical failures on the show that ironically became cutting-edge innovations. What the Perjovschis knew to be mistakes on air, such as conversations off-camera that could be heard on-camera between Dan and Lia and the team were the very things that spurred aesthetic experiments in the media. In addition, aesthetic choices such as the Perjovschis' use and simultaneous presentation of both black-and-white and color material was quickly adopted, a style of production that is currently fashionable in the United States. The program also proved successful enough for the editor for the literature section, Daniela Zeca-Buzura,

to be later appointed director of the Romanian Cultural Channel, State Television 3.

All these activities show how Dan and Lia's actions as dizzydents have made four fundamental contributions to Dizzy (Romanian) culture over the past decade. They have supported the independent art scene by helping establish emerging artists' alternative spaces, magazines, and visibility abroad. They have partnered with various cultural institutions and collaborated with the media. They have responded to the cumulative impact of decentralizing art away from Bucharest by emphasizing the expansion of art centers and maintaining cultural dialogue with artists throughout the country. They have made determined efforts to ensure transparency in culture and a remembrance of the past.

AFTER AS FUTURE

The dizzydents do not only contribute to Dizzy. Dan and Lia Perjovschi's art has also had a growing impact around the world. [Fig. 159] In 2007, Dan completed a

Fig. 159
Dan Perjovschi, *My World Your Kunstraum*, 2006; cover drawing for artist book.

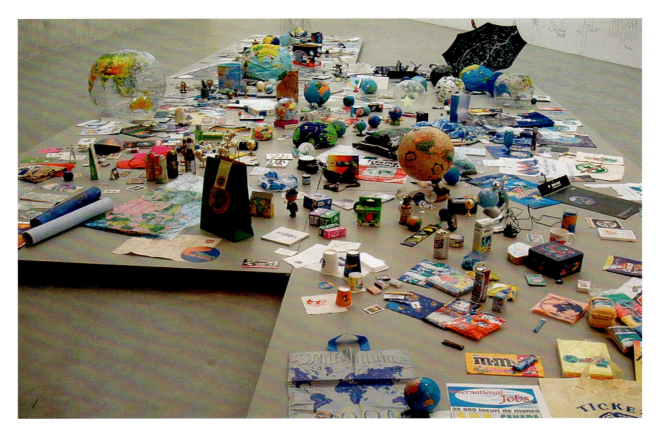

large-scale drawing installation, *WHAT HAPPENED TO US?* at the Museum of Modern Art in New York, as part of its "Projects 85" series; and Lia installed a study for her *Knowledge Museum* in the exhibition "Timeout! Art and Sustainability" at the Kunstmuseum in Liechtenstein. [Figs. 169, 226, 297–299] Dan also did a drawing installation at the Venice Biennale, and both participated in the "Venice Agenda V" series, speaking on the panel "Is Art a Form of Debate?" Indeed, in 2007 alone, one or both of the Perjovschis have worked in Austria, Denmark, England, France, Germany, Italy, Liechtenstein, the Philippines, Poland, Romania, Russia, Slovenia, Spain, the United Arab Emirates, and the United States. What is it about the Perjovschis' art and projects that capture the imagination of the global public and international art world? The last section of this essay contemplates this question.

The context for Lia's *Knowledge Museum* in Liechtenstein is telling. The exhibition considered the relationship between selected contemporary artworks and the concept of sustainability, a multivalent term that refers generally to the goal of managing the environment in order to provide for current and future world populations. But as the materials for the exhibition make clear, sustainability also applies to the economic, social, institutional, and cultural welfare of the earth, and signifies the concomitant desire for discovering alternatives to the accelerated pace of life in the new movements focusing on "slow food, slow city, slow medicine, and slow sex."[137] Much of Lia's work since the mid-1990s can be understood as a response to this quickening of life in an era of globalization. Certainly this is one of the topics suggested by Lia's *The Globe Collection* (1990 to the present). This body of work includes about 1,500 items in the shape of, or imprinted with, the image of the planet. [Figs. 160, 316–321, 324] In addition to actual globes, there are postcards, books, balloons, toys, T-shirts, umbrellas, balls, change purses,

perfume bottles, hats, kitchen articles, stationery, coins, stamps, beer cans, advertisements, and much more. Lia chooses objects carefully based on their intrinsic interest and design, as well as their cultural significance. Together with such works as *Knowledge Museum*, *Mind Maps (Diagrams)*, *Research Files*, and *CAA/CAA*, *The Globe Collection* aesthetically models the way information can be collected, organized, and analyzed. In this way, Lia's installation implicitly suggests how a more integrative, self-reflective life might be lived. By modeling a collection as a practice that responds to an individual's actual needs, experiences, and goals, rather than to the imagined needs generated by capitalism and the culture of consumption, Lia's work suggests, further, that such a life might help ensure sustainability more broadly.

When she first began to travel in 1990, Lia was immediately drawn to popular cultural artifacts that reflected the planetary impact of globalization and its implications for the quality of life. At that time, she began three collections: plastic bags from Romania and the former Eastern European countries, unavailable before 1989; all variety of objects featuring the image or form of angels, called *Angels*; and *The Globe Collection*. All three collections are ongoing. Lia exhibited these bags in 1994, when she installed the collection in the meeting hall of the Group for Social Dialogue, a collective founded to monitor the transition from communism to a civil society. [Fig. 348] Dan is a member of this group, which also publishes *Revista 22*. In this context, the plastic bag collection visibly signified the transit of goods to and from Romania from the perspective, in Lia's terms, of "a person who judges the value, worth, beauty, or excellence of something."[138]

To better understand Lia's fascination with objects that conjure images of commerce, one needs to appreciate the absence of such things in Romania well into the 1990s. For example, in 1991, while traveling in northern Romania, it was necessary to light matches to negotiate three flights of stairs to a room in a good hotel in the university town of Satu Mare. Why? There were virtually no light bulbs in the country. [Fig. 239] This is why the satellite map revealing Romania as a black hole in the 1980s has become so infamous. [Fig. 162] During this period, shops were completely devoid of goods; restaurants also had nothing, despite customers being given multipage, leather-bound menus by embarrassed waiters who could not provide what the menus offered. Few can imagine the shame such scarcity imposed upon a proud people. Upon landing at Otopeni in 1991, the international airport in Bucharest, travelers entered a tiny room with one bare bulb hanging from an electrical cord. There they surrendered their luggage to an ancient, noisy conveyor belt that nearly ground suitcases to pieces before spitting them out on the other side of the wall. Military aircraft and guards surrounded the entire airstrip, and sullen, suspicious guards met passengers. These sentries were as threatening as any East German border guards in the 1970s and 1980s. Everything suddenly changed in 1995, at least in appearance. Seemingly overnight, cappuccinos, for example, could be had in a new airport café where one could pay in u.s. dollars, handing over money that represented the wages of days of Romanian labor.

Like aesthetic radar, Lia's plastic bag collection and *The Globe Collection* anticipated these radical and abrupt changes, showing how "outside" and "before"—terms Romanians used to indicate the times before the Revolution—now concretized what I titled this section, "after as future."[139] By the end of the 1990s, major cities like Bucharest, Timisoara, and Iasi were inundated with commercialism, manifested in mammoth advertising banners that literally covered the entire façades of most buildings in the city centers. What was desired arrived as an avalanche. "The great hum of truth that was in the

Fig. 162, left
1980s satellite map of Europe at night, showing Romania with almost no lights.

Fig. 163—168, opposite page
Lia Perjovschi, *Research Files. General Timeline: From Dinosaurs to Google Going China*; 1997–2006; collage and paper, six details.

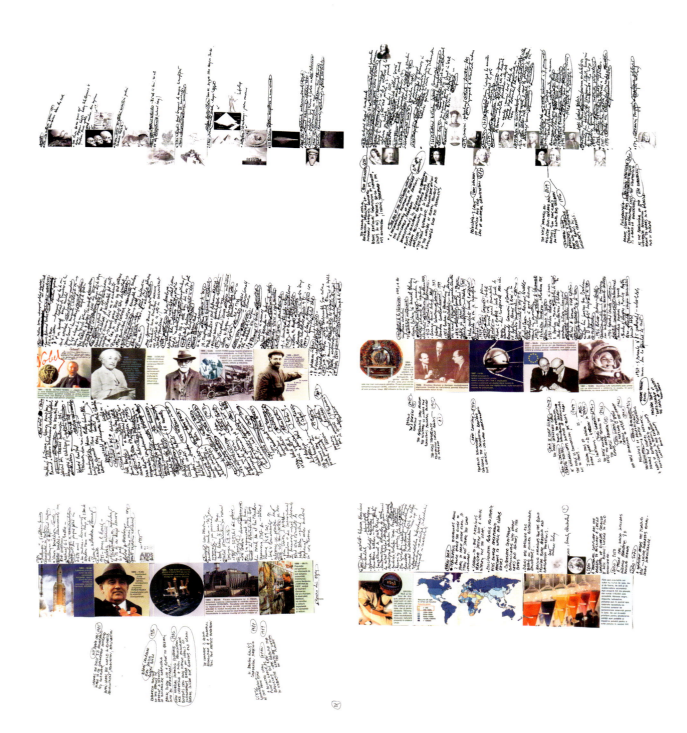

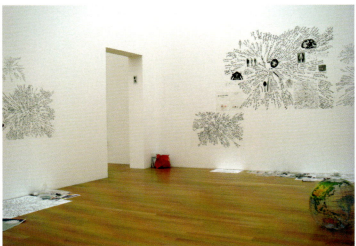

and those who nevertheless (along with and because of the others) also despoil the planet as an effect of global poverty.[141]

The related work, *Knowledge Museum* (with its seven departments: The Body, Art, Culture, The Earth, Knowledge and Education, The Universe, and Science), derives from Lia's intrinsically interdisciplinary approach to art and information, and belongs to the long tradition of artists' similarly arcane systems of accounting for the world, from esoteric museums to museums in a hat.[142] *Knowledge Museum* is also a contemporary Cabinet of Curiosities, "an interdisciplinary Museum [where] everything is connected and not isolated . . . [as if] you enter inside of a mind."[143] One enters Lia's mind first through her *Research Files*, which anticipated *Knowledge Museum*. [Figs. 163–168] Each *Research File* is comprised of collaged images and texts devoted to a particular subject. For example, "Subjective Art History from Modernism to Present" explores areas of visual interest to Lia and the impact of art on culture. "My Visual cv, from 1961 to the Present" details her biography. "Detective Draft" surveys contemporary culture, alluding as much to the legacy of Romania's massive spy system as to current regimes of global surveillance and their detective apparati. Such *Research Files* as "Subjective History of Romanian Culture in the Frame of Eastern Europe and the Balkans, from Modernism to the European Union" and "Subjective General Knowledge, from Dinosaurs to Google Going China" ask viewers to consider idiosyncratic frames of reference and expand upon Lia's long-standing preoccupation with arresting and reshaping time. [Figs. 241–268] Like the photographs, drawings, and paintings of *32 Moments in the Life of Hands*, *Research Files* plunge viewers into Lia's world of allusion and memory. While the form of aesthetic contemplation in *Research Files* is unusual, viewers are invited into an artist's mind in the same way that they would enter into and engage with a traditional work of art, where one confronts an artist's concepts through color, expression, and form as in a painting or sculpture. *Knowledge Museum*, *Research Files*, and the sixty drawings that comprise *Mind Maps*

Fig. 169
Lia Perjovschi, *Knowledge Museum*, 2007, installation, Kunstmuseum Liechtenstein; ink and collage on paper.

world looking for means of expression," Andrei Codrescu wrote in 1986, three years before the Revolution, "became the generalized din of consumption."[140] My point is that Lia's works of the late 1990s and 2000s are not about sustainability per se. They meditate on the globe itself, and on the endless consumption and self-absorption of that part of humanity able to own and produce such goods. But also secreted away in *The Globe Collection* (as in Lia's *Hidden Things*) is the unseen but palpable presence of those unable to own such objects, those absorbed in their own survival,

(Diagrams) constitute evidence of Lia's distinctive mind, busy at work scrutinizing the world. She does so with a rare combination of skepticism and awe, a mixture of uncertainty and reverence replaced in global culture by pseudo-sophistication and faux cynicism.

In addition to engaging with topics like sustainability, other themes have also been important for Lia's work, which has been included in an international series of exhibitions, panels, and symposia on the subject of the Academy.[144] This movement grew out of the critique of the museum launched by experimental artists throughout the world in the late 1960s and 1970s from Hélio Oiticica (Brazil) and Art & Language (England) to Joseph Kosuth (U.S.) and Michael Asher (U.S.). It was sustained over the next two decades in self-consciously political art that assumed the language of platforms and was usually installed outside the walls of museums.[145] Today, the consortium of academics associated with the Academy attempts to build upon this trend at the same time that it seeks to reverse it by posing the questions: "What does the museum make possible beyond itself? How can the museum become a series of exchanges and responses, and how can it move beyond acting as a vehicle of established values?"[146] Such queries bring

Fig. 171
Dan Perjovschi, *Beautiful Bird Flu*, 2006; pencil on paper.

to mind a 1966 essay by artists Mel Bochner and Robert Smithson titled "The Domain of the Great Bear." This text analyzed the American Museum of Natural History and concluded: "History no longer exists."[147]

Bochner and Smithson's essay anticipated Fukuyama's announcement of the end of history (quoted in the Introduction to this essay) by nearly twenty years. Yet the earlier pronouncement was significantly different in content from Fukuyama's post–Cold War political analysis. Resisting the Academy and the Museum, as well as academic and museological histories, Bochner and Smithson posed an alternative to such institutional structures by invoking Jorge Luis Borges's notion of a "labyrinth that is a straight line, invisible and unceasing."[148] Lia's 1980 Ex Libris, *J. L. Borges*, belongs to this tradition. Already as a teenager, Lia had intuitively acknowledged the conundrum of history — its institutions and representations — and was beginning to forge a new form of art through the most traditional of means, a bookplate. Her *Mind Maps (Diagrams)* are her most visible manifestation of the Borges maze, models of history and mind dependent upon but separate from the Academy and the Museum. [Figs. 11, 161, 322] They, along with her work since the late 1990s, respond to the question of Academy and Museum by being sympathetic to, but distant from, both critical traditions.

Fig. 170
Dan Perjovschi, *Do You Remember My PIN?* 2006; pencil on paper.

And Dan? What is the central significance of his drawings? Dan pays attention to the prattle of everyday life, picturing such nattering on the huge walls of the most illustrious museums of the world, walls that have been constructed to both intimidate and impress. But Dan's drawings do not participate in this posturing: he mocks himself and pokes fun at the mores, customs, beliefs, prejudices, and general behaviors of the audiences that adore him for his honest self-deprecation, ironic humor, and sincere affection for humanity. *Do you remember my PIN?* illustrates a man at an ATM machine. [Fig. 170] Forgetting his PIN number, he turns to the camera behind him, the very surveillance system that has repeatedly recorded his daily or weekly transactions, and asks with the anticipation of an answer: "Do you remember my PIN?" *Beautiful Bird Flu* depicts only a floating, gracious swan, serene and unknowing. [Fig. 171] *Global Warming* shows an ice cream cart where the vendor has crossed out the word "ice" and left only "cream." [Fig. 172] Dan laughs wickedly, but his eyes reveal a grave expression.

Fig. 172
Dan Perjovschi, *Global Warming*,
2006; marker on wall.

Everyone wants a Perjovschi, no matter how ephemeral his astonishing installations may be. Of all the illustrious museums that have exhibited his work, however, only the Van Abbemuseum in Eindhoven, the Netherlands, has gotten wise: it will lease Dan's installation rather than destroy it. Why not? These are magnificent works, commanding in their breadth and depth of analysis, bold in technique and drawn with a sense of immediacy, confident as any Jackson Pollock painting. This suggests that Dan masks self-doubt similar to Pollock's anxieties, even as his drawings are also arrogant in their knowledge of their own technical facility, just as Pollock was when he painted. [Fig. 347] When I summon Pollock here, it is not in the spirit of a shameless hagiography about Dan Perjovschi; that would be the result if I did not permit myself to make such contemporary comparisons with historical figures. Dan knows how to fill and balance aesthetic information in large expanses of space, and his work has changed the scale and language of drawing. He comes prepared when he faces the walls of such institutions as the Ludwig Museum, Cologne, Van Abbemuseum, Eindhoven, and the Moderna Museet in Stockholm. [Figs. 178–180] Dan spends hours analyzing television and the news; he reads dozens of international newspapers and magazines; he watches people all over the world in order to discern and translate local customs and ideas into universally understood visual representations of human experience; and he fills dozens of notebooks with notations and drawings that do so. [Figs. 278, 375] Dan Perjovschi works hard.

Dan attracts what activist artists from the Situationist International to the present have not: a multinational, multigenerational, multiethnic audience whose languages he speaks in visual form. But Dan is not a conventional activist. Instead he translates the complexities of social behavior into art. Dan is funny. This gift is exceptional in an international art scene that takes itself too seriously, relying upon easy slapstick, banal cartoons, and salacious pornography as substitutes for rigorous, philosophic dissection of human inconsistency, anomaly, and desire, some of

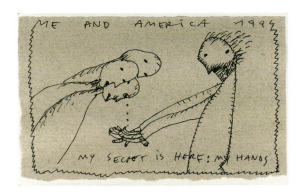

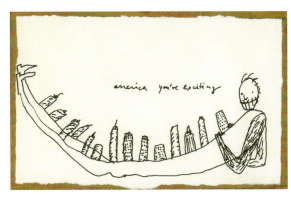

Figs. 173—177
Dan Perjovschi, five of sixty-seven, *Postcards from America*, 1994. Courtesy of private collection. Cover of artist book *Naked Drawings*, 2005.

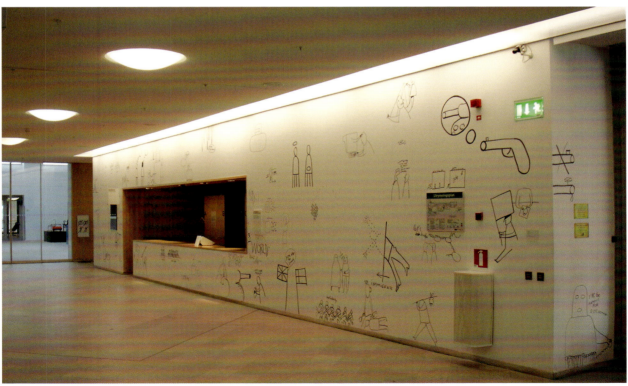

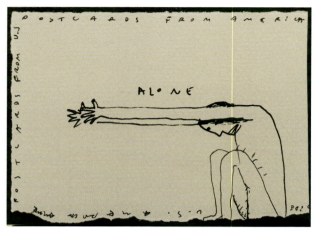

Fig. 178–180, previous pages
Dan Perjovschi, three installation views: *Naked Drawings*, 2005, DC Space, Ludwig Museum, Cologne, Germany; *Dan Perjovschi*, 2006, Van Abbemuseum, Eindhoven, The Netherlands; *May 1st*, 2006, Moderna Museet, Stockholm, Sweden; marker on walls.

Fig. 181, above
Dan Perjovschi, one of sixty-seven, *Postcards from America*, 1994. Courtesy of private collection.

the essential elements that comprise the foundation of laughter and humor. In order to achieve his astutely perceptive vision, Dan turns to himself, to the life of an artist, and to the everyday world, taking the incongruity of ideologies, the ineptitude of sociability, the absurdity of strangeness, and the inability to come to terms with "the other" (that inelegant and alienated manner of describing human beings supplementary to ourselves) as the subjects of his work.

Many of the images in *Postcards from America* (1994) attend to the simultaneity of pride and self-doubt in an artist's life. In *My Secret is Here: My Hands*, Dan provides only half of the key to the sources of his work. The other half may be found in *Artist Thinking*, where masses of ideas, like mental noise, pour from the artist's brain while he cradles his head from the strain. Heads

litter the floor in *I Try to Change My Style*, which sympathizes with the artist's effort to cope with the need to be flexible in a market voraciously in search of the new. In *America is Exciting*, Dan's own male body becomes a landscape of phallic skyscrapers, alluding simultaneously to scopophilia (the erotic pleasure in looking) and to how human beings anthropomorphize their environment. *Look at Me and My Drawings* presents the artist as a flasher, acknowledging his sensual relationship to his art and to the erotic nature of the gaze. [Figs. 173–176] But Dan's use of the naked body is always subtle, exceedingly polite, modest, and funny—as is the cover of his 2005 artist book *Naked Drawings*, where, in the mere act of reaching to draw, the artist exposes himself. [Figs. 177] While the unobtrusive phallus peeking

Figs. 182–183, above and left
Dan Perjovschi, *Wonderful World*, 1995, with detail of one page from the set of flip drawings; ink on paper. Courtesy of private collection.

out from under the artist's smock brings a smile, on a deeper, often unconscious level, viewers may recognize the double entendre: the artist's emotions, intellect, and artistic abilities are exposed to scrutiny. Dan's work is intelligent, simultaneously provoking laughter and understanding, and it is intimate. Drawings like *Naked Drawing* must be understood in content as similar to *Alone*, which is as telling of Dan's private emotions as Lia's apparently more personal expressions. [Fig. 181]

The theme of the artist is only one of numerous subjects that appear in *Postcards from America*, which consists of over 500 handmade cardboard cards faced with the pastel paper on which Dan drew. [Fig. 286] Other topics include the huge size of commodities in the United States, from super-size sandwiches and supermarkets to the super prices of hotels. [Figs. 287–293] Images of the dollar bill or its sign permeate *Postcards from America*, and are often juxtaposed with images of violence. But Dan also draws about friendships, as well as the loneliness a foreign land and his longing for Lia. [Fig. 227] Throughout the series Dan visually narrates manifestations of the power that accounts both for his attraction to and criticism of the United States of America.

Wonderful World, begun in the early 1990s and finished in the mid- to late 1990s, is similar to *Postcards from America* in its focus on specific topics. [Figs. 182–183, 283–285] *Wonderful World* delves more deeply into such topics as HIV/AIDS, drug addiction, violence, the media, and religious conflict, unpacking cultural confusion and malaise all while filled with wonder at the world's fullness. In formal terms, *Wonderful World* picks up where *Anthropoteque* concluded: the flip drawing. The number of drawings in any specific unit of *Wonderful World* can vary widely, from eight or ten to over twenty, and the drawings are usually on various shades of pastel paper, as in *Postcards from America*. Exiting primarily in two large assemblages, containing forty and sixty units of flip drawings respectively, some different iterations of the work also exist. [Fig. 184] For Dan originally conceived *Wonderful World* to consist of both individual or groups of units. One unusual example includes a

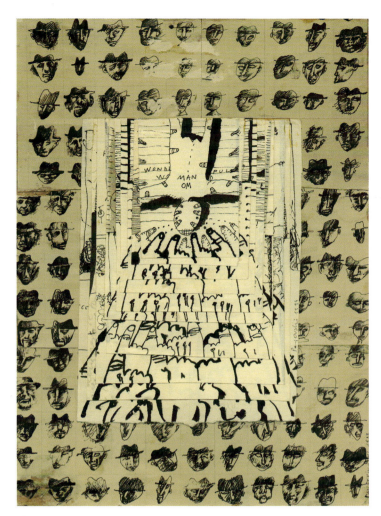

Fig. 184
Dan Perjovschi, *Wonderful World* (flip unit), background drawings, 1988, flip drawing, 1994; collage on pastel paper. Courtesy of private collection.

background containing portraits of a mélange of men wearing different hats, which Dan drew in 1988, on top of which he pasted a flip drawing from 1994. This piece demonstrates how Dan's earlier work continues to inform his current work. Another unusual example from *Wonderful World* is a series of portrait drawings in a grid, over which Dan pasted a small contact print of a photograph of protestors on the streets in Bucharest during the Revolution. *Wonderful World* provided Dan with a flexible format through which he experimented with a wide range of possible combinations.

CEA MAI FRUMOASĂ ȚARĂ DIN LUME

POST R
dan perjovschi

CSAC București
Expoziția Anuală
MEdiA CULPA
octombrie 1995

Foto: Cosmin Bumbuț Layout: Alexandru Cirip (Two & Two) Tipărit la FED

MEREU
ÎNTRE
DOUĂ
IMPERII

POST R
dan perjovschi

CSAC București
Expoziția Anuală
MEdiA CULPA
octombrie 1995

Foto: Cosmin Bumbuț Layout: Alexandru Cirip (Two & Two) Tipărit la FED

ÎNSETAȚI DE LIBERTATE

POST R
dan perjovschi

ELIBERARE

CSAC București
Expoziția Anuală
MEdiA CULPA
octombrie 1995

POST R
dan perjovschi

UN POPOR MIC
CU O CASĂ ATÎT DE MARE

CSAC București
Expoziția Anuală
MEdiA CULPA
octombrie–noiembrie 1995

Wonderful World also reminds viewers that forty-five years of life in Romania taught Dan the truth and the practice of what French philosopher Henri Lefebvre wrote in 1945: "The theory of superhuman moments is inhuman. . . . Man must be everyday, or he will not be at all."[149] Forgiving Lefebvre's gender exclusive terms as artifacts of the past, Lefebvre's insistence on the *"greatness in everyday life"* (his emphasis) is what counts, and that greatness constitutes the stuff of Dan's wonderful world.[150] Lefebvre concluded his comments on humanity with the following admonition:

> Going beyond the emotional attempts by philanthropists and sentimental (petty-bourgeois) humanists to "magnify" humble gestures, and beyond that allegedly superior irony which has systematically devalued life, seeing it merely as back-stage activity or comic relief in a tragedy, the critique of everyday life—critical and positive—must clear the way for a genuine humanism, for a humanism which believes in the human because it knows it.[151]

Figs. 185—188, previous pages
Dan Perjovschi, *Post R*, 1995; four posters. Translation of posters, top left to bottom right: The most beautiful country in the world; Always between two empires; Freedom thirsty; A tiny people with such a big house.

Fig. 189, above
Dan Perjovschi, *Beliefs*, 2005; marker on wall.

Dan knows what it means to be human, and a series of four posters, *Post R* (1995), evince that knowledge. [Figs. 185–188] The title puns on the words "poster" and "R" (for Romania), as well as suggests "post" for the function of a poster. In each of the four posters, Dan appears with a thoughtful look on his face, while carefully displaying his bicep tattoo, "Romania." Thus does he show himself to be coextensive with his country, both the object and author of his critique. In each poster, Dan presents a site or a situation steeped in Romanian myth contrasted with history and the aftermath of actual life following the dictatorship. Poster #1 portrays the Romanian countryside where, next to a rushing river, a dilapidated wooden outhouse leaks toxic waste into the flowing water. The accompanying text states: "The most beautiful country in the world." Poster #2 shows an elegant, well-proportioned Eastern Orthodox church squeezed between two ugly contemporary high-rise buildings. "Always between two empires," Dan quips, summoning the history of a Romania sandwiched between Eurasia and the Roman Empire, the Ottoman and Hapsburg Empires, the Soviet and Western Empires, and now between the outer reaches of the European Union and Eurasia. In #3, a homeless man sleeps on the ledge of an empty shop window: "Freedom thirsty," Dan announces matter-of-factly. #4 presents Palatul Poporului/Casa Poporului/Palatul Parlamentului, that grand building of multiple personalities, with the comment: "A tiny people with such a big house."

The smiles that *Post R* produces are grins of recognition, which Freud analyzed in "Wit and its Relation to the Unconscious."[152] Dan's work deploys what Freud recognized comprises the structure of humor: juxtaposition of dissimilar elements that surprise and unseat expectations; mixing of words and images; condensation of complex meanings into contradictory and double valent meanings; plays on words, ambiguity, punning, displacement; and unification of disparate ideas and concepts. *Post R* is particularly rich in all these elements, as is a recent drawing: *Beliefs* (2007). [Fig. 189] There Dan shows three vertical elements: the steeple

of a church, the minaret of a mosque, and the upright barrel of a machine gun (something like the the AK-47 or AKM assault rifle). Dan's message is as biting as the subject is deadly: beliefs cause wars and wars are waged and supported by the multibillion-dollar international weapons industry. This drawing is not funny; precisely why it causes the nervous laughter of recognition.

Though laughter was once believed to be the preserve of humans alone, scientists now suggest that it derives from the animal kingdom. "Indeed, neural circuits for laughter exist in very ancient regions of the brain," psychologist Jaak Panksepp reports. He continues, "ancestral forms of play and laughter existed in other animals eons before we humans came along."[153] In addition, laughter is social, and pioneering areas in the treatment of depression have discovered that it is a key mode for accessing nonverbal feelings and emotions. Dan's art connects with the pre-cognitive animal source of the human disposition toward laughter, with animal/human sociability, and with laughter's capacity to relieve tension. Dan's work conjures laughter that emerges from deep sources in the human psyche. Thus is Dan's art potent, necessary, and dangerous.

CONCLUSION: INSTEAD OF NOTHING, OR ON THE OTHER HAND

In 1990, soon after the Revolution, Lia performed an agitprop action aimed at inciting students to become socially engaged. [Fig. 190] Disturbing a class in session, she entered one of the rooms of the Theological Institute in the University of Sibiu and asked the seminarians to act for a just future. "A priest interrupted me," she explained, "and asked me to leave, but not before he advised his students, 'You need her motivation and passion.'" Next Lia handed out her manifesto in the streets, "urging people to act rather than accept the current situation."[154] Finally, she scattered the tract over the famous medieval walls and "Passage of Stairs" of Sibiu, calling her action *Instead of Nothing*.

Lia Perjovschi has devoted her life to creating art that is conscious of its purpose and aware of its role in society.

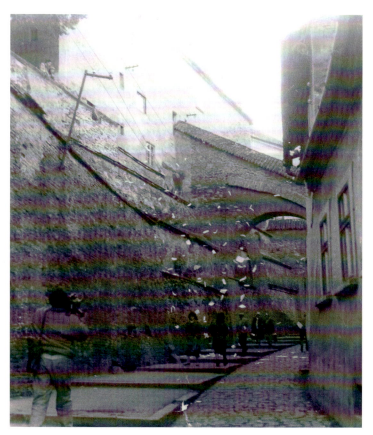

Fig. 190
Lia Perjovschi, *Instead of Nothing*, 1990, agitprop action in Sibiu.

From the delicate yet exacting drawings she made for the installation of the *CAA/CAA* archive to her designs for theater and television, from sculpture and painting to performance, Lia has attempted to awaken viewers to the present in order to act for the future. [Fig. 367] No visual image is more representative of this aim than her *Visual Archive of Survival*, a series of pillowcases on which she printed images of her performances and art objects in 1994. [Fig. 191] The significance of *Visual Archives of Survival* in Lia's oeuvre may be measured by the fact that in 1996, after the publication of her first monograph, *AmaLia*, she had a second set of pillows emblazoned with the entire contents of the book. [Fig. 193] This set of pillowcases included photographs of her art, the book's essay, and even the captions for the photographs.

Lia first exhibited *Visual Archives of Survival* in 1994 at the Art Museum in Arad, Romania, in an exhibition titled "Complexul Muzeal" (The Museum Complex), curated by Judit Angel. The show examined the relationship between the display and the meaning of works of art, questioning how the content and reception of art is altered by the mode of its installation. For her work, Lia chose a room displaying antique Victorian chairs. There she arranged her pillows in small piles on top of each seat, placing some on the floor underneath the fragile chairs. [Fig. 192] In addition, she put a few plastic bags from her collection under some chairs. In an extremely complicated and subtly evocative set of metaphors, *Visual Archives of Survival* connected the way in which sleep renews the body to the thesis that art can be an agent for survival and healing. The pillows on top of the chairs served, further, as a cautionary reminder not to sleep through the present by being overcome with reverence for the past (symbolized by Victorian chairs), and to be conscious of shifts in history (represented in the plastic bags). As this installation also acknowledges, pillows have a significant role in Romanian culture, especially in Romanian folk culture, where beds are traditionally covered in intricately designed, colorfully dyed hand-loomed carpets and pillows, decorations

that also function as practical household items, transforming beds into sofas. By joining her academic training as an artist to an appreciation of her culture and its traditions, *Visual Archive of Survival* exhibits Lia's ability to produce experimental art both engaged with the past and suggestive of alternative ways of being in the world.

Dan's work, too, assumes the mantle of experiment, but from a decidedly contrarian perspective. *On the*

Figs. 191–193, above, left, and opposite page
Lia Perjovschi, *Visual Archives of Survival*, 1994, 1996; screen-printed pillowcases; 1994 installation of pillowcases on top and beneath Victorian chairs in Museum of Art, Arad; detail of images on one pillowcase from 1996 series.

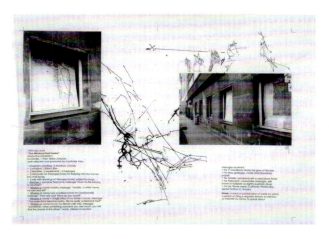

Other Hand, the title of Dan's installation at Portikus (an exhibition hall for contemporary art), declares the conditions of debate always latent in his work. [Fig. 194] Confirming his focus on "the clash of heterogeneous political contexts that briefly interact before they drift apart or dissolve completely," Dan drew (in white chalk on the gray surface of the Portikus floor) a partial circle of stars representing a section of the European Union flag.[155] He left the circle incomplete with a cluster of stars near the breach and also next to the question: "ARE YOU AFRAID?" The cluster represents those stars (countries) waiting to enter the EU and both symbolizes and names Europeans' fears of the social ramifications of religious diversity and the economic costs of absorbing especially Slavic and Turkish nations into their Union. The title of the installation, *On the Other Hand*, points to a variety of alternative directions the EU might take. By presenting his aesthetic dialogue in Germany with such an open proposition, Dan also flagged the history of that nation, intimating that its response to the question—"ARE YOU AFRAID?"—had historical antecedents that would impact the future. But because the phrase "on the other hand" neither condemns nor resolves the question, Dan signals how, as the most powerful state in the EU, Germany might redress its past in its present relationship to countries entering the EU, or not.

Dan's drawings have challenged the European Union, Germany, Romania, and many other nations in the same way that he threw down the gauntlet to the United States in *WHAT HAPPENED TO US?* This was the title of his 2007 exhibition at the Museum of Modern Art in New York, curated by Roxana Marcoci. [Figs. 297–299] His title served two purposes: it implicated the general public—"us"—in the drawings' messages, and it offered a pointed commentary on the current negative reputation of the United States in the world. One of Dan's drawings from that exhibition even visually questioned whether the citizens of the United States still have the capacity to stand for the principles embodied in the Stars and Stripes. In this drawing, Dan depicted the flag as if the stripes were window shades, and placed a figure before the flag, timidly peeking through its strips/slats. [Fig. 195] As an admirer and defender of the core values for which the U.S. has always claimed to stand, Dan created a seemingly simple drawing addressed to extremely difficult and complicated questions.

Taking his title as the source of the query, one might ask: What happened to U.S. to make it hide behind the Stars and Stripes as a symbol of justice, at the same time that it instigates war and aggression around the world? What happened to U.S. that it permits tampering with elections and allows its Supreme Court to select a president? What happened to U.S. that it enables the government to trespass upon freedom, arrogantly violate international laws, torture prisoners, incarcerate detainees without trial, and pass laws that permit governmental agencies to spy on its own people? What happened to U.S. that it turned its back to genocide in Rwanda and then in Sudan, permitted rampant consumerism that made it dependent upon oil, and ignored international treaties that would protect the environment? What happened to us?

"My drawings are not funny at all," Dan insists:

> I disguise them under the humor stance, because humor is a kind of international language, no? But after you laugh, it strikes you in your stomach. I am also coming from the media. The way media picks up a subject and how they deal with it. Sometimes you look at the TV and it looks so infantile.[156]

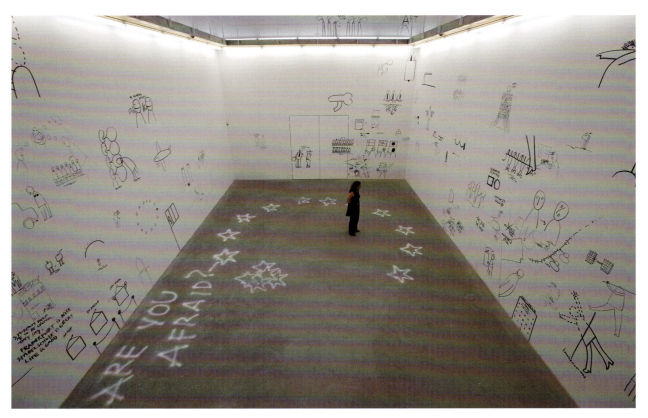

Fig. 194

Dan Perjovschi, *On the Other Hand*, 2006, Portikus, Frankfurt-am-Main, Germany; marker on walls, chalk on floor.

One month after Dan's MOMA exhibition opened, the cover of *Newsweek* (11 June 2007) announced Fareed Zakaria's article, "After Bush: How to Restore America's Place in the World." The cover also illustrated the U.S. flag, and conveyed a message far from laughable.

Dan's large installations are as much about performance as they are about drawing. While Dan realized his first performance, *Tree*, in 1988, he has never been quite comfortable with performing, sometimes participating awkwardly in a festival by doing precisely what his titles suggest: *Begging for Contemporary Art Museum* (1996) and *Doing Nothing* (1996).[157] At one festival, he simply read aloud for five hours a text by Paul Goma, the Romanian writer and anti-communist dissident.[158] [Fig. 357] Given his growing dissatisfaction in the late 1990s with performance as a medium, it is ironic that *Have a*

nice day (1997), a performance that Dan does not hold in particularly high regard, is one that could be said to demonstrate most accurately how his highly sociable character informs his art. [Fig. 353] Realized in Israel for the performance festival "Blur," curated by Sergio Edelsztein, *Have a nice day* was a three-day performance, which Dan spent shaking hands with strangers on the street. But not just any street. Dan positioned himself on the sidewalk outside a military installation in Tel Aviv. Flagrantly calling attention to himself as an outsider (and a Slavic one at that), knowing that his approach to strangers would be scrutinized, aware that the foreigner is always suspect in a country forever under attack, Dan put himself in the middle of the same type of charged political situation that his drawings continually address. All the elements intrinsic to Dan's work were present.

Dan mentally boxes his way through life, and his approach to drawing might be compared to a

Fig. 195
Dan Perjovschi, untitled drawing,
2006; marker on wall.

three-minute boxing round. He angles, sizes up, and intellectually dances around an idea before choosing an unusual, exceedingly concise perspective and rapidly executing it. "I find myself in the situation, to invent a drawing to illustrate a text," Dan has remarked. But the drawing "has to survive without the text: text is gone, drawing remains."[159] In representing a "text," Dan refers not only to actual texts (like newspapers or magazines) but also to behavior, attitudes, and ideologies, the social texts that his drawings decipher. Dan's process may be compared, in its quick but elliptical approach, to the special "bolo punch" in boxing: a curved short jab, shot from the arm and hand. With this analytical and defensive strategy, Dan Perjovschi delivers knockout drawings that are impossible to counter. *Think Positive* is one such drawing. [Fig. 196]

One of hundreds Dan made for his multi-room installation *White Chalk Dark Issues* (2003), *Think Positive* is a devastating image.[160] *Think Positive* displays a gravely ill victim of HIV/AIDS in his or her hospital bed, attended by someone urging the patient to positive thoughts. But the word "positive" is the most dreaded declaration someone tested for the disease will ever hear. In the chalky light, Dan unveils a murky darkness, the shadow

of infirmity and death cast by AIDS. He visually probes the complexity of the word "positive," which suggests certainty in the midst of soul-wrenching doubt; an affirmative and explicit sign, the word can also be the bearer of harm, negativity, and destruction.

With similar attention to ambiguity, in *Common Grave, Bunker, Oil* Dan drew the image of three consecutive shafts dug into the earth at the bottom of which he depicted ever larger round chambers. [Fig. 198] Tiny figures at the top of the shafts gaze into the subterranean hollows. Dan labeled the first shaft "common grave," but it has no corpses; the second space is a "bunker," also empty; the third and deepest shaft is "oil," suggesting the black gold of an oil reserve shown equally as a void.

Dan indicts those who would profit from controlling oil in the bunkers where so many have been killed during war. Although the drawing points a finger at an anony-

Fig. 196
Dan Perjovschi, *Think Positive!*,
2003; chalk on wall.

mous target, in a global economy of multinational military and business consortiums, viewers recognize who the nefarious culprits are. In case the criminal remains anonymous, in *Patriot*, a strategic drawing positioned not far away, Dan depicts another figure hiding behind the stars and stripes of the U.S. flag. [Fig. 197] In it, a blindfolded man holds a flag containing no insignia. Empty of content, it covers half of his face, revealing as it conceals the hollow patriotism the drawing names. Dan takes no prisoners in his battle with global ethics. But as usual, throughout the inspiring installation, Dan also implicates the artist in the human tragicomedy. In his drawing *Ugly Nice*, a figure views a painting with the word "Ugly" written on it, and comments: "Nice." Dan knows that the best art will itself foil the artist's attempt to create a socially responsible meaning, a moral that reaches outside of the work itself. Art — at least Dan's art — may name the ugly, but in the very act of naming makes it nice.

A temporary work that was destroyed at the end of its exhibition, *White Chalk Dark Issues* remains, nevertheless, one of the most stunning ephemeral installations of the opening years of the twenty-first century. For with white chalk on the mottled, stark, gray walls of the industrial space, Dan confronted confounding issues of the new millennium with a determined and uncompromising honesty.

———

In drawing after drawing, Dan unpacks the venal, the treacherous, the aesthetic, and the comic absurdities of human nature in a manner that visualizes the beauty of truth. Lia shows the impact of world truths on the body, as in her video *Loop* (1997). A simple work with a chilling message, Lia merely jumped up and down. But the image of her hair and neck also resembles the icon of the atomic age, the mushroom cloud rising in the sky. This is how close humanity is to its own demise. [Fig. 199]

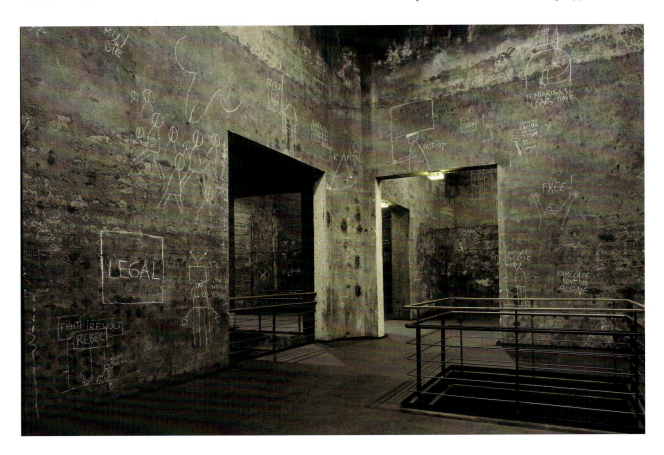

For nearly thirty years, Lia and Dan Perjovschi have made art that is true to history, nation, and self. They have produced very different oeuvres. But as the composite LiaDan, they remained within the confines of a couple, illuminating the meaning of each other's work, collaborating on behalf of other artists and Romanian society, and seeking, through art, to make global history more transparent. Both artists have produced astonishing works with the delicate, fragile, ordinary, and ephemeral materials available to them, without ever fetishizing either their art or actions. But in working with common materials, the Perjovschis' art must not be confused with the ideologies represented in "poor art" associated with the Arte Povera movement of the late 1960s and early 1970s. For the materials the Perjovschis used embodied the very situation with which they and their art were coextensive. Rich in content, if initially poor in opportunity, they have continued to maintain the initial integrity and purpose of their art in global contexts.

Never tethered to the past but always cognizant of history, the Perjovschis are at the center of a growing international conversation about the state of the planet. Their aesthetically and politically charged art assists the public to think, feel, and laugh, all at the same time. This rare combination is vital in a political and cultural environment where questions of freedom and autonomy, the construction of knowledge, and the need to confront actual experience with candor are ever more demanding. Dan and Lia Perovschi have made art about crisis, change, and endurance that reaches beyond the personal to engage the world and inspire viewers to live with courage.

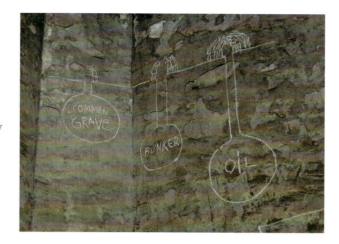

Figs. 197–198, opposite page and top
Dan Perjovschi, installation view of *White Chalk Dark Issues*, 2003, Kokerei: Zollverein Zeitgenossische Kunst und Kritik, Essen, Germany; and one drawing from the installation, *Common Grave, Bunker, Oil*, 2003; chalk on wall.

Fig. 199, above
Lia Perjovschi, *Loop*, 1997; video still.

NOTES

1 Transylvanian Saxons settled Sibiu (known as Sibiu/Hermannstadt) in the twelfth century. A thriving trade and cultural center with a multicultural population and the site of many important innovations in Romanian history, Sibiu was brought under the Ottoman and Austro-Hungarian Empires before finally becoming a part of Romania.

2 Lia Perjovschi in conversation with the author, February 1992, Bucharest.

3 Ibid.

4 On the Union of the Artist, see Ileana Pintilie, *Actionism in Romania During the Communist Era*, trans. by Silviu Pepelea with Dorothy and Stuart Elford (Cluj, Romania: Idea Design & Print, 2000, 2002): 17.

5 Dan worked for the Ministry of Culture from 1990 to 1991.

6 Group for Social Dialogue brought out *Revista 22* one week after the Revolution began. Dan stood in line for "two or three hours just to buy this magazine where all these famous people were telling the truth for the first time!" Dan Perjovschi in conversation with the author in Bucharest, 1 May 1997.

7 Dan Perjovschi email to the author, 14 May 2007.

8 See *AutoChronology* in this volume.

9 See *Piece and Piece*, Dan's first publication in newspaper format, sponsored by Norrtalje Kunsthalle, Norrtalje, Sweden.

10 This installation was adapted from *Lia's Research Files: Timeline Romanian Culture from 500 BC until Today*, 1997–2006.

11 Periferic Biennial was founded in 1997 by artist Matei Bejenaru.

12 See cover of Dan's newspaper *art of today—yesterday news* (Bucharest: Dan Perjovschi and KulturKontakt, 2002).

13 The international movement of Concrete Poetry began in the early 1950s, treating words and letters as material and auditory objects. The intersection of Concrete Poetry and Performance Art is central to the development of both forms.

14 Dan Perjovschi email to the author, 7 May 2007.

15 See Siegfried Kracauer, "Photography" (1936), in *Critical Inquiry* 19 (Spring 1993): 421–36.

16 Percy Bysshe Shelley, *Shelley's Poetry and Prose*. Selected and Edited by Donald H. Reiman and Sharon B. Powers (New York: W.W. Norton, 1977): 103.

17 This site was chosen by Marius Babias, curator of a section of the Biennial in Iasi. Dan also exhibited in the Turkish bath.

18 Lia's *Mind Maps (Diagrams)* address the following topics, whose titles reflect their eclectic range: "Critical Theory," "Contemporary Literary Theory," "Cognitive Science," "Form Follows Fiction," "Film Studies," "Objects," "History of Art," "Utopia," "Quantum Theory," "Deconstruction," "Projects," "Glossaries," "From Text to Action," "Memory Study," "Postmodern Postmodernity-Modernism Modernity," "Power," "Cool," "Subculture," "Artist," "How to Survive," "Memory," "Trauma," "Space and Time," "Totalitarianism," "Cultural Center 21st Century," "Anthropology," "Detective," "Critical Thinking," "Cultural Theory," "Mind Body," "Communism," "Key Ideas," "Culture Jamming," "Spraycan Art," "Scheme CAA," "Failure," "Cultural Context," "Art Therapy," "Romania," "21st Century Capitalism," "Noise," and "Black Holes."

19 Francis Fukuyama, "The End of History," *National Interest* 16 (Summer 1989): 3–18.

20 Dan Perjovschi email to the author, 13 May 2007.

21 These taped interviews were damaged beyond repair.

22 Before 1990, all Romanian artists were required to belong to the Artists' Union to gain employment, exhibit, and sell works.

23 Dan Perjovschi email to the author, 5 February 2007.

24 In Oradea, they also lived temporarily in such a room.

25 Dan Perjovschi in conversation with the author, February 1992, Bucharest.

26 Pintilie: 11.

27 Ibid: 14.

28 Ibid: 16.

29 Ibid.

30 Ibid: 17.

31 Kristine Stiles, "Shaved Heads and Marked Bodies: Representations from Cultures of Trauma," *Strategie II: Peuples Méditerranéens* [Paris] 64–65 (July-December 1993): 95–117.

32 Pintilie: 17.

33 Dan Perjovschi in conversation with the author, 7 October 2006, Bucharest.

34 Ibid.

35 For Dan's account of his patrilineage in Bessarabia, see Dan Perjovschi, "HISTORY/HISTERY: A Project by Dan Perjovschi," in Octavian Esanu, ed., *MESSAGES FROM THE COUNTRYSIDE: REFLECTIONS IN RE* (Chisinau, Moldova: Soros Centre for Contemporary Art, 1997): 72.

36 Dan collected boats as a child.

37 Targu-Jiu is near Hobita, where Brancusi was born.

38 Emil Constantinescu was president of Romania from 1996 to 2000.

39 Gabriel Brojboiu, "Interview with Dan Perjovschi," in *Dan Perjovschi. Exhibition Catalogue* (Iasi: Conservator George Enescu, Iasi Sectia Arte Plastice, and Galeria Cronica, March-April 1985). Translated from the Romanian by Dan Perjovschi and Kristine Stiles in Bucharest, 7 October 2006.

40 Dan Perjovschi email to the author, 29 May 2007.

41 Dan Perjovschi email to the author, 19 May 2007.

42 *The Bride* referred to Dan's marriage to Lia in 1983.

43 Brojboiu, "Interview with Dan Perjovschi."

44 Dan Perjovschi in conversation with the author, 7 October 2006, Bucharest. During this period Dan also developed two additional motifs: *Urzeala* (meaning to weave or to plot, as in conspire) and *Marele chip* (meaning big face).

45 Confessional has been exhibited in different versions, comprised of drawings from 1986 up to 1994. Dan's use of the grid dates to about 1983. He began working on tiny figures, drawing on his lap while living in closet-sized spaces.

46 Dan made other scrolls in brown ink on beige paper.

47 "Gram" comes from the Romanian term *grammatica*.

48 Andrei Oisteanu is a researcher at the National Museum of Romanian Literature.

49 Dan Perjovschi email to the author, 20 May 2007.

50 Werner Meyer, "The Absurd Illuminates Cognition," in *Dan Perjovschi AutoDrawings* (Göppingen: Göppingen Kunsthalle, 2003): 5.

51 Dan Perjovschi email to the author, 29 May 2007.

52 Janet Koplos, "Dan Perjovschi at Franklin Furnace," *Art in America* 84 (July 1996): 91–92.

53 Meyer: 7.

54 Calin Dan, in *Perjovschi: DAN* (Bucharest: Lia and Dan Perjovschi and Galeria Simeza, 1992): 1, quoted in Judit Angel, "Report II," in *Dan Perjovschi rEST* (Bucharest: Romanian Ministry of Culture and Romanian Ministry of Foreign Affairs, 1999): 9.

55 For more on affect, see Charles Altieri, *The Particulars of Rapture: An Aesthetics of the Affect*. Ithaca, N.Y.: Cornell University Press, 2003.

56 Henri Bergson, *Matter and Memory* (1896). New York: Zone Books, 1988.

57 Dan represented Romania along with the group SubREAL, comprised of Calin Dan and Iosif Kiraly.

58 Dan Perjovschi email to the author, 29 May 2007.

59 Ibid.

60 Dan Perjovschi in conversation with the author April 1996.

61 Ibid.

62 Ibid.

63 Dan has credited my 1997 article as the moment when he first realized that his work for *Revista 22* could also be understood as his art. See my "Concerning Public Art and 'Messianic Time,'" in Marius Babias and Achim Konneke, eds., *Art & Public Spaces* (Hamburg: Kulturbehürde, 1997): 48–65.

64 Timisoara has been a crossroads between the West and Eurasia for millennia.

65 The Astra Library has a celebrated history dating to the mid-nineteeth century. Lia spent days there and "felt it was like mine." Lia Perjovschi email to the author, 17 May 2007.

66 Mikhail Bakhtin used this term to describe the multiplicity of voices in language. See Bakhtin's "Discourse in the Novel," in Michael Holquist, ed., *The Dialogic Imagination* (Austin: University of Texas Press, 1981): 259–422.

67 Between 1985 and 1988, Lia and Dan participated in the international and amorphous Mail Art movement, which emerged in the late 1950s. Dan explained that he and Lia enjoyed doing Mail Art so much that they would stay home on such special nights as New Years Eve, sitting together at a table working on art to send abroad. Dan Perjovschi in conversation with the author, 8 October 2006.

68 Lia remembers Mexican poets of the Nucleo Post-Arte group, organized by César Espinosa, who also sponsored International Biennials of Visual and Experimental Poetry in 1985–86 and 1987–88. Brazilian poet Philadelpho Menezes organized the first "International Show of Visual Poetry"

in 1988, likely the exhibition in which Lia first exhibited *Test of Sleep* photographs.

69 Lia Perjovschi, *amaLIA Perjovschi* (Bucharest: Soros Foundation for Contemporary Art, 1996): 11.

70 This title has been translated both as *Our Collected Silences* and *The Book of Our Silences*.

71 Romanians' keen interest in other languages does not mitigate the conservative, xenophobic aspects of their culture.

72 Lia Perjovschi in conversation with the author, February 1992, Bucharest.

73 Aurelia Mocanu, "Cartea-Object: Reactia la bibliocid [The Object-Book: Reaction to Bibliocide]," *Arta* [Bucharest] 38:5 (1991): 17.

74 Calin Dan quoted in Mocanu's "Cartea-Object," *Arta*: 17.

75 Andrei Oisteanu, "From Visual Poetry to Object-Book," in *cARTe* (Amersfoort, The Netherlands: De Zonnehof Culutral Center, 1993): 15–21.

76 Oisteanu cites St. John's Revelation (10, 10). See his "The Object-Book and The Bibliocide Crime," in *cARTe*: 27.

77 See Eco's *The Name of the Rose* (San Diego: Harcourt Brace Jovanovich, 1983), which personifies Borges as a blind librarian devouring the mystery of books.

78 *Babel* no longer exists; Dan cut it up for use in another project and, when dissatisfied with that one as well, destroyed it too.

79 Andrei Plesu, "Image, Writing, Breathing," *cARTe*: 6.

80 Lia produced additional *Map of Impressions* that have been sold to buyers with whom she has lost contact.

81 Lia Perjovschi in conversation with the author, 8 October 2006.

82 Plesu: 13.

83 Lia Perjovschi in conversation with the author, February 1992, Bucharest.

84 One of the most significant archives of Mail Art is "Artpool," founded in Budapest in 1980 by György Galántai and Júlia Klaniczay.

85 Czech artist Milan Knizak was arrested over 300 times in Prague between 1959 and 1989 for his happenings, Fluxus art, eccentric fashion, and musical activities. See my "Uncorrupted Joy: International Art Actions," in Paul Schimmel, ed., *Out of Actions: Between Performance and The Object 1949–1979* (Los Angeles: Los Angeles Museum of Contemporary Art): 226–328.

86 See De Campos, "Questionnaire of the 'Yale Symposium on Experimental, Visual and Concrete Poetry Since the 1960's.'" http://www2.uol.com.br/augustodecampos/yaleeng.htm

87 Alexandra Cornilescu, "Transitional Patterns: Symptoms of the Erosion of Fear in Romanian Political Discourse," talk at the Modern Language Association Annual Meeting, New York, 1992.

88 Ibid.

89 Stiles, "Shaved Heads."

90 Cornilescu.

91 Elaine Scarry, *The Body in Pain: The Making and Unmaking of the World* (New York: Oxford University Press, 1985): 4.

92 Ibid: 6.

93 Some other Romanian precursors of performance include Alexandru Antik, Rudolf Bone, Geta Bratescu, Andrei Cadere, Calin Dan, Ion Grigorescu, Iosif Kiraly, Ana Lupas, Wanda Mihuleac, Paul Neagu, and Mihai Olos.

94 Lia Perjovschi, *amaLIA Perjovschi*: 6.

95 On the similarities between Lia's *Annulment* and Rudolf Schwarzkogler's last work *Action, No. 6*, 1966, see my "Shadows in a Vertical Life," in Lia Perjovschi's *amaLIA Perjovschi*: 49, 56.

96 Lia Perjovschi, *amaLIA Perjovschi*: 16.

97 Participants included Sorin Vreme, Gina Hora, Rudolf Bone, Vioara Bara, and Dan Perjovschi.

98 Plato, *Republic*, translated by G.M.A. Grube, revised by C.D.C. Reeve. (Indianapolis and Cambridge: Hackett Publishing, 1992): 187.

99 Lia Perjovschi in conversation with the author, February 1992, Bucharest.

100 Ibid.

101 Lia Perjovschi in conversation with the author, 4 May 2007, Durham, North Carolina.

102 *Lao-Tzu Te-Tao Ching: A new translation based on the recently discovered Ma-Want-Tui Texts* (New York: Ballantine Books, 1989): 63.

103 Fluxus artist Dick Higgins coined the term "Intermedia" in 1965 to identify new forms of art practice that fuse but become distinct from separate media and disciplines. See Higgins's "Intermedia (1966)," in *foew&ombwhnw: A Grammar of the Mind and a Phenomenology of Love and a*

Science of the Arts as Seen by a Stalker of the Wild Mushroom (New York: Something Else Press, 1969): 11–14.

104 Ileana Pintilie, untitled text in *Pamintul: Intermedia* [Earth: Intermedia] (Timisoara: Museum of Art, 1992): 13.

105 Ibid: 17.

106 Lia Perjovschi in *AmaLIA Perjovschi*: 80–81.

107 Stiles, "Shadows in a Vertical Life," in Lia Perjovschi, *amaLIA Perjovschi*: 5–6.

108 Lia changed the title from *I am me now*, which she used in 1993.

109 Lia Perjovschi in conversation with the author in 1994, Bucharest.

110 Ibid.

111 Lia and Dan proposed to "make a baby" as their project for an artist residency at the Künstlerhaus Bethanien, Berlin. Their proposal was rejected.

112 Lia experienced temporary blindness as a child, indicative of post-traumatic stress.

113 Lia Perjovschi email to the author, 15 October 2006.

114 Lia Perjovschi in conversation with the author, 6 May 2007, Durham, North Carolina.

115 Lia Perjovschi, *amaLIA Perjovschi*: 53.

116 Calin Dan, "Media Arts Get Media Free," in *Ex Orient Lux* (Bucharest: Soros Center for Contemporary Art, 1994): 7, 8.

117 Lia Perjovschi, *amaLIA Perjovschi*: 58. See *Ex Orient Lux* pages 69–71 for Lia's *Similar Situations* and pages 77–79 for Dan's *Scan*.

118 Such drawings were the subject of Lia's solo exhibition *Fünf Fenster* (1994) at the Kunsthalle, Vienna.

119 Esanu is a Moldovan art historian and curator, and was the first director of the Soros Art Center for Contemporary Art from 1996–1999.

120 Dan Perjovschi email to the author, 19 April 2007.

121 This is a sarcastic reference to Romanian hyper-exaggeration of tales related to its mythic origins.

122 Dan Perjovschi, untitled statement, in Octavian Esanu, ed., *Gioconda's Smile from Mythic to Techno-Ritual* (Chisinau, Moldova: Soros Center for Contemporary Art, 2001): 37.

123 Andrei Codrescu, *Comrade Past & Mister Present* (Minneapolis: Coffee House Press, 1986): 45.

124 Stiles, "Shaved Heads:" 114.

125 Dan Perjovschi email to the author, 26 September 2004.

126 See Nicolas Bourriaud's *Relational Aesthetics* (Dijon, France: Les Presses du Reel, 1998).

127 See my "Remembrance, Resistance, Reconstruction, The Social Value of Lia and Dan Perjovschi's Art," in Marius Babias, ed., *European Influenza* (Venice: Romanian Pavilion, La Biennale de Venezia, 51. Esposizione Internazionale D'Arte 2005): 574–612.

128 Robert Burns, "Military sets up outposts," *The News & Observer* [Raleigh, North Carolina] Thursday, 23 September 2004: 3a.

129 Both artists regret selling a work of art in the early 1990s to a collection that found its way into MNAC. They will not permit these works to travel or to be exhibited.

130 Dan Perjovschi email to the author, 25 August 2004.

131 Dan Perjovschi email to the author, 26 September 2004.

132 Ibid.

133 Raluca Voinea email to the author, 2 October 2004. On MindBomb see Dan Mercea's article, "Exploding Iconography: The MindBomb Project." http://209.85.165.104/search?q=cache:oqobAJ7eJ3YJ:www.personal.leeds.ac.uk/~icsfsp/papers_files/files/Dan_Mercea-paper_final.doc+MindBomb+collective+in+Cluj&hl=en&ct=clnk&cd=1&gl=us.

134 Dan Perjovschi email to the author, 25 September 2004.

135 Dan Perjovschi email to the author, 11 October 2004.

136 Ibid.

137 Quoted from the Kunstmuseum Liechtenstein's press release: http://www.kunstmuseum.li/web2306e/index.html.

138 Lia Perjovschi, *amaLIA Perjovschi*: 67.

139 One country where these terms are consistently used is Israel.

140 Codrescu, *Comrade Past and Mister Present*: 43.

141 See Susan E. Rice's paper, "The Threat of Global Poverty," *The National Interest* (Spring 2006): 76–82.

142 See museums by Marcel Duchamp and Marcel Broothaers to Robert Filliou and Ilya Kabakov, among many others.

143 Lia Perjovschi email to the author, 29 May 2007.

144 See Siemans Art Program press release for *Academy. Learning from Art / Learning from the Museum*: https://interhost.siemens.de/artsprogram/presse/bildende_kunst/archiv/2006/akademie_antwerpen_eindhoven/index.php?lang=en&PHPSESSID=fced6992fa4c222fda6d

145 See the language used in
 "Documenta X."

146 Hatto Fischer, "Academy:
 Learning from Art / Learning
 from the Museum," on Heri-
 tage Radio Network, 26/07/06:
 http://www.heritageradio.
 net/cms2/debates-network-
 ing-single-view/article/
 academy-learning-from-art-
 learning-from-the-museum.

147 Mel Bochner and Robert
 Smithson, "The Domain of
 the Great Bear," in Nancy
 Holt, ed., *The Writings of Robert
 Smithson: Essays with Illustra-
 tions* (New York: New York
 University Press, 1979): 31.

148 Ibid: 25.

149 Henri Lefebvre, *Critique of
 Everyday Life* (1945), vol. I
 (New York and London: Verso,
 1991): 127.

150 Ibid: 129.

151 Ibid: 252.

152 Sigmund Freud, *The Basic Writ-
 ings of Sigmund Freud*. (New
 York: Modern Library, 1938):
 633 – 806.

153 Jaak Panksepp quoted in
 Robert Roy Britt, "No Joke:
 Animals Laugh," *Live Science*
 (31 March 2005): http://
 www.livescience.com/ani-
 mals/050331_laughter_ancient.
 htm154. Lia Perjovschi in
 conversation with the author, 9
 October 2008, Bucharest.

155 From a press release for Dan
 Perjovschi's exhibition, *On
 the Other Hand*, at Portikus:
 http://www.portikus.de/
 ArchiveA0141.html.

156 Dan Perjovschi in Roxana
 Marcoci, "Interview with
 Dan Perjovschi," Museum
 of Modern Art on YouTube:
 http://youtube.com/
 watch?v=d9KWXuf5RSM.

157 Dan realized these perfor-
 mances at the "Sf Gheorghe
 and Anna Lake Performance
 Festival," curated by Uto Gus-
 tav and Konya Reka.

158 Dan performed *HISTORY/
 HISTERY* in 1997 during "Mes-
 sages from the Countryside,
 Reflections in RE" (see n. 35).

159 Dan Perjovschi in Roxana
 Marcoci, "Interview with Dan
 Perjovschi."

160 *White Chalk Dark Issues* was part
 of the exhibition "The Open
 City: Models of Application,"
 curated by Marius Babias
 and Florian Waldvogel at the
 Kokerei Zollverein, a coal
 plant opened in 1961 in Essen,
 Germany, and in opera-
 tion until 1993. Babias and
 Waldvogel converted the site
 into an arena for art installa-
 tions between 2001 and 2003,
 inviting artists to do projects
 and transforming the rusting
 buildings into a unique, vital
 cultural staging ground for
 artistic interventions on social
 issues. See Marius Babias,
 "Reconquering Subjectivity:
 Kokerei Zollverein/Contem-
 porary Art and Criticism"
 (Translated by Aileen Derieg
 and available on Babias' web-
 site: http://www.republicart.
 net/disc/institution/babias01_
 en.htm.)

Andrei Codrescu

THE ARTS OF THE PERJOVSCHIS

IN "TEST OF SLEEP" (JUNE 1988), Lia Perjovschi scripted her body with a host of symbols and displayed her hieroglyphic self before her husband, Dan Perjovschi, in an apartment in the provincial city of Oradea, Romania. [Figs. 69–70, 200–208, 305] Her description of the work consists simply of the definition of the word "complain," meaning "to express grief, pain, or discontent; to make a formal accusation or charge." In this work her body follows this double injunction, silently opening in two directions: toward her husband, in a proto-feminist stance that is a "complaint" aimed at the core of couplehood; and toward the outside, in an "accusation" hurled at a political space where nothing is being heard. This private act alluded not just to politics but also to the Romanian poetry of the time, which often wrapped itself around the metaphor of "complaint" or "accusation." Available to be read as local critiques of the regime, these metaphors were also almost always open to universal, often mystical interpretations—just in case the alert censor found the lyric a threat to the regime. (There is an essay to be written, perhaps, on communism's fetishization of poetry, a hangover from the Bolshevik cult of the printing press and Stalin's own autodidactic concern with "literature.") Mystical metaphors provided the poet with an escape route, but Lia's knowing allusion to this escapism, in her own "complaint," commented self-consciously on the very poetic tendency it seemed to replicate.

Test of Sleep was followed by Annulment (September 1989), and by Magic of Gesture/Laces (November 1989), both performed moments before the Ceausescu regime collapsed, in December of 1989, in a loud flurry of "revolutionary" gestures brought to a grand finale by the televised execution of the "royal" couple. Like Test of Sleep, Annulment was an apartment performance, expressly political, though still fiercely private. [Figs. 211–219] In the work's description, Lia writes that her body is "maculated, wounded, bandaged, bound, treated, recovered." This admission is attended by three definitions: "annulment" ("the act of annulling, or being annulled; a legal declaration that a marriage is invalid"); "aikido" ("self-defense"); and "clean" ("free from dirt or pollution"). Here, Lia's body, bound by personal and collective strictures, speaks also of "self-defense" and of healing. It no longer voices solely a complaint.

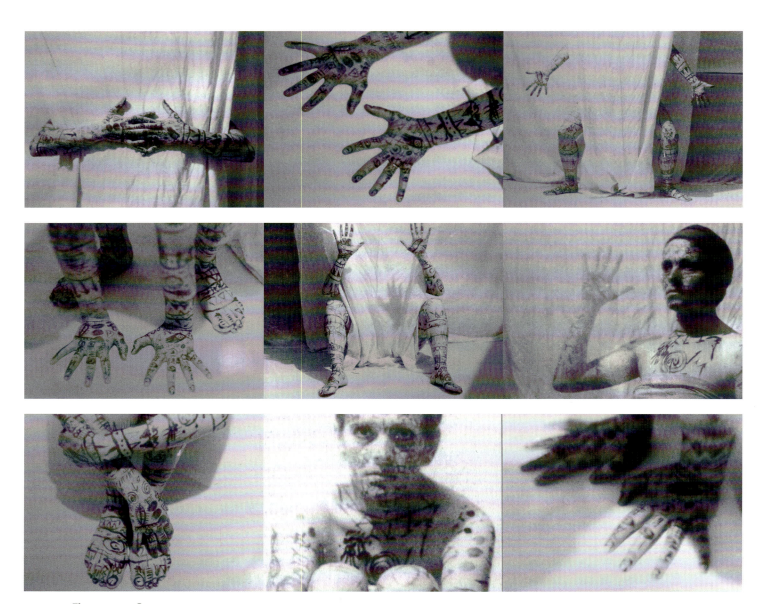

Figs. 200—208
Lia Perjovschi, *Test of Sleep*, June
1988; performance in the artist's
flat, Oradea.

Likewise concerned with its political moment, *Magic of Gesture/Laces* involved twelve art students tied together with laces that tightened every time they tried to free themselves. [Fig. 209] The title of the piece was accompanied by the definitions for three words: "bind," "connect," and "choice." While "bind" and "connect" are a perfect, paradoxical pair, "choice" is both ironic and hopeful. Despite the apparent impossibility of freeing oneself from the binds of Romanian reality—there was no choosing, only living—one had to hope that soon, something like a choice might present itself.

Very few Romanians knew about conceptual performance art at that time, one month before the spasmodic collapse of Ceausescuism. There were no public spaces for this sort of thing. Without performance as an outlet, the muted stream of dissent ran more publicly instead through poetry, where the imagined liberties and critical possibilities associated with the West, including feminism, were being tested, evaluated, enacted. The regime tried to silence this dissent-flavored poetry by blocking it, displacing it with a loud, regime-approved white noise of flowery patriotardism. In this desperate and state-friendly counter-discourse, mass meetings of songsters appealed to nationalist and chauvinistic sentiments, the last defense of a dying order. But this loud

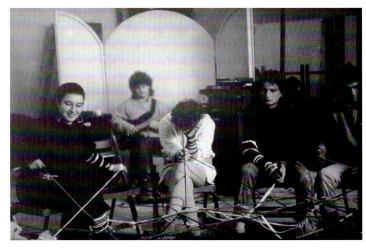

Fig. 209, above
Lia Perjovschi, *Magic of Gesture/ Laces*, November 1989; performance at Academy of Fine Arts, Bucharest.

Fig. 210, below
Dan Perjovschi, drawing from *Revista 22*, 1991.

kitsch fell into an abyss of silence as well, as regime-touting songs and protest poetry alike fell on deaf ears. Romania's people in the 1980s moved within the silent gloom like shades in fog. [Fig. 210] Repression and hunger had driven Romanians within themselves, making them two-dimensional to one another—flat, inexpressive, lost in a forest of meaningless symbols. The silence of artists during those years was layered under many levels of censorship: self-censorship, compromise, self-disgust, renunciation, and monastic retreat. After 1977, when Ceausescu repressed a brief renaissance in Romanian literature, this complex, multi-layered silence took on new depths each year.

The regime's cardboard ideology gave way suddenly in 1989, and everything was heard, simultaneously and indiscriminately. Long hoped for, the apparent miracle of liberation had taken place: not unpredictably, in its wake came the accumulated, repressed anguish of decades. It emerged in a litany of celebration that included, alongside genuine relief and testimony, kitsch, resentment, and fantasy visions of a forbidden West. From December 1989 onward, Lia's work can be seen as the story of her divesting herself of a previous silence—a narrative of personal emergence that is also

● 20—27 DECEMBRIE 1991

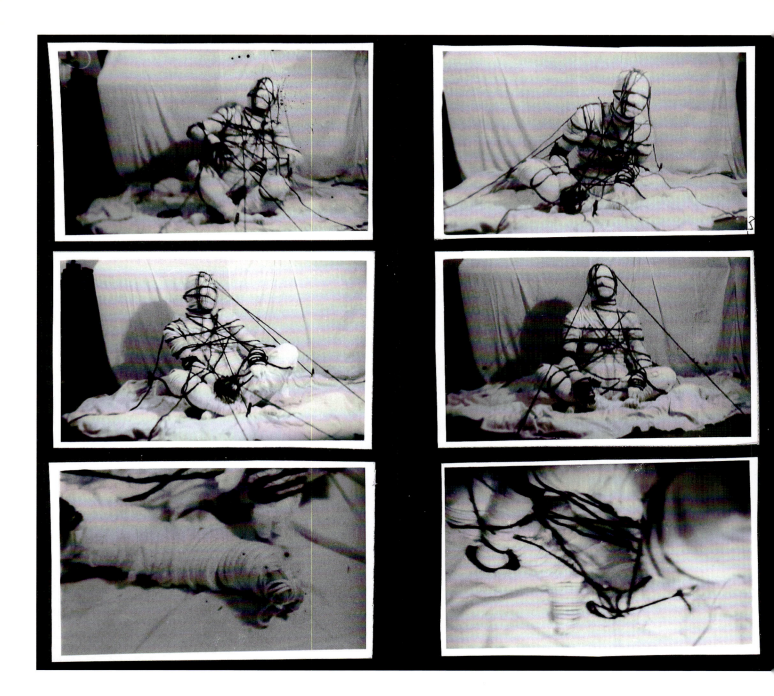

Figs. 211–219
Lia Perjovschi, *Annulment*,
September 1989; performance in
the artist's flat, Oradea.

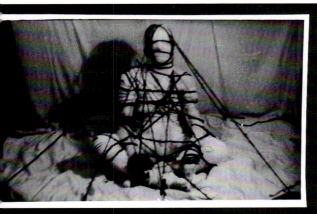

the story of Romania waking from its sleep (and nightmares) into a neon-lit new world. As an artist long tied up with the political fortunes of her nation, Lia's job, now, became infinitely more complicated: she had to live not only the story of Romania, but make art that redeployed silence amidst so much noise. In addition to being *about* the new reality, that is, her work sought also to act as a discriminating critique of the surrounding babble, a critical silence set against the clatter of a new "freedom."

Her first post-Decembrist work was an elegy to the dead of the "Revolution." In *Nameless State of Mind* (June 1991), Lia walked through Timisoara, the nexus of dissent in 1989. [Figs. 59, 95, 220] During the perfor-mance, she carried her "shadows" (they were two paper dolls) as she walked up the steps of the cathedral, where bodies had been displayed for the world's media, and through the streets where so many protesters had been killed. After touring through the sites of revolution-ary violence, Lia abandoned her dolls at an arbitrary place, an abandonment that might be considered hopeful—indicating, perhaps, that she was now rid of both her private and her public silence, her "shadows." The victims of "the Revolution" were real enough, even if the event itself was best set between quotation marks. The coup that deposed the Ceausescus was accompanied by a genuine mass revolt, but it was an insurrection that the plotters quickly represented as a civil war, a battle between "old" defenders of the regime and the new dis-senters. In fact, there was only one side to the revolt of 1989, and everyone was on it. The loud, gaudy projec-tion of the execution on national television was theater, a public spectacle whose remove from realism joined it to a long Romanian tradition of performance.

Lia must have already known at the time that her performance in *Nameless State of Mind* was taking place in the context of another performance, a national one; she must also have known that despite a long his-tory easily read as tragedy, Romanian politics, like its art, has maintained a penchant for operetta. In the work of Romania's two best-known playwrights, I.L. Caragiale and Eugène Ionesco, the nation is a land of

Fig. 220, above
Lia Perjovschi, *Nameless State of Mind*, June 1991; performance in Timisoara.

Fig. 221, right
Dan Perjovschi, detail of *Scan*, 1993; ink on cotton canvas.

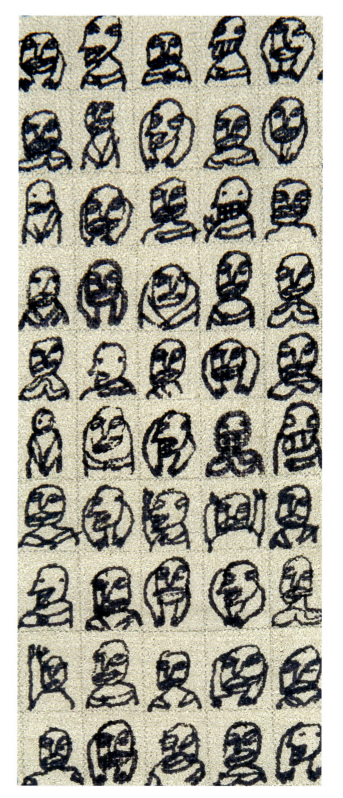

performers, a space of gestural exaggeration and obfuscation in which everyone performs and expects everyone else to perform. Theater is the country's dominant mode. Everyone is an actor, and each player is capable of reading the other's performance, of measuring its quality against one's own routine—and, even more important, of reading it against a much larger cultural-historical act. Romanian plays therefore anthologize a multitude of pathetic and absurd gestures. [Fig. 221]

In developing their own self-conscious performance pieces, Caragiale and Ionesco drew characters and situations from a seemingly inexhaustible well of natives "in transition." Romania itself is the name for a region in perpetual "transition," the current state being merely the latest in a long series of iterations. Political transitions, and the societies that endure them, are ready-made for satire: caught between identities, people are unsure about who they are supposed to be. They try on and discard masks; they act. In Caragiale's work, for example, Romanians are building history with the tools of light opera: characters gesticulate, emote, and, simultaneously, judge their own and others' performances. Urbanites are fresh from the

Fig. 222, left
Dan Perjovschi, *You Cook Kind of Balkanic*, 2006; chalk on wall.

Fig. 223, below
Dan Perjovschi, *Bravo You Got Your 0.005 Seconds of Fame*, 2006; marker on wall.

country, testing out a fragile democracy with psyches formed in a colonial past, their self-presentations once removed from their own history. They perform their light, hyperbolic capers with a critical and, paradoxically, a tragic eye. Ionesco shared this double vision, this "tragic eye" (as later critics have so reliably termed it). One of the founders of the Theater of the Absurd, Ionesco developed a deadly repertoire of inauthenticity that signifies universally but has a local source: it would have been impossible if it hadn't started in Romania. Ionesco's own protagonists are being "transitioned" from the fragile democracy destroyed by Caragiale's urbanites into a brutish dictatorship where they lose all coherent language, and even human form. As in Ionesco's 1959 play, they become "rhinoceroses."

Somewhere after Caragiale and before Ionesco came Dada, the movement co-founded by another Romanian, Tristan Tzara. Dada was the fountainhead of many avant gardes and, especially, performance art: its legacy can be traced from Fluxus to whatever political-artistic action is being planned, as we speak, in New York or in Ashtabula. Intended to be immediate

and fleeting—"transitional"—Dada has proven, paradoxically, to be the most enduring art movement of the twentieth century, with generative sprouts reaching well into the twenty-first. Balkan humor and absurdity have often been cited as Dada's chief influences, but its more melancholy disposition has been often ignored. [Figs. 222–223] Conceived in the global wreck of World War I,

Dada was tragic if it was anything at all. Perhaps not by coincidence, Tristan Tzara's name means "sad in the country" ("*trist in tzara*"), and the sad national eye of Dada, so legible in Caragiale and Ionesco's double-works, peers out of Lia Perjovschi's art as well.

Lia's generation inherited the legacy of post-rhinoceros, post-Ionesco "transition," and also a kind of Dadaist birthright. Yet by the time her career began, the international language of a new *fin-de-siècle* "performance art" also became available, and presented her with a number of choices. Her 1992 *Nothing is Accidental*, described in its accompanying material as an "intervention," is an almost perfect Dadaist piece, dealing with the dilemmas of a collapsed world still pulsing within a brand new reality. [Fig. 224] Her head covered by a papier-mâché globe, in this piece Lia stands on a sidewalk in Hungary between paper bags filled with words. Two black cubes marked with the phrase

Fig. 224, above
Lia Perjovschi, *Nothing is Accidental*, 1992, performance in Vac, Hungary.

Fig. 225 , above right
Dan Perjovschi, *I Have to Do, I Like to Do*, 2003: marker on wall.

"nothing is accidental" flank her. For hours, Lia speaks words chosen randomly by throws of dice. As her description of the work indicates, "sometimes it rains." She further describes the piece by defining the word "game": it is, she tells us, "a physical or mental context; rivalry or struggle." This time, the definition shows her to be poised at the intersection of Dada, Romanian history, and the rivalrous machinations of the international art system. With even the material conditions of its own circulation in view, the tragic eye of this Romanian artwork is looking in all directions at once.

A word on this metaphor. In shaping their own stories of the national artistic tradition, Romanian commentators have placed the nation's "tragic eye" in all kinds of meta-positions. In descriptions of Caragiale, Ionesco, and Dada, the tragic eye is conventionally invoked, then described as "paradoxical" because it is manifested in grotesque, laughable, absurd actions. For nationalists, who are offended by all three of the above, History and Fate (always capitalized) have birthed the tragic eye; this dark birthright is a heroic mode of elevating the nation's chosen (or cursed) people. It is the path of the downtrodden to glory. For these critics, if the tragic eye was somehow proven not to exist (it can't be), a national-regional scandal would ensue: the art of Romania, the Balkans, and Eastern and Central Europe—even including Austria and Germany—would collapse into a series of incomprehensible and illegible performances,

random shows that could only give pleasure to a Dada-ist. And indeed, to many Dadaists, they have.

The ubiquity of writing and pictograms in Lia's work links her art to the art of her husband, Dan Perjovschi. Dan is a talented graphic artist who can capture quickly complex realities within the single frame of a drawing. Through his work in the Romanian weekly, *Revista 22*, he is one of Romania's most accomplished political and social commentators. [Fig. 230] His collaboration with Lia is complex. While each of them is an artist in her/his own right, their collaboration forms an "art body," a collective product that speaks of issues of couplehood and gender, while also making the political comments for which both of them are known. Crudely put, Dan draws on Lia, or around Lia. Sometimes Dan draws a whole world spontaneously, and sometimes Lia steps into the picture or out of it. Sometimes he adds an interesting dimension to Lia's performance by dancing around and inside her critiques. Sometimes her body frames a field for his drawings. [Fig. 227]

Whatever universals of couplehood and cooperation the two of them share, the tragicomic reality inherited by Dan and Lia Perjovschi was local, specific — it was

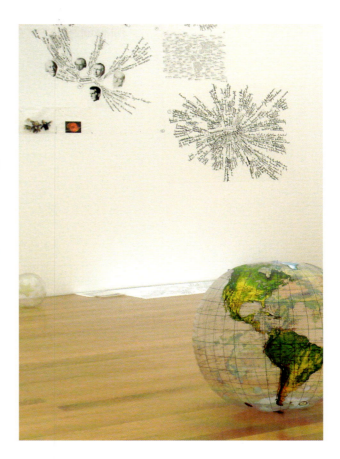

Fig. 226 , above
Lia Perjovschi, *Knowledge Museum*, 2007; installation, drawing on paper on wall and objects.

Fig. 227, left
Dan Perjovschi, one of sixty-seven, *Postcards from America*, 1994; ink on pastel paper on cardboard. Courtesy of private collection.

that of the Ceausescu couple. [Fig. 228] The Ceausescus were the subject of a vast oral and (carefully) written literature throughout their reign (1965–1989). They were featured in jokes, disguised in the form of folk characters and historical figures, and were referred to, in the end, simply as "him" and "her." During this period every Romanian couple became "him" and "her" in some way, since these pronouns took on a great deal of weight. Like other Romanian couples, Dan and Lia embodied these politically magnetized pronouns. As a "him" and "her" pair in a country recently ruled by a "him" and "her" with definite ideas about everything from the human body to its eventual disposition in the planned future, Lia and Dan were inevitable partici-pants in the historical tragedy (and farce) initiated by the Ceausescus. They took part in its cycles even as they critiqued those cycles. In the 1980s, the dictatorial couple promulgated sexual Puritanism, forbade birth control, and mandated that each Romanian woman produce five citizens for the socialist state. In practice, this led to the murder of women by illegal abortionists, the abandonment of babies to state orphanages, and to general promiscuity, horrors accompanied by an entire

Fig. 228, above
Nicolae and Elena Ceausescu during their trial on 25 December 1989; television screen capture broadcast after their execution.

Fig. 230, opposite page
Dan Perjovschi, cover of *Revista 22*, no. 119 (1992), with drawing of Securitate files.

Fig. 229
Dan Perjovschi, *KLM, SAS, CIA*, 2005: marker on wall.

22
gds

PUBLICAȚIE SĂPTĂMÎNALA EDITATA DE
GRUPUL PENTRU DIALOG SOCIAL

ANUL III ● Nr. 19 [120] ● 15-21 MAI 1992 ● 16 PAGINI ● 25 LEI

ANCHETĂ ASUPRA UNEI INSTITUȚII
SECURITATEA

— Mărturii; Anchete
Interviuri cu SORIN ROȘCA STĂNESCU
și FLORIN GABRIEL MĂRCULESCU

„Domnul Măgureanu ar trebui judecat, nu doar schimbat din funcție"

Interviu cu NICOLAE MANOLESCU, președintele P.A.C.

22 ● După doi ani și jumătate de la Revoluție, știți mai multe despre Securitate decît știați înainte ?

● Știu tot atît de puțin ca și înainte. (Și mi-e tot așa de puțin frică de ea, ca și înainte.) Dar cred că nu știm, deoarece este o instituție anume concepută ca să se știe foarte puțin despre ea.

● Ce vi se pare important să știm despre Securitate, numele informatorilor săi, de pildă, organigrama instituției ?

●● Important ar fi mai întîi să știm exact care a fost structura ei, care au fost direcțiile, care au fost responsabilii și să putem desprinde pe adevărații responsabili de plevușcă, pe cei ce erau doar funcționari în sistemul răului, de factorii de decizie. În al doilea rînd, ar trebui ca fiecare cetățean să aibă acces la dosarul lui propriu, după metoda din fosta R.D.G. Sigur, eu pot să mă duc să-l văd, sau pot să nu vreau să mă duc să-l văd : dar asta depinde de mine. Eu decid dacă îmi face bine sau nu consultarea propriului meu dosar. În al treilea rînd, în ce privește oamenii cu funcții de decizie (parlamentari, membri ai guvernului, șefi de partide), trebuie să li se aducă la cunoștință existența unui dosar compromițător și să li se permită ca într-un timp oarecare (mai lung sau mai scurt) să se retragă pașnic, fără silvă. Și atunci dosarul să nu fie făcut public. Sau dacă rămîn în funcție, să se publice dosarului — ceea ce s-a propus și s-a făcut în Cehoslovacia. Oricît de neplăcută ar fi această deschidere a cutiei Pandorei pe care o reprezintă dosarele, mai devreme sau mai tîrziu ea trebuie făcută. Altfel nu reușim să ne vindecăm de suspiciune, să ne închidem rănile și să deschidem un alt capitol al vieții noastre. Cîtă vreme această cutie a Pandorei va sta cu capacul astupat, în orice moment se poate da drumul unei părți din răul de aici. Așa de exemplu cele întîmplate cu Măgureanu, care, după ce a fost atacat prin publicarea dosarului său, n-a găsit altceva mai bun de făcut, decît să publice el însuși niște dosare. Ceea ce a făcut Măgureanu mi se pare mult mai grav decît faptul că a avut un dosar din care a rezultat că a fost căpitan de Securitate. Că directorul Serviciului Român de Informații a putut proceda așa, nu mai ține de supărarea lui „pe lume" și nici de dorința lui de răzbunare. Domnul Măgureanu ar trebui judecat, nu pur și simplu schimbat din funcție, dacă se dovedește că din mîna lui au plecat acele dosare. A încălcat legea și și-a încălcat atribuțiile. Unde am ajunge dacă fiecare șef de instituție care are în mînă asemenea lucruri s-ar apuca să le publice împotriva dușmanilor lui ? Am ajunge în infern.

● Credeți că în timpul campaniei electorale ne așteaptă dezvăluirea altor dosare ?

●● Cu siguranță că se vor folosi toate mijloacele. S-ar putea întîmpla să vedem și dosare falsificate. Toată lumea se teme de confuzia pe care ar stîrni-o amestecarea unor lucruri valabile cu lucruri inventate. Dau de pildă cazul televiziunii : în timpul lui Ceaușescu absolut nimeni nu credea că măcar o miime sau o milionime din ce se spune la televizor este adevărat. Acum, cînd ceea ce se spune este mai mult sau mai puțin adevărat, lumea ar trebui să aibă dovadă de un imens discernămînt ca să înțeleagă exact ce-i mincinos din propaganda pe care o face televiziunea. Or, cîți sînt în stare de asta ? Într-un fel, o televiziune sută la sută mincinoasă e preferabilă unei televiziuni care în parte minte și în parte spune adevărul. Același lucru se va întîmpla și cu dosarele care se așteptăm să apară. Și care ar putea fi falsificate, ceea ce ar crea o confuzie imensă. Toată lumea ar putea bănui pe toată lumea. Să sperăm că nu sînt în stare — nu din punct de vedere moral, ci din punct de vedere material — să facă aceste dosare. Nu e foarte ușor să falsifici un dosar. Eu încă mai trag nădejde că nu sînt capabili din punct de vedere material, tehnic, să fabrice dosare. Sau nu suficient de multe care să devină importante.

ANUNȚ

Aducem la cunoștința cititorilor noștri că revista „22" nu și-a schimbat prețul care, dintr-o eroare, nu a fost trecut pe numărul anterior.

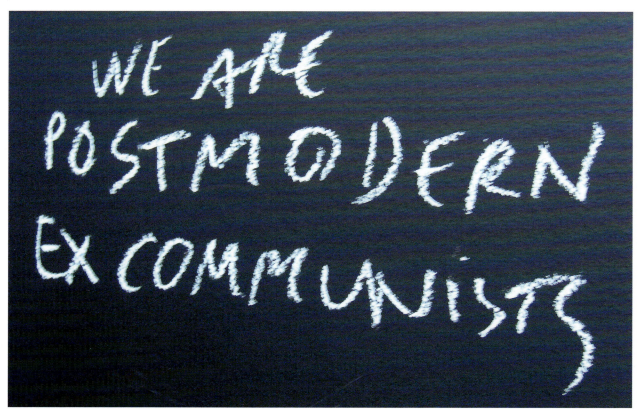

register of trauma whose effects are very much present today. Kristine Stiles's profound discussion of trauma and art (in her essay "Shaved Heads and Marked Bodies: Representations from Cultures of Trauma") [see bibliography in this book] analyzes Dan's tattoo, suggesting how marked bodies display silence as an image of trauma and the destruction of identity. This dark history was performed on the bodies of Romanian women who didn't and couldn't tell their stories. Even today, now that it is possible to speak of it, this story remains mostly buried in the multi-layered silences that surrounded each of its (female) players: it remains buried in their bodies. Lia Perjovschi's art expels some of these silences from within her own body, bringing them to the surface of her skin. Dan performs a supporting role for these narratives, but he has also used his own body to tell stories, to make explicit what was once silence.

In Lia and Dan's earliest body-art, one finds the story of the pro-lapsed commie kingdom of Romania, one brutalized by the same grim, tyrannical couple who were the dark genitors of the Perjovschis' formation as artists. [Fig. 231] In their later works, the specter of this dark "him" and "her" fade, making room for wider experiences and engendering multi-leveled performances that comment on themselves as well as on the art scene.

The 1994 piece *It's Your Turn*, glossed by the word "allude" ("to make indirect reference"), presents what the description calls an "aggressive, tormented, jammed space" full of images, video, and text. "If something is to be done," the commentary enjoins, "then it's your turn. You are your unique chance." Significantly, the artists' bodies are absent here, making room for their debris, their "message"; their own absence testifies to their intention of remaining elusive by "alluding."

The Perjovschis have succeeded in framing their work in the international language of art. [Figs. 233–234] This

distinction enables discussion of their work in a well-established, "global" context, and allows for the specific effects of the work to communicate new contents to new audiences. There have been a number of Romanian art-performers before the Perjovschis, artists who took the practice of performance art to mean "ritualistic art." To be sure, this nearly ritual evocation of "ritual" is part of what keeps a patchy national consciousness chugging along, but it also keeps an entire thinking class in business. The wellspring of this tradition of ritualistic exegesis is Mircea Eliade, a scholar of myth and religion who converted *almost* all thinking Romanians into hunters of ritual and explicators of myth. It is clear that Romanians do not have any more rituals (or myths) than other people; it is clear, too, that those they do have are shared universally. Still, the thirst for ritual-spotting and the satisfaction gained from deducting an ethos from myth is a national obsession. This, we could say, is a pursuit drawn from an obsolete store of thinking tools. This Romanian archive of myth, like a warehouse brimming with flintlock pistols, is stocked with the dusty ideologies of the 1930s and 1940s, a mix of nationalism and religious orthodoxy. Romania's cartoon dictator, Nicolae Ceausescu, reopened this musty storeroom in the mid-1970s, in a late effort to prop his failing regime with the authority of repressed but by no means dead deities.

Some of the Romanian performance artists who preceded Lia and Dan performed rituals that were mostly

Fig. 232, left
Dan Perjovschi, *You New in Town?*, 2006; marker on wall.

Figs. 233–234, above
Dan Perjovschi, *I shoot myself in the foot*, 2005, fax installation at Exit Gallery, Peja, Kosovo; detail of drawing *Chaos and Order* being examined by Romanian NATO troops.

impressionistic renditions of *faux* folk art. This sort of performance had the double effect of placating the official line while expressing a recognizable dissidence, lending the work a frisson of critique even as it worked in step with orthodoxy. Dissidents suffering like Christ (or like Prometheus, Icarus, or St. Sebastian) was an acceptable trope in all quarters, since it simultaneously broadcast an allegiance to ancestral (and current) religious themes and suggested torment due to material privation, such as lack of food, heat, and electricity.

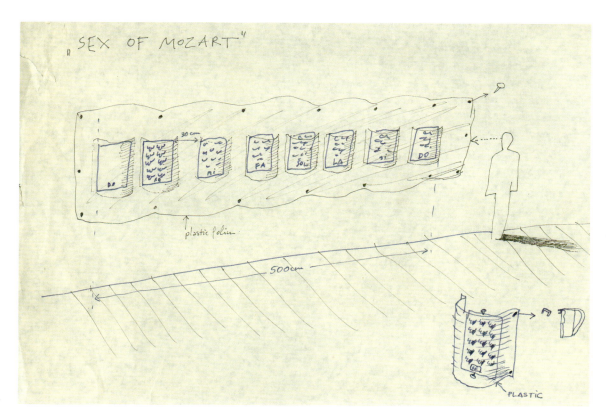

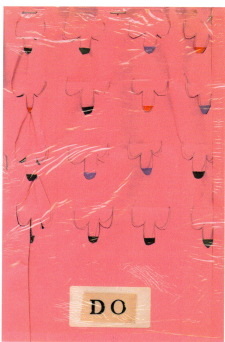

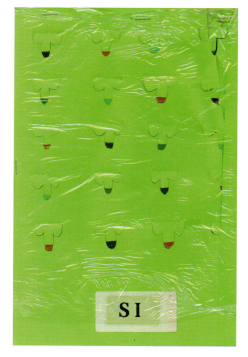

Figs. 235–237
Dan Perjovschi, *Sex of Mozart*, 1992; ink sketch on paper and two collaged, plastic-wrapped original units from the installation for the exhibition "Sex of Mozart," Bucharest.

ANDREI CODRESCU

Fig. 238
Dan Perjovschi, *Dick Gun*, 2006;
postcard.

Like all good artists, Dan and Lia provide numerous friendly pointers to interpreters, without giving up the game of art, which remains, properly, mysterious. Mystery in art is that which lingers after the interpreters are through with a given work; or, even better, mystery in an artwork is that which intuits and incorporates in advance everything that might be said about it. (Or it may be that which goes even further, leaving its very survival to a future interpretation—making room, as it were, for critiques of its own critiques.) I do not know if Dan and Lia's literariness goes that far by itself, but with the help of Romania, Romanian history, Romanian literature, Dada, the Ceausescus, and the contemporary crush on performance art, it does.

[Fig. 232] Privation was clearly the fault of the Ceausescu regime, but in these easy metaphors, suffering was represented as eternal, a recurring condition of a small people "cursed" by history.

Romanians who wanted to be part of an international art community were not the only ones to think "ritual" was self-evidently "art." In the 1980s and 1990s, prior to or immediately after the collapse of Red Fascisms, one found all over Eastern Europe many performers who thought that their interpretations of nativistic folklore would cause great delight (and sales) in the West. Dan and Lia Perjovschi avoided that trap, intelligently preferring instead to stage their events without religious or pseudo-mythical undertones. They invented rituals that ironically deconstructed the religious metaphors that came so easily to many of their predecessors.

The Perjovschis are Dadaist psychological realists, producers of sober situations based on linking the body with writing. [Figs. 235–239] They foreground the insecurities of the body, linking them to feminist questions that are universally recognizable. At the same time, Lia's body, placed in the historical and political geography of its moment, broadcasts an exegetic enterprise that questions its own assumptions. By reversing the traffic flow, by recasting its local antagonisms in a wider, even "global" idiom, their art is oriented toward an important international conversation.

Fig. 239
Lia Perjovschi, detail from *The Globe Collection*, 1990–present; lightbulb.

Marius Babias

THE INCOMPLETE SELF:

The Transformation of Romanian National Discourses in the Context of Europeanism

This essay examines a cultural mechanism dominant in post-communist Romania that is also typical of Southeastern Europe: anti-modernism rooted in the national discourse of communism. My discussion in what follows aims to shed light on the situation in which Dan and Lia Perjovschi's art emerged by describing the Romanian national context in relation to the European community. Especially in Romania, the construction of a post-communist European identity has relied on models of national discourse that have been revived in the early twenty-first century's atmosphere of neoliberal change. Seen from the neoliberal perspective, communism is commonly interpreted as a "wrong way" or a "dead end," but this view is too limited. The current process of restructuring post-communist society in Romania, based on this neoliberalism, is not grounded in a critical approach to history, but instead tends to present a continuity of national history, myths, traditions, and cultural self-appreciations. The construction of the "self-as-European" is the unspoken goal of this new restructuring, but this too relies upon a blocking out of the communist past and its profound cultural impact. I shall argue that the combined devices offered by the new elites — of traditions, national mythologies and cultural self-appreciations — represents a reiteration of communist national discourse now dressed up as liberalism.

This essay is based on the premise that the complex process of European acculturation cannot be understood using outdated monocausal or bipolar terminologies. Rather one could describe the emerging outline of a total Europe — one that includes Romania — under the auspices of deterritorialization, and its role as the dominant critical framework of a new Euro-identity. The hybrid, cosmopolitan, or fluid identity that this term connotes is itself based on efforts to dissolve borders and avoid containing individual personal and political practices. Some new positive representations of the other, of otherness, and especially of the self must be formulated. Before this new self can be established, a self that (as Edward Said has remarked) has always to be considered as an "other," the ballast of some cultural representations and conceptual determinations of European unity must be discarded. Some of these are centuries old. Nevertheless, outmoded, unitary concepts such as nationality, ethnicity, reli-

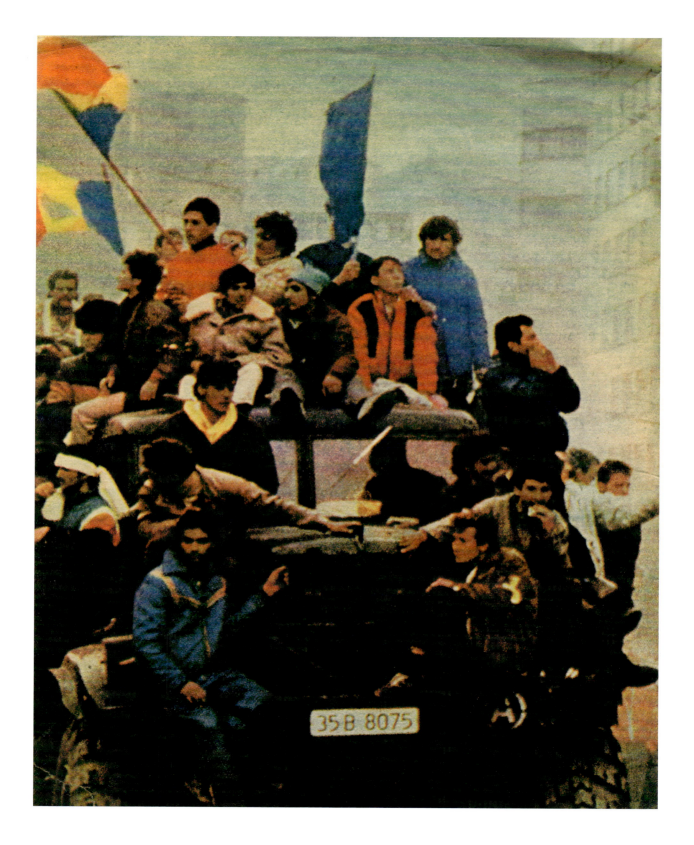

gion, and even "identity" itself must be overcome. (It is worth noting that all of these have paradoxically been revived in post-communism, especially as the European Union becomes a reality.) This overcoming can begin through the practices of discursive analyses: dissection, transformation, and reassembly. In mobilizing these techniques, this essay is intended as active participation in the development of a critical framework for engaging with the ideology of Europeanism; in this way, perhaps, it parallels the cultural activities of artists Dan and Lia Perjovschi.

A line of argument with specific concepts, borrowed partly from adjacent discursive fields, runs through my text. This eclectic approach attempts to understand the cultural ideology offered by the post-communist elites—their anti-modernism—as a mechanism of renewal for communism, and for communism's specific national discourses. Anti-modernism is to be understood here in its narrow sense, as a political stance that is critical of the post-communist practices of denial, displacement, and the revision of history.[1] I also deploy the concept of anti-modernism to designate three trends related to this critical stance: (1) the revival of hostility toward the middle class and art in Romanian post-communism; (2) Romania's reinvention of the authentic subject as a driving force of national history; and (3) the combination of identity politics and Europeanism that currently forces Romania to create itself as a new historical European self.[2] More profitable and instructive than engaging in the anti-modernism offered in these iterations is a procedure that would present Romania's deep historical involvement with the Nazis' *Großraum* (territorial expansion) and *Großwirtschaftsraum* (economic expansion) policies. It would then document the post-communist transmutation of these concepts and procedures in the sublimated form of the EU and its supranational policies. Taken to an extreme, such an argument would culminate in suggesting that the developing superpower of Europe was born out of the Nazi policies of territorial and economic expansion, policies to which the Balkan states, which pleasantly present themselves today as Hitler's victims, made their own historical contribution.

II. EMERGENCE OF THE ROMANIAN NATION STATE

Romania's political and cultural ostracism after World War II led intellectuals, artists, and writers to develop a national discourse that imagined the Daco-Roman continuity from antiquity to the communists, a discourse that proved especially useful in positing Nicolae Ceausescu (and his wife Elena) as the seemingly legitimate successor(s) to Romania's national history.[3] The personality cult surrounding Ceausescu began in the late 1960s and grew throughout the 1970s, as he increasingly proclaimed himself leader of the Romanians, a figure historically akin to the mythical Dacian king Decebal.[4] Seen with this nationalist narrative in mind, a central element in the process of recasting Romanians as Europeans concerns the alleged ethnogenesis of today's Romanians, the history of the Romanian people. It is most commonly understood as a history of racial mixing that extends from the year 106 CE, when the Daci blended with Roman colonists under Emperor Trajan. (This transformation took place especially in the areas that are today known as Transylvania—the regions of Banat and Oltenia—as well as south of the Danube, in eastern Serbia and northern Bulgaria; the Dacia province, which the Romans abandoned in 271 CE, was founded in present-day Transylvania and Banat.) The Romanians' affirmation of a Latin identity, however, lacked ancient sources, and their claims to Roman descent appear, today, to be a racial myth. Nevertheless, the Romanian language preserves linguistic structures from Latin, and now belongs indisputably to the family of Romance languages. But the Romanian language also has Slavic, Greek, Albanian, Turkish, and Hungarian influences, testifying to Romania's territorial place and historical role as a Eurasian crossroads.

Fig. 240, previous page
Historical photograph of jubilant citizens holding the Romanian flag with a hole in the center where the Coat of Arms of the Socialist Republic was cut out.

Figs. 241–268, following pages
Lia Perjovschi, *Research File: Subjective History of Romanian Culture in the Frame of Eastern Europe and the Balkans, from Modernism to the European Union,* 2000–present. This work of art is reproduced consecutively throughout Marius Babias's essay.

Many different migrating tribes crossed this territory until the burgeoning Hungarian kingdom colonized it around the year 1000. The theory of Daco-Roman continuity holds that a population of Roman colonists and Romanized Dacians remained in Dacia after the Romans' withdrawal, and that during the Migration Period, these merged into what may be described as the basic cell of the Romanian nation, which then defended itself against Slavonic influences. Christianized over the centuries, the incipient Romanian population remained the dominant culture in Transylvania during the Middle Ages, until the Hungarian invaders cast them out. However, another argument suggests that after the Roman troops and administration withdrew, the Romanized Dacian population was evacuated across the Danube to present-day Serbia. As a result, this argument suggests, the ethnogenesis of Romanians took place in the southwest Balkans, probably near present-day Albania. The fact that Romanian and Albanian share common linguistic roots adds weight to this historical account. The actual territory of present-day Romania, according to this second hypothesis, was not populated until the Slavonic and Hungarian migrations. Arguments and counterarguments can be brought to bear for either theory. But it is not historical evidence or irrefutable linguistic proof that will decide the dispute. The issue, instead, is political: the affirmation of a Daco-Roman ethnogenesis (as the first theory proposed) would legitimize Romania's current cultural affiliation with the history of Western civilization, and suggest that the ethnically heterogeneous territories within the state's present borders are rooted in the history of Roman settlement. The second hypothesis questions this, and argues that Romania's civilization and territories are not the natural settlement area of a cultural nation descended from the Romans. The first hypothesis, proposed exclusively by Romanian researchers, implies a prevalently Christian, Western origin; the second hypothesis, supported by almost all international research, starts from the idea that Romanian culture has its roots with Slavs in the southwest Balkans.

The contentious and relatively recent debate over Romania's ethnogenesis did not affect the creation of the Romanian national state or its maintenance over the last five hundred years, a period that included two princedoms that developed in the fourteenth century: Moldavia and Wallachia. These states fell under Ottoman domination in the sixteenth century, but were largely allowed to preserve their autonomy and their Christian religion until the eighteenth century. Beginning in the nineteenth century, Romania's ethnogenesis, and the implicit question of its cultural and civic affiliations, motivated violent confrontations with Hungary. Reciprocal claims over possession of Transylvania were one reason for political conflict. Another explanation runs much deeper than this, and concerns discursive frames of identity formation and Romania's

MARIUS BABIAS

affirmation of itself. Here the issue is Romania's self-diagnosis as a cultural nation with a Christian-Western sense of mission, a nation surrounded and threatened by Slavic peoples. This self-affirmation conjures an efficient cultural-ideological topos that, as we will see, further developed in later national discourses, as well as in questions of sovereignty and foreign policy in relation to Moscow, under Ceausescu. Today the myths of Romania's inherent "Westernism" are promulgated with the aim of uniting it to the larger European community (Union) of culture and values.

Romania was not internationally recognized until the late nineteenth century, in the San Stefano peace treaty of 3 March 1878. Up to that point, both Romanian princedoms, Wallachia and Moldavia, had been the playthings of the superpowers: Austria-Hungary, Russia, and the Ottoman Empire. In 1690 Austria established rule over Transylvania, which since the Middle Ages had traditionally belonged to Hungary. By the eighteenth century, Austria had conquered large sections of the Danube region from the Ottomans and settled the Banat with colonists, most of whom were Catholic. The other territories of today's Romania remained under Ottoman hegemony until the second half of the nineteenth century. In 1859, Alexandru Ioan Cuza was elected as prince of the two Romanian princedoms, and in 1861 he proclaimed the sovereign state of Romania.[5] Five years later, in 1866, Cuza was forced to

resign as a result of a parliamentary coup. Romania's independence was obtained only after the Russo-Turkish war (1877–1878), when Romania backed Russia in its victory against the Ottoman Empire. At San Stefano (today Yesilköy, near Istanbul), the Ottoman Empire was forced to concede parts of Armenia and Dobrogea to Russia. The Berlin Congress took place several months later (13 June to 13 July 1878) and was led by the German chancellor Otto von Bismarck. Attended by Great Britain, Austria-Hungary, France, Germany, Italy, Russia, and the Ottoman Empire, the Congress revisited the Treaty of San Stefano *in extenso*. As a result, Montenegro, Serbia, and Romania were recognized as independent states, though Romania had to exchange South Bessarabia with Russia for the less-favored Dobrogea. In 1881, the Romanian Parliament established monarchy as its form of government, under Prince Carol of Hohenzollern-Sigmaringen. During the reign of Carol I (1881–1914), central Bucharest was modernized: grand boulevards and buildings, designed after French, Austrian, and German models, shaped the townscape. It was Bucharest's first great surge toward European modernization; during it, the city gave itself the nickname "Little Paris."

Romania entered World War I in 1916 on the side of the Entente Powers, and after the war could feel like a great territorial winner: it doubled its territory, incorporating Bessarabia in the northeast (today the Republic of

Moldova), Transylvania in the west (until then, part of Hungary), and Bucovina in the north. Romanian troops stationed in Transylvania attacked Hungary in 1919, conquering Budapest and occupying it for several months. The treaties of Versailles and Saint-Germain (both in 1919) confirmed the dismantling of the Austro-Hungarian Empire, and the new states of Austria, Hungary, Czechoslovakia, Poland, Romania, and the Serb-Croat-Slovene State were born from the successional body of its former territory. The Treaty of Versailles confirmed the unification of all territories inhabited by Romanians. The exchange of Transylvania from Hungary to Romania was accomplished in 1920 through the Treaty of Trianon. King Ferdinand I, enthroned in 1914, was crowned in 1922 as king of Greater Romania, and until 1927 he ruled the new territory in the west as a Romanian national state, a decision that led to the political and cultural marginalization of the Hungarian, German, Jewish, Slovak, and Armenian minorities.

Carol II governed Romania with an iron fist between 1930 and 1940, a period that is nevertheless now viewed as Romania's golden age.[6] In 1927 a fascist movement called the Iron Guard was formed under the command of Corneliu Codreanu;[7] this group engaged in a bitter power struggle with the king during the 1930s, a time characterized by political disunity and social disintegration. Provoked by the fascists, a state of civil war prevailed that paralyzed the country. In response, Carol II instituted a royal dictatorship, arresting and eliminating prominent fascists in 1938. In 1940 Great Britain withdrew from the Balkans, causing Romania to lose the territories it had acquired after World War I; Great Britain, meanwhile, issued a "guarantee statement" for Romania. Germany, Europe's new superpower, was only interested in Romania's oil and grain supplies. At the end of June 1940, the Soviet Union, locked into the Hitler-Stalin Pact, forced Romania to give up Bessarabia and North Bucovina. Bulgaria and Hungary also announced new territorial claims. With the approval of the superpowers, Bulgaria managed through negotiations to regain South Dobrogea, a region they had lost in 1913 to Romania. Romania could not reach an agreement with Hungary, and the result was the so-called Vienna Arbitration Award of 1940, in which Hitler decreed the surrender of North Transylvania to Hungary. With Hungary and the Soviet Union marching before his eyes, and having recovered what were, before World War I, "Romania's territories," Carol II resigned and went into exile, handing over power to his minister of war, Ion Antonescu.[8]

Worshipped in Romania today as a national hero despite his fascist leanings, Marshal Antonescu established a dictatorship together with allies from the Iron Guard between 1940 and 1941, and then declared Romania a national legionary state. After managing to quell an

MARIUS BABIAS

attempted coup in January 1941, Antonescu governed alone. He dissolved the cumbersome legionaries, but his policies continued to reflect the anti-Semitism and ultra-nationalism of the Iron Guard. In fact, during Antonescu's reign, anti-Semitism became a state ideology: Antonescu's military-fascist regime sided with Germany in the invasion of the Soviet Union in 1941; it then declared war against the Allied powers, and recovered Bessarabia and Bucovina. During these years it also incorporated Transnistria, a part of Ukraine, where Antonescu's regime built, and then ran, concentration camps for the annihilation of Romanian Jews. According to the final report of the International Commission on the Holocaust in Romania (2004), four hundred thousand of Romania's approximately one million Jews were killed on Romanian soil. Another leader, King Michael I, wrested power from Antonescu in an August 1944 coup,[9] and Romania switched allegiances, siding now with the Soviet Union against Germany. (The territories of Bessarabia and Bucovina were then returned to the Soviets.) The Soviet Red Army, quartered in Romania until 1958, helped the Romanian communists acquire power after World War II; with that military backing, the communists identified the bourgeois elites of the former system, persecuted them, and killed them.

The northern part of Bessarabia, now the independent state of Moldavia, was inhabited mostly by Romanians and remained under Soviet rule for a long time. After the war, the southern part of Bessarabia (Bugeac) went to Ukraine. In return, North Transylvania, which had been ceded to Hungary and was mostly populated by Romanians, was returned to Romania in 1947. Established by the victorious powers (the Soviet Union, the United States, Great Britain, and France) through the Treaty of Paris that same year, the western borders of Romania were now identical to those of 1920. The Romanians' long-standing request for restitution of North Bucovina and Bessarabia, both of which had been annexed by the Soviets, was not canceled after the war ended, but the request was not expressed openly because under communist leader Gheorghiu-Dej in the 1950s,[10] Romania developed into a satellite state at Moscow's mercy. Nevertheless, the vision of a "Greater Romania," along with the related question of minorities and how they should be dealt with, remained the central concerns of Romanian security policy. When opposition was crushed under the Groza government in 1947,[11] King Michael I was forced to resign, and the Communist Party became the leading force in all areas of society. The idea of a Greater Romania, always decisive in Romanian domestic politics, now became vital for the state, and during the later Ceausescu era this ideology proved especially useful for its ability to stabilize domestic affairs. While Gheorghiu-Dej's attitude toward the Hungarian minority in Transylvania was still equivocal (partly for fear that the 1956 Hungarian

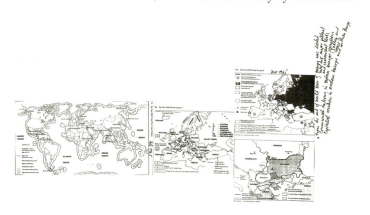

rebellion could spread to Romania's Hungarians), his successor, Ceausescu, often acted repressively. Hungarian-language schools, publishing houses, and cultural institutions were closed on a grand scale. Jews and Germans were treated more carefully, as they turned out to be useful bargaining chips with Israel and Germany. In 1967, Romania became the first state within the Soviet bloc to establish relations with the Federal Republic of Germany. Romania's national discourse, and the subsequent anti-modernist ideology that underlies political and cultural life in the country even today, are both the products of the Romanian security doctrine under Nicolae Ceausescu. Long (and falsely) considered by the West to be a sign of Ceausescu-era benevolence, Romania's policy toward Moscow, as well as the militarization, socialization, and nationalization of its own political culture, starting in the 1960s, have their origins in the geopolitical events of the two world wars.

III. NATIONAL DISCOURSE UNDER CEAUSESCU

With Ceausescu came an ideological shift from Marxist internationalism to ethnic nationalism, and to the related aspiration of becoming a European superpower. This ambition today seems ridiculous, but in terms of domestic politics, the strategy of relating Romania's national myth to an aggressive economic policy proved highly efficient. A massive industrialization program, funded on Western credit, was carried out in Romania's

agricultural sectors. Other efforts to mechanize society included a 1966 law aimed at raising the birth rate by banning abortion—a project now considered to be one of the most monstrous social experiments in recent history. Proposed to cultivate a new crop of national children, the policy showed in concrete form the "success" of Romania's nationalist ideology: the naturalization of "the people," fatherland, and nation had become a party program, and this organized indoctrination was showing results. The 1989 revolution brought to light a host of policies just as sinister as the birth rate management program. One included the incarceration policy that served to demonstrate the fact that sick children and those with disabilities had been mercilessly excluded from Romanians' common destiny. Placed in orphanages shielded from public view, they were neglected and left to die in a selection process designed precisely with that goal in mind. By the 1980s, this ethnically essentialized generation had been transubstantiated by the dominant national ideology into the Romanian "new people." Elena and Nicolae Ceausescu called them "our children"—but ironically, it was some of these same "children" who overthrew and killed the dictatorial couple in 1989.

In March of 1965, Ceausescu assumed the position of general secretary of the Communist Party, of which he was elected president in 1974. At the Ninth Party Congress in 1965, with Ceausescu as general secretary,

members openly articulated Romania's emancipation from the Soviet hegemony in Eastern Europe. The rehabilitation of nationalism that this claim announced had as an ideological consequence the abandonment of proletarian internationalism. Marxist-Leninism had long critiqued narrow nationalism, and by reversing the Leninist doctrine of class-based internationalism, the Romanian Communist Party (RCP) declared socialism the form, and the nation the guiding force of their history. Turning inward, valuing nation above class, the party leadership then launched on a collision course with Moscow. The policy of antagonizing the Soviets was controversial, but proved a useful way for the RCP to make its mark at home, one that promised to bring stability to domestic affairs and, in the area of foreign policy, commercial partnerships and a good reputation as a friend of trade. The creation of these national "masses" opened the door to state violence. In her 1951 *The Origins of Totalitarianism*, Hannah Arendt took the Soviet Union and Stalin's 1928 five-year plan as an example, and made clear that "transformation of classes into masses and the concomitant elimination of all group solidarity are the condition *sine qua non* of total domination."[12] In Stalin's case, a policy of massification was aimed at eliminating peasants, proletarians, and the middle class (all seen by Stalin as threats to his power) as well as their forms of organization, which had been encouraged under Lenin in order to realize agricultural reform, the nationalization of industry,

and the New Economic Policy (NEP). Ceausescu, rather than attempting to dispel class altogether, carried out a policy that fused class with the mechanism of nation. The result was the establishment of a Romanian Euronation, one with putatively ancient Roman roots and a Christian-Western sense of mission that contrasted sharply with the internationalist ideologies of its neighboring Slavic states. This turn toward nationalism was not, however, articulated entirely within the discursive framework of Marxist-Leninist theory. Rather it was a total theory aimed to overhaul fundamental political practice, tailored to fit the specific needs of a given nation. In a report to the Ninth Party Congress in 1965, Ceausescu wrote:

> The way each party accomplishes its tasks is not a matter for discussion; it is the exclusive right of every party to independently elaborate their political line, the forms and methods of their activities, and to specify their objectives by creatively applying the universal truths of Marxism-Leninism to the concrete conditions of their country.[13]

His injunction is for "creatively applying universal truths" to the particular Romanian case, an improvement on Marxist doctrine that would prove crucial in solidifying Romanians as a national people in the years of Ceausescu's power.

Romanian national ideology continued to develop in the wake of this innovation. A rapprochement with China had already initiated an emancipation of Romania within the communist bloc in advance of the Ninth Party Congress. With opportunist party historians having provided a narrative of the "people's" history and a mythological past dating as far back as antiquity, the question of the socialist nation of Romania's future remained open. How, if at all, would it collaborate with the other socialist states, especially with the Soviet Union? Emil Bodnaras, Romanian minister of defense and member of the Politburo, gave this question a sharp answer in the party's newspaper *Scanteia*:

> Proletarian internationalism acquires its content and efficiency between independent, sovereign, equal socialist nations and states and represents the incorporation of a giant, unified force. (*Scanteia*, 24 July 1965)

Again the discourse inflected the prevailing Marxist-Leninist vocabulary by turning toward the nation, and toward national sovereignty. As a result, after the Ninth Party Congress, relations with Moscow cooled. Romania drew closer to replicating China's stance of political self-determination, an anti-internationalism that was manifested in Ceausescu's resistance to the Prague Spring. In a speech he gave on the occasion of the RCP's 45th anniversary in May 1966, Ceausescu accused the Comintern and the Cominform of gross

mistakes, and categorically ruled out the formation, in Romania, of a similarly global center for communist education. A flurry of nervous diplomacy followed. In May 1966 Bodnaras flew to Beijing to have a series of talks with Prime Minister Zhou Enlai, while Brezhnev visited Bucharest at the same time (10–13 May). Just four weeks later, Zhou Enlai's visit to Romania demonstrated the deep anxiety in the relationships among Beijing, Bucharest, and Moscow at the time. But while the Romanian press reported on Zhou Enlai's trip in detail, Brezhnev's visit was kept a secret.

The ideological dissension with Moscow reached its climax with the events of the Prague Spring in 1968.[14] The RCP realized that the liberalization tendencies becoming evident in Czechoslovakia—much more than the Moscow-Beijing conflict—could provide the leverage needed to effect Romania's emancipation from the bloc policy of the Warsaw Pact nations. As a result, Romania supported Alexander Dubcek's audacious policies of reform, announcing that the Czech reformer's efforts represented "the attempt of the Czechoslovakian brother party to place social life on the road to socialism" (*Scanteia*, 14 August 1968). Despite this apparent nod to liberalism, Romania rejected internal reforms as a threat to the RCP's social supremacy, a fact suggesting that the RCP did not welcome Dubcek's reform policy per se, but rather its collateral effect, namely the questioning of Soviet hegemony. Immediately before Prague

was occupied by Warsaw Pact troops (on 21 August 1968) and the Prague Spring was brought to an abrupt seasonal change, Ceausescu visited Czechoslovakia. On 16 August, only days before Soviet tanks pushed through the Prague streets, the Romanian leader signed the Romanian-Czechoslovakian Treaty of Mutual Friendship, Collaboration, and Support. Article 11 of this audacious anti-Soviet document even stipulated mutual military help in the case of attack by "a state or a group of states"—code, all parties knew, for the Soviets and their Warsaw Pact allies.

Ceausescu's criticism of the military intervention in Prague was seen in the West as spectacularly courageous. The impression of anti-Soviet activism this episode produced spurred favorable Western policy toward Romania until the end of the Ceausescu era, a policy characterized by a mixture of calculated *realpolitik*, diplomatic indulgence, and moral and economic support. Even before the Prague episode brought Romania's antagonism toward the Soviets into relief, Richard Nixon had done the country a great honor by visiting it in 1969: he was the first U.S. president to visit a communist country since the start of the Cold War. In the late 1960s, Romania was recognized abroad as a sovereign nation and respected for its brave independence from Moscow. The result of this indulgent view was that Ceausescu now had a free hand with regard to domestic affairs. Through American intercession,

Romania became a member of the International Monetary Fund and the World Bank in 1972. In 1975 it was granted most-favored-nation status by the United States, a move that made clear the solidarity between these unequal partners. Ceausescu's nationalist dictum had specified that each socialist nation bears the unique responsibility for its revolutionary achievements without any foreign interference: this mantra of sovereign independence was formulated during the Prague events, and formed the basis of the Romanian government's security doctrine until the first Iliescu regime, in 1990.[15]

The sovereign independence announced in Romania's foreign policy, first established during the Prague events, had an organizational connection with repressive domestic policies and an actively maintained climate of fear. The "brave," anti-Soviet position that so pleased the West unfolded alongside domestic policies characterized by a decline in political and economic culture under Ceausescu. The anti-Soviet character of the Ceausescu era resulted in two lines of political action: (1) increasingly loud demands for the return of the territories that had been annexed by the Soviets, North Bucovina and Bessarabia; and (2) the emergence of the RCP's autocratic leadership (with Ceausescu at the helm), as the party began to perceive itself as the legitimate heir of Romania's patched-together national-ethnic history. Now Romanians could imagine

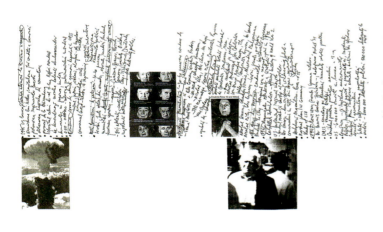

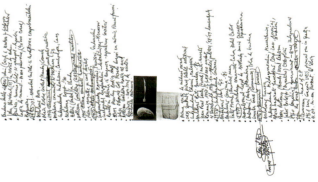

themselves as Latins, with roots in Rome and a common destiny constantly threatened by the Russians. The foreign policy emancipation from Moscow thus laid the foundations for political repression inside the country. Spurred by a combination of corruption and striving for national self-sufficiency, an economic crisis likewise followed in the wake of Romania's foreign policy "emancipation."

In the early 1970s, Romania's gradual disengagement from the Eastern bloc economic organization, COMECOM, and the industrialization of its own petrochemical sector (a project funded by Western credit), combined with its neglect of the agricultural sector to bring on shortages and social misery. By 1981 Romania was no longer considered eligible for Western credit. Though it left shortages of basic food provisions, the regime exported all goods that could be sold in order to pay off its foreign debts. The lack of coal, oil, and electricity caused a crisis of raw materials, which further intensified the dire economic situation within Romanian borders. Propaganda attempted to defuse the social emergency by stressing that Romania had to remain economically self-sufficient, independent from Western and Russian influences. In fact, however, what had once been $10 billion in Western debt had been reduced to $6.5 billion by 1985, and by 1989 the country was debt-free. Nevertheless, in 1987 unrest arose at Brasov, where factory workers were denied their wages for not having fulfilled their quota; the same year, in Iasi, students reacted to being denied privileges as part of a cost-cutting program. These instances of dissent can be explained by the fact that these local manifestations of the economic emergency could not be entirely blamed on outside forces, and thus could not be defused by recourse to nationalist appeals. The Program to Systematize the Villages, passed in 1988, proposed to raze eight thousand villages and resettle the rural population in so-called agroindustrial centers—concrete slab buildings. Once again, the government was unable to justify itself. For while this project was never carried out in full, it simultaneously revealed discrimination against minorities and, paradoxically, exposed government propaganda as contradictory. Ready to demolish traditional villages in service of the "great historical nation," the regime seemed prepared to destroy and save its national history all at the same time. The aims were manifestly sinister: the policy was intended not only to extend agrarian areas, but also, and more, to eliminate cultural diversity and regional differences among rural areas. It was a policy of national standardization. Yet even this was undertaken unevenly, with economic redistribution made in favor of Moldavia and Wallachia (predominantly Romanian regions) while in the Transylvanian areas inhabited by the Hungarian and German minorities, sparse allotments were the rule.

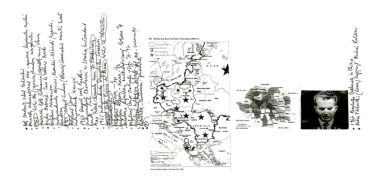

Alongside the discontent this unevenness fostered, an increasing political dissatisfaction emerged, a discontent stemming from the autocratic leadership and human rights violations increasingly perpetrated by the government. Inspired by Mikhail Gorbachev's program of *perestroika*, the National Salvation Front, though still acting anonymously, asked delegates in advance of the Fourteenth Party Congress to remove Ceausescu from the position of general secretary and to replace the party's leadership entirely.[16] Already in March 1989, an open document of protest called the "letter of the six," had been broadcast into Romania by foreign radio stations, creating anxiety within the regime. Among the signatories were old guard communists Constantin Pirvulescu, Grigore Raceanu, Silviu Brucan, Gheorghe Apostol, and Alexandru Birladeanu (the last two had been removed by Ceausescu from the Politburo in 1969), as well as Corneliu Manescu, the former foreign affairs minister and the first communist to be president of the United Nations General Assembly, serving from 1967 to 1968.[17] The National Salvation Front's letter was doubly effective, since it was evident that on one hand, the authors were reformist communists, and, on the other, that they were concerned with creating a common platform of opposition.

The reform movement in the socialist states (USSR, Hungary, Poland) reflected Gorbachev's request to de-ideologize international relationships, a shift in strategy that isolated Romania politically. Gorbachev's request implied that the Soviet Union would recognize the independence and national sovereignty of smaller states, as well as renounce its policy of interference and forgo the use of force from the outside. Gorbachev's move thus ironically recapitulated the very "dissident" position represented by the RCP in 1965. But despite the nearly identical nature of these positions, the "new thinking" politics claimed by both Gorbachev and Ceausescu were based on different presuppositions and aims, a fact that became clear in September 1989. Just one month before the start of the Fourteenth Party Congress at the CC plenum, several fundamental ideological issues were surprisingly put on the agenda.

A debate had become necessary. Domestic political developments at the end of August 1989, when the National Salvation Front had called for Ceausescu's removal, meant that the legitimacy of the RCP leadership had to be asserted. Pressure also needed to be taken off of the party leaders' shoulders, especially in view of the fast-moving, systemic changes in adjacent Hungary, Poland, and East Germany. Ceausescu's speech on that high-pressure occasion took a polemical stance against two issues: first, against the de-ideologization of international relations, which he himself had propagated until that time; and second, against the Soviet-facilitated, pan-European establishment Gorbachev had called "the Common European Home." Ceausescu

saw that reform movements in the socialist states represented a serious threat to the dictatorially governed Romania. In foreign policy terms, the RCP was already isolated, while domestic opposition was rising. Aware of the threats to his power closing in both from within and from without, Ceausescu did not retreat, but took a step forward, refusing Gorbachev's plan of a Common European Home. The dictator said:

> The idea of a Common European Home could seem attractive for some. But we must consider the necessity that we all create at home "a house as good as possible," which grants to all the inhabitants of the "national house" equal working and living conditions—and this implies building millions and millions of apartments and houses in each country, in order to create a social whole, in which people enjoy the best living and housing conditions.[18]

Ceausescu's rhetoric twisted Gorbachev's formula by taking the term "Common European Home" literally, disavowing the policy by making a pun on housing conditions. In doing so, Ceausescu showed a certain sense of humor, but he also revealed his loss of pragmatic political and social sense and demonstrated the RCP's stubbornness in sticking with its anti-Soviet scheme until the end. Ceausescu's rhetorical flourish was the last great appeal to a Romanian people who had been numbed by forty years of national discourse and

governed like inhabitants of a Roman outpost. In the wake of the speech, the unity shown at the Fourteenth Party Congress proved to be the illusory calm before the storm.

IV. THE EURO-SELF

The storm came. Together with his wife Elena, Ceausescu was cast out and executed on 25 December 1989, by an execution squad consisting of three soldiers. Elena Ceausescu screamed at them: "You are my children, I raised you!" It is somehow tragicomic that before his execution, Ceausescu started to sing *The Internationale* and shouted: "Long live the Romanian Communist Party!" His last words were an agrammatical prediction, "History will revenge me." Despite these references to history, revenge, and the future, the dictator's thirty-minute show trial before a military tribunal was not a Shakespearean drama; it rather resembled a Marx brothers farce, though one with a bloody ending. Though vaguely formulated, the accusations against Ceausescu included (1) perpetuating genocide against the Romanian people, resulting in more than sixty thousand victims; (2) voluntarily destroying thousands of historical buildings in Romania; and (3) systematically undermining the Romanian economy. The use of the term "genocide" highlighted the fact that the court was less interested in producing a perfectly accurate account of the Ceausescu era than it was in casting out a national demon. The roles assumed by intellectuals

and poets during this exorcism appear questionable, too, since these players seized control over Romanian television and, rather than calling for moderation and clarification, chose to stir the population's fears. Broadcast on national television, the traumatic image of the execution was etched into the memories of Romanians and the whole world. The spectacle appeared to many viewers not liberating but barbaric, and the whole process was received as if tribalism had returned to the middle of Europe. Even as distaste manifested itself over the trial and execution, the world remained shocked that the Romanian Revolution had itself been so crassly staged. First, on 21 December 1989, a mass demonstration in front of the Central Committee building in Bucharest had ended in chaos. Next, before being captured, Ceausescu had escaped in a helicopter from the roof of the Central Committee building, an episode followed by reports that alleged Securitate terrorists had withdrawn to the Carpathian Mountains. Finally came the execution of the dictator and his wife in what appeared to be cold blood. Abandoned by his secret police, party, and an army already led by his successors, Ceausescu seemed to have died an archaic death: for many viewers, the violent, hasty event conjured images of a distant epoch, when serfs carrying pitchforks stabbed their feudal lords and divided their lands among themselves. Fostered during decades of nationalist posturing, Romania's national discourse reemerged during the days of the Romanian Revolution, freeing the deeply hidden cultural atavism at the country's innermost core. Despite the deactivation of Romania's "Balkan" identity, despite the country's recent entry into the EU, and despite its newly minted Euro-identity, it is this core of atavism that today more than ever permeates Romania's transubstantiated Euro-self.

The West has long considered the Balkan region to be disorderly, deficient, and tarnished with its many ethnicities, languages, and faiths existing concurrently in cramped surroundings. Following this assessment, Romania has viewed its own identity as an anomaly, an unfinished project. According to Bulgarian historian and philosopher Maria Todorova, "this in-betweenness of the Balkans, their transitionary character, could have made them simply an incomplete other; instead they are constructed not as other but as incomplete self."[19] The "other" to whom Todorova refers here is, I suggest, none other than the despised and repressed ego of the Euro-self. Maintained by the directing principles of rationality and purity, this clean, Western-friendly self has been expurgated from Romania's deepest core, banished in a flurry of equivocations about identity. Building on Todorova's theories, German/Dutch ethnographer and folklorist Arnold van Gennep has described such a self-image as liminal, marginal, and lowermost.[20] Given such a description, the Euro-self now being developed in Romania may be classified

as "lowermost"—that is, as a despised alter ego, the unspeakable supplement to a deep-seated atavism. Europe, here we come!

V. CONCLUSION

Like most of the Eastern European states that came under Soviet hegemony, Romania is today undergoing a difficult and masochistic metamorphosis. The contradictions of its sociopolitical reality and of the processes of its post-communist cultural transformation have collided with the EU's efforts to maintain a comprehensive colonization of the East according to Western values and profit-making interests. Under these conflicted circumstances, the ideology of anti-modernism exerts a powerful influence on domestic political culture: it combines the authoritarian social engineering, insistent reference to national traditions, new deployments of authority, and an ever-present religion, then mobilizes this combination as the heir to communism. Post-communist anti-modernism thus forms its subjects monolithically, authoritatively, from above; capitalism, on the other hand, tends to produce its subjects permissively. Capitalism and neoliberalism both aim to exploit resources, ideas, and subjectivity while extending markets. In pursuing these goals, capitalism seeks not only the economic exploitation of the East, but also cultural hegemony in the new territories, a hegemony imposed with the help of Romania's own new political agenda of globalism.

Adding to this equation is the fact that the over-saturated cultural markets of the West yearn for cultural manifestations of "the East." In the contemporary process of reconstructing the Romanian Euro-identity, culture is gradually turning into a commodity, and Eastern artists and intellectuals like the Perjovschis are involved whether they like it or not. The ideology of globalization, with the promise of freedom at its center, makes no territorial difference, in principle, between West and East, North and South. But "freedom" means freedom of the markets, not political geography. The globalist concept of freedom is not concerned with political emancipation, but rather with the production of cultural distinction and the happy promise of skimming surplus value. The more varied and "interesting" consumer goods and tastes can become, the more the production of desire for those commodities can take hold. One effect of this process of commodification is the growing homogenization of visual culture worldwide; a further effect is the rise of regionalism and the resurgence of national and racial mythologies, a reflex against Western modernism and its apparently dominating claim to cultural totality.

But the countervailing appeal to Euro-globalism, seductive as it is, should also be treated with extreme caution, since it implies the false promise of a modernization that will "make up for lost time" and spur an economic readjustment between the East and the West.

A more fundamental analysis would see the transformations of Romania's post-Ceausescu late capitalism in the context of European society as a whole. Even as these processes move apace, a critical cultural perspective is developing, if hesitantly and selectively. These critical perspectives, however, are themselves always in danger of becoming a lifestyle and social design. In getting tied into the process of commodifying "the East," the critical energies of these positions become dulled. Even worse, their development is hampered in the first place by being so fully anchored in the social life of Eastern and Southeastern Europe, where failing institutions provide inadequate training. The existing cultural institutional establishments in those regions — the universities and academies — are for the most part traditionally aligned. As a result, the social appreciation of critical culture is generally very low.

The old technocratic elite that overthrew Ceausescu and took power did so relatively easily, culturally speaking, by instituting the beginning of a post-communist identity that would reimagine Romanians as Europeans. The ease with which they made this transition was due in no small measure to the fact that they could fall back on a nationalist discourse, the deep-seated and powerful mechanism that had already been well developed under Ceausescu, who linked the affirmation of Romania's Latin origins with aggressive sovereignty and security policies. The cultural elite in today's Romania has blended these already-existing mechanisms into a strange, anti-modern cultural ideology that has ironically re-implemented the old communist tools. Indeed, before 1989 Romanian culture refused modernity, preferring traditionalism, nationalism, and racial mythologies. In the post-1989 Romania, these positions have not gone away but have instead proven all-too-easily Europeanized. The proto-fascist 1930s, with intellectuals like Constantin Noica, Mircea Eliade, and Emil Cioran as its protagonists, are now exclusively considered to be the foundational period of Romanian culture.[21] Romanian anti-Semitism, now as before, is taboo. Neo-spiritualism and eclecticism blur the boundaries of an unresolved communist past, at the same time recalling the fascist entanglements of Ion Antonescu's time. Now is the moment for a critical genealogy to relate the dominant mechanism of anti-modernism to Romania's own communist history, and to expose this anti-modernism as a discursive form of national discourse. Now is also the time, so long delayed, for Romania and its intellectuals to reshape the nation's own history into a discourse about the history all of Europe holds in common.

NOTES

1 Space does not permit me to offer an account of the confrontation between the modernism of Marxist-Leninist aesthetics, with its primacy of matter over spirit, and the avant-garde conception of historical modernism. Neither is this essay devoted to a consideration of the redevelopment of the late 1980s debate over postmodernism under the anti-modernist banner that led Fredric Jameson to argue that the historical dimension of postmodernity could only be understood via a "detour through the modern." Indeed, the articulation of the Marxist-Leninist criticism of modernism, as formulated by the persecuted Michail Lifsic (1905–1983), Russian philosopher and cultural theorist, might inform this discussion, but it could also reveal that Marxism's destructive criticism of the bourgeois world, as well as of the radicalism of avant-garde art, tried to a certain extent to preserve the memory of the October Revolution, as well as the euphoria of the beginning of a new era (before Stalinism completely discredited the Marxist project and post-communism turned it into an object for archeological research). My essay is just as little concerned with elaborating the Stalinist campaigns against cosmopolitism from the 1940s and 1950s, which may also be subsumed under the "anti-modernist" banner.

2 I cannot pursue a second line of argument, which is important to keep in mind: the history of the European Union from its inception as a cultural-ideological construct, a European community of culture and values — an ideology that has enabled the EU to control the new Eastern and Southeastern European member states.

3 Romania is a Latin nation whose ethnogenesis consisted of the blending of the autochthonous Daci and Roman colonists.

4 King Decebal (87–106 CE) presided over the Dacian Wars between the Roman Empire and Dacia during Emperor Trajan's rule; these took place between 101–102 and 105–106 CE.

5 Moldavian-born Romanian politician Alexandru Ioan Cuza (1820–1873) ruled over the United Principalities of Wallachia and Moldavia between 1859 and 1866.

6 Carol II, King of Romania (1893–1953) was the eldest son of King Ferdinand I of Romania and Queen Marie, a daughter of Prince Alfred, Duke of Edinburgh, a son of Queen Victoria.

7 Corneliu Zelea Codreanu (born Corneliu Zelinski, 1899–1938) was also an anti-Semite.

8 Ion Victor Antonescu (1882–1946) served as Prime Minister of Romania during World War II from 4 September 1940 to 23 August 1944.

9 King Michael I of the Romanians (1921–present) is Prince of Hohenzollern and reigned as King of the Romanians from 1927 to 1930, and again from September 1940 until deposed by the communists on December 1947. A great, great grandson of Queen Victoria and a third cousin of Queen Elizabeth II, he is one of the last surviving heads of state from World War II.

10 Gheorghe Gheorghiu-Dej (born Gheorghe Gheorghiu 1901–1965) was the communist leader of Romania from 1948 until his death.

11 Petru Groza (1884–1958) became Premier of a coalition government from 1945 to 1952, founding an Agrarian movement — the Ploughmen's Front — during the depression. Known as "The Red Bourgeois," Groza aligned himself with the left and forced King Michael I to abdicate, calling the nation a "People's Republic."

12 Hannah Arendt, *Elemente und Ursprünge totaler Herrschaft* (München and Zürich: Piper, 2005): 643.

13 Nicolae Ceausescu, "Rechenschaftsbericht des ZK der RKP," in *9: Parteitag der Rumänischen Kommunistischen Partei* (Berlin: Dietz, 1965): 72–73.

14 Slovakian politician Alexander Dubcek (1921–1992) was the first secretary of the Central Committee of the communist Party of Czechoslovakia and led that country, between 1968 and 1969, in the reform of the Communist regime known as the Prague Spring.

15 Ion Iliescu (1930–present), President of Romania for three terms: 1990–1992, 1992–1996, and 2000–2004.

16 Mikhail Sergeyevich Gorbachev (1931–present) was the last premier of the Soviet Union between 1985 and 1991. The National Salvation Front (FSN) governed Romania after the Romanian Revolution in 1989 and transformed into a political party that became the common foundation for two of the three most significant political parties in Romania today: the Social Democratic Party (PSD) and the Democratic Party (PD).

17 Constantin Pirvulescu (1895–1992) was one of the founders of the Romanian Communist Party (RCP) and an opponent of Ceausescu. Grigore Raceanu was a Romanian communist politician (birth date unknown). Silviu Brucan (born Saul Bruckner, 1916–2006) Romanian communist politician and writer, was recognized as a dissident under Ceausescu. Gheorghe Apostol (1913–present), leader of the Communist Party in Romania and a rival of Ceausescu. Alexandru Birladeanu (1911–present) served in Parliament member 1990–1992. Corneliu Manescu (1916–2000) also belonged to the council that administered Romania in 1990 after the assassination and overthrow of Ceausescu.

18 Nicolae Ceausescu, "Plenartagung des ZK der RKP," in Anneli Ute Gabanyi, "Ideologiedebatte am Vorabend des 14. Parteitags: Ceausescu verteidigte den Sozialismus." *Südost-Europa* 11/12 (1989): 654.

19 Maria Todorova, *Die Erfindung des Balkans* (Darmstadt: Primus, 1999): 37.

20 Arnold Van Gennep, *The Rites of Passage*, (Chicago: University of Chicago Press, 1960),

21 Constantin Noica (1909–1987) was a Romanian philosopher and essayist preoccupied with philosophies of culture from anthropology to epistemology and logic. Romanian philosopher Mircea Eliade (1907–1986) was a historian of religion and a leader in religious studies, as well as a professor at the University of Chicago. Romanian philosopher Emil Cioran (1911–1995) was also a highly influential essayist.

Fig. 269, opposite page
Romanian flag (above) and European Union flag (below).

Roxana Marcoci

WHAT HAPPENED TO US?

Interview with Dan Perjovschi

ROXANA MARCOCI: To start, let's discuss the beginnings of your practice. You were formally trained as a painter at the University of Art George Enescu in the academic city of Iasi, Romania. Probing the value of your classical training, you mentioned on more than one occasion that, if one medium cannot allow complete expression, a complementary one must be identified. What made you question the inadequacy of painting in the late 1980s, and how would you describe your medium?

DAN PERJOVSCHI: My practice started at a young age, but for a while it was suspended. The "while" part relates to the 1980s, the years of my formal artistic education in communist Romania. The Soviet-style educational system was based on specialized schools that identified special talent, which explains why I began studying art at the age of ten. By the time I joined the university, I was already dead sick of official art. The political situation had also changed. The liberal Communist ideology of the 1960s had been replaced by [Nicolae] Ceausescu's autocratic cult of personality. The good life of pretending not to know anything was over; the surviving mode was in. Painting was not my

medium. [Figs. 270–272] After fourteen years of painting still-life motifs, I felt I had had it with that kind of art. When I talk about my practice, I refer to my natural drawing instinct. Early on I used that talent to mock my teachers in cartoons. It took me the full length of studies in high school and at the art academy to understand that the only way I could express myself was through drawing. Painting was just an intermediary stage. Water was freezing in the glass, no soap, no books, and no future. How could one paint that?

RM: You decided to turn to performance and drawing to articulate your views on social and political issues. Some of your earliest actions, such as *Red Apples* (1988), involved wrapping the full interior of your home—everything from bed and table to television set and bookshelves—in white paper on which you scrawled text and drawings. [Figs. 54, 273–275] Was this done in response to the climate of increasing censorship in Romania?

DP: Yes. The repressive system allowed us to play a little, and we did. We organized exhibitions, lots of them. But we had to pay a price. Each show was submitted to three censorship committees, one more stupid

than the other. After a
while you naturalized that
mentality. Thinking that
you could outsmart Communism or exercise freedom, you ended up reinforcing
the system. Self-censorship ruled. Corrupted values
were first established, then imposed. We complied. It
was a big lie. That's why Lia and I took refuge in our flat.
We could do whatever we wanted because what we did
was just for ourselves and some friends (in Lia's case I
was the only witness to her performances). I wrapped
our flat in paper and drew all over. It was as if I was living in my own drawing. I performed something poetic
to offset the gray, boring life outside. We lived this way
for two weeks. It was great.

RM: At about the same time, you became loosely
associated with an alternative group of artists in the city
of Oradea known as Studio 35. What was its project?

DP: In Romania the Artist's Union Association owned
all the studios and exhibition spaces in the country.
Studio 35 was the "waiting room" before one became a
full-fledged member of the union. I worked a lot with
these guys and loved them dearly. On one hand, we
were living in a blind spot. We were pretending that the
repressive system did not exist, turning to culture as a
refuge from reality. On the other hand, doing something in a frozen society was in itself a radical act. Every
ten days we organized a show. There was no career, no
money, and no recognition involved. We were engaged

in artistic practice because art was a way to feel alive.
But we sacrificed the truth. This was a big mistake.

RM: In 1991, after the fall of Communism, you staged a
performance similar to *Red Apples* titled *Nameless Mood
[Nameless State of Mind]* for the first "free art festival,"
organized in the city of Timisoara. [Figs. 276–277] On
that occasion you transformed the janitor's room at the
art museum into an allover environment of drawings.
Was the change from a private activist to an institutionally based activist intended?

DP: How could I face my generation when we did
nothing against dictatorship? We shut up and played
our little game. That's why I stayed locked up inside the
janitor's room. I had to address the questions of who
we were, what we did, and what art was for. I also wanted
to undermine the elitism of high art and exercise
modesty. The working classes, the simple people, the
common lives were totally fucked up by Communism. I
used the janitor's room for three days, drawing all over

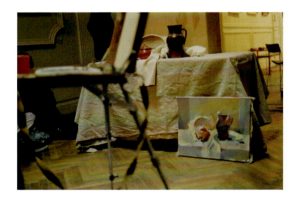

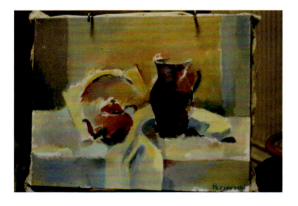

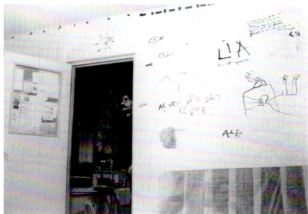

Figs. 273–275
Dan Perjovschi, *Red Apples*, 1988,
installation in the artist's flat
in Oradea.

it until the room turned black. And yes, it was the beginning of a sort of activism that Lia and I engaged with throughout the following years.

RM: Was there a decisive break in your artistic outlook following the end of Ceausescu's autocracy?

DP: Yes. Three things made an impact on my art: the political events of 1989, free press, and the international art scene. It was not an immediate change. It was a slow process, but it all started with freedom of expression. I had to learn anew how to speak and express myself freely.

RM: In 1991 you were asked to join the Bucharest-based weekly oppositional newspaper 22. What is your role at the newspaper? [Figs. 55–56, 230, 279–282]

DP: I was not asked to join it. I somehow found my way in. I had previously published drawings in the young writers' magazine *Contrapunct*. People at 22 noticed my work. I proposed some drawings to 22 and they took me on board. At the beginning of the 1990s, 22 was the most prestigious intellectual paper in Romania. Shortly after I started working there, I was involved with every aspect of the press, from editing and proofreading to designing the layout of the paper. Although I am the second oldest member of the team, my presence is nowadays more virtual than real. Since I travel a lot, I send my drawings to 22 from all over the world, but I am no longer involved in editorial decisions. 22 was the first independent weekly in Romania and it may be the

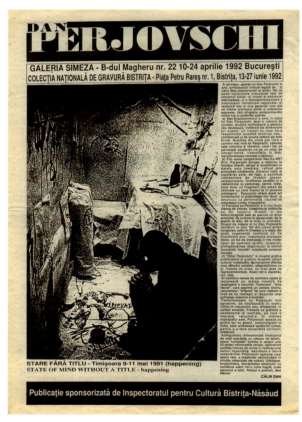

Fig. 276, above
Dan Perjovschi, *DAN Perjovschi*, 1992; newspaper.

Fig. 277, above right
Dan Perjovschi, *State of Mind Without a Title*, 1991; performance/installation in Timisoara, on the cover of *ARTa* [Bucharest] 1991.

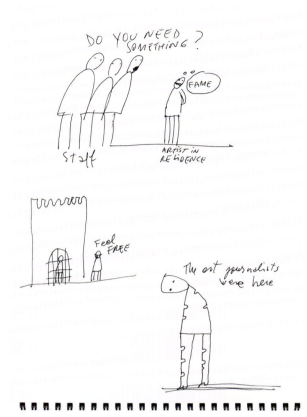

DP: Actually, I started working on *Wonderful World* in 1993 after completing a huge piece titled *Anthropoteque*. Consisting of five thousand drawings, *Anthropoteque* was difficult to handle. I was looking for a more mobile format. I like cumulative pieces and wanted to work wherever I was travelling. *Wonderful World* is made of several letter-sized modules, each comprising some twenty drawings, like a flipbook. Easy to carry, it allowed me to draw in hotel rooms, trains, or other places. I could put the work in a suitcase and carry it around the world. Every time I exhibited the piece it was in a different format, since new modules were added. Basically, *Wonderful World* has two components: a Romanian part comprising thirty elements, and an American part of one hundred elements. The American grouping was made in 1995 and 1996 when Lia and I received successive ArtsLink grants in New York, and it was completed in 1997 when we were invited back to the States by Kristine Stiles to teach for a semester at Duke

Fig. 278, above
Dan Perjovschi, page from artist book, *Castle Stories*, 2000.

Figs. 279–282, right
Dan Perjovschi, cover page and three details from *Revista 22*, 1991.

last. Nearly all other newspapers are owned by media conglomerates.

RM: I noticed that you carry a notebook with you, always ready to jot down another sketch. What are the primary sources for your ideas? [Fig. 278]

DP: Everything: talks, sightseeing, rumors, newspaper articles, gossip, television, jokes, major stories, insignificant stories, global news, local events, everything. The notebooks are my resources, my private Wikipedia. Out of two hundred drawings sketched down in the notebooks, twenty will make it to the wall.

RM: The two large series of drawings, *Postcards from America* and *Wonderful World*, were conceived in 1994 during your first trip to the United States. Can you talk about them? [Figs. 283–293]

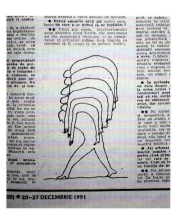

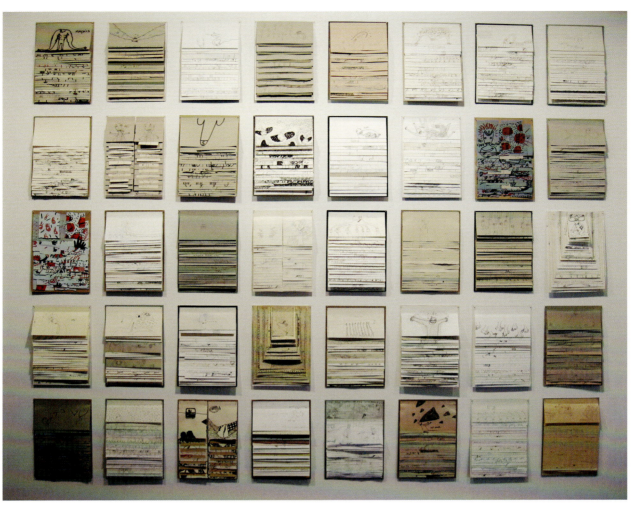

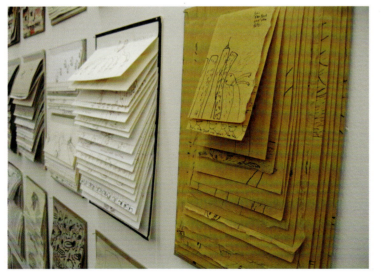

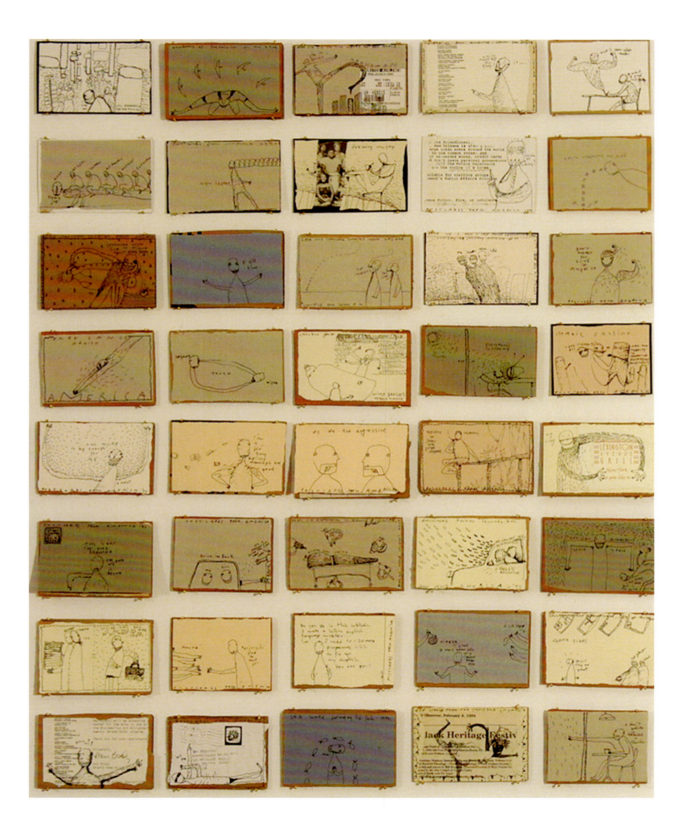

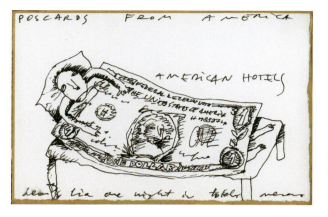

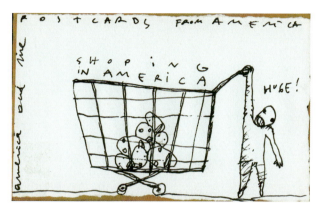

Figs. 283–285, previous page
Dan Perjovschi, installation view and two details of *Wonderful World*, 1994–1997; ink and watercolor on paper. Courtesy Lombard-Fried Projects.

Figs. 286, previous page
Dan Perjovschi, installation view of *Postcards from America*, 1994; ink on pastel paper mounted on cardboard. Courtesy Lombard-Fried Projects.

Figs. 287–292, above
Dan Perjovschi, six of sixty-seven *Postcards from America*, 1994; ink on pastel paper mounted on cardboard. Courtesy of private collection.

Figs. 293, opposite page
Dan Perjovschi, two pages from artist book, *Postcards from America*, 1995.

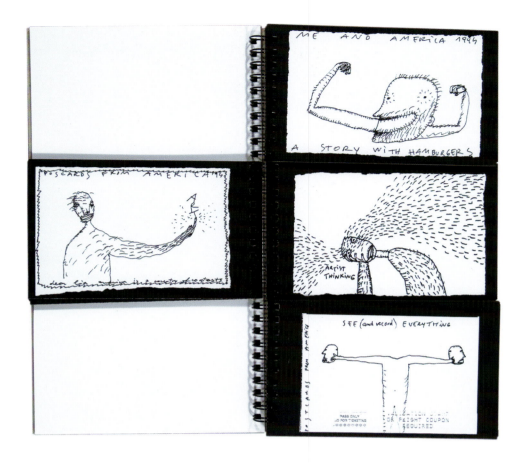

University. The work is like a library of drawings. *Post-cards from America* is a happy testimony of a trip I made cross-country as part of a USIA grant, which allowed me to travel east, west, north, and south, to big cities, middle-of-nowhere towns, and coast to coast from New York to Topanga Canyon and from San Francisco to New Orleans. It was fantastic. My first encounter with the enormity and diversity of America was like a kid's adventure book, including a 4 A.M. shuttle launch in Cape Canaveral, my first fast-food dinner, a visit to MOMA, a meeting with Chris Burden in Los Angeles, and a biking excursion in Florida. I enjoyed every second of that trip. After making the grand tour, I had a one-month residency at Atlantic Center for the Arts, where I made an installation of five hundred drawings. I was seduced by America, so I called the series *Post-cards*. I used colored paper, and each sheet was the size of a postcard.

RM: What is the Group of Social Dialogue (GDS) and how does it relate to 22?

DP: GDS is the editor of 22. It was founded as an intellectual think tank. It is a nongovernmental association that brings together former dissidents, writers, political analysts, and cultural historians, a who's who of contemporary Romanian society. The mission of GDS has been to assist the newly founded democracy. In the beginning it focused on anti-Communism. Like any other Eastern European intelligentsia, it promoted a liberal society. Each millimeter of democratic reform— feminism, minority rights, free press, etc.—was achieved with pain, struggle, and determination. At the beginning of the 1990s, GDS had unlimited power. Luckily, it lost most of it. That's why it is still independent. Overall, GDS delivered its promise: Romania is now part of the European Union and it's NATO-shielded

against its powerful neighbor, Russia. GDS's offspring, 22, grew more independent and equilibrated than its parent editor.

RM: In 1990 you and Lia co-founded the Contemporary Art Archive (CAA) in Bucharest. This is a privately funded collection of materials that has served as an important resource in the city. Can you elaborate on the contents of the CAA?

DP: CAA is more Lia's business. [Figs. 144, 146–153] She organized the enormous quantity of information that we received from abroad (catalogues, slides, video tapes, etc.). Our work was successfully received abroad but not properly understood in our own backyard, so Lia created a context for our work. Creating that context became her artistic practice. She organized an archive of contemporary art files and we disseminated that knowledge. According with the rapid changes in art, CAA switched from being an archival bank to a center for art analysis. For a while CAA was the only platform for institutional critique in Romania. Now it is on hold, waiting to be transformed again into something different.

RM: In 1996, the year I visited you in Bucharest, you and Lia staged the first Open Studio event, a forum for discussion among artists, curators, and scholars. Can you name some of the participating guests and explain the studio's infrastructure?

DP: Everything that happened in the studio was part of CAA. Basically, our studio has been open since 1991 when we first rented the space. In 1996 we staged a three-day event focusing on the Romanian underground and experimental art scene since the 1960s. [Figs. 154–155, 325] The studio was used as a site for debate. We believed that sharing information was more radical than any other form of artmaking. We wanted to send a signal that dialogue is essential in society. There were lots of informal meetings reuniting art professionals to expand the way art was understood and practiced. We did not have funds to make formal invitations, but we were flexible enough to react quickly if somebody was in town. We asked artists and curators to give lectures (Mike Nelson and Rachel Lowe from London,

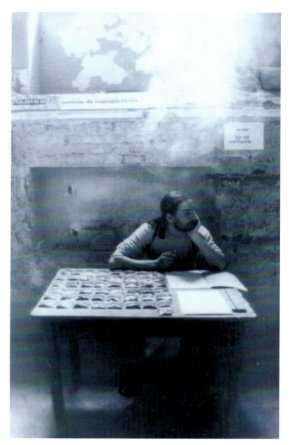

Fig. 294
Dan Perjovschi, *Appropriation (of Land) Committee*, 1992, performance in Timisoara.

Cristian Alexa from New York, Kristine Stiles from Duke University, Claire Bishop from the Royal College of Art, Werner Meyer from Kunsthalle Göppingen, etc.). Some recorded and live TV programs were also held in the studio. For one memorable broadcast about art education, we invited students who had recently been expelled from the art academy because they had protested against the conservative curriculum in schools. Actually, I have lost track of all these activities. I just remember making coffee and carrying chairs around.

RM: Let's go back to your artistic practice. What prompted you to draw directly on the wall instead of using the traditional support of paper?

DP: I wanted to be quick, mobile, and direct. When traveling with nothing, I could improvise on the spot.

Like in performance, there is a huge sense of creative freedom. My practice always subverted the market. It's a transitory event that makes me very focused and charged. I make ephemeral works with permanent markers.

RM: In fact, your drawings are erased at the close of each exhibition. Is there an instance when the artwork was preserved as part of the architectural structure?

DP: Nope. Only the Van Abbemuseum in Eindhoven kept the wall drawing I did in its enormous lobby for a full year instead of three months. The interesting part is that the erasure of that wall was transformed into a[n] [Allan] Kaprow Happening. It was pure Dutch practicality. They had a Kaprow exhibition that included a happening that took place every Friday when a guy came to paint a wall. So they asked me if I would agree to have my wall erased. I instantly said, "Yes!"

RM: How do you see the ephemeral nature of your projects relating to issues of memory and remembrance?

DP: I can only understand the world if I draw it. If I draw it, I will remember it. I mean this in a metaphorical way. Actually, looking back at my notebooks or at the illustrations in 22, I am surprised to see the same drawings repeating themselves in different contexts. I have sort of a repertoire, but it's in my mind. If I remember it, I redraw it. On the other hand, every time I do a drawing it's like for the first time.

Fig. 296
Dan Perjovschi, *Say Cheese*, 2005; marker drawing.

Fig. 295
Dan Perjovschi untitled drawing, 2007; marker on wall.

RM: Yes, you often recycle old images by mixing them with new ones. How do you understand the concept of a visual archive?

DP: As I told you, it is not on paper but in my mind. Each project takes about fifty percent of its drawings from previous projects. I redraw them and therefore I keep them alive.

RM: Let's talk about the series of performances you made explicitly in reaction to changes in Romanian politics. For *The Appropriation (of Land) Committee* of 1992, you "sold" one square meter of your land to the public in the form of small soil-filled packages. [Fig. 294] In the aftermath of the 1989 revolution, two slogans—"We want land" and "We don't sell our country"—underscored the premise that in Romania the privatization of land is but another footnote to xenophobic dissent. What was the outcome of your performance?

DP: When I did the land piece I was furious that the government kept postponing the return of private properties that had been nationalized in the aftermath of World War II. I wanted to do something absurd. I gave out 10 x 10 cm packs of soil to mock the property papers. If you think of it now, it seems like a joke, but at

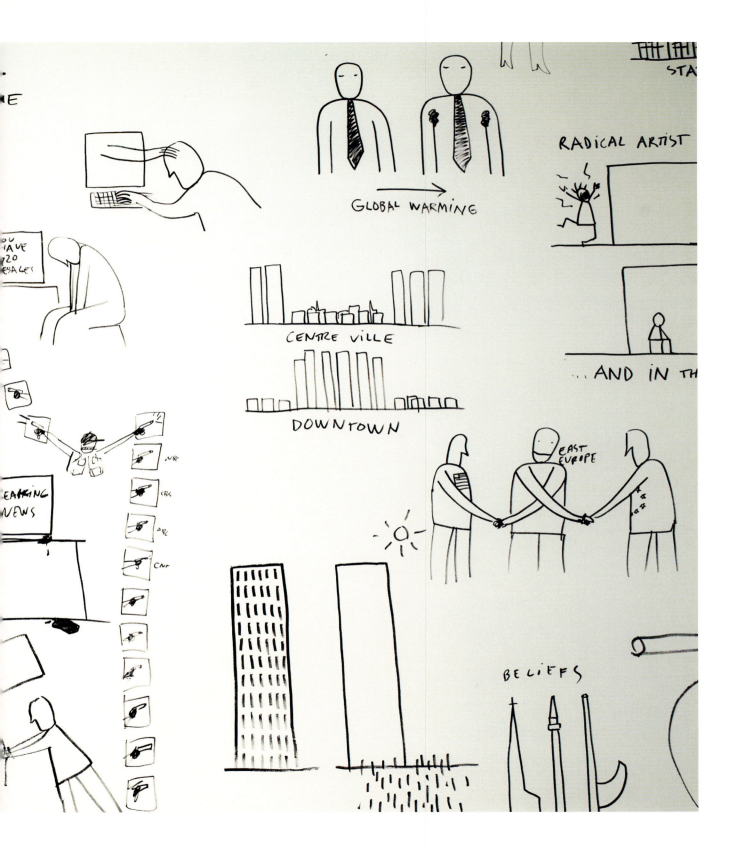

GLOBAL WARMING

RADICAL ARTIST

...AND IN TH

STA

CENTRE VILLE

DOWNTOWN

EAST
EUROPE

BELIEFS

NBC

CBC

ABC

CNN

REAKING
NEWS

ME

163

The [...] the [...]e C. Marron Atrium

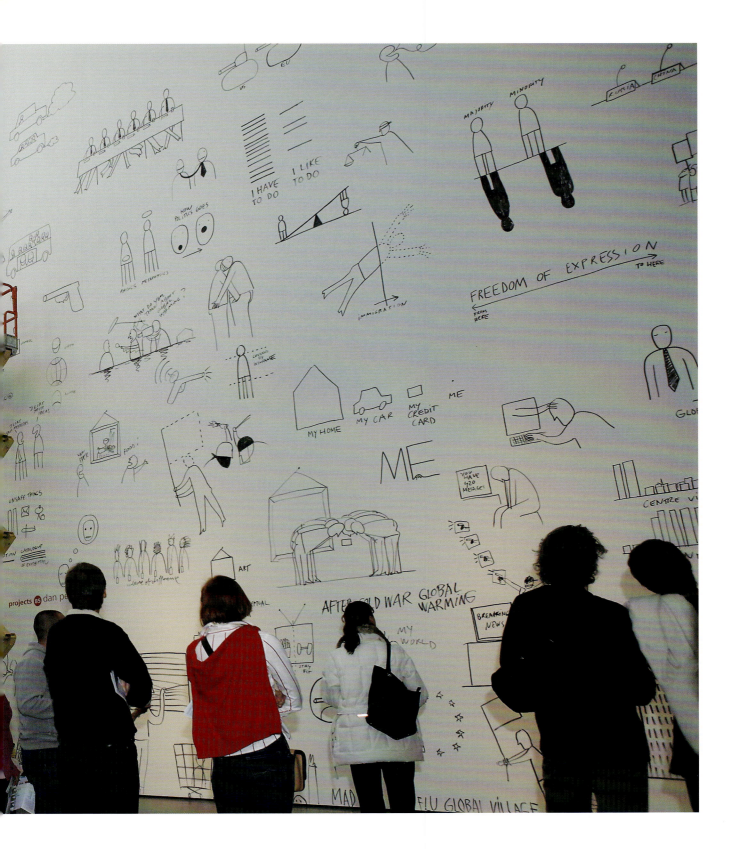

the time one brother was killing another for a meter of land. That's why I chose to give out one square meter. Nowadays, peasants want to sell their land, either because they are too old to work it or because agriculture is bankrupt. Romanians no longer buy land in the countryside. Only the Dutch buy it to grow tulips or the Scots to build summer resorts. Isn't it ironic? I don't recall that my performance had any effect, although it meant a lot to me. At that time, politically inflected works were of no concern to art critics. Only American theorists reacted: you and Kristine Stiles.

RM: Do you see drawing in institutional or other spaces as a gesture of public reclamation of space?

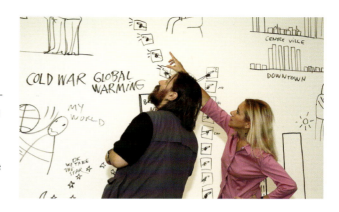

DP: Yes. It is my way of reclaiming space. Given my Communist heritage, I may seem an obedient artist. I do what I am told. But once I comply, I try to get out of the frame and expand the borders. For me, more is more.

RM: In 1993 you had "Romania" tattooed on your arm during a performance festival. A decade later, for the exhibition *In the Gorges of the Balkans* organized at the Kunsthalle Fridericianum in Kassel, you had the tattoo removed. Can you talk about the decisions that led to these two actions? [Figs. 135–138, 140–141, 300, 343]

DP: Tattooing the word Romania on my arm was a political statement. It was done in the context of Europe Zone East, the first national festival of performance, organized by Ileana Pintilie in Timisoara, the city where the Romanian anti-Communist revolution started. Living in Romania, I felt like cattle—marked and owned by someone beyond my reach. I had to engage in action. I was also interested in defying the canonical definition of performance as a time-based event. I thought performance should last as long as its author did. However, ten years later the context changed. I too changed my views and decided to remove the tattoo. This was a political statement made within the international context of the Balkans. You see, in 1995 I was exhibiting in East Central European shows, at the end of the 1990s in East European shows, at the beginning of 2000 in South East European shows, and subsequently in Balkan shows. Yet I have never moved from Bucharest. This geopolitical situation compelled me to remove the tattoo. I sometimes joke that erasing the word Romania

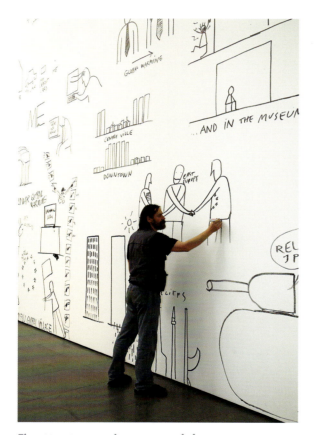

Figs. 297–299, previous pages and above

Dan Perjovschi, *WHAT HAPPENED TO US?*, 2007, installation view. Courtesy of The Museum of Modern Art, New York.

Dan Perjovschi and Roxana Marcoci, curator of photography, discussing his drawing installation *WHAT HAPPENED TO US?* at the Museum of Modern Art, May 2007.

from my shoulder marks the moment when I became an international artist.

RM: As an artist who is also an activist, and as an activist who is also a journalist, why do you think art should be politically engaged?

DP: Not necessarily politically engaged, but engaged. Artists are sensible humanists. Our statements should be heard outside the art world. I have something to say about my society, in the same way a sports icon has something to say. I opted for the popular language of political cartoons in order to reach more people and the media.

RM: You include text alongside the drawings, either in the form of speech bubbles or punning wordplay. These pictographic fragments function through visual analogy. What comes first to your mind, the text or the image?

DP: They both come at once. I have such dexterity now that I draw as I talk. Image and text are interrelated. Because I use a minimal vocabulary, a square can signify a tableau, a museum, a house, a TV, or a room. I just have to name it.

RM: Who has influenced your artistic practice?

DP: I admired 1960s and 1970s artists as smart and courageous. I also looked at newspaper cartoonists. In the end, I am mostly influenced by the media.

RM: In January 2007 Romania became an official member of the European Union. How do you think this will impact the production and reception of contemporary Romanian art?

DP: Certainly we don't have the same problems that cheesemakers faced when they suddenly realized that they didn't match international standards and risked going out of business. We will have to face other problems. As an outsider, one is helped and encouraged. As an insider, one is part of the club. The good news is that we don't need imported paper for our art (I did not need it anyway); the bad news is that the little exoticism we had is gone (I did not have it anyway). I go for an optimistic viewpoint: more idea exchanges will occur. Let's see who gets the dividends.

Interview made in conjunction with the exhibition Projects 85: Dan Perjovschi, titled "Dan Perjovschi: WHAT HAPPENED TO US?" held at the Museum of Modern Art, New York, 2 May–27 August 2007. Published on April 26, 2007, on the Museum of Modern Art's website at www.moma.org/projects.

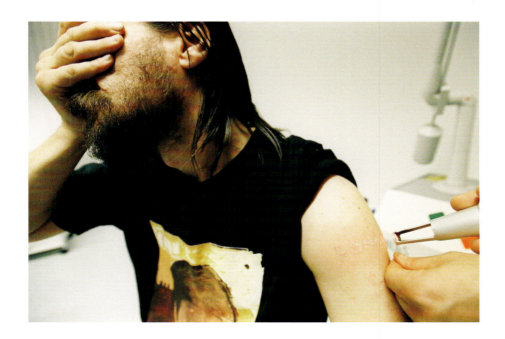

Fig. 300
Dan Perjovschi, *Erased Romania*, 2003, Kassel, Germany. Courtesy of Galerija Gregor Podmar, Ljubljana.

Kristine Stiles

PASSAGES 1992– 2007:

Interview with Lia Perjovschi

KRISTINE STILES: While you studied art throughout your childhood and adolescence, would you say that your work as a professional artist began in 1985, so to speak, with the international Mail Art movement dating from the early 1960s?

LIA PERJOVSCHI: Mail Art was an important beginning, but it came out of a larger situation. [Fig. 303] It coincided with a new beginning in my life when I moved from Sibiu to Oradea in 1985 and worked painting sets in the State Theater. In Oradea, I was able to watch Hungarian TV, and I used a Hungarian dictionary to try to understand and analyze images on television. Life in Oradea was a period that made more sense to me, coming after 1980–1984, which was the worst phase of my life. During that time, I repeatedly failed my entrance exams for the art academy because of the corrupt system of selection in Romania. Each year the application process (and the ultimate rejection) was a surrealistic experience. Even my second choice—to study psychology—was not possible anymore, as Ceausescu closed all the psychology departments in the universities around the country in 1980. So between 1980 and 1984,

I had temporary jobs decorating Christmas glass balls, making leather suitcases, and collecting state fees for electricity. Each was a brutal experience. During these four years, I worked on perfecting the drawing of still life and the figure in order to acquire the standardized academic "methods" of representation necessary for passing the exams. Actually, I preferred to draw mostly in abstract lines, not figurative, and to make signs only for myself. I always liked abstraction, and in childhood I drew rain. Growing up and being fascinated by TV, I also drew "films," kind of like what we would today call storyboards for films. My first exhibition, *Ex Libris* at Astra Library in Sibiu, was in 1980 after I finished high school. It was of notes and drawings that recorded what I felt or ideas that I had while reading books. [Figs. 301–302] In 1988, these drawings were collected in a small artist book published in Italy.

All this history contributed to making Mail Art appealing, as it brought imaginary people, networks outside Romania, and other issues into my life. Dan and I found out about Mail Art from older artists from Oradea and Timisoara who gave us some addresses from Europe, Asia, Mexico, and the U.S. My Mail Art consisted basically of empty envelopes that I saturated in colors used

for textiles with which I painted costumes for the stage. Sometimes the envelopes also had painted drawings or collages as discreet messages. Through mail art, I could mentally travel. Mail Art was also a kind of resistance, as we (like most Romanians) had no money, and were not given passports or permission to leave Romania in the 1980s. In general 1980 to 1987 was a kind of coma for me, a kind of somnambulism. I was not capable of understanding anything. My messages were discreet and disarticulated, perhaps similar to William Golding's novel *Pincher Martin* (1956), whose character is drowning but still trying to fight for his life in slow motion with a heavy body that is incapacitated and cannot escape. [Fig. 304] Things changed again in 1987 when I was finally admitted to the Art Academy in Bucharest. I started to be clearer in what I wanted both from others and myself. I developed a double personality: one to play the rules of the school (in order to have good grades and the fellowship that sustained my studies); and one that rejected the academy because, after so many years of being told I had failed my entrance exams, I no longer trusted anyone.

KS: The action called *Test of Sleep* that you performed in your apartment in 1988, in Oradea, is also about discreet communication if one considers the indecipherable script you wrote on your body. [Figs. 69, 200–208, 305]

Fig. 301, above
Lia Perjovschi, *In Memoriam, Nichita Stanescu*, 1980–1987 bookplate: ink on paper.

Fig. 302, above right
Lia Perjovschi, *In Memoriam, George Bacovia*, 1980–1987 bookplate: ink on paper.

LP: *Test of Sleep* represents overwhelming feelings. To explain it better I can approach it by recalling the Gilgamesh story, in which Gilgamesh lost his best friend because he fell asleep.[1] I was impressed by the idea of losing and of being weak. I can also mention *The Pilgrim Kamanita* (1906) by Karl Gjellerup, which also deals with the theme of losing something important because one doesn't pay attention, or *Il Colombre* (1966) by Dino Buzzati, where the theme is of being afraid. I cannot explain this concept better in words because they sound so banal. Or, I have to use too many words; better to keep silent. Returning directly to *Test of Sleep*, I also thought of it as visual poetry, with no real words, just invented symbols on my body that were similar to the ones I used to decorate the envelopes in my Mail Art.

KS: This discussion also makes me think about your book-objects *Our Withheld Silences*, 1989, the balls made from sections of text that you cut from books and glued in patterns on papier-mâché balls. [Figs. 71, 73, 307]

LP: I wanted to make a round book, like a collection of all my readings. I cut up a French travel diary into very fine strips. I cut vertically so that you can read a letter but not a word in the collaged cuts. In this way, it is

about the silence of books. Books are read in silence. We understand different things from the same books. Also, books hold secrets for people who have not yet read them. Each book offered me a new experience and was very important to me. After 1989, I could not read fiction any more, only nonfiction because after the Revolution I needed facts. I didn't want to waste any more time. But before 1989, I needed fiction to escape.

KS: Romanian social conditions produced silence.

LP: A woman told me that one of the balls from the series *Our Withheld Silences* was a stone because it was not round and it looked heavy.

KS: What you just implied in response to my point about Romania is that Romania itself is a stone.

LP: Yes. Romanians keep something inside that is very heavy. This reminds me of something very interesting about Romanians: we save all kinds of things because we are poor. For example, people keep cups without handles. After some time, we don't bother to buy a new cup. This way of keeping things became a mentality that resulted from the forty-five years of Ceausescu's regime.

KS: Why didn't people go to the streets to protest Romanian conditions?

Fig. 304
Lia Perjovschi, *Mail Art/Discreet Messages*, 1985–1988; dyed and collaged envelopes.

LP: That is a question we ask ourselves: why didn't we go onto the street before Timisoara? The answer is that we didn't have enough courage because we feared that we could die for nothing.

KS: What do you think is the artist's role in society?

LP: Art helped me to understand many things. I had moments when I had the feeling that a book or a movie was special for me; it was not an accident that I read or saw them. I like to think that some of my works are there for someone else. I want and I like to help others, to empower people: but discreetly. So I create situations for special moments to happen.

KS: Is the subject of silence a theme in your work?

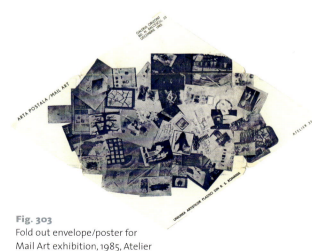

Fig. 303
Fold out envelope/poster for Mail Art exhibition, 1985, Atelier 35, Galeria Orizont, Bucharest.

LP: Yes: become without knowing. I like silence. I have a lot in me. I was a silent child. I like better to look and to listen, as in *Mein Name sei Gantenbein* [*A Wilderness of Mirrors*] (1966) by Max Frisch, where one pretends to be blind. My father was also very silent. Silence is

like a gesture in a dream, or like the game of charades in which you have to find words for the actions of other players. Also, my works at the beginning were a kind of therapeutic act or game.

KS: The psychology of the body clearly informs your *Maps of Impressions* of 1989.

LP: I made the first *Map of Impressions* in 1989 in Oradea, and exhibited it first in a window niche in Sibiu in 1990. [Figs. 74–81, 306–307, 314] These were costumes for my feelings. I compare them to the Möbius strip, linking the inside and outside of the body in one continuous line. We modify and are modified by the environment and by others. The difference between inside and outside is not clear. *The Maps of Impressions* are for me also like armor.

KS: *Magic of Gesture/Laces*, 6 November 1989, the happening you made just two months before the Romanian Revolution, makes an interesting connection to the Möbius strip. You tied your classmates, who were seated on chairs in a circle, together such that they were required to work together to extricate themselves.

LP: It was an experiment. I wanted to make visible the ties that hold us together, making us dependent on one another, being destructive or positive. The cameraman arrived eight hours late but nobody left. Waiting so long created a special mood. Then it took

me forty-five minutes to tie everyone's hands and legs together. Everyone was calm. Suddenly by accident someone made a gesture and, like with dominos falling, everyone was affected. After some time a lot of confusion took place. For some people, the laces became unbearable and they tried to untie themselves. Others worked very quickly and some regretted being untied. After the event was over, I asked everybody to talk about the experience. People told me that they remembered a lot of events in their personal and social lives. Some still felt the experience of being tied; some liked the experience and were sorry that it was over. People made of their actions what they wanted, behaving as their personalities dictated.

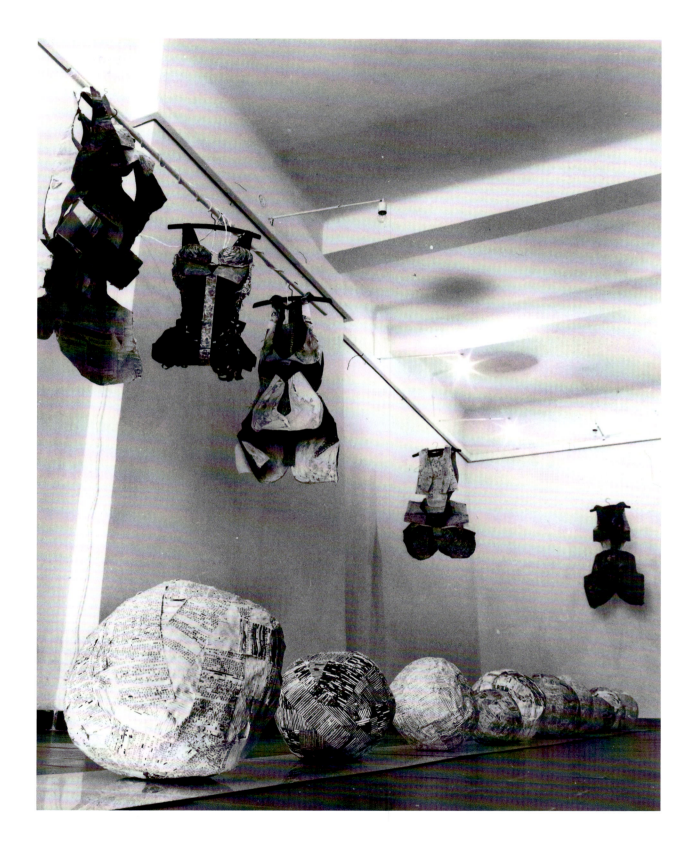

Fig. 308
Lia Perjovschi, *I'm fighting for my right to right to be different*, July 1993, Art Museum, Timisoara.

KS: I think that *Magic of Gesture/Laces* is also related to your installation *About Absence*, 1990, made soon after the Revolution. [Figs. 88, 93–94, 209] You constructed this ephemeral work from charred window frames that you found, which had been burned during the Revolution, and then you constructed a system to hold them up with string and bricks painted black.

LP: Maybe it was like a monument to nothing: about absence, about empty space. I needed something but nothing was there.

KS: Your performance *I'm fighting for my right to be different*, 4 July 1993, in which you performed with a doll dressed as your double, reminds me of how you developed two personalities during your years in the art academy. [Figs. 10, 99–110, 308]

LP: In *I'm fighting for my right to be different*, I started by wearing a black outfit like a man's suit. Then I took the suit off and put it on the doll. I sat and spoke to the doll through hand gestures. Next I became aggravated with the doll and threw her in a large bowl of black paint. I began throwing her around, against the walls, at the public. Then I took the position of the doll next to her on the ground. This performance was about accusing myself and others of being weak, but also about being sorry for being too tough, and about going into another period of my life, beginning a different dialogue with myself, at another age. The doll was an image of me, like a photograph.

KS: Why didn't the audience move when you threw the wet doll covered in black paint at them?

LP: Two people said that they liked to be punished. Some people liked to have the black paint on their clothes because it marked them.

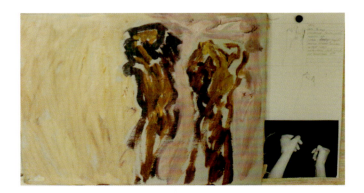

Figs. 309–310
Lia Perjovschi, installation photograph of two units of *32 Moments in the Life of Hands*, 1993; oil paint on canvas, together with photograph and drawing of hands in the same position as the painting.

KS: Why do hands play such an important part in your work?

LP: *32 Moments in the Life of Hands* was about gestures and their messages. [Figs. 119–125, 309–310] If you are confused about a face, you can always look at the hands. Hands have their language. Hands play, are bored, are absent, nervous, dirty. I tried to explore the state of hands. In my happening, *For My Becoming in Time*, October 1989, I washed with white paint the hands of participants that were painted in various colors—black, violet, blue, green, pink, red, and orange. [Figs. 84–85] My own hands were also covered with white paint. I then shook hands with the audience, transferring the white paint to their hands as well. It was a symbolic gesture for a new beginning, for a less dirty society. [Figs. 311–313]

BUCHAREST: LIA EMAIL, 16 DECEMBER 2003[2]

I am in between (artist–curator–researcher, art coach)

I am a detective in contemporary art

I am interested in what is relevant in art/culture, local, regional, international: ideas, issues, attitudes, critical discourse, issues of context changes

I am a facilitator

I like to help people to have access to contemporary art

I like to empower people

I live on the interval (in between East and West)

Because an exhibition consisting of real works is practically impossible to organize—at least for the time being)—I propose a solution, which I think is very clever and can be read on many levels— informative, creative, ironic, provocative—a work of art too

Fig. 313
Lia Perjovschi, drawing of installation *Similar Situations*, October 1993, in *amaLIA Perjovschi*, 1996.

The entire project has to be a project in process (depending on many factors), open, flexible, organic, dynamic (open to have quick reactions)

Long term (we all hope)

A laboratory of ideas

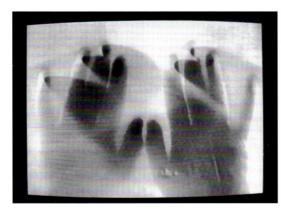

Figs. 311–312, above and right
Lia Perjovschi, *Similar Situations*, October 1993; eight-minute, silent video installation of hand motions; nine monitors; rain installation, Bucharest.

"Our heads are round so that our thoughts can change directions," Picabia

Open platform for Contemporary Arts, Everyday life (time between arrival and departure)

What is important is the content not the size, form—

A generator of ideas, attitudes—

In order to be able to invite artists and curators we have to create a conceptual platform

I am thinking of interesting artists selecting interesting curators—interesting curators will bring interesting artists—if there are good conditions, theoretical and financial

Each exhibition will take and make its own distinctive curatorial perspective

CAA CAA

KS: The first newspapers you produced in 1992 were on your own and Dan's work. [Figs. 276, 314] These anticipate the development of your art in a more conceptual and social direction. They also mark the beginning of the formation of your archive (CAA) in 1997, which eventually you renamed as *Contemporary Art Archive Center for Art Analysis (CAA/CAA)* in 2000. [Figs. 146–153, 315]

LP: Maybe. But we already began organizing informal meetings for film directors, artists, literary people, and journalists to discuss their work in our apartment in Oradea in 1985. Those meetings might be considered part of this history. I was curious at that time to know how different people worked in different fields. What are their professional interests? How do they manage their profession? And so forth. So this history might

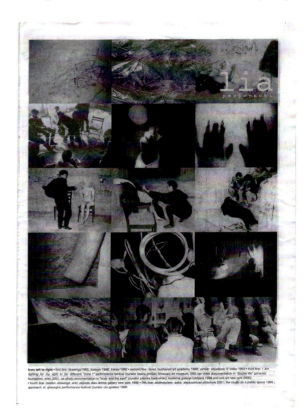

Figs. 314–315, above and right
Lia Perjovschi, *Perjovschi LIA*,
1992, and *lia perjovschi*, 2002;
newspapers.

be part of the chronological development of CAA as an archive of knowledge. Also, in 1987, I created an experimental place in my studio in the Bucharest Art Academy, and I opened it to all students. I did my events, such as *Magic of Gesture/Laces* and *For My Becoming in Time*, in this context. In addition, we opened the studio that we received from the Union of Artists (located ironically in the yard of the Bucharest Art Academy) in the fall of 1990 to anyone who knocked at the door: foreigners, Romanian journalists, artists, critics, and the general public. From the beginning, the studio was less a place to produce artworks in the classic sense, but more a place to produce relationships. It reflected the time after the Revolution and our fight for a democratic society. I began to collect materials on art in 1990 when we started to travel abroad. Others borrowed these archival materials. Very quickly the materials helped to create a context, a platform, a frame for our ideas and projects, but also for other artists' and scholars' ideas and projects. Before the Revolution, there was no history for us: it was just suspended time. My obsession with collecting and archiving is a desire to make history. It is a response to the lack and distortion of history. I now dream of making a *Knowledge Museum*, an interdisciplinary space which will have three departments: Body, Earth, and Universe. [Figs. 169, 226] It will be my next step after my globe collection, *Globe Endless Collection*. [Figs. 160, 239, 316–321, 324, 363] It is a bit like André Malraux's *Musée Imaginaire* [Museum without

Figs. 316–321, above and below
Lia Perjovschi, *The Globe Collection*, 1990–present, installation view, Generali Foundation, Vienna; five details of objects in the collection.

Walls], 1947, Marcel Duchamp's *Boîte-en-valise* [Box in a Suitcase], 1934–41, or Marcel Broodthaer's *Musée d'Art Moderne, Département des Aigles, Section Financière* [Museum of Modern Art, Department of Eagles], 1970–1971. Also, all the time as a child, I wanted to have a globe but it was too expensive. In 1990, I found a pencil sharpener that was a globe. After that I began to find banal things. I started to collect them, being intrigued by the object that made me dream so much about travel and knowledge. It says something about the time in which we are living.

Your questions from 1992 launched a long chain of questions (thank you for being with us all these years).

I became a detective in the local/international/art-culture context and a Dizzydent from Dizzy when the Romanian Contemporary Art Museum was established in Ceausescu's Casa Poporului, which was then turned into the Palace of the Parliament.

Living in a transition time/context, my intellectual attitude replaced the classic art form, becoming my new art form.

I insist upon these explanations because I want things to be well understood

(of course, everybody is free to interpret as he/she wants).

From my point of view, it is not about me. It is about art (how it happens, what it has to say).

Today is my birthday (only a nice coincidence).

DURHAM: KRISTINE EMAIL, 11 APRIL 2007

KS: As you pointed out in 1992, "There are no coincidences."

NOTES

1 In about 2700 B.C.E., Gilgamesh was the King of Uruk in Babylonia, on the River Euphrates, in what is now Iraq. Known as the one who saw all the great mysteries of the universe and had recovered lost knowledge of the world before the Great Flood, Gilgamesh was believed to be both man and a god. As a young man, he journeyed with his best friend, who was killed while Gilgamesh slept. The only way that he could imagine living was to attain immortality and eternal life. In the end, Gilgamesh recognized his folly.

2 This text is an excerpt from a draft statement in Lia's exhibition "Detective (in art history from modernism till today)," at the Stanica Center, Zilina, Slovakia, 2004.

Fig. 324, above
Lia Perjovschi, object from *The Globe Collection*, 1990–present.

Fig. 325, opposite page
Exterior of Dan and Lia Perjovschi's studio.

PERJOVSCHI AUTOCHRONOLOGY

1961

1967

Fig. 326 Fig. 327

1971
- Lia and Dan enter the special Art School in Sibiu. School was closed in 1977, when they were sixteen and in the tenth grade, to Nicolae Ceausescu's official policy, which considered the study of art irrelevant. Many art academies throughout Romania were also closed at this time.

1980
- Graduate from the Pedagogic High School Sibiu, Art Section (Liceul Pedagogic Sectia Arta Sibiu).
- Queue for daily food and basic goods throughout the 1980s, like most Romanians until 1990.

1981

1982

Fig. 328

1983
- Wed on 23 July

1984

Fig. 329

1985
- Move to Oradea when the state requires Dan to take a position at the Cris Land Museum—Art section (Muzeul Tarii Crisurilor Sectia Arta); Dan moves from Iasi and Lia from Sibiu; first time the couple live together after their wedding.
- Group Exhibition: "Mail Art," Studio 35, Orizont Gallery, Bucharest.

Fig. 330

Fig. 326 Lia Perjovschi, 1996.
Fig. 327 Dan Perjovschi, 2006.
Fig. 328 Dan Perjovschi (kneeling) and Lia Pacurar (second from left, back row), c. 1979.

Fig. 329 Dan and Lia Perjovschi at their wedding, 1983, and wedding invitation designed by Dan.
Fig. 330 Romanians lining up for bread, c. 1985.

Fig. 331 *Dan Perjovschi*, exhibition catalogue, Atelier 35, Oradea, 1987.

Lia	Dan
· Amalia Pacurar, born 11 April, Sibiu, Romania.	· Dan Sorin Perjovschi, born 29 October, Sibiu, Romania.
· Lia enrolls in General School no. 5, Sibiu.	· Dan enrolls in General School no. 15, Sibiu. · Group Exhibition: "International Day of the Child," a competition for children creating images of "World Peace," wins second or third prize.
· Applies to various art institutes (Bucharest, Iasi, and Cluj). Each year she is rejected, as a result of the corrupt system. · Works in a glass factory painting Christmas balls in Sibiu. · First solo exhibition as a student: "Ex Libris," Astra Library, Sibiu.	· After passing the exam for the Art Academy, does obligatory military service for nine months in the infantry in Rimnicu Sarat.
· Applies to various art institutes (Bucharest, Iasi, and Cluj). Each year she is rejected, as a result of the corrupt system. · In Sibiu, makes diplomat suitcases in a leather factory.	· Begins studies at the Conservatory George Enescu (Conservatorul George Enescu) in Iasi, Painting Section.
· Applies to various art institutes (Bucharest, Iasi, and Cluj). Each year she is rejected, as a result of the corrupt system. · Collects fees from the populace for state electrical bills in Sibiu.	· Continues studies at Conservatory George Enescu in Iasi.
· Applies to various art institutes (Bucharest, Iasi, and Cluj). Each year she is rejected, as a result of the corrupt system. · Collects fees from the populace for the state electrical bills in Sibiu.	· Continues studies at Conservatory George Enescu in Iasi.
· Applies to various art institutes (Bucharest, Iasi, and Cluj). Each year she is rejected, as a result of the corrupt system. · Collects fees from the populace for the state electrical bills in Sibiu. · Has an illegal abortion.	· Graduates from Conservatory George Enescu, Fine Arts faculty, Painting Section, Iasi. · First solo exhibition as a student: "Dan Perjovschi," Tribuna Gallery, Iasi.
· Applies to various art institutes (Bucharest, Iasi, and Cluj). Each year she is rejected, as a result of the corrupt system. · Works for State Theater (Teatrul de Stat Oradea). · Organizes in their apartment informal meetings with professionals from artists, art historians, journalists, and actors to stage designers, theater directors, and students. · Has access to Hungarian TV in Oradea (a city situated near the border of Hungary and Romania), which prompts her interest in analyzing images without knowing the content of the language in which they are presented.	· Joins Atelier 35 Oradea (Studio 35), an association for young artists, before being accepted into the Union of Artists, the only national artists' organization in Romania. · Begins exhibiting with Atelier 35.

Fig. 331

1985, continued

1986
- Chernobyl nuclear accident, 26 April, drops radioactive fallout on Romania.
- Meet in Sibiu Simion Costea, their high school teacher, on his way to the opening of the National Young Artist Exhibition. It took place in the basement of the historic medieval Pharmacy Museum. Costea invites them to attend the opening of the three-day exhibition curated by artist Ana Lupas and art historian Liviana Dan.

1987
- Lia lives in Bucharest, Dan lives in Oradea, and they begin traveling between Bucharest, Oradea, and Sibiu.

1988
- Group exhibition: "Mobil Photography," Atelier 35, Galeria Noua, Oradea.

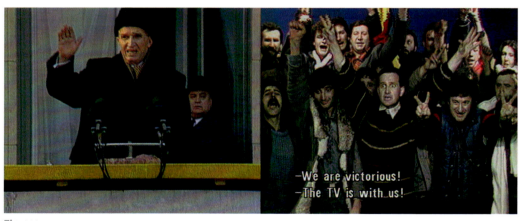

Fig. 332

1989
- Group exhibition: "International Exhibition of Visual Poetry," Mexico City; Lia submits photographs from *Test of Sleep*; Dan submits drawings from the *Antropograme* series.

Fig. 332 Harun Farocki and Andrei Ujica, *Videograms of a Revolution*, 1992; two stills from the film, showing television coverage of Nicolae Ceausescu at the moment of his overthrow, December 1989, and cheering crowd.

Fig. 333 Dan Perjovschi, 1989 installation of drawings and scrolls, Galeria Sibius, Sibiu: group exhibition with Lia Perjovschi, Rudolf Bone, Gina Hora, and Sorin Vreme.

Fig. 334 Lia Perjovschi, detail of *Our Withheld Silences*, 1989; strips of paper, printed text, and mixed media.

Fig. 335 *Dan Perjovschi*, exhibition catalogue, Atelier 35, Oradea, 1989.

· Gains access to forbidden books by Freud, Eliade, and others through a female archivist from the reading room of the public library.

· Applies to various art institutes (Bucharest, Iasi, and Cluj). Each year she is rejected, as a result of the corrupt system.
· Creates first stage design at State Theater Oradea (Hungarian department).

· Group exhibitions: Participates in various Atelier 35 Oradea group exhibitions, such as "Subject Photography" (Mobil Fotografia), an annual exhibition of photography at Galeria Noua, Oradea. Begins to show works from *Antropograme* series

Fig. 333

· Enters the Nicolae Grigorescu Academy of Art in Bucharest.
· Founds the Experimental Studio, a common studio for student experimentation in the Art Academy at Bucharest.
· In November, Lia organizes and participates in *Moving Picture*, an event she created for fellow students at the Art Academy, Bucharest; this is her first performance; photographs of the performance are lost.

· First solo exhibition after graduation: *Dan Perjovschi: Anthropograme*, at the Galeria Noua/New Gallery, Oradea, including drawings and scrolls.

· *A Small Sky*, April, happening in the yard of the Art Academy, Bucharest.
· *Don't See, Don't Hear, Don't Speak*, happening in Art Academy, Bucharest.
· *Test of Sleep*, performance without audience in June, in the artists' flat (Italiana Street 22 Bl. y3 apt. 53) in Oradea; photographed by Dan Perjovschi.
· Curates "Self Portrait," a group show of drawings at the Art Academy, Bucharest.

· *The Tree*, performed 20 February. Dan's first performance. Photographed by Ion Budureanu, a self-taught photographer from Oradea.
· *Red Apples*: Dan's first installation in the artists' flat in Oradea. For two weeks (10–24 April), the artists lived in the installation in their apartment.
· Receives the Grand Diploma Prize at "The Biennial of Portraits," Tuzla, Yugoslavia (now Bosnia-Herzegovina). As part of the prize, Dan is invited to participate in an artists' summer camp to be held the following year. Dan cancels his participation when he is visited and pressured by the Securitate (Romanian secret police) to become an informer to receive a passport to travel.
· Group exhibition: "Young Artist Biennial," Atelier 35, Baia Mare, Romania. National survey of Romanian young artists.
· Group exhibition: "Studio 35 Oradea," a large group exhibition, which later traveled to Bucharest, Cluj, Bistrita, and Bacau. Exhibits *Antropograme* and the first version of *Confessional*.

Fig. 334

· *Our Withheld Silences*, numerous book/ball/objects.
· *Map of Impressions*, costumes/sculptures.
· *Annulment*, performance in the artists' flat in Oradea; photographed by Dan Perjovschi.

· Two-person exhibition: "Bone Rudolf and Dan Perjovschi," Atelier 35, Orizont Gallery, Bucharest; Dan exhibits *Alone and Gray* drawings.

Fig. 335

1989, continued

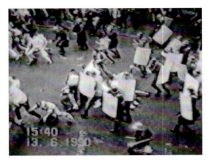

Fig. 336

- Group exhibition: In April, they organize and participate in a group show, "Bone, Gina Hora, Dan Perjovschi, Lia Perjovschi, Sorin Vreme," at Galeria Noua and Galeria Arta in Sibiu; Lia exhibits Mail Art envelopes and performed a happening with slides, *Helpless Dialogue*; Dan exhibits *Anthropograme* scrolls, drawings, and other works in an interactive installation. Bone does a street performance in the city where Nicu Ceauscescu (the son of Nicolae Ceausescu) holds ultimate power, a fact that makes the practice of experimental art potentially dangerous.
- First visit to Geta Bratescu's studio in Bucharest in November, where they first learn the word *performance* to describe artists' visual actions. Bratescu used the word to describe photographs of Lia's actions and introduced the couple to Allan Kaprow's happenings.
- Anthropologist Andrei Oisteanu shows them videos from "Experimental House pARTy" (1987, 1988), a series of private happenings and installations that took place in artist Decebal and Nadina Scriba's home in Bucharest.
- The fall of communism begins with the fall of the Berlin Wall, 9 November 1989.
- 14 December, Romanian Revolution begins in Timisoara.
- 20 December, revolution spreads to Sibiu, Cluj, and Brasov. By coincidence Dan (from Oradea) and Lia (from Bucharest) travel in Sibiu to be with their families over Christmas and participate in the street protests.
- 21 December, the majority of Transylvanian cities are in revolt.
- 21–22 December, revolution reaches Bucharest. Dan and Lia meet Liviana Dan and Mircea Stanescu on the streets in Sibiu during the shooting of civilians and remain in their apartment for several days, trapped by the violence.
- 25 December, Elena and Nicolae Ceausescu shot; images of the execution are televised.

1990

- Begin to participate in street protests, demonstrations, and meetings for a democratic society; for political, social, and cultural changes; as well as for the possibility to travel outside Romania. Participate in the biggest ongoing public protest, Piata Universitatii (branded as the "Romanian Tiananmen"), May–June 1990, and survive the miners crushing the protest.
- Receive Union of Artists studio formerly occupied by Geta Bratescu at Berthelot 12, Bucharest. From the beginning, Lia and Dan used the studio as a place for public exchange and communication. They begin hosting meetings with foreigners and local journalists, as well as artists, critics, and specialists from different fields. They organize lectures and workshops. First foreign guest to visit the studio is Belgium Mail Art artist Jose Van Der Brucke.

Fig. 336 Rioting and protests in Bucharest streets during the Romanian Revolution, 1989.

Fig. 337 Dan Perjovschi, *Scrolls*, 1987; ink on paper.

- *My Becoming in Time*, performance organized for and with classmates in the Art Academy in Bucharest. While Lia gained permission from the rector of the academy for the performance, Professors Ion Stendl and Razvan Teodorescu are required to attend; photographed by Dan Perjovschi.
- *Magic of Gesture/Laces*, November, private performance organized by Lia for selected classmates in the Art Academy in Bucharest; photographed by Dan Perjovschi.
- With other art students in the summer who are required to create mosaics for Casa Poporului, Lia threatens to quit because she feels that she is wasting her time. An official from the Ministry of Education threatens to have her expelled from the Art Academy if she abandons the project.
- Curates the group exhibition "Study – Drawing," at Art Academy Bucharest.
- Curates and moderated a discussion on the subject of "Experiment" with guest artists and theorists from outside the Art Academy. Among the participants were Dan Perjovschi, Geta Bratescu, Josif Kiraly, Andrei Oisteanu, and Giorgianna Stanciu.

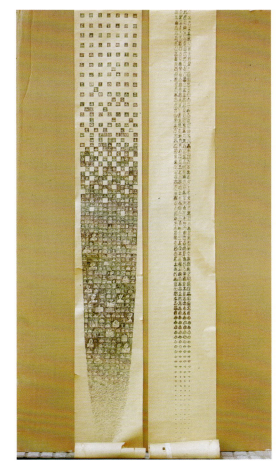

Fig. 337

- Invited by film director Andrei Popovici to join the Youth Department of the Ministry of Culture administered by philosopher Andrei Plesu. She declines but proposes Dan for the position. Dan is subsequently appointed.

- Moves to Bucharest; the couple lives in a small room in the cellar of a house.
- Reinvited to Tuzla "Biennial of Portrait"; Dan and Lia travel to Tuzla to attend.
- Begins to publish drawings in the young writers' magazine *Contrapunct*, Bucharest.
- Begins work on *Anthropoteque*, the large wall drawing installation completed in 1992.
- Works as a low-ranking desk officer at the Youth Department and later the Art Department of the Ministry of Culture (under Andrei Plesu), organizing national and international exhibitions and gradually losing the initial enthusiasm for the position.

1990, continued

· Begin first international travel.

· Group exhibition: "Expectation and Outburst: Young Romanian Art," at the Contemporary Art Gallery, Sombathely, Hungary; curators Calin Dan and Dan Perjovschi. For the first time an entire Romanian generation of artists is shown abroad; Lia exhibits *Knot*, a sculptural object, *The Movement of Silence– Tensions*, painting of "shadow captures," and *Work for the Vertical Edge of a Wall*, a collage; Dan exhibits works from *Alone and Gray* series. These are the first and only works acquired by the Romanian Ministry of Culture.

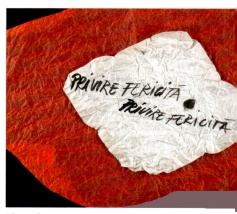

Fig. 338

1991

· Group exhibition: "State of Mind Without a Title," Art Museum, Timisoara; curators Sorin Vreme and Ileana Pintilie; Lia performs *Nameless State of Mind*; Dan performs *State of Mind Without a Title*, a four-day drawing installation in the museum janitor's room.

· Group exhibition: "cARTe [Object–Book]," Bucharest Museum of Collections of Art and De Zonnehof Art Center, Amersfoort, The Netherlands; curators Dan Perjovschi and Andrei Oisteanu.

1992

· First visit to "Documenta," in Kassel, Germany.

· Meet artist Ion Grigorescu in Bucharest.

· Meet Kristine Stiles, artist and art history professor at Duke University, who gives a series of three lectures on "Contemporary Art and Visual Culture" at the University of Bucharest, as well as a four-hour slide lecture on the "History of Performance Art" at the Bucharest Art Academy. Artist Ion Bitzan introduces Stiles and she visits Dan and Lia's studio (next door to that of Bitzan).

· Hold a series of meetings in their Bucharest studio for twenty-four newspaper journalists from leading publications in the United States; for Romanian artists and art critics; and for students of Professors Carmen Popescu and Gheorghe Vida from Bucharest Art Academy, Art History Department.

Fig. 338 Lia Perjovschi, *Prohibited Area to Any External Utterance*, 1991; performance in Constanta, Black Sea coast; text balled up in red tissue paper and thrown to the audience; translation:"Joyful Gaze."

Fig. 339 Dan Perjovschi, *Babel*, 1989; ink on paper.

Fig. 340 Lia Perjovschi, 1992, Bucharest.

Lia

Dan

- Leader of the Student League in the Art Academy, Bucharest, an organization involved in sustaining the growing protest movement, Piata Universitatii, an anti-neocommunist, several-months-long demonstration for a democratic society in Piata Universitatii, the main square of Bucharest by the University of Bucharest. The demonstration was crushed between 13 and 15 June when President Ion Iliescu called in the Romanian miners, led and infiltrated by the Securitate, as a paramilitary force. After this incident, Romania entered a period of isolation from the world community, as its burgeoning democracy appeared to have failed.
- Begins collecting art books, postcards, multiples, globes, East EU plastic bags, and other objects.
- Begins researching both local and international events in art and culture to recuperate fifty years of missing history altered and suppressed by the Romanian communist state under Ceausescu.
- *About Absence*, installation in a courtyard of the Art Academy in Bucharest.
- While artist-in-residence for International Meeting of Young Artists, Ankara, Turkey, creates *Paper Shadows*, an installation, and *Look Back with Anger*, a happening in the main square of Ankara.
- Receives one of the Union of Artists (UAP) young artist prizes.
- Co-curates, with art historian Liviana Dan, an experimental art camp in Sibiu.

Fig. 339

- Organizes experimental international student artist camp at Costinesti on the Black Sea and performs *Prohibited Area to Any External Utterance*.
- Curates "Modified Space," Caminul Artei Gallery, Bucharest.

- First drawings are published in *Revista 22* magazine's 100th issue; drawings and writings by Dan in this publication continue to the present.

- *Nothing Is Accidental*, a street happening, for "Expanzio 4," Performance Festival in Vac, Hungary.
- Distributes a questionnaire to artists and art critics in Bucharest, asking such questions as, "What is art?" "What is the role of the artist?" "What is the role of the critic?" No one responds.

- Fellowship at KulturKontakt, Vienna.
- Artist-in-residence in Kunstlerhaus Horn, Austria.
- Starts *Wonderful World* series.

Fig. 340

189

1992, continued

- Solo exhibition: "Perjovschi/Perjovschi," Simeza Gallery, Bucharest; Lia exhibits a sound installation inserted in her *Maps of Impressions*, as well as balls from the series *Our Withheld Silences*, and for two weeks performs the role of gallery dealer; Dan exhibits *Anthropoteque*, a 5 x 3 meter wall installation of 5,000 drawings. Lia and Dan produce their first newspapers as the catalogues for this show.
- "Trans Art Communication," an international performance festival in Nove' Zamky, Czechoslovakia; Lia performs *The Vertical*; Dan performs *The Reverse Room*, a drawing performance.
- Group exhibition: "The Earth," Art Museum, Timisoara; curator Ileana Pintilie; Lia creates *Topsy Turvy World*, interventions in the balcony of the museum; Dan performs *The Appropriation of Land, Committee*.
- Group exhibition: "Transparency," Podul Gallery, Bucharest; curator Alexandra Titu; Dan and Lia create *4us*, their first collaborative installation, in the basement of the building.
- Group exhibition: Participate in a group presentation of performances on video at the Goethe Institute, Bucharest; Dan shows *The Tree*; Lia shows all her work for the first time in Bucharest to artists and art historians.

1993

- Artists-in-residence at Boville Ernica, Italy.
- First visit to Venice Biennale.
- Kristine Stiles publishes "Shaved Heads and Marked Bodies: Representations from Cultures of Trauma," devoted, in part, to Romania, and the first international text on Lia's *Test of Sleep* (1988) and Dan's *Romania* (1993).
- Group exhibition: "Ex Oriente Lux," Dalles Gallery, Bucharest, the first soros Center for Contemporary Art Bucharest annual exhibition; curator Calin Dan; Lia exhibits *Similar Situations*, a video installation; Dan exhibits *Scan*, a video/drawing installation. Following the exhibition, they organize a meeting in their studio for participating artists and critics from Bucharest, Timisoara, Oradea, Targu Mures, and Arad.
- Group exhibition: "Young Romanian Artists," Contemporary Art Center, Gallery Espace, Besançon, France; curator Mircea Oliv; Lia shows *Maps of Impressions*; Dan shows *Anthroprogramme* scroll; first public lectures outside of Romania on their work.
- Group exhibition: "Zona 1: East Europe," the first international festival of performance art at the Art Museum, Timisoara; curator Ileana Pintilie; Lia performs *I'm fighting for my right to be different*; Dan performs *Romania* (tattoo performance).

Fig. 341

Fig. 341 Lia Perjovschi, Kristine Stiles, and Dan Perjovschi, 1992, Bucharest.

Fig. 342 Lia Perjovschi with *Map of Impressions*, 1989, during the exhibition *Perjovschi/Perjovschi*, Simeza Gallery, 1992, Bucharest.

Fig. 343 Dan Perjovschi, *Romania*, 1993; tattoo performance, Timisoara.

Fig. 344 Dan Perjovschi, detail of *Scan*, 1993; ink on three canvases, computerized scanner, and monitor.

Fig. 342

- Artist-in-residence Maastricht, The Netherlands.
- Graduates from the Bucharest Art Academy, and for her graduation exhibits *The Pinky Life of My Parents*, installation, and *32 Moments in the Life of My Hands*, paintings, drawings, and photographs.
- Invited by artist Ion Bitzan to be his assistant in the Art Academy Design Department; Lia proposes to manage an experimental studio, but when the rector refuses this suggestion, Lia declines Bitzan's invitation.
- Approached for participation in "Aperto: The Body," by Antonio d'Avosa, who wanted to exhibit *Maps of Impressions* for the Venice Biennale. Without institutional support, she is unable to participate.
- Group exhibition: "11th International Biennial of Small Sculpture," Murska Sobota, Slovenia; curator Calin Dan; Lia exhibits a new, altered, and compressed *Maps of Impression* contained in plastic.

- Group exhibition: "Erste Schritte/First Steps. Art in Romania after 1990," IFA Galleries, Stuttgart, Bonn, and Berlin, Germany; curator Calin Dan; Dan exhibits *Anthropoteque*, 1990–1992.

Fig. 343

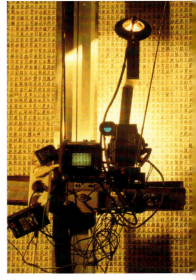

Fig. 344

1994

Fig. 345

· Apply to Simeza Gallery, Bucharest, to live for two weeks in the gallery; the board of the Union of Artists rejects the project.

· Create site-specific installation with empty plastic bags in the Group for Social Dialogue's building, Bucharest, on the theme of European Union integration.

· Create *Back to Back*, at Galeria Etaj ¾, Bucharest, in the context of a survey of Romanian contemporary art (prepared for a visit by German collector Peter Ludwig); Lia exhibits *Maps of Impressions*; Dan exhibits *Anthropoteque* (purchased by Ludwig for the Ludwig Stifftung, Aachen).

· Create installation *It's Your Turn*, Gad Gallery, Bucharest; gallery directed by Ruxandra Balaci.

· Organize meeting in studio for artists from Iasi, Cluj, Oradea, Arad, Sibiu, and Timisoara.

· Group exhibition: "Art Unlimited srl," Fine Arts Museum, Arad; curator Angel Judit; Lia exhibits *Archive of Survival*, pillowcases printed with her performances; Dan exhibits an early version of *Press Stress*, an installation based on pages from *Revista 22*.

1995

· Apply for a one-year residency at Künstlerhaus Bethanien, Berlin, with the project to have a baby, a proposal the board rejected.

· Two-person exhibition: "Zusammen," Aspekte Gallery, Waibstadt, Germany.

· Group exhibition: "INTERn," Fine Arts Museum, Arad; curator Angel Judit; Lia creates *Passing By*, an installation intervention with magnifying glasses throughout the city; Dan performs *Telephone*, calling random people in the city to tell them about the exhibition.

· Group exhibition: "Media Culpa," Architecture Institute Bucharest, the annual exhibition of the Soros Foundation; curator Aurelia Mocanu; Lia exhibits *The Robot Portrait of the Future President*, an interactive installation; Dan creates *PostR*, a series of four posters. Organize meeting in their studio with artists and critics who participated in the exhibition.

Fig. 345 Lia Perjovschi, invitation to her solo exhibition "Fünf Fenster," 1994, Kunsthalle, Vienna.

Fig. 346 Dan Perjovschi, one of sixty-seven, *Postcards from America*, 1994; ink on pastel paper. Courtesy of private collection.

Fig. 347 Dan Perjovschi, one of sixty-seven *Postcards from America*, 1994, ink on pastel paper. Courtesy of private collection.

Fig. 348 Lia Perjovschi, installation view of plastic bags from former Eastern European countries, 1998, Cris Land Museum, Oradea.

Fig. 349 Lia Perjovschi, study for *Project for Europe*, 1994, installation in the space, "N2," Lia created in the Perjovschis' Bucharest flat: headphones and taped sound.

Lia

- Fellowship to *Nuova Borsa*, Brera Academy, Milan, invited by Antonio D'Avossa.
- Artist-in-residence, Gallery Christine König, in conjunction with a fellowship from KulturKontakt, Vienna.
- Participates in International Art Fair, Basel, Switzerland; represented by Gallery Christine König, Vienna.
- Creates "N2" alternative space in her and Dan's apartment in Bucharest (Telita nr. 8 Bl. 66A apt. 41), a short-lived gallery for experimenting with installations.
- Designs sets and costumes for Chekhov's play *The Seagull*, directed by Catalina Buzoianu at Teatrul Mic, Bucharest, tour in Agrigento, Sicily, and in Sciacia Barcelona.
- Solo exhibition: "Fünf Fenster," Kunsthalle, Vienna.
- Group exhibition: "Europe Rediscovered," Turbine Hall Copenhagen, Denmark; curator Niki Diana Marquant; Lia exhibits *Go West, Go East, Go North, Go South*, a sound and video installation.

Dan

- Travels to New York, Chicago, San Francisco, and Los Angeles, among other cities in the United States on a Mid-America Art Alliance, USIA fellowship; meets many artists, including Chris Burden, and visits various artist-run alternative spaces such as Washington Projects for the Arts.
- Performs *Untranslatable* at City Gallery, Raleigh, North Carolina.
- Artist-in-residence, Atlantic Center for the Arts, New Smyrna Beach, Florida, and creates *Postcards from America*.
- Resigns from the Visual Art Department of the Ministry of Culture after his experiences in the United States, and because of renewed conservatism in the Ministry of Culture; begins working full time at *Revista 22*.

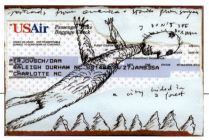

Figs. 346–347

Lia

- Creates Max Pacurar, a false identity invented to test the selection process of the International Center for Contemporary Art (formerly known as SOROS Center for Contemporary Art); Max was accepted in the exhibition but Lia Perjovschi's proposal was not accepted.
- Participates in Kristine Stiles's weeklong seminar "Representations of Trauma in Art, Literature, and Film" at the University of Bucharest.

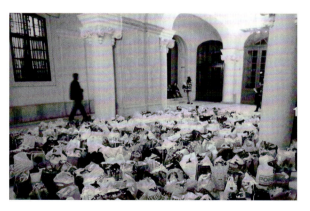

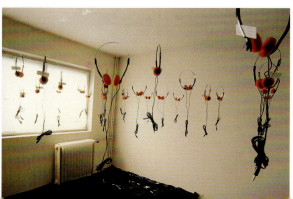

Dan

- Receives Artslink Fellowship, New York, and artist-in-residence at Franklin Furnace, New York.
- Solo exhibition: *Acumulari /Accumulations*, National Museum of Art, Contemporary Art Department, Bucharest; Dan does first wall drawing with pencil.
- Solo exhibition: *Anthropogramming*, first large-scale room drawing installation at Franklin Furnace, New York. For one month, he covers the walls with drawings, and for one week erases the drawings. First erasing project.
- Group exhibition: "Beyond Belief: Art from Central East Europe," Chicago Museum of Contemporary Art and Institute of Contemporary Art Philadelphia; curator Laura Hoptman.
- First artist book: *Postcards from America*, designed by Karen Davidson and with text by Kristine Stiles. New York: Pont La Vue Press.
- Illustrates H.-R. Patapievici's book *Cerul vazut prin lentila* [The Sky Seen Through the Lens]. Bucharest: Nemira 1995. Due to its critical content, the book created a scandal and became a bestseller for years; it was reprinted six times.

Figs. 348–349

Fig. 350

Fig. 350 Two views of the Perjovschis' Bucharest studio.

Fig. 351 Lia Perjovschi, two views of *Searching, Selecting, Measuring (Height and Weight)*, 1996; performance, Sf Gheorghe, Romania.

Fig. 352 Dan Perjovschi, cover design for H.-R. Patapievici, *Cerul vazut prin lentila* [Sky Seen Through the Lens], 1995.

Fig. 353 Dan Perjovschi, *Have a nice day*, 1997; performance, Tel Aviv, Israel.

1996

- Selected for group exhibition, "Experiment: In Romanian Art Since 1960," the 4th Annual Exhibition of soros Center for Contemporary Art; curator Alexandra Titu, at ¾ Gallery, National Theater, Bucharest; Dan and Lia's contribution to the exhibition is to organize a three-day "Open Studio" in their studio. This is the beginning of their direct, sustained interaction with the public. Open Studio attracts a very diverse audience, including families, young people, artists, and critics. Special guests include well-known Romanian intellectuals Mona and Sorin Antohi, Ioana and H.-R. Patapievici, tvr broadcasting live with Ruxandra Garofeanu. Among the guests were Smaranda Vultur (Timisoara), anthropologist, and Andrei Oisteanu (Bucharest), anthropologist.
- Leave their studio to American art historian Roanne Barris to use for her design classes at the Art Academy in Bucharest when invited to teach at Duke University in North Carolina.
- Participate in international conference organized by Liviana Dan at the Brukenthal Museum, Sibiu; Lia exhibits *Magnifying Glass*; Dan exhibits *Telephone*. Following these proceedings the group moves to Bucharest, where the Perjovschis hold informal meetings in the studio.
- Host lecture, "Contemporary Sculpture," by sculptor Mike Nelson (uk) and "Art in Public Space," by Cristian Alexa and Roxana Marcoci, New York, in their studio.
- Group exhibition: "Sf Gheorghe and Anna Lake Performance Festival"; curators Uto Gustav and Konya Reka; Lia performs *Approach and Searching, Measuring, Selecting*; Dan performs *Begging for Contemporary Art Museum* and *Doing Nothing*.
- Group exhibition: 4th St. Petersburg Biennial, Spatia Nova at Smolnii Cathedral, St. Petersburg, Russia; Lia performs *I am fighting for my right to be different*; Dan creates a marker drawing on the floor.
- Group exhibition: "The Museum Complex," Arad; curator Angel Judit; Lia creates an installation *Archive of Survival*; Dan makes *Sponsor*, donating his budget for show production to pay the international telephone bill of the museum.
- Group exhibition: "Zone 2: Performance Festival," held at Timisoara State Theater, Hungarian Section, because the Art Museum would no longer sponsor performance; curator Ileana Pintilie; Lia performs *Incomprehensible*; Dan performs *Echo*.

1997

- Visiting professors and artists-in-residence for one semester at Duke University, Durham, North Carolina. Lia teaches a course titled "Zoom in Contemporary Art: Performance, Installation, Photography, Video, and Media Theory and Practice"; Dan teaches "To Draw Drawing," a course on drawing.

Lia

- Awarded fellowship, ArtsLink, New York.
- Artist-in-residence at Dieu Donne Gallery, New York.
- Solo exhibition: "Is More than First Meet the Eye," Dieu Donne Gallery, New York.
- Solo exhibition: "Lia Perjovschi," 28 Gallery, Timisoara.
- Group exhibition: "Balt Orient Express," IFA Berlin, and Kunsthalle Exnergasse, Vienna; curator Dan Mihaltianu; Lia exhibits *Virtual Voyage/Real Voyage*.
- Group exhibition: "The Bridge: Europe Rediscovered Part II," West Belfast, Ireland: Lia exhibits *Go East, West, North, South*
- First monograph published: *amaLIA Perjovschi*. Bucharest: Soros Center of Contemporary Art. Text by Kristine Stiles.

Dan

- Illustrates the second book of H.-R. Patapievici, *Politice* [On Politics]. Bucharest: Humanitas, 1996.

Fig. 352

Fig. 351

Fig. 353

- Founds Contemporary Art Archive (CAA), an archive of international materials on art collected since 1990.
- Interviewed for French/German television "Arte" on the topic of the archive CAA.
- Creates *Loop*, a video performance.

- Begins writing "Vis-à-vis," a weekly political social column in *Revista 22*.
- "Akcja [Action]," an international event at Bunkier Sztuki, Kracow, Poland; curator Ileana Pintilie; Dan performs a different version of *Untranslatable*.

1997, continued

- Lecture at Duke University Museum of Art, Durham, North Carolina; and at the University of Chapel Hill, Chapel Hill, North Carolina.
- Lecture at Ludwig Museum Forum, Aachen.
- Lecture at Brasov University, Romania.
- Host a live television broadcast on artistic education on TV1 in their Bucharest studio; producer Ruxandra Garofeanu, and including The Cutter Group (a protest group recently expelled from the Art Academy for their activities, including Cosmin Gradinaru, Ion Godeanu, Sergiu Nicolici, Dan Panaitescu).
- Solo exhibition: "Lia Perjovschi/Dan Perjovschi," Institute for the Arts, Duke University, Durham, North Carolina.
- Group exhibition: "Blur," an international festival of performance in Tel Aviv, Israel; curator Sergio Edelzstein; Lia performs *Approach*, a street performance, and *I'm fighting for my right to be different*; Dan performs *Have a nice day*, a three-day performance of shaking hands with strangers on the street next door to a military installation in Tel Aviv.
- Group exhibition: "Ad hoc," Ludwig Museum Budapest; curator Dora Hegyi. Lia presents *East EU*, an installation of a collection of plastic bags, and performs *Approach*; Dan exhibits *Glasnost*, a installation of seven glass panels with drawings from *Revista 22*, and seven albums of *Revista 22*, representing seven years of Dan's drawings for the magazine from 1991–1997. The installation is later included in the collection of the museum.

Fig. 354

1998

Fig. 356

Fig. 354 Dan Perjovschi, syllabus for the course he taught at Duke University, 1997: "Drawing Course: Come Late, Split Early."

Fig. 355 Lia Perjovschi, four drawings for the course she taught at Duke University, 1997: "Zoom: Performance, Installation & Video Art."

Fig. 356 Exhibition poster, *Contemporary Art from Romania: Lia & Dan Perjovschi*, 1997, Institute of the Arts, Duke University, Durham, North Carolina.

Fig. 357 Dan Perjovschi, HIS-TORY/HISTERY, 1997; performance, Chisinau.

- Organizes meetings with students from ECUMEST (International Cultural Management Course) run by Corina Suteu. Their collaboration with ECUMEST continues to the present.
- Presents *CAA Kit*, lecture in the Art Museum in Oradea, Brasov, Bistrita, Iasi, Cluj, and in Chisinau, Moldova.
- Presents a workshop on contemporary art at the Art Museum, Oradea.
- Organizes a lecture by Joanne Richardson on "Experimental Film from 1950 Until the Present" in their Bucharest studio.
- Group exhibition: "Body and the East: From the 1960 on the Present Day," Moderna Galerija, Ljubljana; general curator Zdenka Badovinac, curator for Romania, Ileana Pintilie; Lia and Dan show documentation from their performances.
- Group exhibition: "Gioconda Smile," the annual exhibition by the SOROS Center, Chisinau, Moldova; curator Octavian Esanu; Lia performs *Approach*; Dan performs *Live from the Ground*, a street performance.
- Group exhibition: "Money/Nations," Shedhalle Zurich, Switzerland; curator Marion von Osten; Lia exhibits CAA files; Dan exhibits *To Whom it May Concern*, a collaborative work with Peter Riedlinger and Pascal Petignat.

- Invited to curate a workshop at the Art Academy in Posnan, Poland, and invites Romanian artists Anca Ignatescu and Cosmin Gradinaru to participate.
- Organizes meetings in Bucharest studio with artists and critics from Arad, Timisoara, Iasi, and Bucharest.

- Group exhibition: "Selest'Art," Biennale d'Art Contemporain, Selestat, France; Dan draws on the floor.
- Group exhibition: "Bucharest nach '89," Ludwig Forum für Internationale Kunst, Aachen, Germany; Dan exhibits *Anthropoteque*.

Fig. 355

- First CAA publication *Zoom 1*, includes a dictionary of contemporary art terms; an international chronology of social, political, cultural, and art events after 1945; a chronology of political events in former East Europe; a chronology of international and Romanian installation art; and a bibliography.
- Receives CIAC (International Center for Contemporary Art, former SOROS Center) Prize for curatorial practice.
- Proposes to create a gallery space called "Physical White Cube" with the budget for the Annual CIAC exhibition; proposal rejected by the board of CIAC.
- Solo exhibition: "DiaPOZITIV," A35 Gallery Eforie, Bucharest; exhibits *CAA Kit*, consisting of one hundred small viewers for individual slides (*dia*) of installations and files from CAA. For the exhibition, she invites many different lecturers from different fields: Radu Filipescu, former Romanian dissident; H.-R. Patapievici, writer; Georgiana Ivanescu, psychoanalyst; Dr. Mariana Trifa, homeopathic doctor; forensic detective specialists from the Bucharest Police Department; as well as numerous artists, critics, and journalists.

- Group exhibition: "Manifesta 2," Luxembourg; Dan publishes drawings in two local newspapers: the weekly *d'Lezeburger Land* and the daily *Tagezeitung Luxembourg* for the duration of the exhibition. He works for one month in Luxembourg. Continues to collaborate with *d'Lëtzebuerger Land* until 2005.

Fig. 357

1998, continued

- Group exhibition: "Concept Contemporan/Contemporary Concept, Young Artist Biennial+Guests," Cris Land Museum Oradea; curators Daniel Jarda and Adrian Buzas; Lia exhibits her collection of *East EU Plastic Bags* and lectures on "How to Become an Emerging Artist"; Dan exhibits 32 cm metal sculpture.
- Group exhibition: "Periferic Festival," Iasi; curator Matei Bejenaru; Lia performs *Blank*, Dan performs *Still Life* in the French Cultural Institute.

1999

- Awarded fellowship at IASPIS Stockholm, Sweden.
- Attempts to institutionalize CAA as a nonprofit organization. The Romanian court system rejects it at various levels. When it finally reaches the Supreme Court, Dan and Lia, disgusted by the process, withdraw and maintain CAA as a private project.
- Lecture at Art Institute, Bergen, Norway.
- Does workshop and lecture with students at Norwich Art Institute, Norwich, England.
- Lectures on CAA at Public Library, Brasov, and Art Museum, Braila, Romania.
- Holds brainstorming meetings with artists, theorists, critics, curators, cultural managers, and journalists in their Bucharest studio for a Contemporary Art Museum in Bucharest.
- Solo exhibition: "Witness," a cumulative installation, at Sylvie Moreau Gallery, Cluj, Romania.
- Group exhibition: "Periferic Festival," Iasi; curator Matei Bejenaru; Lia presents *CAA Kit*; Dan exhibits *Piece*, a drawing made from wire.

Fig. 358 Dan Perjovschi, two installation views of *rEST*, 1999, 48th Venice Biennale, Romanian Pavilion.

Fig. 359 Lia Perjovschi, *My Subjective Art History*, 2004; newspaper.

Fig. 359

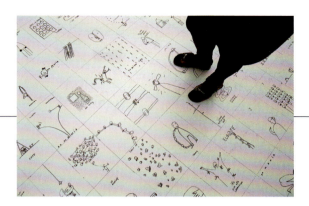

· Creates a new male identity named Luca.

· Applies with the CAA project to ProHelvetia for funds and space to City Hall (then Bucharest City Gallery, now Galeria Nous). The application is rejected.

· Identifies herself as a "detective" in national and international art fields, history, and culture.

· Changes the name of Contemporary Art Archive (CAA) to Center for Art Analysis, designed especially for theoretical research on art and its contexts, artistic practices, histories of art and criticism, curatorial studies, cultural studies, and theory.

· Presents *zoom 2*, (on performance art), and *zoom 3* (on photography, video, and media) in their Bucharest studio and on tour at different Romanian institutions, such as Art Museum Iasi in the context of Periferic Festival, or at the Tranzit Foundation, Cluj, where a public discussion with several local intellectuals active in public space took place under the context of CAA. Speakers included: Doina Cornea and Eva Gymesi (former dissidents), Csilla Konzey (director of Tranzit), *Balkon Art Magazine* editorial board (Timotei Nadasan, Alexandru Antik), Studio Protokoll founders Atilla Tordai S. and Peter Szabo, Philosophy and Staff group (Ovidiu Tichindelean, Vasile Ernu, Alexandru Polgar).

· Receives the Marcel Hiter scholarship to attend an international course on cultural management in Belgium. The first day of the course coincides with a performance festival at Triangle Arts Trust in Marseille; Lia chooses to attend the festival, forfeiting her scholarship.

· Leads guided tour in "After the Wall," Moderna Muséet, Stockholm, for art students from Göteborg.

· Lectures on CAA at Ipswich Art College, England.

· Curates "By the Way," IASPIS, Stockholm, Sweden, inviting artists "to bring, to hang, to leave, to take, to throw . . . to forget, to hide . . . something . . . in the studio space."

· Organizes "Working Brunch" at CIAC, Bucharest, a national meeting of artists, curators, and art historians involved in contemporary art to create a national network to force democratic practices in art in state institutions.

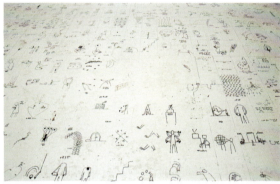

Fig. 358

· Receives Gheorghe Ursu Human Rights Foundation Award, Bucharest, for the articles and drawings published in *Revista 22*.

· Solo exhibition: "Piece and Piece," Nortalje Konsthall, Nortalje, Sweden; exhibits first project including a newspaper with drawings.

· Two-person exhibition: "rEST" (with SubReal), 48th Venice Biennale, Romanian Pavilion; curator Judit Angel; Dan creates large-scale floor drawing with permanent marker. For the first time in the recent history of the Romanian Pavilion at the Venice Biennale, the exhibition is the result of an open application and a jury decision.

· Group exhibition: "Faisseur d'histoire," Casino Luxembourg, Belgium; exhibits one hundred handmade notebooks as a drawing diary; curator Enrico Lunghi.

· Group exhibition: "Rondo," Ludwig Museum, Budapest, Hungary; exhibits *Glass-nost*.

· Group exhibition: "After the Wall," Moderna Muséet, Copenhagen, Switzerland; exhibits *Press Stress*; curators include Bojana Pejic, Iris Mueller Westerman, and David Elliot.

1999, continued

Fig. 360

2000
- Lecture in their Bucharest studio on "Art Administration" with Olga Stefan from the Chicago Art Institute.
- CAA invited to take part in various cultural management and policies for culture meetings in Barcelona, Ljublijana, Bucharest, and Sinaia (Romania), proposed by Ecumest Dijon/Bucharest and European Cultural Foundation Amsterdam
- Create "Everything on View," a televised series for Romanian national television on TVR 1, produced by Ruxandra Garofeanu and directed by Aurel Badea. The three-hour show runs each Saturday for ten weeks from October to December, from 10 A.M. to 1 P.M., and is hosted by Lia and Dan Perjovschi and historian Adrian Cioroianu. Programs include sections on Visual Art, Politics, Dance, Film, Theater, Literature, and Architecture, with such topics as the Human Body, the City, XXI Century, Center and Periphery, Art Market, Cultural Policies, and Manipulation.
- Group exhibition: "2000+ Arteast Collection," Moderna Galerija Ljubljana; Orangerie, Innsbruck, Austria; and ZKM Karlsruhe, Germany; curator Zdenka Badovinac.
- Group exhibition: "Transitionland," National Museum of Art, Bucharest; curator Ruxandra Balaci; Lia exhibits the installation *East EU Plastic Bag* collection and the photo prints *CAA Activities*, *Globe Endless Collection* and *US-EU Exhibitions*; Dan exhibits his newly published book *Vis-à-vis*.

2001
- Artists-in-residence, Schloss Pluschow, Pluschow, Germany.
- Artists-in-residence, Institute Claude Nicolas Ledoux, The Royal Salt Mines, Arc-et-Senans, France.
- Artists-in-residence at Kunsthaus, Essen, Germany.
- Declare themselves Dizzydents (dissidents) against the Bucharest National Contemporary Art Museum being located in Nicolae Ceausescu's Casa Poporului, renamed the Parliament Palace.
- Two-person exhibition: "Working Title," Kultur Kontakt Pavilion, Museum Quarter, Vienna; Lia shows posters (1990–2000) of EU and U.S. exhibition, CAA activities, Globe Endless Collection, and the newspapers *caa contemporary art archive and its context*. Dan shows *Piece*, the wire drawing, and the "I am not exotic" newspaper.
- Group exhibition: "Invitation," Kunsthaus Essen, Germany; Lia shows *Abdekplane Extrastark*; Dan shows *Recycle*, a mixed-media installation.

Fig. 360 Dan and Lia Perjovschi, *Everything on View*, 2000; screen captures of the live broadcast of their television series.

Fig. 361 Lia Perjovschi, *Pain H Files*, 1996–2003; one of twenty-four dolls.

Fig. 362 Lia Perjovschi, *Pain H Files*, 1996–2003; two of fourteen drawings.

· Group exhibition: "BELEF Festival," Belgrade, Serbia, invited by Milena Dragicevic Sesic, one month after NATO bombing in August; Lia performs *Listen*, working as an unofficial reporter in various neighborhoods to interview the public about the bombing; Dan creates *Quotidian*, a installation at Belgrade Young Artist Center Gallery.

· Group exhibition: "In Full Dress," Brukenthal Museum, Sibiu; curator Liviana Dan. Lia exhibits *Maps of Impressions*.

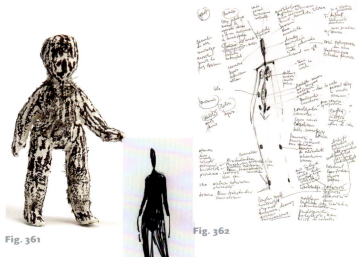

Fig. 361

Fig. 362

· Awarded fellowship and artist-in-residence at La Napoule Art Foundation, La Napoule, France.
· Solo exhibition: "Quotidien," La Napoule Foundation, France; curator Patricia Corbett.
· Group exhibition: "Voilà! Le monde dans la tête," Musée d'Art Moderne de la Ville de Paris, France; creates his first fax piece, faxing drawings with political commentary on the exhibition for three months; curated by Laurence Bosse, Beatrice Parent, Hans Ulrich Obrist, and Julia Garimoth.
· Group exhibition: "Café Helga und Galerie Goldankauf," Kunstraum, Munich, Germany; second fax piece.
· Group exhibition: "Leaving the Island," Pusan Biennial, Korea; curators Young Chul Lee, Rosa Martínez, and Hou Hanru; third fax piece.
· Artist book, *Castle Stories*. La Napoule, France: La Napoule Art Foundation and Edition La Mancha.

· Creates stage design and costumes for *Wit* by Margaret Edson, directed by Catalina Buzoianu for the Mic Theater, Bucharest.
· Solo exhibition: "CAA Kit: Visual ID/Defragmentation," a35, Eforie Gallery, Bucharest; presents material on contemporary art institutions, visual identity, and concepts from CAA publications.
· Group exhibition: "Double Life," Generali Foundation, Vienna, Austria; curator Sabine Breitwieser; Lia exhibits *Performance 1988–1996*, a video selection of her performances.
· Group exhibition: "Global Fusion," Palais Porcia, Vienna; curator Claudia Luenig; Lia shows *Globe Endless Collection*.
· Group exhibition: "Esprit de Finesse + and Esprit de Finesse," Brukenthal Museum, Sibiu; curator Liviana Dan; Lia exhibits *Hidden Things*, drawings, and a video.

· Group exhibition: "Flux," First Göteborg Biennial, Göteborg Konsthalle, Göteborg, Sweden; Dan exhibits for the first time a project based on daily process of email, sending drawings to be projected on the walls of exhibition space; curated by a collective of artists and art historians.
· Group exhibition: "New Ideas—Old Tricks," hARTware Projekte, Dortmund, Germany; curators Iris Dressler and Hans D. Christ; Dan exhibits sections of *Wonderful World* and prints the second newspaper of drawings.
· Group exhibition: "Conversation—a short notice show," Belgrade Museum of Contemporary Art, Serbia; curators Branislava Andelkovic and Dejan Sretenovic; Dan exhibits framed newspaper pages with his drawings published in the *Danas Belgrade* (a local daily) prior to the exhibition.

Fig. 363

Fig. 363 Dan Perjovschi, 2002, promissory letter to Ileana Pintilie to have his tattoo, *Romania*, removed on its 10th anniversary in 2003.

Fig. 364 Lia Perjovschi, *Globe Collection*, 1990–present.

Fig. 365 Dan Perjovschi, installation view of *Perjovschi*, 2003, Galerie de l'ESBAM, Marseille, France: bent wire figures, or drawing in wire. They resemble Dan's early drawings, *Urzeala* [Weave or Plot], 1986–1987, in which the line is continuous and interlocking.

Fig. 366 Dan Perjovschi, *Me Out of Fashion*, 2004: marker on wall.

LiaDan

2001, continued

- Group exhibition: "Small Talk," Skopje Museum of Contemporary Art, Skopje, Republic of Macedonia; curators Zoran Petrovski and Luchezar Boyadjiev; Lia presents 200 small paper angels (as an intervention) and lectures on CAA; Dan presents his fourth fax piece.
- Group exhibition: "Willing Refugees," Kunsthalle, Rostock, Germany; Lia shows *Abdeckplane Extrastark*; Dan shows the drawing slide projection based on his Schloss Pluscow residency drawings.

2002

- Artists-in-residence at Kunstler Haus, Worpswede, Germany.
- Co-curate, with Susanne Neuburger, "Position Romanien" for Forum A9 Transeuropa, Museum Quareter 21, Vienna. Part of the project is the artists' presence in Vienna: H.arta (Timisoara), MindBomb (Cluj), Peter Szabo and Csiki Csaba, Cristina Coleasa, Dan Panaitescu, Raluca Voinea, and Marius Stefanescu.
- Create "Short Guide," a CAA publication with fragments from historian Lucian Boia, political analyst Alina Mungiu Pippidi and text labels for each artist.
- Lecture on the subject of CAA at Depot: Kunst und Diskussion, Vienna, and about art in public space at the Architecture Institute, Bucharest.

2003

- Curate "Waiting Room: Several Artistic Positions from South-East Europe," part of the conference "Enlargement of Minds/Crossing Perspectives" at Theater Art Institute, Amsterdam; exhibition includes Anri Sala, Daniel Knorr, Nevin Aladag, Rassim, Mircea Cantor, Matei Bejenaru, Oliver Musovik, and Pavel Braila.
- Give lectures and workshops at Northwestern University Department of Art and Art History and Practice, Barat Art College, and Columbia University English Department.
- Two-person exhibition: "Endless Collection," Kunsthalle, Goppingen, German; curator Werner Meyer; Lia exhibits *Globe Endless Collection*; Dan does a pencil wall drawing.
- Group exhibition: "Tangible Instability," Barat Art College and LIPA Gallery, Chicago; curator Olga Stefan; Dan exhibits a wall drawing; Lia exhibits *Globe Endless Collection*.
- Publication of *Lia Perjovschi, Endless Collection: 1990 – Today* and of *Dan Perjovschi, Autodrawings*, edited by Werner Meyer. Göpingen: Kunsthalle.
- Group exhibition: "Zona 4: Performance Festival," Timisoara; Lia performs *Official End* (with Kristine Stiles). In 2002, Dan sent a letter to Ileana Pintilie, the curator, promising to have his tattoo made at Zona 1 erased. The letter is signed and witnessed by Lia and Kristine.

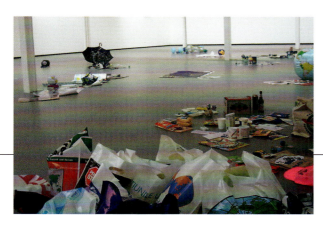

· Solo exhibition: "Sense," H.arta, Timisoara, and Protokoll Studio, Cluj. Lia produces CAA newspaper *Sens*, with diagrams on the Romanian art context, curatorial studies, cultural studies, key words in contemporary art, on how to become emerging artist, on conceptual art from 1960 to the present, and a timeline of CAA activities.

· Group exhibition: 4th Cetinje Biennale, Cetinje, Montenegro; curator Iara Boubnova.

· Receives Henkel CEE Prize for Contemporary Drawing, Vienna, the first award of this newly created prize.

· Two-person exhibition: "3(6)" (with Nathaniel Mellors), IBID Projects, London; curators Vita Zaman and Magnus Edensvard; Dan's first installation with permanent markers on the wall covering the entire space.

· Releases CAA publication *Normalcy Meaning Relaxation*; includes questions for Romanian intellectuals from different fields: Sorin Antohi (cultural critic), Ciprian Mihali (philosopher), Dan Petrescu (former dissident), Alina Mungiu-Pippidi (political analyst), and Marius Oprea (analyst for Securitate files).

· Conducts a week-long workshop with groups of students on the topic of the *Globe Endless Collection* at Kunsthalle, Goppingen, Germany.

· Group exhibition: "Balkan Consulate-Budapest," *rotor* Gallery, Graz, Austria; curator Angel Judit; in the frame of CAA other artist positions are presented: Anca Ignstescu, Cosmin Gradinaru, Attila Tordai S. Mihai Stanescu.

· Group exhibition: "Prophetic Corners," First International Biennale, Iasi; curator Anders Kreuger; Lia exhibits *Globe Endless Collection*, an *object with no significance*, and *Normalcy Meaning Relaxation*, a CAA newspaper with interviews of some leading Romanian intellectual positions.

· Group exhibition: "The Last East European Show," Museum of Contemporary Art, Belgrade, Serbia; curators Zoran Eric and Stevan Vucovic; Lia exhibits *CAA Kit*.

· Artist-in-residence ESBAM (Ecole Superieure de Beaux Art), Marseille, France.

· Solo exhibition: "Ich habe keinnen zeitraum," Brukenthal Museum, Sibiu; curator Liviana Dan; Dan exhibits a pencil wall drawing installation, bound volumes of *Revista 22*, 1991–2002, and other artists' documents.

· Solo exhibition: "Perjovschi," Galerie de ESBAM, Marseille, France; Dan exhibits a large floor drawing with permanent marker and a wire drawing.

· Two-person exhibition: "Perjovschi/Roggan" (with Ricarda Roggan), Kunstverein, Arnsberg, Germany; Dan creates a pencil wall drawing.

· Group exhibition: "Undesire," Apexart, New York; curator Vasif Kortun; Dan emails daily images of the drawings he was doing at the *White Chalk Dark Issues* project in Essen Germany; images shown as a slide show on a monitor.

· Group exhibition: In den Schluchten des Balkans" [In the Gorges of the Balkans], Kunsthalle Fridericianum, Kassel; curator René Block; Dan creates temporary graffiti street drawings for two weeks, and performs *Erased Romania*, having his 1993 tattoo removed in four laser sessions over three months.

Fig. 366 203

2003, continued

2004

- Lecture on CAA at BAK (Basis voor Actuele Kunst, Utrecht, the Netherlands).
- Organize a meeting in their Bucharest studio with international and Romanian artists and curators on the subject of contemporary art museums.
- Group exhibition: "Cordially Invited" in the frame of "Who if not we?" BAK, Utrecht, the Netherlands; curator Maria Hlavajova; Lia exhibits CAA Kit; Dan exhibits a wall drawing; Dan and Lia are invited by the artist group Bik van der Pool.

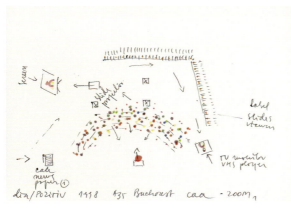

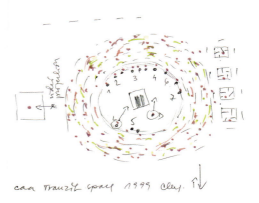

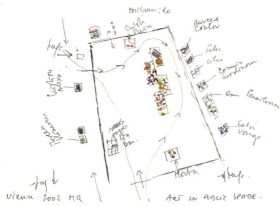

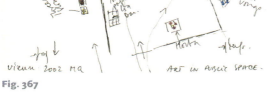

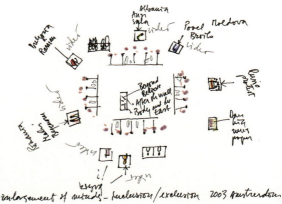

Fig. 367

Fig. 367 Lia Perjovschi, studies for *CAA Archive* installations in Bucharest 1998, Cluj 1999, Vienna 2002, and Amsterdam 2003: ink on paper.

Fig. 368 Dan Perjovschi, installation view of *No Idea*, 2004, Schnittraum, Cologne. These drawings in marker on glass also resemble Dan's early drawings, *Urzeala* [Weave or Plot], 1986–1987.

· Group exhibition: "Open City Models for Use" Kokerei Zollverein Zeitgenossische Kunst und Kritik, Essen, Germany; curators Marius Babias and Florian Waldvogel; Dan exhibits *White Chalk Dark Issues*, the first and largest wall drawing installation made with chalk, including seven rooms; the rooms took eights weeks to complete.

· Co-curates, with Marek Adamov, "FLUX," a one-year project for Station Zilina SK, consisting of lectures and exhibitions. Lectures: "Noise" by Stefan Tiron; "Short Carriers" by Susanne Neuburger; "Culture Jamming" by Florian Waldvogel; "Critical Thinking" by Claire Bishop; "Art in Public Space" by Hedwig Saxenhuber; "Documenta 12—The art magazine project," by Georg Sollhammer. Exhibitions and projects: "Jumping alphabet," Dan special newspaper, interactive installation, "Lost," solo exhibition of Robo Blasko; "Open call" interactive installation and "Detective (in Art)" installation.

· Co-organizes, with Georg Schollhamme in their Bucharest studio, "Formats: Vienna Days in Bucharest," a meeting of artists, critics, theorists from Vienna, Bucharest, Cluj, Timisoara, Iasi, Sibiu, and Arad.

· Creates stage design for *First Man* by Albert Camus, director Catalina Buzoianu, a UNESCO production, touring to Marseille, Paris, Bucharest, Brasov, Iasi, and Brussels.

· MA students from Curatorial Course Royal College London visit CAA.

· Group exhibition: "Chaos," Institute for Contemporary Art Dunaujivaros, Hungary; curator Zsolt Petranyi; Lia exhibits *Mind Maps*.

· Group exhibition: "Studfest," Art Academy, Timisoara; curators are a collective of students; Lia exhibits *CAA Kit*.

· Wins George Maciunas Triennial Prize, Wuppertal, Germany, presented by René Block in Bucharest at GDS Conference Hall. Laudatio by Marius Babias.

· Artist-in-residence for "Off-Site," Collective Gallery, Edinburgh, Scotland.

· Awarded fellowship, Henry Moore Foundation Grant, Edinburgh.

· Creates first private wall drawing in the home of Timotei Nadasan, editor in chief of *IDEA: Art & Society*.

· Publishes "Sexing up the Insert" in *Parkett* 71 (2004): 157–168.

· Solo exhibition: "Attila," Protokoll Studio, Cluj, Romania; Dan does pencil drawings on walls of the space, drawings inspired by daily conversations with curator Attila Tordai S.

· Solo exhibition: "No idea," Schnittraum, Cologne, Germany; curators Lutz Becker and Sabine Oelze; Dan draws with black marker on the glass window of the gallery and with pencil on the walls.

· Two-person exhibition: "Drawing-Drawing" (with Goran Petarcol), Gregor Podnar Gallery, Lublijana, Slovenia; curator Gregor Podnar; Dan does a pencil wall drawing.

· Group exhibition: "Normalization," Nova Galerija, Zagreb, Serbia; curated by WHW, curatorial collective; Dan draws with chalk on black walls.

· Group exhibition: "Communauté," Institut d'Art Contemporain, Villeurbanne (Lyon), France; curator Dirk Snauwaert; Dan sends postcards with drawings for two months and creates a pencil room drawing.

· Group exhibition: "Passage d'Europe," Musée d'Art Moderne de la Ville de Paris, France; curator Lorand Hegyi; Dan creates a black marker wall drawing.

· Group exhibition: "Off-Site," Collective Gallery, Edinburgh, Scotland; curator Sarah Munro; Dan does daily drawings with chalk in the public space. *No Vacancy*, a newspaper publication with drawings, is printed as part of the project.

· Group exhibition: "Love It or Leave It," the Fourth Cetinje Biennial, Cetinje, Montenegro, Dubrovnik section; curator René Block; Dan creates *The Dubrovnik Drawing*.

Fig. 368

2004, continued

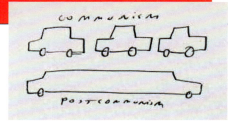

Fig. 369

2005

· Co-curate with Iris Dressler, Hans D. Christ, and Daniel Garcia Andujar "On Difference #1, Local Context-Hybrid Spaces," Wurtenberghischer Kunstverein, Stuttgart, Germany. In their section, "The Detective Office," they presented young artists: Nita Mocanu, Cluj, Cezar Lazarescu, Iasi, Eduard Constantin and Echo Group, Bucharest. They also included "The Meeting," Ion Grigorescu's iconic photographs from the 1970s.

· Lecture on topic "Dyizzydent," for the exhibition "After the Happy Nineties," Goethe Institute, Bucharest; meet with the participants in the studio.

· Lecture on "Dizzydent" at CAM Conference; Ludwig Museum, Budapest.

· Begin supporting ArtPhoto Association (Razvan Ion and Eugen Stefanescu), editors of *ArtPhoto* (later *Pavillion Art Magazine*) and directors of the future Bucharest Biennial.

· Co-organize with Ratiu Foundation, London, a documentary trip (Bucharest, Iasi, Cluj) for curators from England: Sian Bonnell, director, TRACE; Ben Borthwick, assistant curator, Tate Modern; Jenny Brownrigg, Exhibitions Department, University of Dundee; Kim Sukie Dhillon, independent curator; Elisabetta Fabrizi, assistant curator, BALTIC Art Center; Kerri Morgan, program manager, Centre for Contemporary Arts, Glasgow; Nansi O'Connor, arts projects manager, Visiting Arts; and Simona Nastac, independent curator from Bucharest.

· Co-organize with Posibila Gallery (Bucharest) and Schnittpunkt ausstellunstheorie and praxis, a documentary trip (Bucharest, Iasi, Cluj) for independent curators and theorists from Austria and Germany: Horst Campman, Gabrielle Cram, Sophie Goltz, Mikael Horstmann, Renate Hollwart, Beatrice Jaschke, Therese Kaufmann, Concordia Kulterer, Nora Sternfeld, Regina Wonisch, and Luisa Ziaja.

· Hosts (under the umbrella of CAA) a meeting with Romanian and Swedish artists and curators as part of "Zvon de Suedia/Sueden Rumor—The Swedish Culture Days" in Romania; lectures by Johanna Billing and Liza Torell.

Fig. 371

Fig. 369 Dan Perjovschi, *Communism Postcommunism*, 2005; marker on wall.

Fig. 370 Lia Perjovschi, example of *CAA Kit*, 2005: archival materials.

Fig. 371 Dan Perjovschi, cover of artist book *Toutes Directions*, 2005, and installation view of *Back to Back*, Lombard-Freid Projects, New York, 2006.

Fig. 372 Dan Perjovschi, installation view of *Naked Drawings*, 2005, DC Space, Ludwig Museum, Cologne; marker on wall.

Fig. 370

- Group exhibition: "Abstract Expressionism in Contemporary Figurative Sculpture," Johann Koening Galerie Berlin, Germany; curator Johan Koenig; Dan creates a pencil wall room drawing.
- Group exhibition: "Flipside," Artist Space, New York; curator Katherine Carl; Dan makes his fifth fax piece.
- Artist book: *I Draw — I Happy*. Edited by Lutz Becker. Koln: Schnittraum and Verlag der Buchhandlung Walter König.

- Publish CAA publication *Detective Draft* in the context of "On Difference #1, Local Contexts — Hybrid Spaces," Wurttemberghirscher Kunstverein, Germany.
- Co-organizes, with Georg Schollhammer of Tranzit Network, annual meeting focusing on Romanian culture and art scene. Participants: Roger Buergel (director, *Documenta 12*), Piotr Piotrowski (professor), Adam Mickiewicz (University, Poznan), Martina Hochmuth (director, Tanzquartier, Vienna), Vit Havranek (director, Tranzit, Prague), Boris Ondreicka (director, Tranzit, Bratislava), Dora Hegyi (director, Tranzit, Budapest), Boris Marte (president of Tranzit International Board), Christine Böhler (member, Tranzit International Board and the Art Advisory Committee of Erstye Bank Art Collection), Silvia Eiblmayr (director, Galerie im Taxispalais, Innsbruck), Walter Seidl (curator, Silvia Bohrn Erste Foundation), Barbara Lindner (Tranzit, Vienna); Romanian participants: Gabriela Adamesteanu (novelist, director of Romanian Pen Club and editor in chief of *Revista 22*), Matei Bejenaru (artist, director of Periferic Biennial, Iasi), Cosmin Costinas (art critic, Cluj/Bucharest), H.arta group and artist-run space (Maria Crista, Anca Gyemant, Roddica Tache, Timisoara), Catalin Gheorghe (philosoper, member of Vector group Iasi), Oana Radu (director, ECUMEST Bucharest), Stefan Tiron (artist and curator, Bucharest), Attila Tordai S. (curator, Protokoll Studio, Cluj, and editor *IDEA: Art & Society*, Cluj), Raluca Voinea (curator and editor of *E-cart*, Ploiesti).
- Organizes meeting in the Bucharest studio with students from Art Academy class of Aurelia Mocanu.
- Declares CAA in quarantine (a project institution who got a virus) and quasi-stops its activities.
- Group exhibition; "Studfest," Art Academy, Timisoara; curated by group of students; Lia exhibits *CAA Kit*.

- Solo exhibition: "Naked Drawings," DC space, Ludwig Museum, Cologne, Germany; curator Kasper Koenig; Dan makes a large-scale room drawing installation, requiring six weeks of daily drawing.
- Solo exhibition: "The School Drawing," Athens, Greece; curator Locus; special project in which Dan draws on the wall to the school and in one classroom of Moraitis School; students write about the drawings as a class assignment.
- Solo exhibition: "I shoot myself in the foot," New Gallery, Peja, Kosovo; curator Erzsen Skololi; Dan's sixth fax project.
- Two-person exhibition: "Perjovschi/Tevet" (with Nahum Tevet), Le Quartier, Quimper Bretagne, France; curator Dominique Abensour; Dan does black marker room drawing.
- Group exhibition: 9th Istanbul Biennial, Istanbul, Turkey; curators Charles Esche and Vasif Kortun; Dan draws on the walls, floors, and the glass ceiling of the Bilsar Building, mixing black marker and white chalk.
- Group exhibition: "I Still Believe in Miracles: Dessins sans papier," ARC Musée d'Art Moderne de la Ville de Paris, Couvent de Cordeliers, Paris, France; curators Laurence Bosse, Hans Ulrich Obrist, and Angeline Scherf; Dan does a room drawing with black marker.
- Group exhibition: "Just Do It! The Subversion of Signs from Marcel Duchamp to Prada Meinhof," Lentos Museum, Linz, Austria; curators Floriaan Waldvogel and Reimar Stange; Dan draws with white chalk on museum lobby.
- Group exhibition: "Leaps of Faith, Public Art Projects," Nicosia, Cyprus; curators Katerina Gregors and Erden Kosova; Dan draws with white chalk and black charcoal in the public space in both north and south parts of the divided city; Dan also publishes drawings in Turkish Cypriot and Greek Cypriot newspapers.
- Group exhibition: "Paradoxes: The Embodied City," Gulbenkian Foundation, Lisbon, Portugal; curator Nuno Faria; Dan creates *What we are afraid of?* black marker and white chalk room drawing.

Fig. 372

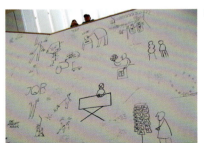

2005, continued

· Group exhibition: "New Europe: The Culture of Mixing and Politic of Representation," Generali Foundation, Vienna; Lia exhibits *Globe Endless Collection* and a series of sixty *Mind Maps*, drawing-diagrams; Dan does a 20-meter-long wall drawing. Among other relevant institutions, IDEA, *arts & society* and CAA were included in the documentary part of the exhibition.

· Group exhibition: "IDEA," the Goldsmith curatorial MA students squatting ICA London; Lia presents a *CAA Kit*; Dan does a transfer-drawing project; curator Simona Nastac.

2006

· Group exhibition: "Dada East, Cabaret Voltaire," Dadahaus, Zurich; curator Adrian Notz; Lia exhibits *CAA Kit*; Dan does white paint drawing interventions.

· Group exhibition: "Periferic 7 Biennale, The Social Processes," Turkish Bath, Iasi, Romania; curators Marius Babias and Angelica Nollert; Lia exhibits *Timeline on Romanian Culture* and *CAA Kit*; Dan does a black marker, white chalk, and wall scratch drawing installation.

· Group exhibition: "Contemporary Institutions Between Private and Public," CIMAM International meeting, Tate Modern, London; Lia and Dan lecture on "The Practice of CAA."

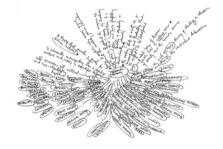

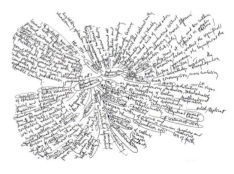

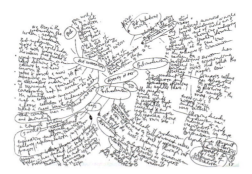

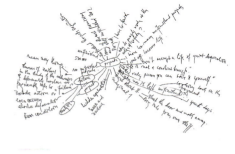

Fig. 373

Fig. 373 Lia Perjovschi, *Mind Maps (Diagrams)*, 1999–2006; ink on paper, four of a series of sixty.

Fig. 374 Lia Perjovschi, installation view of *CAA Kit* at The Royal College of Art, London, 2006.

Fig. 374

- Group exhibition:"Projekt Migration," Kölnischer Kunstverein, Cologne, Germany; curators Kathrin Rhomberg and Marion von Osten Copy; Dan creates carbon transfer drawings scattered on the walls around the venues.
- Artist book, *Toutes Directions*. Edited by Dominique Abensour and Marc Geerardyn. Quimper, France: Le Quartier Centre d'art contemporain de Quimper.

- Lectures on "Sense," Stedelijk Museum, Amsterdam.
- Designs set for *Glass Menagerie* by Tennessee Williams for TNB (National Theater Bucharest); director Catalina Buzoianu.
- Designs set for *The Encounter* for the 31st UNESCO World Congress, Theater Olympics of the Nations, World Festival of Drama Schools, Second Ministerial Meeting and Workshop on Media Content and Creative Industry, Manila, Philippines; director Yuriy Kordonskiy; Corneliu Dumitriu, producer.
- Meets in the CAA with MA students from the curatorial course De Apple, Amsterdam.
- Solo exhibition: "Chronology," Yujiro Gallery, London; Lia exhibits *Timeline* on general culture, Romanian culture, and personal research. Catalogue produced in conjunction with the exhibition *Lia Perjovschi Chronology*. London: Gallery Yujiro.
- Solo exhibition: *CAA Kit*, Project Room, Kunstraum, Innsbruck, Austria.
- Group exhibition: "ACADEMY. Learning from Art," Museum van Hedendaagse Kunst, Antwerp, Belgium; curator Angelica Nollert; Lia exhibits *Timeline*, "My Subjective Art History."
- Group exhibition: "Again for Tomorrow," Royal College of Art, London; Lia exhibits *CAA Kit W*.
- Group exhibition: "Interrupted Histories," Moderna Galerija, Ljubljana, Slovenia; curator Zdenka Badovinac; Lia exhibits *CAA Kit E*.
- Group exhibition: "Check in Europe," Europaisches Patentarmt, Munich, Germany; curator Marius Babias; Lia exhibits *Mind Maps*.
- Group exhibition: "Auditorium, Stage, Backstage," Kunstverein, Frankfurt, Germany; curators Vit Havranek, Boris Ondreicka, and Dora Hegyi; Lia exhibits *Mind Maps* (on Transit Philosophy).

- Solo exhibition: "The Room Drawing," Tate Modern, London; curator Maeve Polkinhorn; drawing installation using black markers on walls and windows of Tate Members Room.
- Solo exhibition: "On the Other Hand," Portikus, Frankfurt, Germany; curator Nicola Dietrich; drawing installation and daily workshop with Stedleschulle, black markers on walls, white chalk on floor.
- Solo exhibition: "Dan Perjovschi," Van Abbemuseum, Eindhoven, the Netherlands; curator Charles Esche; drawing installation with black markers; shows newspaper projects such as *Press Stress*, *The L'and insert*, *The Cyprus insert*.
- Solo exhibition: "May First," Moderna Museet Stockholm, Sweden; curator Karen Diamond; drawing installation on the cloak room walls and museum lockers.
- Solo exhibition: "First Class," Montcada Space La Caixa, Barcelona, Spain; curators Marta Gili and Silvia Sauquet; drawing installation on the stairs to the gallery.
- Solo exhibition: "Not me but you, not now but later," Kunstraum, Innsbruck, Austria; curator Stefan Bidner; black marker drawing installation with which the public can interact, and artist book.
- Solo exhibition: "From Now On," Kunsthalle, Budapest, Hungary; curator Livia Paldy; drawing installation/work-in-progress using black markers on the wall; Dan's first project to start at the opening and continue for ten days as a performance.
- Solo exhibition: "Encore une foi," Michel Rein Gallery, Paris; a retrospective of four fax projects, Paris, New York, Kosovo, and Lubljana, 2001–2006.
- Two-person exhibition: "Back to Back," (with Nedko Solakov), Lombard-Freid Gallery, New York; curator Cristian Alexa; drawing on wood panel structure.

2006, continued

Fig. 375 Dan Perjovschi, page from *Brown Notebook*, 2005: ink on brown paper. Courtesy of private collection.

- Three-person exhibition: "Borremans, Bryce, Perjovschi," Wurtenbergischer Kunstverein, Stuttgart, Germany; curators Iris Dressler and Hans D. Christ; drawing installation using black marker and white chalk on white, gray, and black walls.
- Group exhibition: "The Vincent Biennial Prize for European Art 2006," Stedelijk Museum, Amsterdam, the Netherlands; black marker and white paint drawing installation.
- Group exhibition: "Unhomely," Seville Biennial, Seville, Spain; curator Okwui Envezor; Dan creates insert in *ABC de las Artes*, 768 October, *Tank You*, an eight-page publication freely distributed during the exhibition.
- Group exhibition: "Normalisation," Rooseum Center for Contemporary Art, Malmo, Sweden; curators Katarina Stenbeck and Charles Esche; drawing installation.
- Group exhibition: "Phantom," Charllotenburg Gallery, Copenhagen, Denmark; curators Soren Andersen and Jesper Rasmussen; Dan creates *The Lobby Drawing*.
- Group exhibition: "Happy Believers," Werkleiz Biennial, Halle (Saale) Germany; *Believe me I am not happy* outdoor drawing installation; section curated by Jan Schuijren.
- Group exhibition: "The Large Piece of Turf," Public Space Art project, Nurnberg, Germany; curators Florian Waldvogel and Raimar Stange; Dan performs *Football My Foot!* one month of temporary graffiti with chalk on the streets during the Football World Cup hosted by Germany.
- Group exhibition: "Give (a) Way, ev+a 2006," Biennial International Exhibition, Limerick, Ireland; curator Katarina Gregos; drawing installation with black markers in Limerick City Gallery of Art.
- Group exhibition: "October Salon," Turkish Bath, Belgrade, Serbia; curator Rene Block; creates drawing installation black markers and white chalk on the walls and ceramic tiles of the former Turkish bath.
- Group exhibition: "Chaos. The Age of Confusion," Second Bucharest Biennial, Bucharest, Romania; curator Zsolt Petranyi; black marker wall drawing on the Glass House Botanical Garden Bucharest, one insert in the *Bucurestiul Cultural* monthly, and a skateboard drawing shown in Skate Shop.
- Group exhibition: "U-turn," Quadrienale for Contemporary Art, Copenhagen 2008, starts with Dan drawing on the quadrienale office space. He will continue to add new drawings each year until the grand opening; curators Charlotte Bagger Brandt, Solvej Helweg Ovesen, and Judith Schwarzbart.

2006, continued

2007

- Co-found *ReSources*, a platform project (with Manuel Pelmus, Mihai Mihalcea, Stefan Tiron, Stefania Ferchedau, Corina Suteu).
- Solo exhibition: "States of Mind: Dan and Lia Perjovschi," mid-career retrospective, Nasher Museum of Art at Duke University, Durham, North Carolina; curator Kristine Stiles.
- Solo exhibition: "Perjovschi/Perjovschi," Christine Koenig Gallery, Vienna; Lia exhibits *Mind Maps (Diagrams)*; Dan exhibits a window and wall drawing.
- Group exhibition: "Brave New Worlds," Walker Art Center, Minneapolis; curators Yasmil Raymond and Doryun Chong; Lia exhibits *My Subjective Art History* and *Knowledge Museum Project*; Dan does *Mid America Drawing*.
- Group exhibition: "Le Nuage Magellan," Centre Georges Pompidou, Paris; curator Joanna Mytkowska; Lia exhibits *My Subjective Art History*; Dan does *The Pompidou Drawing*.
- Group exhibition: "Public Space," Bucharest; curator Marius Babias; Lia exhibits *CAA Inventory*; Dan exhibits *The Public Monument*.
- Group exhibition: "Studfest," Art Academy, Timisoara; Lia exhibits *My Subjective Art History*; Dan does the first delegation of power project, making students draw his images.
- Group exhibition: "Artists, Gossips and Critics," Venice Biennale; curator Malcolm Quinn; round table/debate.

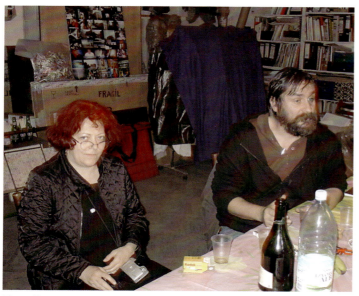

Fig. 376

Fig. 376 Dan and Lia Perjovschi in their Bucharest studio, October 2006.

Fig. 377 Lia Perjovschi, installation view of *Timeline: Romanian Culture from 500 B.C. until Today*, 2006, in Turkish Bath, Iasi; collage and drawing.

Fig. 378 Dan Perjovschi, installation view of *The Drawing Room*, 2006; marker on wall. Courtesy of the Tate Modern, London.

Fig. 379 Dan Perjovschi, *Free*, 2003; marker on wall.

Fig. 377

Curates "Words Marathon," a round table event at Gallery Yujiro, London; includes Dale and Andrea Adcock (curator and dealer of Yujiro Gallery); Radu Filipescu (former dissident and president of Group of Social Dialogue, Bucharest); Dr. Malcolm Quinn (reader in Critical Practice, London); Dr. Alina Mungiu-Pippidi (political analyst, Bucharest); Mark Pomercy (archivist for the Royal Academy, London); and Traian Ungureanu (journalist, Bucharest/London).

Applies to the Ministry of Culture for the Romanian Pavilion in Venice Biennale, to exhibit the *Knowledge Museum Project*; four projects are accepted, including Lia's. Instead of the pavilion she is offered the space of Romanian Cultural Institute in Venice. She refuses.

Group exhibition: "Learn to Read," Tate Modern, London; curators Maeve Polkinhorn and Vincent Honore; Lia exhibits *Mind Maps (Diagrams)*.

Group exhibition: "Time Out. Art and Sustainability," Kunstmuseum, Liechtenstein; curator Malsch Friedemann. Lia exhibits the *Knowledge Museum Project*.

Group exhibition: "Every Day," Kunstverein, Salzburg, Austria; curator Hemma Schmutz; Lia exhibits documentation of her performances.

Artist book, *My World Your Kunstraum*. Kunstraum Innsbruck, Walter Koenig, Cologne, Germany.

Artist book, *Dan Perjovschi. Non-Stop 1991–2006*. Paris: One Starr Press.

Artist book, *Dan Perjovschi. A Book with an Attitude*. Geneva: Attitudes.

Solo exhibition: "WHAT HAPPENED TO US?" Project 85, Museum of Modern Art, New York; curator Roxana Marcoci; drawing with magic marker on Donald B. and Catherine C. Atrium.

Solo exhibition: "Perjovschi," Culturgest, Porto, Portugal; curator Nuno Faria; white chalk drawing on black walls.

Solo exhibition: "Original," Helga de Alvear Gallery, Madrid, Spain; Dan does five drawings, multiplies them by hand one hundred times, and presents them as sculptures.

Solo exhibition: "Cultural Resistance," Protokoll Studio, Cluj, Romania; curator Attila Tordai S.; mixed-media installation.

Solo exhibition: Remember My PIN? Museum fur Moderne Kunst, Passau, Germany; curator Hans-Peter Wipplinger; black marker drawing installation.

Group exhibition: "Footnotes," 2nd Moscow Biennial, Moscow, Russia; in the section curated by Iara Boubnova; drawings on the window of Federation Tower.

Group exhibition: "Still Life: Art, Ecology and the Politics of Change," Eighth Sharjah Biennial, Sharjah, United Arab Emirates; in the section curated by Eva Sharer; charcoal and marker drawing on the glass entrance, the cafeteria, and the parking lot of the art museum.

Group exhibition: "Think with your senses — Feel with your Mind. Art at Present Tense," 52nd Venice Biennale, Venice, Italy; curator Robert Storr; white chalk and black marker in Arsenale and Giardini Italian Pavilion.

Group exhibition: "This Place Is My Place," Kunstverein, Hamburg, Germany; curator Yilmaz Dziewior; Dan does *This wall is my wall*, a black marker drawing.

Group exhibition: "Space Invader," SKUC Gallery Ljubljana, Slovenia; curator Alenka Gregoric; seventh fax project.

Group exhibition: "Last News," LAZNIA Centre for Contemporary Art, Gdansk, Poland; curators Magdalena Ujma and Joanna Zielinska; wall drawing.

Group exhibition: "Comix," Kunsthalle Brandts, Odense, Denmark; curator Anna Krogh; black marker wall drawing.

Group exhibition: "Europe-Europe," Swiss Institute, Paris; curator Michel Ritter; white chalk wall drawing.

Group exhibition: "Altenburg-Provinz Europa," Lindenau Museum, Altenburg; curator Matthias Flugge; wall drawing.

Artist book, *Postmodern Excommunist*. Edited by Marius Babias. Cluj, Romania: IDEA.

Fig. 379

Fig. 378

Contributors

Kristine Stiles is professor of Art, Art History & Visual Studies. Her expertise is in contemporary art, with a specialization in performance, destruction, violence, and trauma in art. She is the recipient of numerous fellowships, including a J. William Fulbright to Romania and a John Simon Guggenheim for her work on documentary photography of the nuclear age. She has published widely in u.s. and international art journals. Stiles is co-editor with Peter Selz of *Theories and Documents of Contemporary Art: A Sourcebook of Artists' Writings* (1996), forthcoming in 2008 in a revised, expanded 2nd edition. Stiles's forthcoming books include: *Concerning Consequences of Trauma in Art and Society* (The University of Chicago Press, 2009); *Correspondence Course: An Epistolary History of Carolee Schneemann and her Circle* (Duke University Press, 2009); and co-authored with Kathy O'Dell, *World Art Since 1945* (Laurence King Publishers, 2011).

Andrei Codrescu was born in Sibiu, Romania, and immigrated to the United States in 1966. Codrescu has authored over fifty books including works of poetry, fiction, essays, memoirs, and travelogues. He edits *Exquisite Corpse: A Journal of Life & Letters* (online at www.corpse.org), is a regular columnist for National Public Radio's "All Things Considered," and MacCurdy Distinguished Professor of English at Louisiana State University in Baton Rouge. He won the Peabody for his film *Road Scholar*, and is the recipient of other awards, including The Big Table Poetry Award, the Literature Prize of the Romanian Cultural Foundation, and the American Civil Liberties Union Freedom of Speech Award.

Marius Babias, director of the Neuer Berliner Kunstverein (NBK), was born in Romania and studied literature and political science at the Free University in Berlin. In 1996 he won the Carl Einstein Prize for Art Criticism. He was artistic co-director at the Kokerei Zollverein | Zeitgenössische Kunst und Kritik in Essen from 2001 to 2003. He was commissioner of the Romanian Pavilion at the 51st Venice Biennale (2005), and has curated the exhibitions "The New Europe," Generali Foundation, Vienna, and "Formats for Action," Neuer Berliner Kunstverein, Berlin. He co-curated the 2006 Periferic 7 — International Biennale of Contemporary Art in Iasi, Romania. Babias teaches art theory at Universität der Künste, Berlin. He has edited *Im Zentrum der Peripherie* (1995), and co-edited *Die Kunst des Öffentlichen* (1998), *Arbeit Essen Angst* (2001), *Campus* (2002), *Handbuch Antirassismus* (2002), *Critical Condition — Writings by Julie Ault, Martin Beck* (2003), and *The Balkans Trilogy* (2007). Babias is also the author of *Herbstnacht* (1990), *Ich war dabei, als . . .* (2001), *Ware Subjektivität* (2002), and *Berlin: Die Spur der Revolte* (2006). He lives in Berlin.

Roxana Marcoci, Curator, Department of Photography, Museum of Modern Art, has organized a number of exhibitions at MOMA including "Projects 85: Dan Perjovschi—WHAT HAPPENED TO US?" (2007); "Comic Abstraction: Image-Breaking, Image-Making" (2007); "New Photography 2006: Jonathan Monk, Barbara Probst, Jules Spinatsch" (2006); the retrospective "Thomas Demand" (2005); "Worlds and Views: Contemporary Art from the Collection" (with Klaus Biesenbach, 2005); "Projects 82: Mark Dion—Rescue Archaeology" (2004); "Projects 80: Lee Mingwei—The Tourist" (2003); "Projects 73: Olafur Eliasson—Seeing Yourself Sensing" (2001); and "Counter-Monuments and Memory" (2000). She is also the curator of the exhibitions "Here Tomorrow" (Museum of Contemporary Art, Zagreb, 2002); and "Clockwork 2000" (Clocktower/P.S.1, 2000). In addition to the publications accompanying her exhibitions, Ms. Marcoci has written widely on modern and contemporary art and is currently working on a survey exhibition of Olafur Eliasson's work scheduled to open at MOMA and P.S.1 in April 2008. Ms. Marcoci holds a Ph.D. in twentieth-century art history and criticism from the Institute of Fine Arts, New York University.

Exhibition Checklist

All artwork courtesy of the artists, unless otherwise stated.

All measurements are height precedes width precedes depth.

Works by Dan and Lia Perjovschi

Black and white and color compilation video
Performances by Dan Perjovschi, 1988–2003, and Lia Perjovschi, 1988–2005
Approximately sixty minutes
Courtesy of the artists and the Nasher Museum of Art at Duke University
Historical documents; artist books, magazines, and newspapers; catalogues; photographs; ephemera

4 Us, 1992
Cellar installation in "Transparency," Podul Gallery, Bucharest
Black and white photograph
6 ¼ x 4 ½ inches
Photo: Iosif Kiraly

Commissioned Works

Dan Perjovschi
The Duke Drawing, 2007
Drawing installation with black marker on windows
Nasher Museum of Art at Duke University
Courtesy of the artist and Lombard-Freid Projects

Lia Perjovschi
Knowledge Museum, 2007
Drawing installation, pen on paper, entrance to the Nasher Theater
Nasher Museum of Art at Duke University

Works by Dan Perjovschi

Scroll I, 1986
White ink on black carbon paper
63 x 9 ⅞ inches
Courtesy of Collection Brad Marius, Sibiu

Scroll II, 1986
White ink on black carbon paper
107 x 15 ¾ inches
Courtesy of private collection

Cycle Anthropograme I, 1986
Ink on beige paper
18 ½ x 21 inches

Cycle Anthropograme II, 1986
Ink on beige paper
19 x 25 inches

Confessional I, 1986–1994
Three-sided installation of thirteen panels (four, five, four)
Drawings scratched into carbon paper rolls, one roll with mirror
Each panel 80 x 10 inches

Red Apples, 1988
Drawing; installation in the artists' flat in Oradea
Six black and white photographs
Each photograph 5 x 7 ½ inches
Photo: Dorel Gaina

Perjovschi, 1989
Poster from Galeria Orizont, Atelier 35, Bucharest
21 ¼ x 33 inches

State of Mind Without A Title, 9–11 May 1991
Performance/drawing installation
Timisoara
Two black and white photographs
4 ½ x 6 ¾ inches
7 ¾ x 7 ⅛ inches
Photo: Iosif Kiraly

Cover page of *Revista 22* [Bucharest], issue 100, 1991
16 ½ x 11 ⅘ inches

Revista 22 [Bucharest], 1991–2006
Stack of eleven bound volumes of *Revista 22*, newspaper with Dan's drawings
Each volume 16 x 11 x 2 inches

Anthropoteque, 1990–1992
Installation, ink and watercolor on pastel paper
120 x 192 inches
Courtesy of Ludwig Forum für Internationale Kunst, Aachen, Sammlung Ludwig

Scan, 1993
Three canvases with ink drawings, computerized scanner, and monitor with closed-circuit video and live Internet broadcast
Together 197 ½ x 118 ½ inches
Scanner redesigned and fabricated by Tackle Design, Durham, North Carolina

Manual Scan, 1994
Ink on canvas drawing, iron frame, crank to turn the drawing
25 x 40 x 10 inches

Romania, 1993
(Timisoara); Photo: Stelian Acea.
Erased Romania, 2003
(Kassel); Photo: Niels Klinger.
Installation, black-and-white and color video of the two performances and print of Dan's 2002 promissory letter to have tattoo removed
11 ½ x 8 ¼ inches
Courtesy of the artist and Galerija Gregor Podnar, Ljubljana, Slovenia

Wonderful World (A), 1994–1997
Sixty units of flip drawings, pencil and ink on paper
Each unit 8 ¼ x 11 ¾ inches
Courtesy of the Museum of Modern Art, New York, purchased with funds provided by the Friends of Contemporary Drawing, 2006

Wonderful World (B), 1994–1997
Forty units of flip drawings, pencil and ink on paper
Each unit 8 ¼ x 11 ¾ inches
Courtesy of Lombard-Freid Projects, New York

Wonderful World (Flat Unit), 1990–1991
Ink drawing with collaged photograph from Romanian Revolution
8 ½ x 12 inches
Courtesy of private collection

Wonderful World (Flip Unit), 1988, 1994
Background from 1988, flip drawing from 1994
8 ¼ x 12 inches
Ink on paper
Courtesy of private collection

Post R, 1995
Four posters printed on paper
Each poster 18 x 25 inches

Postcards from America, 1994–1995
Installation, five hundred postcard drawings
Each postcard approximately 3 x 5 inches
Courtesy of Lombard-Freid Projects, New York

PLEASE USE A BALLPOINT PEN FOR RECORDING GRADES, 1997
Artist book containing seventeen drawings by Dan Perjovschi's Duke University students
End papers: Dan Perjovschi's drawings of portrait heads in a grid, pen and ink
9 ⁹⁄₁₆ x 5 ¾ inches
Courtesy of private collection

Press Stress, 1999
Wall installation, *Revista 22* and other newspapers for which Dan Perjovschi has made drawings, Romanian lei imprinted with the image of artist Constantin Brancusi, folded into boats
120 x 191 inches
Courtesy of Collection Marius Babias, Berlin

rEST, 1999
Marker on floor
Installation view of Romanian Pavilion, 48th Venice Biennale
Cibachrome, 48 x 75 inches
Photo: Lia Perjovschi

White Chalk Dark Issues, 2003
Chalk on walls
Installation view in "Open City Model for Use," Kokerei Zollverein, Essen
Cibachrome, 48 x 75 inches
Photo: Wolfgang Günzel

On the Other Hand, 2006
Black marker on wall, chalk
on floor
Installation view in Portikus,
Frankfurt-am-Main
Cibachrome, 48 × 75 inches
Photo: Wolfgang Günzel
Courtesy of Portikus, Frankfurt-
am-Main

Perjovschi: DAN, 1992
Newspaper, 16 5/16 × 11 1/2 inches

Post R, 1995
Newspaper, 16 1/4 × 11 3/8 inches

Anthropogramming, 1996
Newspaper, 16 1/4 × 11 1/2 inches

Piece & Piece, 1999
Newspaper, 15 × 10 1/4 inches

Flow, 2001
Newspaper, 16 1/4 × 11 inches

New Ideas — Old Tricks, 2001
Newspaper, 17 1/4 × 12 3/16

Dan Perjovschi in balcon, 2001
Newspaper, 12 3/4 × 9 1/2 inches

art of today — yesterday news, 2002
Newspaper, 16 5/16 × 11 3/16 inches

*No Vacancies: Artist in Residence to
Festival City (Unofficial)*, 2004
Newspaper, 16 × 11 3/4 inches

Railway Station, 2004
Newspaper, 16 1/2 × 11 3/4 inches

Tank You, 2006
Newspaper, 16 1/2 × 11 5/16 inches

WHAT HAPPENED TO US?, 2007
Newspaper, 15 × 11 1/2 inches

Postcards from America. New York:
Pont La Vue Press, 1995.

Pressed Drawings. Bucharest:
Dan Perjovschi, 1996.

rEST. Romanian Pavilion, 48th
Venice Biennale. Bucharest:
Minister of Culture, 1999.

Vis-à-vis. Bucharest: Nemira,
2000.

Castle Stories. La Napoule, France:
Edition La Mancha and La Napoule
Art Foundation, 2000.

*Walls, Floors, Museums, and Mines
1995 – 2003*. Cluj: IDEA, 2003.

Autodrawings. Göppingen:
Kunsthalle, 2003.

I Draw – I Happy. Koln: Schnit-
traum and Walter König, 2004.

Naked Drawings. Cologne: Museum
Ludwig and Walter König, 2005.

Toutes Directions. Quimper:
Le Quartier Centre d'art contem-
porain de Quimper, 2005.

A Book with an Attitude. Geneva:
Edition et Diffusion Attitudes,
2007.

Cover design for H.-R. Patapievici.
Politice. Bucharest: Humanitas,
1996.

Cover design for Herma Köpernic
Kennel. *Jogging cu Securitatea:
Rezistenta tanarului Radu Filipescu*.
Bucharest: Editura Universal
Dalsi, 1998.

Cover design for H.-R. Patapievici.
Cerul vazut prin lentila. Editura
Polirom, 2005.

Artist's postcards, dates, and
dimensions variable

Works by Lia Perjovschi

Don't See, Don't Hear, Don't Speak,
December 1987
Performance, Academy of
Fine Arts, Bucharest
Four black and white photographs
One at 5 × 7 inches; three at
2 7/8 × 7 inches
Photo: Dan Perjovschi

Test of Sleep, June 1988
Performance in the artist's
flat, Oradea
Thirty-six black and white
photographs mounted on black
cardboard, 27 3/4 × 37 3/4 inches
Each photograph 3 5/8 × 5 1/2 inches
Photo: Dan Perjovschi

Annulment, September 1989
Performance in the artists'
flat, Oradea
Nine black and white photographs
Each photograph 3 3/8 × 5 1/4 inches
Photo: Dan Perjovschi

For My Becoming in Time,
October 1989
Performance, Academy of Fine
Arts, Bucharest
Thirty-six black and white
photographs mounted on black
cardboard, 27 3/8 × 39 1/2 inches
Each photograph 3 5/8 × 5 1/2 inches
Photo: Dan Perjovschi

Magic of Gesture/Laces,
November 1989
Performance/experiment, Acad-
emy of Fine Arts, Bucharest
Twenty black and white photo-
graphs mounted on black
cardboard, 27 1/2 × 37 1/2 inches
Each photograph 3 1/2 × 5 1/2 inches
Photo: Dan Perjovschi

Our Withheld Silences, 1989
Three balls: strips of paper, tex-
tile, printed text, and mixed media
Large ball: 50 1/4 inches in circum-
ference; medium ball: 31 inches in
circumference; medium ball: 34
inches in circumference

Our Withheld Silences, 1989
Medium ball: strips of paper,
printed text, and mixed media,
27 inches in circumference
Courtesy of private collection

Map of Impressions, 1989
Five costume/sculptures: paper,
newspaper, paint, thread, staples,
and other media
"Sexy/Frivol": 44 × 22 1/2 × 7 inches
"Paper Drawing": 39 × 24 × 5 1/2
inches
"Black": 46 1/2 × 19 × 8 1/2 inches
"White": 46 1/2 × 18 1/2 × 6 1/2 inches
"Ripped from Wall": 44 × 22 × 6
inches

Instead of Nothing, 1990
Performance, Sibiu
Black and white photograph
7 × 5 inches
Photo: Anonymous

Mail Art/Discreet Messages,
1985 – 1988
Twenty-four envelopes infused
with textile colors by boiling;
dried and ironed, some painted,
some collaged
Each envelope 4 1/8 × 7 1/2 inches

Nameless State of Mind, June 1991
Performance, Timisoara
Sixteen black and white
photographs
Each photograph 5 × 7 inches
Photo: Dan Perjovschi

*Prohibited Area to Any External
Utterance*, 1991
Performance, Costinesti,
Black Sea Coast
Sixteen black and white
photographs
Each photograph 5 × 7 inches
Photo: Marius Baragan

*Prohibited Area to Any External
Utterance*, 1991
Objects from the performance,
Costinesti, Black Sea Coast
Paper artifacts with text in
Romanian, wrapped in red
tissue paper
6 1/4 × 4 3/4 inches
Paper text 5 7/8 × 7 3/8 inches
Red tissue and paper text
9 1/4 × 9 3/4 inches

32 Moments in the Life of Hands,
1993
Eight paintings, oil on canvas
Each painting 10 × 13 1/2 inches

32 Moments in the Life of Hands,
1993
Two sheets of paper, each
with black and white photograph
and graphite drawing
Each set of photograph and
drawing 4 3/4 × 9 3/8 inches

*I'm fighting for my right to be
different*, July 1993
Performance, Art Museum,
Timisoara
Sixteen black and white photo-
graphs; fifteen at 3 1/4 × 5 1/4
inches; one at 4 1/2 × 3 1/4 inches
Photo: Dan Perjovschi

Visual Archives of Survival,
1994, 1996
Pillowcases screen-printed with
images of the artist's work, 1994
Pillowcases screen-printed
with the entire contents (im-
ages and texts) of Lia Perjovschi's
monograph, *amaLIA Perjovschi*.
Bucharest: Soros Center of Con-
temporary Art, 1996
Three pillowcases at 16 x 16
inches; ten at 16 x 24 inches

Hidden Things, 1996
Three collages embedded in hand-
made paper
Each collage 10 x 12 ½ inches

Hidden Things, 1996
Four ink drawings on hand-
made paper
10 ½ x 13 ⅜; 11 x 13 ⅛; 13 x 10 ½;
14 x 11 inches

Hidden Objects, 1996
Three balls: styrofoam covered
with handmade paper
Circumference black 19 ¾; white
and pink each, 19 inches

Hidden Object, 1996
One ball: styrofoam covered
with handmade paper and
graphite drawing
Circumference 18 ½ inches
Courtesy of private collection

Abdeckplane, 1996
Black marker on plastic sheet
196 ⅘ x 157 ⅖ inches flat; variable
dimensions installed

Abdeckplane, 1996
Black marker on plastic sheet
(colors faded in some areas to
purple and beige)
196 ⅘ x 157 ⅖ inches flat; variable
dimensions installed

Pain H Files, 1996–2003
Fourteen black ink and color pen
drawings on paper
Each drawing 11 ¾ x 8 ½ inches

Pain H Files, 1996–2003
Twenty-four mass-produced dolls,
hair removed, wrapped in gauze,
and painted in black or red
Each doll 5 x 3 ½ inches

Pain H Files, 1996–2003
Seventeen handmade plaster of
paris dolls, painted in black or red
Each doll 7 x 2 ½ inches

Pain H Files, 1996–2003
Plastic bag with variously colored
homeopathic pill containers
(bag is 8 x 12 x 2 ½ inches)
Pill containers, each approxi-
mately 1 ⅛ inches high

Perjovschi: LIA, 1992
Newspaper 16 ⁵⁄₁₆ x 11 ½ inches

*Contemporary Art Archive Center
for Art Analysis (CAA/CAA)*, artist's
newspapers, and *Critical Analytic
Art (CAA)* newspapers, 1 bound
volume 17 x 12 inches
a. *Zoom 1: diaPOZITIV*, 1998
b. *Zoom: 2 performance art;
3 foto video media; 4 teorie; caa 5
documente*, 2001
c. *Short Guide: Art in Public Space
(ro) some independent positions*,
2002
d. *Sens*, 2002
e. *caa contemporary art archive
and its context*, 2002
f. *lia perjovschi*, 2002
g. *Waiting Room*, 2003
h. *Normalcy Meaning Relaxation*,
2003
i. *Formats*, 2004
j. *Detective Draft*, 2005

Everything in View, 2000
Two ink on paper drawings
Each drawing 11 ⅝ x 8 ¼ inches

The Archive Plans, 1999–2003
Eight colored ink drawings on
postcard paper
Each drawing 3 x 5 inches

*Research File. My Subjective
Art History*, 1997–2004
Computer print, thirty-five pages
Each page 16 ⅝ x 11 ¾ inches

Research File. CAA Activities,
1990–2000
Color photocopy, ten pages
Each page 16 ⅝ x 11 ¾ inches

*Research File. General Timeline:
From Dinosaurs to Google Going
China*, 1997–2006
Collage and drawing on paper,
thirty-one pages
Each page 16 ⅝ x 11 ¾ inches

*Research File. Subjective History
of Romanian Culture in the Frame
of Eastern Europe and the Balkans,
from Modernism to the European
Union*, 2000–2007
Collage and drawing on paper,
thirty-one pages
Each page 16 ⅝ x 11 ¾ inches

*Research File. My Visual CV from
1961 to the present*, 1994–2006
Collage and drawing on paper,
ninety-four pages
Each page 16 ⅝ x 11 ¾ inches

Mind Maps (Diagrams),
1999–2006
Sixty ink drawings on paper
Each drawing 12 x 10 ½ inches

The Globe Collection, 1990–2007
Installation of over fifteen hun-
dred objects, including globes,
postcards, books, balloons, toys,
T-shirts, umbrella, balls, change
purses, perfume bottles, hats,
kitchen stuff, office stationery,
coins, stamps, beer cans, and ads
Variable dimensions installed

Chronology. London: Gallery Yujiro
Publications, 2006

amaLia Perjovschi. Bucharest:
Soros Center for Contemporary
Art, 1996

Endless Collection: 1990–Today.
Göppingen: Kunsthalle, 2003

*Zoom: Performance, Installation,
and Video Art*, 1997
Course packet, Duke University
Plastic envelope with seven sheets
of paper with drawings: "Installa-
tion Art;" "Performance;" "Video
Art;" "YOUR-own experience."
Invitation to exhibition at Bivens
Building, "Contemporary Art from
Romania: Dan and Lia Perjovschi."
Photocopy publication on Dan and
Lia's Bucharest open studio, and
magnifying loupe
13 x 9 ⅜ inches

Harun Farocki and Andrei Ujica

Harun Farocki and Andrei Ujica
Videograms of a Revolution, 1992
Color and black and white,
subtitles, 106 minutes
Harun Farocki, Producer
Courtesy of Harun Farocki and
Andrei Ujica, Berlin, Germany

Grosse, Julia. "Criticism on its Own Four Walls." *Die Tageszeitung* [Berlin] (11 July 2003): 17.

Guta, Adrian. "Arta (cultura) alternativa I, II." *Observator Cultural* [Bucharest] 252–253/254–255 (2005).

Hannula, Mika. "Gothenburg International Art Biennial." *NU, The Nordic Art Review* [Stockholm] 2:5 (2001): 79.

Hansen, Josee. "Archiviste du present." *Lezebuerger Land* [Luxembourg] 35 (1999): 17.

Harleman Carl Frederik. "Introduction." In *Dan Perjovschi: Piece & Piece*. Stockholm: Nortalje Konsthalle, 1999.

Hartmann, Serge. "Selest Art se leve a l'Est." *DNA* 11 (September 1997).

Hegyi, Dora. "Why Iasi?" *IDEA, arts+society* [Cluj] 24 (2006): 44–50.

Hinnsfors, Gunilla Grahn. "Med ett skarpt öga för var tid." *Goteborg-Posten* (14 July 2001).

Horny, Henriette. "Venedig: Die Bestern Pavillons." *Kurier* [Vienna] (1999).

Kahn, Robin, "Identity: Lia Perjovschi." In Robin Kahn, ed., *Time Capsule: A Concise Encylopedia by Women Artists* (New York: D.A.P./Distributed Art Publisher, 1995): 274–275.

Kessler, Erwin. "Perjoteca." *Revista 22* [Bucharest] no. 28 (1998): 14.

Kidner, Dan. "Are you glocal (Interview with Dan Perjovschi)." *Untitled* [London] 38 (Summer 2006): 4–9.

Kipphoff, Petra. "Die Kunst die Exorzierens." *Die Zeit* [Hamburg] 47 (2004).

Koplos, Janet. "Dan Perjovschi at Franklin Furnace." *Art In America* 84 (July 1996): 91–92.

Krajewski, Michael. "Die Welt in Bleistifftformat." *Stadt Revue* [Cologne] 12 (2004).

————. "Zeichen als Subversion." *Kunst Bulletin* [Zurich] 9 (2005): 38–40.

Krausch, Christian. "Invitatie-invitation-Einladung: Kunsthaus Essen." *Kunstforum International* 156 (2001): 381–383.

Lepicard, Agnes. "Le Nuage Magellan." *art 21: magazine critique d'art contemporain* [Paris] 11 (March–April 2007): 48–51.

Leydelier, Richard. "Printemps sur la Cote: Divers lieux." *Art Press* 259 (July/August 2000): 84.

Lorch, Catrin. "Helden zu Strichmannchen, Dan Perjovschi nennt die Dinge in Koln beim namen." *Frankfurter Allgemeine Zeitung* (6 August 2005): 34.

————. "Writing on the Wall." *Frieze* (April 2006): 136–139.

Lunghi, Enrico. "Le suspect habituel." *Lezebuerger Land* [Luxembourg] 26 (1998): 11.

Marcoci, Roxana. "Romanian Democracy and Its Discontents." In Laura J. Hoptman, ed., *Beyond Belief: Contemporary Art from East Central Europe*. Exhibition catalogue. Chicago: Museum of Contemporary Art, 1995.

Martinez, Rosa. "Manifesta." *Flash Art* (November/December 1998): 102.

Mihali, Ciprian. "A Globe, a World, a Sense." In Werner Meyer, ed., *Lia Perjovschi, Endless Collection: 1990–Today*. Göppingen: Kunsthalle, 2003.

Modreanu, Cristina. "Ambasadorul Perjovschi." *Gandul* [Bucharest] (20 January 2007).

Morton, Tim. "Dan Perjovschi, Nathaniel Mellors & A. Araminas." *Untitled* [London] 28 (2002).

Moulton, Aaron. "Periferic 7 and Bucharest Biennale 2." *Flash Art* (July–September 2006): 47, 53.

Musat, Carmen. "Desant cultural la TV." *Observator Cultural* [Bucharest] 33 (10–16 October 2000).

Mytkowska, Joanna. "A Museum Cannot Be an Implant (Interview with Dan Perjovschi)." *Le Nuage Magellan. Une perception contemporaine de la modernite* (Paris: Edition du Centre Pompidou, 2007): 60–68.

Nastac, Simona. "Ich Habe Keine Zeitraum." *Observator Cultural* [Bucharest] 179 (2003): 16.

————. "Institute for the Development and Exploration of Art London/Perjovschi." www.idealondon.co.uk (2005).

————. "Back to Back." *Prezent* [Bucharest] (4 March 2006): 12.

————. "Just a little bit of history repeating: Lia Perjovschi." In Andréa Adcock and Dale Adcock, eds., *Chronology*. Exhibition catalogue (London: Yugiro Gallery, 2007): 39–40.

Nori, Franziska. "On Difference #1, Local Context-Hybrid Spaces." *IDEA: Art+Society* [Cluj] 21 (2005): 68–73.

Oisteanu, Andrei. "Object-books made by Romanian Artists." *New Observations* 106 (1995).

Obrist, Hans Ulrich. "Dan Perjovschi." *Vitamin D: New Perspectives in Drawing*. London: Phaidon, 2005.

Osipovich, Alexander. "Reaching for New Heights: The Moscow Biennale kicks off its flagship event in an unlikely venue—the Federation Tower." *Moscow Times* (2 March 2007).

Paldi, Livia. "Nothing Wrong with being Intellectual: Email interview with Dan Perjovschi." In Edit Molnar and Livia Paldi, eds., *Perjovschi, El-Hassan, E-Flux* (Budapest: Kunsthalle Budapest, 2006): 12–19.

Perjovschi, Dan. "History, A Project." Octavian Esanu, ed., *Messages from the Countryside, Reflections in RE* (Chisinau: Soros Center for Contemporary Art: 1997): 58, 72.

————. "Harta cu Sens." *Revista 22* [Bucharest] 33 (2002): 13.

————. "Lia Perjovschi: Voice Activated Installation." *Gazet'art Magazine for South-East European Contemporary Art Network/Springerin*, Vienna (2002): 4–5; and *Praesens* [Budapest] 2 (2002).

————. "Lia Perjovschi: Alone for the Others." *Again for Tomorrow*. Exhibition catalogue (London: Royal College of Art, 2006): 116–121.

Perjovschi, Lia. "Approach." In Octavian Esanu, ed., *Messages from the Countryside, Reflections in RE* (Chisinau: Soros Center for Contemporary Art: 1997): 59.

————. "Interview with Alina Mungiu-Pippidi." In Matei Bejenaru and Anders Kreuger, eds., *Prophetic Corners*. Exhibition catalogue for *Periferic 6* (Iasi: Vector Association, 2003): 58–61.

Perjovschi, Lia and Dan Perjovschi. "Passing/Intervention." In Judit Angel, ed., *Inter(n)*. Exhibition catalogue (Arad: Museum of Art, 1995): 14–21.

Pintilie, Ileana. *Zone 1: International Performance Festival*. Exhibition catalogue (Timisoara: Ileana Pintilie, 1993).

————, ed. *Orient Occident*. Exhibition catalogue (Bucharest and Timisoara: Ministry of Culture; Soros Center of Contemporary Art; Museum of Art, 1994): 84–85.

———. *Zone 2: International Performance Festival.* Exhibition catalogue (Bucharest and Timisoara: Soros Center for Contemporary Art, 1996): 12, 21.

———. "The Public and the Private Body in the Romanian Contemporary Art." In Zdenka Badovinac, ed., *Body and the East: From the 1960s to the Present.* Exhibition catalogue. Lublijana: Museum of Modern Art, 1998.

———. *Zone 3: International Performance Festival.* Exhibition catalogue. Timisoara and Cluj: Pro Helvetia, 1999.

———. "Problems in Transit: Performance in Romania." *ARTMargins* (February 2000): www.artmargins.com.

———. "Drawing for Freedom: Interview with Dan Perjovschi." Stedelijk Museum BULLETIN [Amsterdam] 3 (2006): 36–39.

Pisano, Hortensia. "Ideen, die wanders." *Art Kaleidoscope Art Journal for Frankfurt and Rhine-Main* [Frankfurt] 3 (2006): 8–12.

Polkinhorn, Maeve. "A Small Democratic Triumph." *Vector* [Iasi] 2 (2006): 179–186.

Reckert, Annett. "About Seeking and Seeing." In Werner Meyer, ed., *Lia Perjovschi, Endless Collection: 1990–Today.* Göppingen: Kunsthalle, 2003.

Rossi, Federica. "Dan Perjovschi. Galerie Michel Rein." *Flash Art* 253 (March/April 2007): 131, 132.

Santos, Juan Jose. "Dan Perjovschi. Galeria Helga de Alvear." *Lapiz. Revista Internacional de Arte* [Madrid] 230/231 (2007): 197.

Sauquet, Silvia. "E-Mail Conversation with Dan Perjovschi." *First Class* eds. Barcelona: Fondacion La Caixa, 2006.

Schmidmaier, Irmgard. "A for Adult. Dizzy wie Dan." *Lezebuerger Land* [Luxembourg] 40 (2002): 24.

Schmidt, Kirstin. "Lia Perjovschi." In Friedemann Marsch, ed., *Auszeit. Kunst und Nachhaltigkeit.* Exhibition catalogue. Liechtenstein: Kunstmuseum Liechtenstein, 2007.

Seidl, Walter. "The Drawings of Dan Perjovschi." *Report. Magazine for Arts and Civil Society in Central Europe* [Vienna] 2 (2005): 24–25.

Serban, Alina. "Sfarsitul inocentei." *Arhitext* [Bucharest] 2 (2005): 42–44.

Sherwin, Skye. "Consumed." *Art Review* (March 2007): 38.

Snodgrass, Susan. "Post-Communist Expressions." *Art in America* 88:6 (June 2000): 47–51.

Stanca, Dan. "O expozitie de expozitii." *Romania Libera* [Bucharest] (15 November 2001).

Stange, Raimar. "Die Offene Stadt: Anwendungsmodelle." *Artist Kunstmagazin* 56 (2003): 40–45.

Stefanescu, Cecilia. "Vid ID." *Independent* [Bucharest] (20 November 2001).

Stefanescu, Marius. "O galerie internet fara computer [An Internet Gallery without Computer]." *Cotidianul* [Bucharest] (28 November 2001).

Stegerean, Calin. "Interviu cu Dan Perjovschi." *Steaua* [Cluj] 4–5 (2006): 123–125.

Stein, Judith E. "Out of the East." *Art in America* (April 1998): 50–55.

Stiles, Kristine. "Shaved Heads and Marked Bodies: Representations from Cultures of Trauma." *Strategie II: Peuples Mediterraneens* [Paris] 64–65 (1993): 95–117; reprinted with a new Afterword in

Jean O'Barr, Nancy Hewitt, Nancy Rosebaugh, eds., *Talking Gender: Public Images, Personal Journeys, and Political Critiques* (Chapel Hill: University of North Carolina Press, 1996): 36–64; excerpted in *Dan Perjovschi: Anthropogramming* (New York: Franklin Furnace, 1996); excerpted in *Lusitania* 6 (1994): 19–25; excerpted in German in *kursiv* 2–3 (1995): 19–25; excerpted in numerous Romanian journals 1994–present; reprinted in Bruce Lawrence and Aisha Karim, eds., *The Chain of Violence: An Anthology* (Durham: Duke University Press, 2007).

———. "Romanica: A Pataphysical Field of Consciousness." In Dan Perjovschi, *Postcards from America* (New York: Pont La Vue Press, 1995); reprinted in *Figurative: Beginning and End of the 20th Century in Romania* (Amsterdam: COBRA Museum for Modern Art); excerpted in "Dan Perjovschi," *IV St. Petersburg Biennale* (St. Petersburg, Russia, 1997): 113; excerpted in a special issue on "The Fringe," *Oxymoron* 2 (1998): 21–25.

———. "Shadows in a Vertical Life: amaLia Perjovschi." In Lia Perjovschi, *amaLIA Perjovschi.* Bucharest: Soros Center of Contemporary Art, 1996; excerpted in *Ad Hoc: Romanian Art Today* (Ludwig Museum, Budapest, 1996); excerpted in *Artelier* 5 (Winter 1999/2000): 42–43.

———. "Concerning Public Art and 'Messianic Time.'" In Marius Babias and Achim Konneke, eds., *Art & Public Spaces* (Hamburg: Kulturbehürde, 1997): 48–65; excerpted in *Balkon* [Cluj] 7 (June 2001): 39–40; excerpted in *Manifesta 2: European Biennial of Contemporary Art* (Luxembourg: Imprimerie Centrale S.A, 1998); excerpted in Romanian for the *Annual Literary Supplement* [Bucharest] 50:460 (December 1998): 6–8; excerpted in *Balcon* 7 (June 2001): 11–12.

———. "INSIDE/OUTSIDE: Balancing Between a Dusthole and Eternity." In Zdenka Badovinac, ed., *Body and the East: From the 1960s to the Present* (Ljubljana: Museum of Modern Art, 1998): 19–30.

———. "300 words on Dan Perjovschi." In *After the Wall: Art and Culture in Post-Communist Europe* (Stockholm: Moderna Museet, 1999): 153; excerpted in *Semaine: Institut d'art contemporain* [Villeurbanne] 12 (2004): n.p.

———. "Comisuri: art-actiunile ca obiecte." Translated by Adriana Bancea. *Balkon* [Cluj] 2 (March 2000): 3–4.

———. "Remembrance, Resistance, Reconstruction, The Social Value of Lia and Dan Perjovschi's Art." *IDEA, arts+society* [Cluj] 19 (March 2005); reprinted in Marius Babias, ed., *European Influenza* (Venice: Romanian Pavilion, 51st Venice Biennale, 2005): 574–612; excerpted in Lia Perjovschi, *Detective Draft* (Bucharest and Wurttemberg: CAA/CAA and Wurttemberghirscher Kunstverein, 2005); excerpted in Iris Dressler, ed., *On Difference.* (Stuttgart: Kunstverein, 2007).

Stjernstedt, Mats. "Dan Perjovschi." *Contemporary* 21 (Summer 2006): 84–87.

Susara, Pavel. "Despre artisti, institutii si critici." *Romania Literara* [Bucharest] 7 (1998).

———. "Instalatia-un curs aplicat [Installation—An Applied Course]." *Romania Literara* [Bucharest] 19 (1998).

Taylor, Candice. "Magic Marker On the Museum Walls." *New York Sun* (26 April 2007): 1, 23.

Tordai, Attila S. "Unstable Narratives. Hartware Medien Kunstverein, Dortmund." *Balkon* [Cluj] 10 (2002): 48–49.

———. "Unde este omul? In abstractia libertatii." *Balkon* [Cluj] 12 (2002): 47.

———. "Working Title." *Balkon* [Cluj] 12 (2002).

———. "Aperto Romania." *Flash Art* 233 (2003): 61–63.

Urquhart, Donald. "Artforum Picks." *Artforum International* 44:1 (2005): 108.

Vladareanu, Elenna. "Nici Gica contra, nici contra, doar Perjovschi: Interview with Dan Perjovschi." *Averea* [Bucharest] (30 January 2006).

———. "Sint un detectiv in istoria artei" [I am a Detective in Art History], Interview with Lia Perjovschi. *Romanian Libera* [Bucharest] (8 January 2007).

Voinea, Raluca. "The Globes of Lia Perjovschi." *e-cart* 1, www.e-cart.ro (2003).

———. "The Artist Fallen into History." In *Dan Perjovschi: Walls, Floors, Museums, and Mines 1995–2003* (Cluj: IDEA, arts+society, 2003).

———. "CAA: A Project by Lia Perjovschi." *Vector* [Iasi] 1 (2005): 99–104.

———. "Contemporary Art Archive" [Interview with Lia Perjovschi]. *e-cart* 6, www.e-cart.ro (2005).

Volkart, Yvonne. "Complexul Muzeal, Das Museum als Import-Export-Agentur." *Springerin* [Vienna] 4 (1996).

———. "Complexul Muzeal." *Flash Art* (1997).

Wege, Astrid. "Cologne, Dan Perjovschi at Schnittraum." *Artforum International* 43: 8 (April 2005): 199.

Wilson, Michael. "Graphic Equalizer: Michael Wilson on Dan Perjovschi." *Artforum International* 44:9 (May 2006): 83–84.

Ziaja, Luisa. "The New Europe: Culture of Mixing and Politics of Representation: Generali Foundation, Vienna." *Flash Art* (International Edition) 38 (May/June 2005): 88.

Zolyom, Franciska. "Changing Dance-Card: Aspects of the Art of Central and Eastern Europe of the 1990s." In Franciska Zolyom and Katalin Neray, eds., *Rondo: A Selection of Works by Central and Eastern European Artists*. Exhibition catalogue (Budapest: Ludwig Museum of Contemporary Art, 1999): 14–21.

Selected General Books on or Related to Romanian History and Contemporary Art

Arendt, Hannah. *The Origins of Totalitarianism*. New York: Harcourt Brace Jovanovich, 1951.

Aubin, Stephen P. *Portrait of a Romanian Revolution: Massacres, Monsters, and Media Manipulation*. Washington, DC: Woodrow Wilson International Center for Scholars, 1992.

Babias, Marius, ed. *European Influenza*. Exhibition catalogue. Venice: Romanian Pavilion, 51st Venice Biennale, 2005.

———, ed. *The New Europe: Culture of Mixing and Politics of Representation*. Exhibition catalogue. Vienna and Cologne: Generali Foundation; Walther König, 2005.

Babias, Marius, and René Block, eds. *Die Balkan-Trilogie*. Munich: Silke Schreiber, 2007.

Babias, Marius, and Achim Konneke, eds. *Art & Public Spaces*. Exhibition catalogue. Dresden: Verlag der Kunst, 1998.

Badovinac, Zdenka, ed. *Body and the East: From the 1960s to the Present*. Exhibition catalogue. Lublijana, Museum of Modern Art, 1998.

Badovinac, Zdenka, and Peter Weibel, eds. *2000+ The Art of Eastern Europe: A Selection of Works from Collections of Moderna Galerija Lublijana, Orangerie Congress-Innsbruck*. Exhibition catalogue. Vienna: Folio Verlag, 2001.

Banac, Ivo, ed. *Eastern Europe in Revolution*. Ithaca and London: Cornell University Press, 1992.

Bjelic, Dusan I., and Obrad Savic, eds. *Balkan as Metaphor: Between Globalization and Fragmentation*. Graz, Austria and Cambridge, MA: Neue Galerie am Landesmuseum Joanneum, 2002.

Boia, Lucian. *Romania*. Chicago: Reaktion Books, 2004.

Brinton, William M., and Alan Rinzler, eds. *Without Force or Lies: Voices from the Revolution of Central Europe in 1989–90: Essays, Speeches, and Eyewitness Accounts*. San Francisco: Mercury House, 1990.

Brown, James F. *Surge to Freedom: The End of Communist Rule in Eastern Europe*. Durham and London: Duke University Press, 1991.

Cârneci, Magda. *Art of the 1980s in Eastern Europe. Texts on Postmodernism, Mediana Collection*. Pitesti: Calin Valasie, 1999.

Codrescu, Andrei. *The Disappearance of the Outside: A Manifesto for Escape*. Reading, MA: Addison-Wesley, 1990.

———. *The Hole in the Flag: A Romanian Exile's Story of Return and Revolution*. New York: W. Morrow, 1991.

———. *The Blood Countess: A Novel*. New York: Simon & Schuster, 1995.

———. *The Devil Never Sleeps: And Other Essays*. New York: St. Martin's Press, 2000.

Conover, Roger, Eda Cufer, and Peter Weibel, eds. *In Search of Balkania*. Graz: Neue Galerie Graz am Landesmuseum Joanneum, 2002.

Crampton, R. J. *Eastern Europe in the Twentieth Century*. London and New York: Routledge, 1994.

Dan, Calin, and Alexander Tolnay, eds. *Erste Schritte: Rumänische Kunst der 90er Jahre*. Exhibition catalogue. Stuttgart: Institut für Auslandsbeziehungen, 1993.

Dan, Calin, ed. *Ex Oriente Lux*. Exhibition catalogue. Bucharest: Soros Center for Contemporary Art, 1994.

Drummond, Phillip, Richard Paterson, and Janet Willis. *National Identity and Europe: The Television Revolution, European Media Monographs*. London: BFI, 1993.

11th International Biennale of Small Sculpture. Exhibition catalogue. Slovenia: Murska Sobota Galerija, 1993.

Eric, Zoran, and Stevan Vukovic, eds. *The Last East European Show*. Exhibition catalogue. Belgrade Museum of Contemporary Art, 2003.

Faria, Nuno, ed. *Paradoxes: The Embodied City*. Exhibition catalogue. Lisbon: Calouste Gulbenkian Foundation, 2005.

Fehér, Ferenc, and Andrew Arato. *Crisis and Reform in Eastern Europe*. New Brunswick: Transaction Publishers, 1991.

Gabanyi, Anneli Ute. "Ideologiedebatte am Vorabend des 14. Parteitags: Ceausescu verteidigte den Sozialismus." *Südost-Europa* 11/12 (1989): 647–662.

Gallagher, Tom. "Nationalism and Romanian Political Culture in the 1990s." In Duncan Light and David Phinnemere, eds., *Post-Communist Romania: Coming to Terms with Transition* (London: Palgrave, 2001): 104–126.

———. *Outcast Europe: The Balkans, 1789–1989*. New York and London: Routledge, 2001.

———. "The Balkans Since 1989: The Rocky Road From National Communism." In Stephen White, ed., *Developments in Central and East European Politics 3* (London: Palgrave, 2003): 74–91.

———. *The Balkans After the Cold War: From Tyranny to Tragedy*. New York and London: Routledge, 2003.

Galloway, George, and Bob Wylie. *Downfall: The Ceausescus and the Romanian Revolution*. London: Futura, 1991.

Gross, Peter. *Mass Media in Revolution and National Development: The Romanian Laboratory*. Ames: Iowa State University Press, 1996.

Groys, Boris, ed. *Privatisations: Contemporary Art from Eastern Europe*. Exhibition catalogue. Frankfurt-am-Main: Revolver, 2005.

Gutov, Dimitrij. "Die marxisitisch-leninstische Ästhetik in der postkommunistischen Epoche. Michael Lifsic." In Boris Groys, Anne von der Heiden, Peter Weibel eds., *Zurück aus der Zukunft: Osteuropäische Kulturen im Zeitalter des Postkommunismus*. Frankfurt: Suhrkamp, 2005.

Hoptman, Laura, ed. *Beyond Belief: Contemporary Art from East Central Europe*. Exhibition catalogue. Chicago: Museum of Contemporary Art, 1995.

Hoptman, Laura J., and Tomas Pospiszyl, eds. *Primary Documents: A Sourcebook for Eastern and Central European Art since the 1950s*. New York: Museum of Modern Art, distributed by MIT Press, 2002.

Ion, Razvan, and Eugen Radescu, eds. *Pavilion 9, Chaos the Age of Confusion/Reader of the Bucharest Biennale 2*. Bucharest: Bucharest Biennale, 2006.

Kennel, Herma Köpernic. *Jogging cu Securitatea: Rezistenta tanarului Radu Filipescu* [Cover designed by Dan Perjovschi]. Translated by Nora Iuga. Bucharest: Editura Universal Dalsi, 1998.

Kiossev, Alexander. "Notes on Self-Colonizing Cultures." In Bojana Pejic and David Elliot, eds., *After the Wall: Art and Culture in Post-Communist Europe* (Stockholm: Moderna Museet, 1999): 114–117.

Kunze, Thomas. *Nicolae Ceausescu: Eine Biographie*. Berlin: Ch. Links, 2000.

Kravagna, Christian, ed. *Related Issues*. Arad: Museum of Art, 1997.

Krastev, Ivan, and Alina Mungiu-Pippidi, eds. *Nationalism after Communism: Lessons Learned*. Budapest: CPS Books, 2004.

Light, Duncan, and David Phinnemore. *Post-Communist Romania: Coming to Terms with Transition*. Houndmills, Basingstoke, Hampshire, and New York: Palgrave, 2001.

Manea, Norman. *On Clowns: The Dictator and the Artist: Essays*. New York: Grove Weidenfeld, 1992.

———. *The Hooligan's Return: A Memoir*. Translated by Angela Jianu. New York: Farrar, Strauss and Giroux, 2003.

McDermott, Kevin, and Matthew Stibbe, eds. *Revolution and Resistance in Eastern Europe: Challenges to Communist Rule*. Oxford: Berg, 2006.

Mungiu-Pippidi, Alina. *Romania after 2000: Threats and Challenges*. Bucharest: United Nations Development Programme, 2002.

———. *Politica dupa communism* [Politics after Communism]. Bucharest: Humanitas, 2002.

Mytkowska, Joanna. *Le Nuage Magellan: Une perception contemporaine de la modernite*. Paris: Edition du Centre Pompidou, 2007.

Oisteanu, Andrei, and Dan Perjovschi. *cARTe: Objects/Books made by Romanian Artists*. Exhibition catalogue. Amersfoort, Netherlands: De Zonnehof Cultural Center, 1993.

Pejic, Bojana. "Postkommunistische Körperpolitik: Die Politik der Repräsentation im öffentlichen Raum." In Marius Babias and Achim Könneke, eds., *Die Kunst des Öffentlichen*. Amsterdam and Dresden: Verlag der Kunst, 1998.

Pejic, Bojana, and David Elliot, eds. *After the Wall: Art and Culture in Post-Communist Europe*. Exhibition catalogue. Stockholm: Moderna Museet, 1999.

Rouillé, André, and Aleksander Bassin, eds. *Becomings: Contemporary Art in South-Eastern Europe*. Exhibition catalogue. Paris: Cultureaccess, 2001.

Roper, Steven D. *Romania: The Unfinished Revolution, Postcommunist States and Nations*. London: Routledge, 2004.

Rosenberg, Tina. *The Haunted Land: Facing Europe's Ghosts after Communism*. New York: Vintage Books, Random House, 1995.

Siani-Davies, Peter. *The Romanian Revolution of December 1989*. Ithaca: Cornell University Press, 2005.

Spatia Nova: IV St Petersburg Biennal. Exhibition catalogue. St. Petersburg, Russia: St. Petersburg Biennial, 1996.

Tismaneanu, Vladimir, ed. *The Revolutions of 1989*. London and New York: Routledge, 1999.

Titu, Alexandra, ed. *Experiment in Romanian Art after 1960*. Exhibition catalogue. Bucharest: National Theater; National Museum of Art at Cluj-Napoca; Soros Center for Contemporary Art, 1997.

Todorova, Maria I. *Imagining the Balkans*. New York: Oxford University Press, 1997.

Weissbort, Daniel, ed. *The Poetry of Survival: Post-War Poets of Central and Eastern Europe*. London: Penguin Books, 1991.

Westad, Odd Arne, Sven G. Holtsmark, and Iver B. Neumann. *The Soviet Union in Eastern Europe, 1945–89*. New York: St. Martin's Press, 1994.

Wye, Deborah, and Wendy Weitman, eds. *Eye on Europe. Prints, Books & Multiples, 1960 to Now*. New York: Museum of Modern Art, 2006.

Zolyom, Franciska, and Neray, Katalin, eds. *Rondo: A Selection of Works by Central and Eastern European Artists*. Exhibition catalogue. Budapest: Ludwig Museum of Contemporary Art, 1999.

Photo Credits

Individuals

Apostol, Corina: fig. 139, p. 76–77; fig. 145, p. 81.

Baragan, Marius: figs. 89–90, p. 55.

Edinger, Jack: fig. 11, p. 8; figs. 15–16, p. 10–11; fig. 17, p. 12; fig. 22, p. 16; figs. 27–28, pp. 20–21; fig. 50, p. 35; figs. 55–56, p. 39; figs. 60–68, pp. 42–43; fig. 72, p. 45; figs. 91–92, p. 55; figs. 116–118, p. 66; figs. 120–121, p. 68; fig. 131, p. 71; figs. 146–153, pp. 82–83; figs. 157–158, p. 86; figs. 163–168, p. 91; figs. 173–177, p. 95; figs. 181–184, pp. 98–99; fig. 210, p. 117; fig. 227, p. 123; fig. 230, p. 125; figs. 235–237, p. 128; figs. 241–268, pp. 134–147; fig. 276, p. 154; figs. 279–282, p. 155; figs. 287–293, pp. 158–159; figs. 301–304, pp. 170–171; figs. 314–315, p. 176; figs. 322–323, pp. 178–179; fig. 331, p. 183; fig. 335, p. 185; fig. 339, p. 188; figs. 345–347, pp. 192–193; fig. 352, p. 195; figs. 354–356, pp. 196–197; fig. 359, p. 198; fig. 362, p. 201; fig. 367, p. 204; fig. 374, p. 208; fig. 375, p. 210–211.

Gaina, Dorel: fig. 54, p. 38; figs. 273–275, p. 153.

Geoffrion, Peter Paul: figs. 23–24, p. 17; figs. 36–41, pp. 25–29; figs. 44–45, p. 31; fig. 71, p. 45; figs. 73–81, pp. 46–50; figs. 111–115, pp. 62–66; figs. 122–129, pp. 69–70; fig. 143, p. 80; figs. 185–188, pp. 100–101; fig. 191, p. 104; fig. 193, p. 105; fig. 221, p. 120; figs. 317–321, p. 177; fig. 334, p. 185; fig. 361, p. 201.

Kiraly, Iosif: back cover image; figs. 5–6, pp. 4–5; fig. 19, p. 14; fig. 20, p. 14; figs. 42–43, p. 30; figs. 46–49, pp. 32–34;

figs. 57–58, p. 40; fig. 277, p. 154; figs. 306–307, pp. 172–173; figs. 312–313, p. 175; fig. 337, p. 187; fig. 342, p. 191; fig. 344, p. 191; fig. 358, p. 199.

Martinoli, Ana: fig. 21, p. 15.

Perjovschi, Dan: fig. 10, p. 7; figs. 13–14, p. 9; fig. 59, p. 41; figs. 69–70, p. 44; figs. 82–88, pp. 52–54; fig. 95, p. 58; figs. 99–110, pp. 60–61; fig. 159, p. 87; figs. 170–171, p. 93; fig. 172, p. 94; fig. 189, p. 102; fig. 195, p. 107; figs. 200–209, pp. 116–117; figs. 211–220, pp. 118–120; figs. 224–225, p. 122; fig. 238, p. 129; fig. 295, p. 161; fig. 305, p. 172; fig. 308, p. 174; fig. 338, p. 189; fig. 351, p. 195; figs. 365–366, pp. 203; fig. 368, p. 205; fig. 369, p. 206; fig. 379, p. 213.

Perjovschi, Lia: front cover, both images; fig. 12, p. 9; fig. 18, p. 13; fig. 53, p. 37; figs. 93–94, pp. 56–57; figs. 96–98, pp. 58–59; fig. 144, p. 80; fig. 142, p. 79; figs. 154–156, pp. 84–85; fig. 161, p. 89; fig. 169, p. 92; fig. 192, p. 104; fig. 199, p. 109; fig. 222, p. 121; fig. 226, p. 123; fig. 231, p. 126; fig. 239, p. 129; fig. 294, p. 160; fig. 311, p. 175; fig. 324, p. 180; figs. 348–349, p. 193; fig. 353, p. 195; fig. 357, p. 197; fig. 358, p. 199; fig. 360, p. 200; fig. 364, p. 203; fig. 370, p. 207; fig. 373, p. 209; fig. 377, p. 213.

Shapira, Nathan: fig. 326, p. 182.

Stiles, Kristine: fig. 4, p. 3; fig. 119, p. 67; fig. 130, p. 71; figs. 132–134, p. 72; figs. 270–272, p. 152; figs. 309–310, p. 174; fig. 325, p. 181; fig. 340, p. 189; fig. 341, p. 190; fig. 350, p. 194; fig. 376, p. 212.

Vreme, Sorin: fig. 333, p. 185.

Museums, Galleries and Exhibitions

ARC Musée d'Art Moderne de la Ville de Paris, Le Couvent des Cordeliers, Paris: fig. 296, p. 161.

Exit Gallery, Peja, Kosovo, and Sokol Beqiri and Erzen Skololi: figs. 8–9, p. 6; fig. 233-234, p. 127.

Galerija Gregor Podnar, Ljubljana: fig. 363, p. 202.

Generali Foundation, Vienna, and Werner Kaligofsky: fig. 160, p. 88; fig. 316, p. 177.

Kokerei Zollverein Zeitgenössische Kunst Und Kritik, Essen, and © Wolfgang Günzel: fig. 197, p. 108; and Andreas Wissen: fig. 196, p. 107; fig 198, p. 109.

Kunsthalle Fridericianum Kassel, and Niels Klinger: fig. 138, p. 75; fig. 141, p. 78; fig. 300, p. 167.

Lombard-Freid Projects, New York, and Cristian Alexa: figs. 283–286, pp. 156–157; fig. 371, p. 206.

Ludwig Museum, DC Space, Cologne: fig. 178, p. 96; fig. 372, p. 207.

Ludwig Forum für Internationale Kunst, Aachen, Sammlung Ludwig: fig. 7, p. 6.

Moderna Museet, Stockholm, and Per-Anders Allstrom: fig. 180, p. 97.

Museum of Modern Art, New York, and Robin Holland: figs. 297–299, pp. 162–166; fig. 327, p. 182.

9th Istanbul Biennale, Istanbul, and Wolfgang Tragger: fig. 35, p. 24; figs. 51–52, p. 36.

Portikus, Frankfurt-am-Main, and © Wolfgang Günzel (Offenbach, Germany): fig. 194, p. 106.

Tate Modern, London, and Lia Perjovschi: frontispiece.; and Tudor Priscaru: fig. 378, p. 213.

Van Abbemuseum, Eindhoven, The Netherlands, and Peter Cox (Eindhoven): figs. 30-33, p. 22; fig. 179, p. 97.

Zona 1, curator Ileana Pintile Teleaga and Stelian Acea: figs. 135–137, pp. 73–74; fig. 343, p. 191.

Books and Films

Constantinescu, Stefan, and Cristi Puiu, and Arina Stoenescu, eds., *Archive of Pain: Testimonies from the Red Terror of Romania* (Stockholm: Pioneer Press, 2000): pp. 12–13. Photo by Goran Arnback and Pressens Bild: fig. 140, p. 78, fig. 330, p. 182.

Editura Meridiane, ed., *Vom muri si vom fi liberi* (Bucharest: Editura Meridiane, 1990), pp 109, 193, and inside cover. Photo: Irina Nicolau: figs. 25–26, pp. 18–19; endpapers.

Farocki, Harun and Andrei Ujica, *Videograms of a Revolution*, 1992. Harun Farocki Filmproduktion, Berlin: fig. 332, p. 184.

Salagean, Viorel, ed., *Singe, Durere, Speranta: 16–22 Decembrie* (Bucharest, 1990). Photo: Anonymous: fig. 240, p. 132; fig. 336, p. 186.